Pacific Encounters

Art & Divinity in Polynesia 1760–1860

STEVEN HOOPER

THE BRITISH MUSEUM PRESS

This book and exhibition
are dedicated to the memory of
James Hooper and Bob Sainsbury
and to Polynesian artists
past and present

Published to accompany the exhibition
Pacific Encounters: Art and Divinity in Polynesia 1760–1860
Sainsbury Centre for Visual Arts
University of East Anglia, Norwich
21 May–13 August 2006

This publication and exhibition are made possible
by the generosity of Lady Sainsbury
and of the Robert and Lisa Sainsbury Charitable Trust

First published in 2006 by The British Museum Press
A division of The British Museum Company Ltd
38 Russell Square, London WC1B 3QQ

www.britishmuseum.co.uk

A catalogue record for this book is available from the British Library

ISBN-13: 978-0-7141-2575-6

ISBN-10: 0-7141-2575-X

Designed by Harry Green
Printed in Spain by Grafos SA, Barcelona

This publication and exhibition form part of the research project
Polynesian Visual Arts: meanings and histories
in Pacific and European cultural contexts
funded by the Arts and Humanities Research Council
(grant no. RG/AN10253/APN16516)

The Sainsbury Centre for Visual Arts
is supported by

Arts & Humanities
Research Council

The Gatsby Charitable Foundation

SAINSBURY CENTRE
for Visual Arts

UEA
NORWICH

THE
BRITISH
MUSEUM
A Partnership UK project

Books are to be returned on or before
the last date below.

Exhibition
Catalogue

LIBREX—

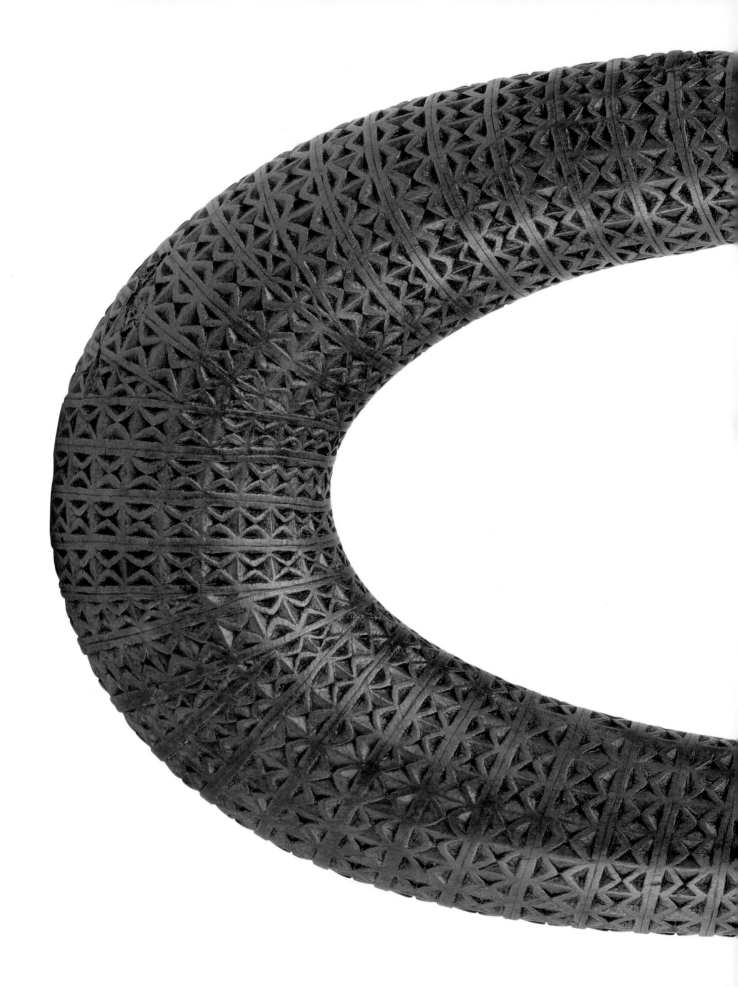

Contents

Foreword

When contemplating these impressive things from the past, one's imagination calls to mind the seafarers and artisans, the elaborate social hierarchies and cultural diversity which are our Polynesian heritage. This book and the exhibition it accompanies capture the essence of that wonderful legacy.

It is, foremost, a tale of engagement – how these peoples in a hitherto remote corner of the globe came to terms with their environment and with the European overtures which followed. It was to be a fruitful if sometimes painful encounter on both scores. Beginning in the age of enlightenment and concluding in the era of missionaries and colonizers, the perspectives of Polynesians and Europeans revealed in this volume speak to the verities of human nature. Wariness, distrust, misunderstanding, conflict, appeasement, accommodation, acceptance and trust occurred in varying degrees. The Polynesians' view of this process would probably have broadly echoed Talleyrand's 'J'ai vécu', when asked about his reaction to the upheavals of the French Revolution. Throughout this period, the pictorial feast now paraded before us was being amassed, recorded and documented for posterity. For that, a debt of gratitude is owed those early collectors.

Although the cultural milieus of Polynesia have been transformed, sometimes beyond recognition, the strength, pride and spirit of our Polynesian forebears are qualities which we need to rediscover. These island societies amounted to far more than the sandy beaches and palm fronds so beloved of Western perceptions. On their own terms, Polynesians were sophisticated and talented peoples – their capacity for intrigue and statecraft was no less subtle or ingenious for its tropical setting. There is no doubt that reflecting on our past can provide useful lessons for contemporary Pacific society. True, the world has changed. However, the way in which these Polynesians harnessed and husbanded their island resources, as well as cooperated with each other and with outsiders, resonates down the ages to the present.

It has been an insightful revelation to see these Polynesians through the implements and the crafts with which they shaped their surroundings. They quite simply mastered them through a combination of determination, strength, acuity and wisdom. To be able to make some connection with our ancestors through these objects is, for the writer, both a profound and humbling experience.

JONI MADRAIWIWI
Roko Tui Bau, Fiji

Preface and Acknowledgements

In the course of preparing a lecture at the British Museum in 2001, a quiet hour was spent with the famous casket figure from Rurutu which was then on temporary display. I looked not only at the small images with which it is covered, but also pondered the work of the maker(s) – how the carving must have proceeded, how the interior was hollowed and the removable back panel shaped and fitted. Trying to get into the mind of a carver faced with particular challenges and opportunities helped me develop the hypothesis that the image was made to contain the skull and long bones of a revered personage – it was a reliquary. Now it stood empty before me, yet despite being empty it was replete with possibilities of many kinds. One was that this and other remarkable objects might form an exhibition which could explore their significance, both in Polynesian contexts and in the contexts of their journeys to places such as the British Museum. From these musings developed a research project, an exhibition and this book, which is intended both as a record of the exhibition and as an introduction to Polynesian 'art' of the period 1760–1860.

My personal motivations for this endeavour derive from spending many weeks in 1970 with my grandfather James Hooper, then gravely ill, cataloguing his collection and being entranced by the objects we examined together and by the books which I read in the evenings. This inspired a resolve to visit the Pacific – something my grandfather had never done – an ambition which was realized by spending over two years in Fiji, living with wood carvers and barkcloth makers who helped me try to understand important things about objects and relationships in Polynesian life. Later I had the privilege of working closely with Bob Sainsbury who, like my grandfather, loved Polynesian art. His enthusiasm led to the establishment of a research department in the Sainsbury Centre for Visual Arts, and eventually to the current project. However, neither book nor exhibition would have been possible without the help and encouragement of many people, and it is my pleasant task to acknowledge them here.

Fundamental to the entire complex enterprise have been the staff of the Department of Africa, Oceania and the Americas at the British Museum. Without their commitment nothing could have happened. The reason so many rare things were available for loan is that there is at present no permanent gallery for the Pacific at the British Museum. Given the extraordinary quality of their Pacific collections – not just Polynesian – this is a situation it is hoped will soon be remedied. Lissant Bolton, Jenny Newell and Jill Hasell deserve my profound thanks, and I wish to thank Jill especially for being a wonderful collaborator during many magical days spent at the stores at Orsman Road. John Mack, Jonathan King, Fiona Grisdale, Stewart Marsden, Pippa Cruickshank, Jim Hamill and Sovati Smith have all given much valued advice or assistance. I would also like to thank Mike Row for all the new photography and for being so patient with my finicky requests for specific angles and positions.

Anita Herle at the Cambridge University Museum of Archaeology and Anthropology was, as

ever, generous with time and support, and I would like to thank David Phillipson, Amiria Henare, Tabitha Cadbury, Mark Elliott, Wonu Veys and Gwil Owen for assistance at various stages. Jeremy Coote and Mike O'Hanlon at the Pitt Rivers Museum at Oxford have been marvellously supportive in the midst of their own rebuilding upheavals. The following people from a variety of institutions (listed on p. 77) have given essential and much appreciated support: Chantal Knowles, Henrietta Lidchi, Lesley-Ann Liddiard, Sally-Anne Coupar, Euan MacKie, Evelyn Silber, Malcolm McLeod, Neil Curtis, Christopher Lee, David Roberts, Sue Giles, Len Pole, Tony Eccles, Victoria Williams, David Jones, Les Jessop, Julia Bazley, Sarah Wilson, Julia Steele, Janet Owen, Sara Grove, Andrew Johnston, Angeline Leung, Winifred Glover, Rachel Hand, Bertrand Radigois, David Verhulst, Roger Neich, Krzysztof Pfeiffer, Sara Perrett, Roger Fyfe and Kate Muirhead. The comments of two anonymous readers have been much appreciated.

The financial support of the Robert and Lisa Sainsbury Charitable Trust is very gratefully acknowledged. Bob, Lisa, David and other members of the Sainsbury family have done so much to encourage us all in the Sainsbury Centre for Visual Arts to strive for high standards, and we hope our efforts are worthy of their confidence in us. I am also grateful to the Arts and Humanities Research Council, whose grant for our Polynesian art project has funded background research costs.

At the University of East Anglia, the first to be thanked is Karen Jacobs, the AHRC project researcher, whose combination of enthusiasm, efficiency and sound judgement have been crucial to putting together a book and an exhibition in less than a year. Her contribution is immeasurable. I also thank her for her meticulous work on the 'Collectors' appendix. The specific and thoughtful contributions of Ludovic Coupaye and, in the early stages, Helen Southwood, are also warmly acknowledged. My colleagues and students at the Sainsbury Research Unit, George Lau, Josh Bell, Francine Hunt, Pat Hewitt, Lynne Humphreys, Julia Martin, Maia Jessop, Andrew Mills, Julie Adams, Wonu Veys and Lucie Carreau have all been generous in their support and in relieving me of departmental tasks, for which I thank them. I would also like to acknowledge the major contributions of Amanda Geitner and Sarah Bacon of the Sainsbury Centre staff, and the help of Nichola Johnson, Kate Carreno, Veronica Sekules, Nadine Parnell, Calvin Winner, Sara Cooper, Pippa Yuill, Charlotte Peel, David Rees and John Squires. Joe Geitner, Phil Atkinson and George Sexton of George Sexton Associates have contributed wonderful exhibition designs.

I have been most fortunate in my editor and designer at the British Museum Press, with both of whom it has been a pleasure to work. Laura Lappin has been a wise and perceptive advisor in the context of tight deadlines; Harry Green has shown great flair in his presentation of the book, and was easily persuaded of the virtues of Polynesian fish hooks. I also wish to thank David Hoxley for his work on the maps.

Finally, I am very grateful to Ratu Joni Madraiwiwi for graciously agreeing to write a foreword and to all the Polynesian artists who made the objects shown in this book. To the following friends, colleagues and family I am indebted for inspiration, instruction and forbearance: Hermione Waterfield, David Attenborough, David King, Richard Cranmer, Mark Blackburn, Christopher Stone, Christopher Foy, Judy Portrait, Adrienne Kaeppler, Marshall Sahlins, Peter Gathercole, Fergus Clunie, Paul Geraghty, Ivan and Ateca Williams, Dickie and Kelera Watling, Mereise Vatu, Jiosefate Volauca, Kenneth Hooper, Babette Coombes, Susan Phelps and Lise Strukelj. My wife Yaidé and sons James and Frederick have suffered much neglect, yet been wonderfully supportive throughout. This book is also for them, with love.

STEVEN HOOPER
December 2005

Timeline

SELECTED EUROPEAN VOYAGES (dates, commander, principal ship(s) and country of origin)

1519–22	Ferdinand Magellan	*Trinidad, Concepción, Victoria*	Spain
1595–6	Alvaro de Mendaña de Neyra	*San Jeronimo*	Spain
1642–3	Abel Janzsoon Tasman	*Heemskirck, Zeehaan*	Netherlands
1721–2	Jacob Roggeveen	*Arend, Thienhoven, Afrikaansche Galei*	Netherlands
1764–6	John Byron	*Dolphin*	Britain
1766–8	Samuel Wallis	*Dolphin*	Britain
1766–9	Louis-Antoine de Bougainville	*Boudeuse, Etoile*	France
1768–71	James Cook (first voyage)	*Endeavour*	Britain
1772–5	James Cook (second voyage)	*Resolution, Adventure (1772–4)*	Britain
1772–3	Domingo de Boenechea	*Aguila*	Spain
1774–5	Domingo de Boenechea	*Aguila, Jupiter*	Spain
1775–6	Cayetano de Langara y Huarte	*Aguila*	Spain
1776–80	James Cook (third voyage)	*Resolution, Discovery*	Britain
1785–8	Jean-François de la Pérouse	*Boussole, Astrolabe*	France
1787–9	William Bligh	*Bounty*	Britain
1789–94	Alejandro Malaspina	*Descubierta, Atrevida*	Spain
1791–5	George Vancouver	*Discovery, Chatham*	Britain
1791–3	Joseph-Antoine Bruny d'Entrecasteaux	*Recherche, Ésperance*	France
1791–3	William Bligh	*Providence, Assistant*	Britain
1796–8	James Wilson	*Duff*	Britain
1803–6	Adam von Krusenstern	*Nadezhda*	Russia
1803–6	Yuri Lisiansky	*Neva*	Russia
1812–13	David Porter	*Essex*	USA
1815–18	Otto von Kotzebue	*Rurik*	Russia
1817–20	Louis de Freycinet	*Uranie*	French
1823–6	Otto von Kotzebue	*Predpriatie*	Russia
1824–5	George Anson Byron	*Blonde*	Britain
1825–8	Frederick Beechey	*Blossom*	Britain
1826–9	Jules-Sébastien-César Dumont d'Urville	*Astrolabe*	France
1836–42	Edward Belcher	*Sulphur*	Britain
1837–40	Jules-Sébastien-César Dumont d'Urville	*Astrolabe, Zélée*	France
1838–42	Charles Wilkes	*Vincennes, Peacock, Porpoise*	USA
1849	John Erskine	*Havannah*	Britain
1852–61	Henry Denham	*Herald*	Britain
1865	William Wiseman	*Curaçoa*	Britain

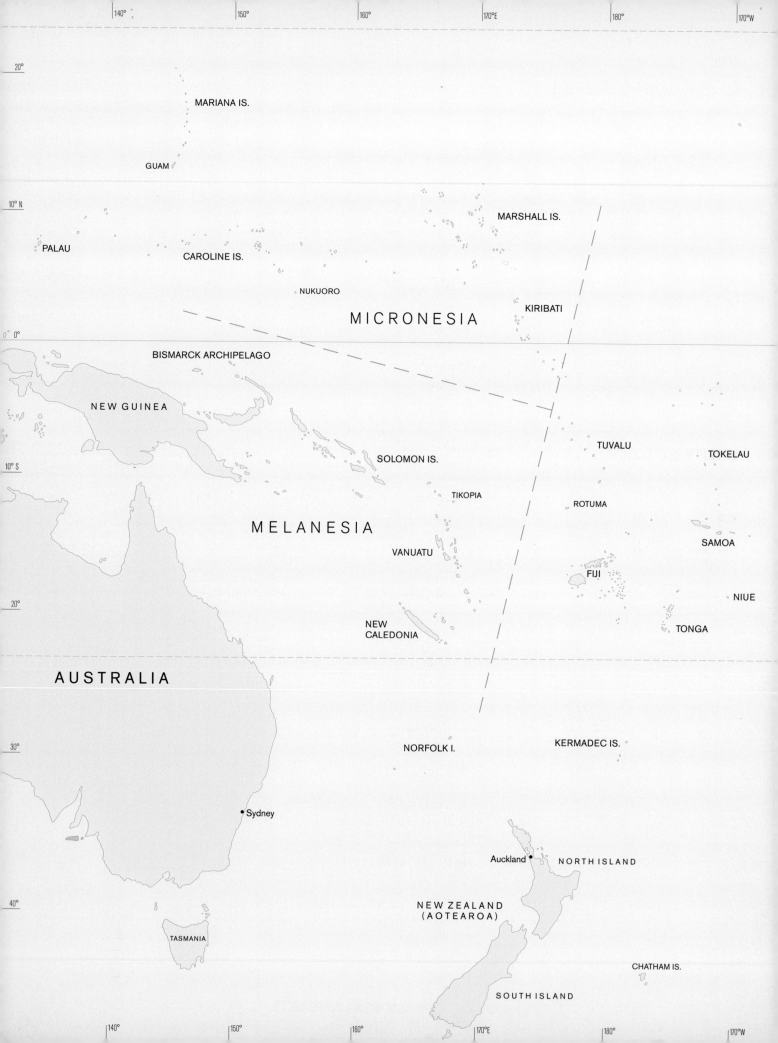

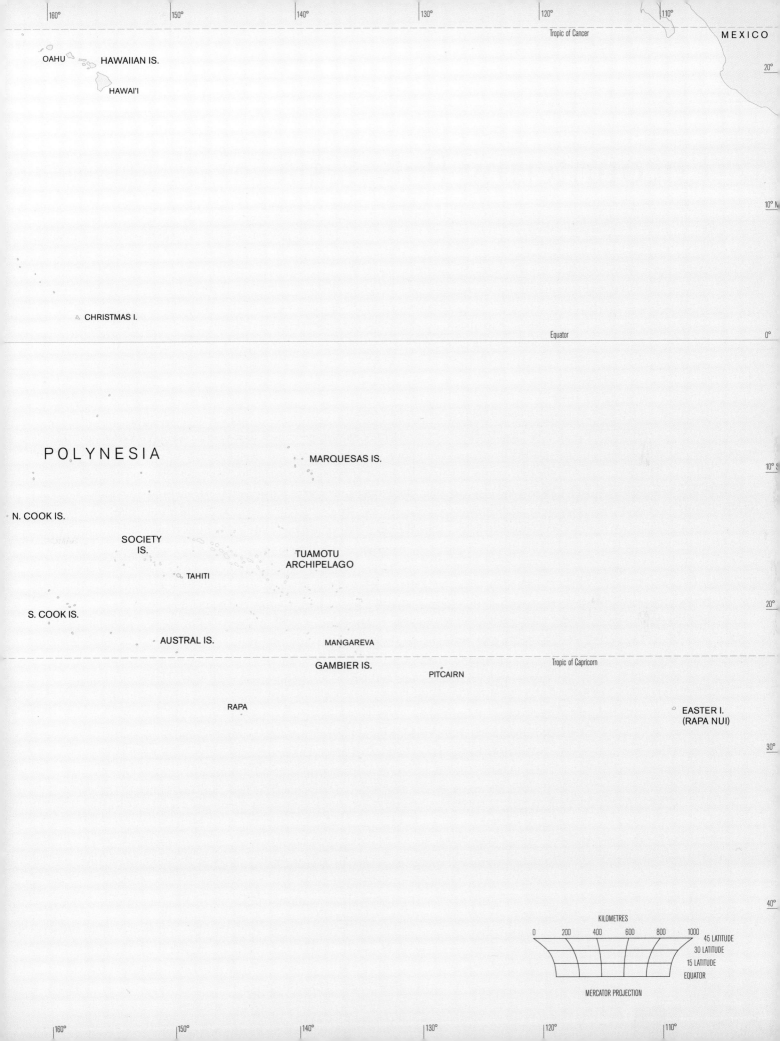

| 160° | 150° | 140° | 130° | 120° | 110° | |

Tropic of Cancer

MEXICO

20°

OAHU HAWAIIAN IS.

HAWAI'I

10° N

CHRISTMAS I.

Equator 0°

POLYNESIA MARQUESAS IS.

10° S

N. COOK IS.

SOCIETY
IS. TUAMOTU
 ARCHIPELAGO
 TAHITI

S. COOK IS. 20°

 AUSTRAL IS. MANGAREVA

 GAMBIER IS. Tropic of Capricorn
 PITCAIRN

 RAPA EASTER I.
 (RAPA NUI)

30°

40°

KILOMETRES

| 0 | 200 | 400 | 600 | 800 | 1000 |

45 LATITUDE
30 LATITUDE
15 LATITUDE
EQUATOR

MERCATOR PROJECTION

| 160° | 150° | 140° | 130° | 120° | 110° | |

1

Encountering Polynesia

'How can we make any progress in the understanding of cultures, ancient or modern, if we persist in dividing what the people join and in joining what they keep apart?'

ARTHUR MAURICE HOCART, *The Life-giving Myth* (1952: 23)

Imagination and experience

The islands which constitute the region now known as Polynesia have been imagined places for voyagers and settlers of all kinds – for the 'Lapita peoples' of 1000 BC, probing eastwards into unknown territory; for their Polynesian successors venturing further east, north and south; and for later European voyagers, missionaries, colonialists, artists, tourists and academics. For Polynesians the islands are home, land, *fenua*, the place of ancestors, the place for descendants, the place with which one is intimately connected as part of one's being, the place one has named, claimed and fought for. The experience of three thousand years of exploration and occupation have embedded in Polynesians a co-identity with the land and the forest, with the lagoon and the deep sea – with all the elements which combine to make up 'Oceania' as evoked by the Tongan writer and scholar Epeli Hau'ofa.[1]

This profound relationship has been manifested in objects, histories, oral traditions, songs, dances, monuments, buildings and cultural practices of all kinds. It is mainly with objects, in their widest possible contexts, that this book is concerned. Yet objects – figures and fish hooks, clubs and fans – do not just exist, they were made by someone, or some group, with painstaking care and with particular purposes in mind. This book is therefore about, and for, those Polynesian makers, and also for their descendants and for anyone else willing to look upon these things with admiration and respect.

The story begins several millennia ago in the islands of Southeast Asia, but by about AD 1200 tenacious Polynesian voyagers had visited or occupied almost every significant island in the whole Pacific Ocean east of Vanuatu. They had also most probably reached and returned from the Central or South American coast. In contrast, the peoples of East Asia and the Americas had not dared to venture into the wide expanses of the Pacific, concerning themselves more with coastal voyaging. However, in the sixteenth century different voyagers – Dutch, Spanish and British – began to probe at the margins of the Pacific. Spanish 'Manila galleons', trading silver for exotic Chinese goods, even began to cross it regularly on an east–west track between the American coast and the Marianas, the Philippines and Canton. Their route for centuries missed the swathe of Polynesian islands to the south of the equator and Hawaii to the north.

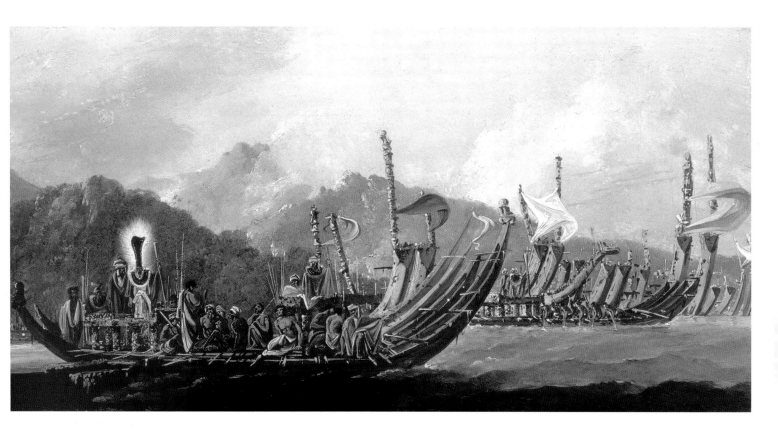

FIG. 1 William Hodges, *Review of the War Galleys at Tahiti, c.* 1776; oil on panel, 24.1 x 47.0 cm. National Maritime Museum, Greenwich. Combining Hodges' imagination and experience, this picture was painted from studies made in April–May 1774 of a Tahitian fleet massing in a display of power prior to an attack on Mo'orea (which did not take place). Chiefs wearing *taumi* breastplates (no. 141) and red cloth robes can be seen in three of the canoes.

This pattern of probing and crossing continued until the 1760s, when an unprecedented period of European[2] voyaging began. These voyagers – explorers, scientists, artists, traders, whalers, evangelists, planters and settlers of all kinds and from many countries – brought their own imaginative constructions about the islands they sought and saw, which in turn have fed the imaginations of generations of Europeans ever since (fig. 1).[3] Paradise and palm trees, people in a state of nature or pagan barbarism, free love and cheap land – the dreams and delusions of European imaginations have often proved a bitter experience both for them and for the islanders. The realities of famine and hurricane, disease and demographic collapse, murder and land appropriation – by fair means or foul – characterize the period under review. Of course, none of these was new to the region, but the encounters and collisions between islanders and outsiders during this period led to transformations of an accelerated kind which have marked the region profoundly.

Between 1760 and 1860 the cultural landscape of Polynesia changed in fundamental ways. At the beginning of this period Polynesian relationships were primarily with each other, as the powers of chiefdoms waxed and waned in different parts of the region. Christianity was virtually unknown. Europeans had been encountered briefly in several places but remained largely mysterious. By 1860 every part of Polynesia was locked into relationships of a colonial or pre-colonial kind with European powers, and most Polynesians had been, nominally at least, converted to one of various competing forms of Christianity. There are many different Polynesian views on this situation and its enduring legacy – joy

FIG. 2 A temple drum with unique pandanus-leaf wrapping around the chamber (not exhibited). Ra'ivavae, Austral Islands; late eighteenth or early nineteenth century; wood, shark skin, fibre, coir; h. 134.0 cm. Private collection.

that Christianity and its 'light' was brought to drive out darkness, pleasure in European-derived technologies, despair at disease, death and alienation, and anger at the powerlessness of those dispossessed in their own lands. Polynesia was indeed a very different place yet, paradoxically, a vigorous Polynesian identity survived, and still survives. Introduced institutions, including the church, were Polynesianized, and alongside the sad tales of epidemics and cultural loss are the uplifting tales of cultural endurance and adaptability. This was, of course, nothing new. Polynesians had been enduring and adapting for millennia.

The aim of this book and the exhibition which it accompanies is to attempt some understanding of this key period in Polynesian history by focusing on two main themes. The first concerns the role and significance of objects in their indigenous contexts. These contexts were intimately connected to Polynesian cosmology, and to social and ritual relations, which increasingly involved Europeans. Such contexts were dynamic. We are not searching to explain some static 'classic' type of Polynesian culture, because that never existed and such stereotypes are best avoided. Rather, an attempt is made to explain cultural situations in Polynesia which were in flux due to both internal and external factors. The second main theme relates to the trajectories of these objects from their places of manufacture and use in Polynesia to their subsequent and current locations. This is a story of shifting meanings, of valuations, evaluations and re-evaluations. This book and exhibition are exercises in evaluation, but they are also intended as celebrations, for it may not be overstating the case to say that Polynesian art of this period is one of the great but least known art traditions of the world. The achievements of those carvers, textile makers and transformers of raw materials into cultural objects deserve to be recognized. It is important that records of this historical period survive not only in European books or paintings, but in material objects made by Polynesians themselves – as physical manifestations of a cultural tradition which is ongoing and strong, and whose past is constantly being re-evaluated. These objects are great things of the past and it is important to cherish them (figs 2–3).

Ultimately, a book of this kind consists of the imaginings of the author, which are imposed on the material and the way it is presented. These imaginings are based on experience of living in one part of Polynesia and visiting others, and on assessments of scholarship, Polynesian and European. They are also written with Hocart's dictum, quoted above, constantly in mind, a caution for us to be aware that indigenous classifications are a pathway to understanding. Fifty years ago it might have been thought that Polynesian societies of the eighteenth century were as documented and known as they would ever be, but over the last few decades new scholarship in history and anthropology has led to illuminating understandings which enable us to comprehend more clearly the complexities and nuances of Polynesian cultural practices. The aim here is to place objects firmly in the forefront of such research, and to show how a study of material culture can enhance understandings rather than just support those derived from other sources. This endeavour is possible because of the remarkable legacy of Polynesian objects which have survived in museums and collections all over the world. If this publication and these objects succeed in evoking awe, wonder and above all respect, then an important task will have been accomplished.

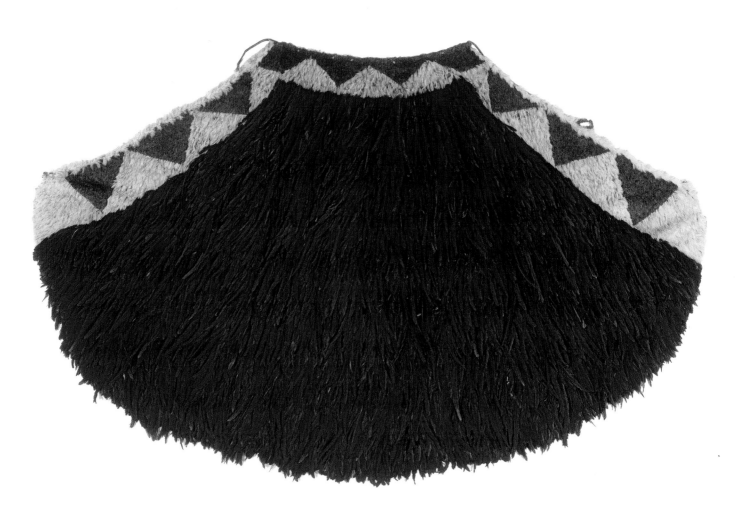

FIG. 3 A magnificent feathered cloak from Hawaii, probably given by Kaneoneo, chief of Kaua'i, to Captain Clerke in 1778 during Cook's third voyage (not exhibited). Cloaks were both high-status robes and important exchange valuables. Fibre, red 'i'iwi, yellow 'o'o and black cock's feathers; l. 175.0 cm. British Museum.

Polynesia: a geographical and cultural region

The term Polynesia, from the Greek for 'many' and 'island', was first coined by Charles de Brosses in his *Histoire des Navigations aux Terres Australes* (1756), when it was used for all the islands in the 'South Seas', as the region was then called. The term did not come into regular use until the 1830s when the French voyager Jules Dumont D'Urville proposed the tripartite classification of the region into Polynesia, Micronesia ('small islands') and Melanesia ('black islands'). These terms have continued to be of geographical utility but they have to be used with care in other respects. The populations of Melanesia are culturally and linguistically extremely diverse – with an occupation time depth running in some places to over 40,000 years. Micronesia also has no clear cultural uniformity, but it can be argued that Polynesia does because of its particular geographical and historical circumstances. From Hawaii in the north to Easter Island in the east and New Zealand in the southwest, the peoples of the eighteenth century inhabiting all the islands within that great 'Polynesian triangle' shared common origins in the western area of Polynesia some three thousand years ago.

Like all large regions, Polynesia does not have tidy boundaries. Fiji is included here in Polynesia because the coastal and eastern Fijians have longstanding kinship connections

with peoples of Tonga and Samoa, although some of the peoples of the interior of the main islands of Fiji are descended from later migrants from the west. There are also Polynesian populations on islands within the geographical areas of Micronesia and Melanesia – the so-called Polynesian Outliers – who migrated there from Western Polynesia during the last thousand years. Archaeologists have divided the region culturally into Western Polynesia (present-day Fiji, Tonga, Samoa, Tokelau, Tuvalu, 'Uvea (Wallis), Futuna, Rotuma and Niue) and Eastern Polynesia (all the other islands east, northeast and south of Western Polynesia, including Hawaii, Easter Island and New Zealand). The latter category includes all the islands which were colonized by eastward migrations from Western Polynesia after about AD 500–600. The term Central Polynesia is also often used, as here, to designate the Society Islands, the Tuamotus, the Australs and the Cooks, which were all in contact in the pre-European period.

With respect to cultural connections, eighteenth-century voyagers noticed similarities in language, institutions, material culture and appearance between the inhabitants of all parts of Polynesia, giving rise to questions about origins and migrations.[4] Despite the evident cultural and historical relationships between Polynesians, Edmund Leach (1985) wisely cautioned against postulating a 'Polynesian culture' as some reified thing which could be identified and demarcated. However, in Polynesia perhaps more than in any region in the world, it can be argued that cultural transformations took place over many centuries with little or no interference from non-Polynesian influences, except perhaps in the west, where Fiji exhibits more complex cultural interactions.[5]

One area of demonstrable relationship is language. Tupaia, the priest/navigator from the Society Islands whom Joseph Banks persuaded Cook to take on board in 1769, was able to converse with people on New Zealand, though not with those he met on the east coast of Australia. All inhabitants of Polynesia speak Austronesian languages, in common with peoples inhabiting large parts of Melanesia, Micronesia, the islands of Southeast Asia and Madagascar. Differences in languages can indicate the period of time since populations diverged from a common stock – the greater the difference, the longer the time since divergence. In Austronesian languages vowels generally change at a slower rate than consonants, and examination of certain key words in Polynesia can demonstrate the similarities which underlie surface differences. In New Zealand Maori, Tahitian and Hawaiian the name of the sea god is respectively Tangaroa, Ta'aroa and Kanaloa. During centuries of separation consonants have shifted while vowels remain constant.[6]

So there is no Polynesian 'culture' as such, but by the eighteenth century the region was inhabited by peoples with close linguistic and cultural connections who shared common ancestry. They had, with great resourcefulness and over many centuries, adapted creatively to local conditions and circumstances.

Multiple encounters

The encounters signalled in the title of this book are of many kinds. At a fundamental level, wherever the early Polynesians went they encountered different environments to which

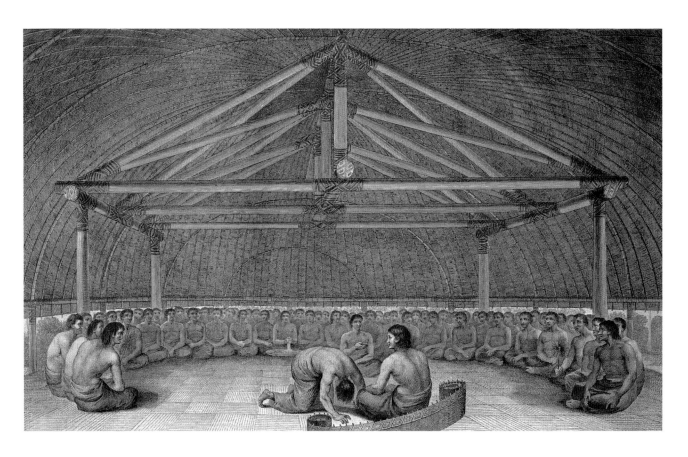

FIG. 4 *Poulaho, King of the Friendly Islands, drinking kava*, engraving by W. Sharp after John Webber. The royal kava is being served with reverence to the Tu'i Tonga from a wooden bowl (similar to no. 248) during Cook's third-voyage visit to Tonga in 1777. A highly *tapu* occasion, the ritual was held in a large house, its roof timbers elaborately bound with coir cordage.

they were able to adapt. Depending on the nature of the islands – volcanic 'high' islands, atolls, raised coral '*makatea*' formations, or combinations of these types – they developed agricultural and marine harvesting techniques to suit local conditions. In many places they were highly successful, in others over-exploitation of resources led to deforestation, species extinctions and survival difficulties. Easter Island and Rapa are examples of the latter case, both being sub-tropical rather than tropical environments. New Zealand, being temperate, presented special challenges in adjusting to a colder climate where familiar staples such as taro and yams did not flourish, and coconuts would not grow. The paper mulberry, source of barkcloth clothing in the tropics, also did not thrive and native flax was used to make cloaks, capes and cordage. These human encounters with environments were also framed by existing cosmological understandings. The sea and the land were attributed with divine associations, often explicitly in the form of gods – for example Tangaroa with the sea and Tane with the forest. These two domains, and the birds which inhabited them, provided the materials which were used to make cultural objects, and often the logic of choosing a particular material was connected to the sea or land domain from which it derived.

During the course of their settlement of the region Polynesians also encountered other Polynesians, as relatives, enemies, or both. The presence of weapons and fortifications are testimony that warfare was no less a feature of life than in any other part of the globe. There were also exchange relationships, usually predicated on affinal ties (through marriage), between chiefdoms or kinship groups. Affinal relationships have

always been extremely important, involving mutual exchanges and offerings on a regu-
lar basis, because the true foundation of a relationship in Polynesia is based on repeated
action, not just on blood ties. Many of the objects in this book were made to be pre-
sented as offerings either to those of higher status, such as chiefs, or to relatives. These
status and kinship relationships were regionally important in Western Polynesia and
Central Polynesia in the eighteenth century, when inter-island voyaging facilitated
complex exchange relations, competition between chiefdoms and 'dynastic' marriages.[7]
In Western Polynesia at that time it is clear that specialist carpenters were moving under
chiefly patronage from Samoa to Tonga and on to eastern Fiji, where excellent hard-
wood resources allowed them to build large and highly manoeuvrable canoes.[8] These
carpenters were also making one-piece four-legged wooden bowls for the public offer-
ing and consumption of the drink kava (fig. 4; no. 248). Dynamic developments of this
kind are likely to have had little to do with European probings in the region, but were
part of a pattern of change which had been going on for centuries.

Another type of encounter which was fundamental to Polynesian life was that
between humans and gods – religious encounters. More will be said about the nature of
these relationships in Chapter 2, but again there is evidence of dynamic shifts taking
place in the eighteenth century, notably in the Society Islands, where a cult dedicated to
the god 'Oro, based on Ra'iatea, was becoming very influential in regional affairs (see
nos 130–34).

A critical set of encounters were those between Polynesians and Europeans, which
occurred throughout the period under review. These were of many kinds and at many
levels. Ships' officers, crew members, traders, castaways, beachcombers, whalers, mis-
sionaries, travellers, settlers, colonial administrators, soldiers, artists – Europeans of all
kinds found their way to Polynesia and some of their interactions are considered in
Chapter 3. For the present, a few reflections will be offered on one type of artefact which
was important in these encounters and which Polynesians and Europeans had in
common – boats.

Encounters have been characterized as taking place actually and metaphorically across
beaches, as liminal spaces, but gunwales and taffrails were also key sites of interaction.
During the visit to Tahiti by Samuel Wallis in 1767, George Robertson, the Master,
referred to the *Dolphin* as 'our great canoe' (1948: 156), and this is possibly a helpful way
of thinking about eighteenth-century European vessels. They were hardly much longer
than some Tahitian, Ra'iatean and Tongan canoes (the *Dolphin* was 34 metres, Cook's
Endeavour 30 metres), and they were similarly plank-built. Polynesians, once on board,
were interested in examining the ships, and in the details of joinery of tables and chairs.
It is likely that the bulk, carrying capacity, cargo, decking and rigging will have impressed
Polynesians, indicating as they did control over resources and technical skills of a high
order. The ships' captains, costumed in 'sacred' red, will have appeared as powerful
chiefs with whom relationships needed to be carefully managed in order to derive maxi-
mum benefit and minimum trouble. There is also no doubt that local canoes impressed
Europeans, which is evidenced by the detailed drawings of canoes done on Cook's voyages
(fig. 5), and the trouble to which Wallis went to bring back from Nukutavake the canoe

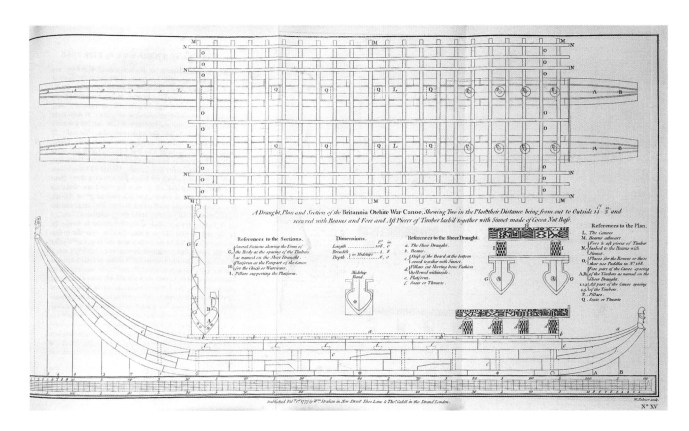

A Draught Plan and Section of the Britannia Otahite War Canoe, Shewing Two in the Plan their Distance being from out to Outside 14 ft 3 in and secured with Beams and Fore and Aft Pieces of Timber lashd together with Sinnet made of Cocoa Nut Bass.

Published Feb.y 1.st 1777 by W.m Strahan in New Street Shoe Lane & Tho.s Cadell in the Strand London.

N.º XV

FIG. 5 *A Draught Plan and Section of the Britannia Otahite War Canoe*, engraving by W. Palmer. Over 108 feet (33 metres) long, this canoe was ready to be launched on 14 May 1774 when Cook gave a grappling hook, rope and flag to the Tahitian chief Tu, his *taio* (exchange partner, see fig. 21), with the request that she be called *Britannia* (Beaglehole 1961: 402). Cook's own ship, HMS *Resolution*, was only 2 feet longer.

presently in the British Museum (no. 121). The dramatic naval review of more than 160 large canoes at Tahiti in 1774 made a considerable impression on members of Cook's second voyage; William Hodges made several drawings and paintings of the scene (fig. 1).

Ships and canoes, of course, were more than skilled constructions. For Polynesians they were great valuables, exchange goods and status objects – a Fijian canoe at Somosomo in the 1830s was measured at 118 feet (36 metres). In the nineteenth century Polynesian chiefs in various places, including Kamehameha in Hawaii and Cakobau in Fiji, acquired numerous European vessels for commercial and status purposes. Conversely, models of canoes became a favourite souvenir for European collectors. Canoes have recently again become important symbols of Polynesian achievements, as we shall now see.

The past in the present

During the last thirty years a series of adventurous voyages has been made all over Polynesia in a 20-metre replica double-hulled sailing canoe named *Hokule'a*, Hawaiian for the star Arcturus. The first voyage in 1976, from Hawaii to Tahiti, was navigated without instruments by an experienced Micronesian sailor, Mau Piailug, from Satawal. Subsequent voyages, navigated by Polynesians, have reached every major group in Polynesia, including Easter Island in 1999.[9] These voyages have spawned further canoe-building and long-distance voyaging throughout Polynesia, and have reawakened an intense interest in Polynesian history, migrations and cultural relations. This is the past in the present for

FIG. 6 A massive figure from Easter Island, carved *c.* AD 1000–1200, collected during the voyage of HMS *Topaze* in 1868 (not exhibited). Called Hoa Hakananai'a ('hidden or stolen friend'), it originally stood on a temple platform, but was collected from the ritual site at Orongo. Many large stone images (*moai*) were made on Easter Island between the ninth and seventeenth centuries (see Van Tilburg 1992; 2004). Stone; h. 2.42 m. British Museum.

Polynesians, re-enacting the achievements of their forebears at a time when identity is under threat.[10] Polynesians are reclaiming and re-engaging with their past in many ways, and one way is via objects such as replica canoes, which can be vehicles for celebrating the great deeds of the ancestors. This is one reason why the preservation of old things is so important, for they are being re-evaluated in the modern context of heritage. This theme will be discussed further, but for the present let us consider some current understandings of Polynesia's past, grounded in the disciplines of archaeology and history.

We know great voyages took place, but what is the story of the human occupation of this part of the world? The central Pacific was the last habitable area of the globe to be explored and settled by humans. Archaeologically the Pacific has been divided by Roger Green (1991) into Near Oceania (Solomon Islands and lands west) and Remote Oceania (Vanuatu and all islands east and south). Populations ultimately originating in Southeast Asia were by about 1000 BC making landfall in Vanuatu, and almost immediately a major upwind voyage of 700 miles was made to the islands now called Fiji. These people must have been sophisticated navigators, and it is highly likely that return voyages were made as part of colonizing expeditions to settle the new and fertile lands which had abundant terrestrial and marine resources.

These early settlers made a distinctive kind of dentate-stamped pottery, called Lapita-ware after the site on New Caledonia where it was first identified by archaeologists. These Lapita peoples, as they have been called, were the early ancestors of contemporary Polynesians.[11] No doubt further groups of settlers moved eastwards from Melanesia at various periods during the last three thousand years, mingling with forerunners to create a complex settlement situation in Fiji. However, the archaeological record is increasingly showing a picture of initial Lapita settlement and consolidation in Western Polynesia after about 1000 BC, followed by an eastward shift to Central Polynesia – to the Society Islands or the Marquesas – during the second half of the first millennium AD. This was followed quickly by further eastward, northward and southward movements until Easter Island (fig. 6), Hawaii, the Australs and the Cook Islands were settled by about AD 900. Until recently it was thought that the eastward shift to Central Polynesia took place more than two thousand years ago, followed by a period of consolidation of several hundred years. It now seems increasingly likely that there was a burst of voyaging over vast areas of the Pacific in a relatively short space of time – the three centuries or so prior to AD 1000.[12]

The reasons for this period of intense activity are unclear, but population pressure is not likely to be among them. It may be best to look for ideological rather than economic or demographic motives for this adventurous phase of voyaging. It is clear that these voyages were made less hazardous by a strategy of periodic eastward probings 'upwind', against the prevailing southeast trades.[13] Easterly progress was always the problem in sailing canoes, and so eastward voyages were undertaken during periods of sustained westerly winds because navigators knew from experience that the southeast trade winds would return and allow a downwind cruise home. This cautious approach, allied to sophisticated navigational skills – knowledge of stars, wave patterns, meteorology, bird

movements and the like – would have allowed many voyages of exploration, colonization and re-colonization to have taken place in relative safety.[14] Sailing across the wind was well within the compass of Polynesian double and outrigger canoes, making the voyages to Hawaii and the Cook Islands less problematic, although of course storms and other mishaps will have taken their toll. On the evidence of their achievements, it would be easy to claim that the Polynesians of that era were the greatest open-ocean voyagers the world has ever known.

The last part of the region to be reached was New Zealand, probably by voyagers from the southern or central Cook Islands. This appears to have taken place around AD 1100–1200, making New Zealand the last significant land mass in the world to be settled by humans. For those voyagers New Zealand presented different sets of problems and opportunities. It was not tropical, so clothing of a more substantial kind had to be developed. There was an abundance of avifauna, including many flightless birds such as the *moa* (a huge ostrich-like bird) which provided a major source of protein, although it was hunted to extinction by about the sixteenth century. The rivers and coasts provided rich marine resources which were exploited by the settlers, but the staple root crops of tropical Polynesia, yams and taro, struggled to grow in the temperate environment, so fern roots and other forest products had to be utilized. A welcome early arrival, either with the first settlers or soon after, was the sweet potato or *kumara*. The appearance of the sweet potato (*Ipomoea batatas*) in the Pacific is both an enigma and a challenge to researchers. It is an American cultigen – it originated in America and it appeared in Polynesia well before any Europeans would have had an opportunity to bring it from the New World (the sixteenth century). It will not survive in salt water, so drift cannot provide the answer.[15] Recent research in voyaging patterns and techniques points towards the likelihood of Polynesian voyagers reaching the American coast and making a successful return voyage (or voyages). After all, if these voyagers had got to the Marquesas and Easter Island by about AD 800, there is no reason why voyaging should have stopped there. They had no knowledge of what lay (or what did not lie) before them. Many expeditions are likely to have set out – some never to return. For those who did reach America, they will have had to provision their canoe for a return voyage of at least six weeks and, being agriculturalists, will have spotted the qualities of the sweet potato.

Once the further reaches of Polynesia were settled, it seems that long-range voyaging expeditions continued, and then gradually ceased. In Western Polynesia there were periods of energetic fortification building and changes in pottery types, although pottery has only been found in Eastern Polynesia in the Marquesas, so other evidence has to be examined to detect cultural change.[16] One further development five hundred or more years ago was Polynesian expansion westwards into islands which are geographically within Melanesia and Micronesia. These are the so-called Polynesian Outliers, islands such as Tikopia, Anuta, Rennell and Bellona in Melanesia, and Nukuoro and Kapingamarangi in Micronesia, all inhabited by populations who originated in Western Polynesia and chose to migrate westwards. The reasons for this voyaging are unclear, but this particular phase is likely to have been prompted by rivalry, warfare, famine or over-population in their homelands, and these voyagers are also likely to have displaced existing populations (fig. 7).

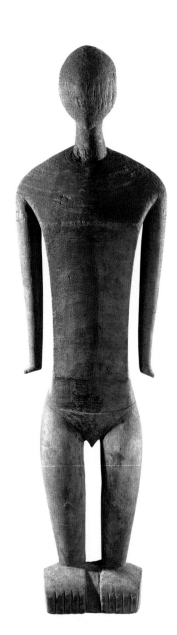

FIG. 7 A large figure from
Nukuoro, a Polynesian Outlier,
it shows formal similarities to
figure sculpture from Tonga
(not exhibited). Mid-nineteenth
century; wood; h. 168.0 cm.
Ethnologisches Museum, Berlin.

Into this situation arrived European voyagers in the sixteenth century. Spanish expeditions were undertaken from the western American coast to take silver to China and return with silks, porcelain and other exotica. Magellan opened up this route in 1520–21 during the first circumnavigation (1519–22). It was followed regularly after that, with apparently no ships visiting major groups such as Hawaii, the Marquesas or the Society Islands. In 1595 the Spaniard Mendaña was the first European to encounter the Marquesas, a brief visit with particularly bloody consequences for the islanders. The Spaniards and the British[17] were active in the region for the following two centuries, but it was the Dutchman Abel Janzsoon Tasman who made significant contacts with Polynesians in the seventeenth century, sailing from the west in 1642 and reaching Tasmania, New Zealand (where several crew and locals were killed) and Tonga.

Growing European interest in possibilities for trade and of discovering the much-rumoured *Terra Australis Incognita* (Unknown Southern Land), which was assumed must exist to counterbalance the great land masses of the northern hemisphere, led to further voyaging in the eighteenth century. But voyagers were hampered by the inability to establish longitude, and therefore locate islands precisely in ways which would allow them to be found again. Latitude could be plotted accurately by observing the sun, but longitude – one's position east or west – required reliable clocks with movements which could withstand a long voyage and still tell the precise time at Greenwich. Clocks of this sophistication were not invented until the second half of the eighteenth century.[18]

Curiosities, trophies and souvenirs

It was aboard HMS *Dolphin* that one of the earliest documented Polynesian artefacts was brought back to Europe – the canoe from Nukutavake in the Tuamotus (no. 121). Collected in June 1767 and accessioned by the British Museum in 1771, this 4-metre vessel appears to have suffered little damage during its voyage home – lashed to the deck of the *Dolphin* – or during its long residence in the stores of the British Museum. It is not perhaps surprising that naval men would be interested in a vessel so ingeniously put together. Nukutavake is an island with relatively poor timber resources, and the skill with which the canoe had been constructed in unfavourable circumstances may have attracted Samuel Wallis, the captain, to acquire it – or approve its acquisition – since the precise circumstances of its collection remain unclear. George Robertson (1948), who wrote the best account of this phase of the voyage, mentions that the islanders abandoned Nukutavake shortly after the *Dolphin*'s arrival. Once ashore, he recorded seeing three large canoes under construction, and also a carpenters' workshop, from which he took some tools and left nails in exchange. He does not mention this smaller canoe or its arrival on deck, where it must have been a not inconsiderable obstruction. Wallis himself does not mention it, although he saw four or five canoes left by the departing islanders. It seems likely that it was borrowed to bring water and fodder on board, and then kept with the other ship's boats. Wallis wrote, 'We also left some hatchets, nails, glass bottles, shillings, sixpences, and halfpence, as presents to the natives, and an atonement for the disturbance we had given them.'[19]

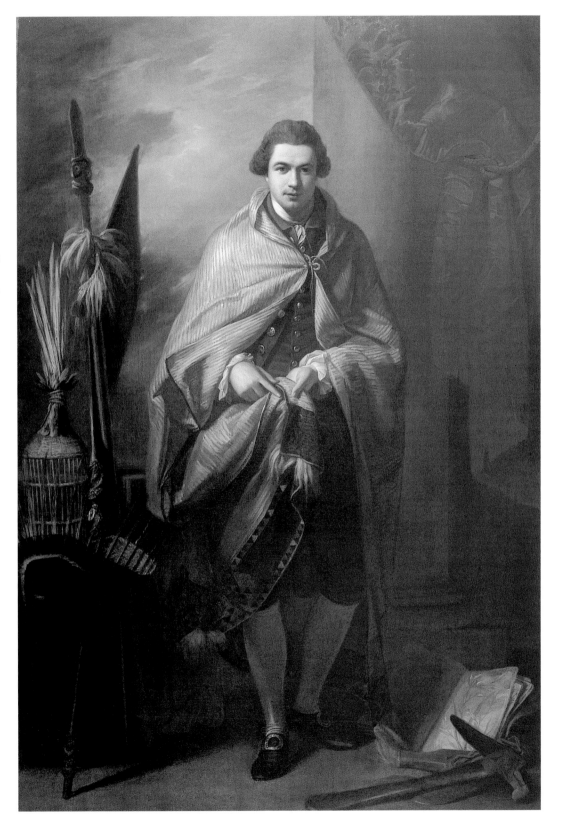

FIG. 8 Benjamin West, *Sir Joseph Banks*, 1771–2; oil on canvas, 234.0 × 160.0 cm. Usher Gallery, Lincoln. The young Banks is shown after his return from Cook's first voyage robed in a fine New Zealand cloak and surrounded by other objects from New Zealand and the Society Islands.

This episode sets up key questions about the circumstances surrounding the acquisition of Polynesian artefacts. The great majority appear to have been acquired in circumstances agreeable to both parties, and at exchange rates, in terms of European and indigenous systems of value, which were satisfactory at the time. There was tremendous mutual interest in the artefacts and materials of the other. The main concern of visiting ships was for water and food supplies, but once these needs had been satisfied, then 'natural' and 'artificial' curiosities (manufactured objects) were in demand.[20] On Cook's voyages, scientifically minded men such as Joseph Banks (fig. 8), Daniel Solander, and Johann and George Forster were avid traders at every opportunity. Shells, fish, botanical specimens and local artefacts were acquired in exchange for nails, cloth, buttons, mirrors and almost any other thing available on board ship. Cook had to give his famous 'No sort of iron' instructions to his crew at Tahiti, to prevent them from drawing nails from the ship's timbers for use in trade, not least to purchase the favours of local women. The men of science on all three of Cook's voyages were interested in assembling collections for classification purposes. They were influenced by Enlightenment philosophies and methods of the period, when documentation of the natural world and its inhabitants was expected of those provided with an opportunity to do so. Banks, for example, seized his chance and built an eminent reputation on his scientific and other adventures as a young man in his twenties in the South Seas.[21] Objects connected to Banks are featured in this book (nos 24, 65), and as far as we can know they were acquired on terms regarded as fair at the time. The Ra'iatean navigator Tupaia, whom Banks invited in 1769 to join his retinue, even drew him in the act of exchanging a handkerchief or sheet of barkcloth for a lobster with a man in New Zealand (fig. 9).

However, what of the 'theft' of the Nukutavake canoe, if such it was? There is perhaps an irony in the fact that had it not been taken it would not now exist and be available potentially for anyone, including Tuamotuans, to study and admire. The *Hokule'a* voyagers regretted the fact that no Hawaiian voyaging canoe of the eighteenth century survived for them to use as a model, forcing them to rely on European drawings and small nineteenth-century canoes upon which to base their 'replica'. In contrast, there is the matter of gift presentation, which happened regularly. The Hawaiian kava bowl (no. 24), for example, was literally pressed upon Captain Charles Clerke in January 1778 by a chief of Kaua'i who had come aboard the *Discovery*. Thomas (1991) has shown that issues concerning theft, trade, gift exchange and the appropriation of objects by both parties are complex, and one should be cautious in judging retrospectively the different cultural values which obtained in these transactions in the Pacific more than two centuries ago.

The artificial curiosities acquired in the eighteenth century entered collections in Europe, notably in Britain, and were subsequently donated, sold and exchanged until they found their current homes. They became vehicles for status competition, as they had been in Polynesia, and they became subject to neglect. Many did not survive into the present, and many others survive but have become separated from their documentation.[22]

It was of course not only Europeans who were interested in exotic objects. Polynesians were selectively interested in what Europeans had to offer: exotic items of metal or cloth, and things which they could incorporate into their own schemes of value. In 1792

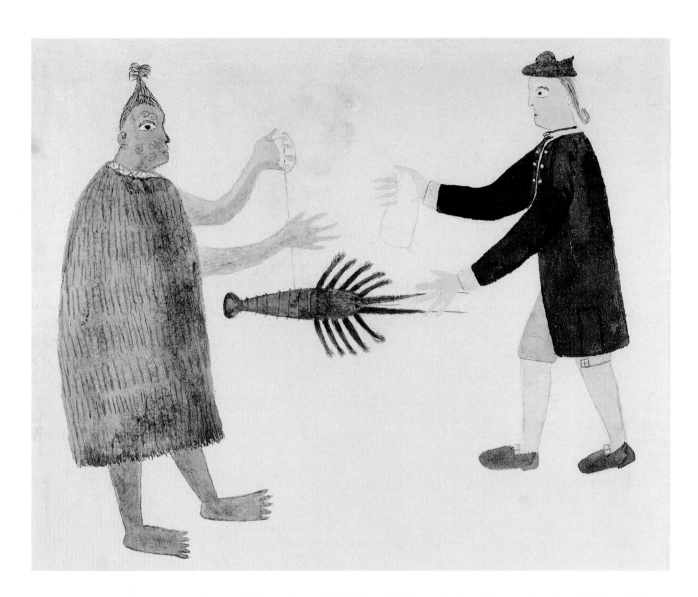

FIG. 9 Tupaia, *An English Naval Officer bartering with a Maori* (detail), 1769; watercolour, 26.7 × 21.0 cm. British Library. Harold Carter (1998) identified this mystery Cook first-voyage artist as Tupaia, the priest/navigator from Ra'iatea who joined the expedition at Tahiti. The 'naval officer' is Joseph Banks, Tupaia's mentor. Banks offers a handkerchief or piece of Tahitian barkcloth in exchange for a lobster, illustrating the kinds of exchanges which took place during early voyages.

George Tobin, sailing with William Bligh on the *Providence*, referred to Tahitian 'cabinets of European curiosities' containing treasured items such as a portrait of Captain Cook and an illustrated book on European statuary, acquired through *taio* (exchange partner) relationships which Tahitians established with visiting Europeans.[23] It was not only European goods which were in local demand, but items from elsewhere in Polynesia, especially red feathers brought by Cook's vessels from Tonga, and even Easter Island figures which the Boraboran Hitihiti (Mahine), sailing with Cook during the second voyage, knew would be highly valued back in Tahiti (see no. 94).[24] There is in the Smithsonian Institution in Washington a wood figure collected from Maori people on the South Island of New Zealand in 1838. There is no doubt that it originally came from Easter Island, though how it came to be in New Zealand remains a mystery.[25]

'Curiosities' were not collected as trophies, since their acquisition did not involve conquest or subordination in any intentional sense. Trophy collecting was more specifically

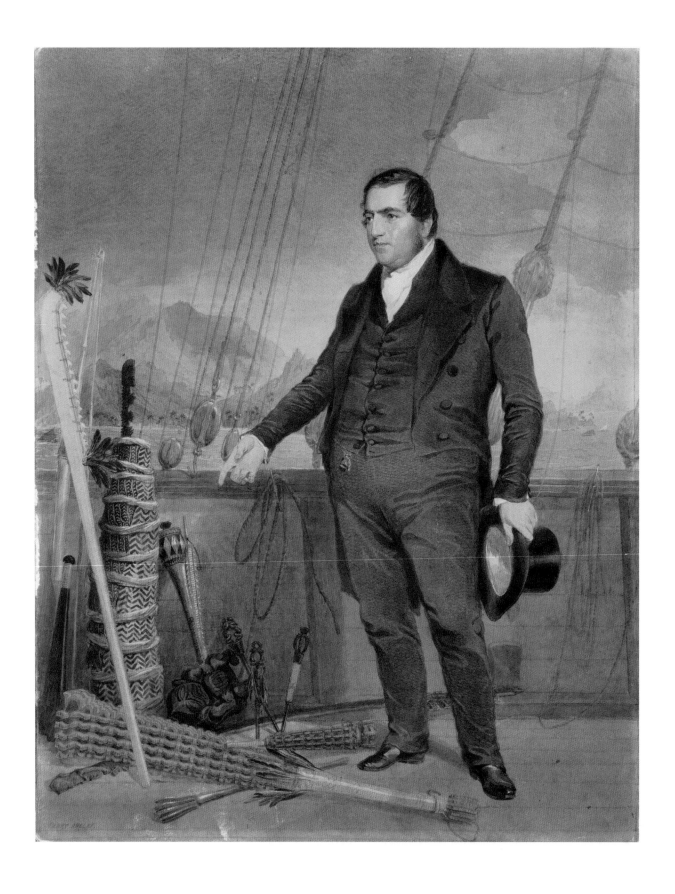

the aim of Christian missionaries, who were not interested, except in some rare cases, in scientific or curiosity value, but in the value of objects, and especially of 'idols', as evidence of evangelical success. Published missionary accounts regularly report in triumphant terms their victories over idolatry. The London Missionary Society (LMS) evangelist John Williams, on returning to Ra'iatea from Aitutaki in 1823, wrote: 'as other warriors feel a pride in displaying trophies of the victories they win, we hung the rejected idols of Aitutaki to the yard-arms and other parts of the vessel, entered the harbour in triumph, sailed down to the settlement, and dropped anchor, amidst the shouts and congratulations of our people' (fig. 10).[26] The pious vehemence of LMS opposition to idolatry is striking, if not unexpected, and the same applied in the case of the Methodists in Western Polynesia. Those religious objects which were not destroyed by zealous converts under the direction of the missionaries were collected as trophies for despatch to missionary museums in Europe. Here they functioned as performance indicators, to use the modern idiom, and as vehicles for fundraising campaigns in which the public was presented with the grotesque horrors of idolatry and encouraged to support continuing mission work. Everyday items, deemed not explicitly religious, were also collected to show the capacity of Polynesians for useful arts, and therefore their ability to achieve salvation. It was important for missionaries to stress that idolaters were not beyond redemption, and therefore worthy of expenditure of energy and funds.

A third category of item is that collected as a souvenir – neither for its scientific value nor as a trophy. Early voyagers and later travellers, traders, whalers, military men and administrators acquired local products as tangible mementos of travels and adventures, of friendships and encounters in the South Seas. Passed down in families, they eventually were presented to local museums or sold as curios in the late nineteenth and twentieth centuries. Comparatively large quantities of this material were in circulation, entering private collections, being auctioned, swapped or sold on, and eventually changing identity from memento to curio to work of art.

Art and authenticity

The term 'art', used in the subtitle of this book, is not used lightly. It is one of the clichés of anthropology that many cultures do not have a word in their languages which corresponds to art, and therefore the use of the term is suspect. There is also the ironic fact that in those European languages which have the term there is no agreement as to an appropriate definition, and such definitions as exist are regularly reassessed. 'Art' was not used widely for the kinds of object illustrated in this book until the twentieth century, when the scope of art shifted under the impact of Modernism. Amongst the avant-garde in European countries, *art primitif* was admitted into the canon of art on account of its form, and by extension as a mark of respect for those who made it. Artists such as Pablo Picasso and Henry Moore, and commentators such as Roland Penrose and Roger Fry were inspired by or celebrated primitive art in their own work. They carried naïve assumptions about the 'artists' and societies which produced it, but they elevated it in a way which increasingly forced people to take it seriously. It is not surprising that

FIG. 10 Henry Anelay, *The Rev. John Williams on board ship with native implements in the South Sea Islands, c.* 1838; watercolour, 42.5 x 33.5 cm. National Library of Australia. John Williams is portrayed pointing to his missionary trophies, several of which are recognizable as objects from the Cook Islands and the Society Islands in the London Missionary Society Museum. The contrast with the portrait of Banks (fig. 8), shown embracing his objects, is striking.

Picasso, Moore and Penrose all owned casts of the Rurutu casket figure in the British Museum (no. 156). Moore himself spent many hours in the 1920s in the British Museum sketching Polynesian and other sculptures.[27] Nowadays the demeaning 'primitive' art has largely been dropped and such epithets as 'tribal' and 'ethnic' are applied to works of this kind. Irrespective of the epithet, the word art is now firmly established, intended not so much to appropriate objects into European systems of classification, but to honour Polynesian skill and creativity in the same way that 'art traditions' from all over the world are now honoured and valued.

Most definitions of art link it to aesthetics, to assessments of beauty, taste, form and skill in manufacture.[28] Anyone viewing objects in this book will notice the enormous care and refinement with which they were made. These qualities were pleasing to the makers and users, and also effective, for such care was intended to please the gods as a form of sacrifice designed to bring about beneficial effects. A kind of aesthetics of divinity was in play here. Whether an object is deemed grotesque or beautiful to the Western eye is beside the point. These things were made to do a job, to have effects in the world – and they still do.

For Alfred Gell (1998) art, in its widest cross-cultural sense, was not about aesthetics or meaning, but about producing effects in the social milieu – about agency. He saw art as a system of action intended to *change* the world, rather than encode symbolic propositions about it. In his view an art object is something which is equivalent to a person (or a god). It need not be 'beautiful', nor does it need to 'symbolize' or 'represent'. Rather, it *is*: it embodies or instantiates that to which it relates as an index. With respect to images or 'idols', he rejects the timid notion that they merely 'represent' a god, as aids to piety, but argues that they *are* the god – a physical instantiation of divinity. Gell's work has profound implications for understanding Polynesian objects, chiefship and religion, and in his terms the objects shown here can be called art. The idea that gods, persons, or social agents can be substituted by objects is one which helps us comprehend the power and value which is often attributed to objects – in the case of religious relics, for example, or objects associated with famous people, such as Captain Cook.[29]

Wherever art is present, ideas and anxieties about authenticity are not far behind. For a long time there was a misguided notion separating authentic and inauthentic Polynesian works of art, usually couched in terms of whether something was 'pre-contact' and made with stone tools (authentic), or made for 'sale' and not for indigenous ritual purposes (inauthentic). The fact is that the vast majority of items illustrated here, including many of the 'great' sculptures, were made with metal tools supplied by Europeans. Whether the tool used was made of stone, shell, shark tooth, shark skin, iron or steel has little to do with authenticity, but with speed of manufacture. In addition, the great majority of things here were made for 'sale', or the local equivalent – exchange. They were commissioned, offered and presented before being used for other purposes. Objects such as Austral Islands' drums or Fiji/Tonga breastplates (nos 160–64, 238–9) were in many cases made for export, because their value and effectiveness was intimately connected to their transactability. Even the elaborately carved Ra'ivavae paddles (no. 184), a development of around 1820 and somewhat scorned by connoisseurs, were

made not only for trade to Europeans but also for local exchanges. LMS representatives recorded several being presented with formal speeches to a chief on Ra'ivavae in 1824.[30] None of the things here belonged to some 'pristine/pre-contact/authentic' Polynesia, for such a construct exists only in a European imagination. Rather, these objects are the products of dynamic indigenous situations which may or may not have involved Europeans. They demonstrate initiative with new tools, ideas and materials, and they are made with greater or lesser amounts of skill.

Discussions of authenticity also inevitably touch on the issue of fakes. This is a different matter, connected to objects or works of art in the context of a cash economy. Replicas or copies are not fakes, indeed most of the objects here are 'replicas' in the sense that they were made on the model of existing prototypes, as indigenous circumstances required. A fake is defined in terms of the intention to deceive and generate profit fraudulently. Even before the commercial value of Polynesian objects began to rise in the second half of the twentieth century, faking was taking place. James Little operated in Britain, mainly making New Zealand Maori-style objects, until he was exposed by the collector Alfred Fuller.[31] No doubt other European fakers are out there now, interfering in contemporary schemes of value. One wonders whether the original makers of the Polynesian sculptures being faked would be flattered or appalled.

1 Hau'ofa 1993. Epeli Hau'ofa is Director of the Oceania Institute for Arts and Culture, University of the South Pacific, Suva, Fiji.

2 The term European is used here and throughout this book to include European-derived peoples of the Americas and Asia. The United States and Russia were active in the region, especially in the nineteenth century.

3 Bernard Smith's *European Vision and the South Pacific* (1985), and *Imagining the Pacific: in the wake of the Cook voyages* (1992) discuss comprehensively the relationship between the Pacific, artists and philosophers.

4 Durrans 1979.

5 This unique status of Polynesia as a kind of sealed region for long periods underlies the thesis of the book *Hawaiki: ancestral Polynesia* by Kirch and Green (2001). They employ what they term a 'triangulation' method involving archaeology, linguistics and comparative ethnology to trace the early history of the region.

6 The glottal stop or hamza, signified by ', is spoken as an aspirated break between the vowels. In Polynesian languages all vowels are sounded, so Tane is pronounced 'Tar-né', with the emphasis on the first syllable.

7 Kaeppler 1978b.

8 These canoes had the newly introduced Micronesian rig and were sailed by the 'shunting' technique, by which the centrally placed mast was swung fore or aft so that the sail could be reversed. The canoe did not have a fixed bow and could move ahead or astern without going through the wind (see Lewis 1994: 59–62).

9 Finney 2003.

10 Historians of the Pacific such as Greg Dening (1992; 1996; 2004) have eloquently emphasized the nature of history as a culturally constructed phenomenon, as a version or interpretation of past events in the light of contemporary concerns.

11 Kirch 1997.

12 The most recent archaeological research is summarized by Kirch (2000) and, more briefly, by Bellwood (2001), who also published an earlier major regional survey (1978). Allen (2004) has challenged the early dates for the Marquesas. Anderson (2002) advocates dates of first settlement of Eastern Polynesia of AD 800–900. For group-specific information see the individual catalogue section introductions.

13 The result of research by Geoff Irwin (1992), an archaeologist and sailor.

14 The El Niño Southern Oscillation (ENSO) causes westerlies to take over periodically from the more usual southeast trade winds, a regular phenomenon which seasoned voyagers will have noted. The 'accidental drift' theory of Pacific voyaging prevailed for some time, championed by Andrew Sharp (1964), but gave insufficient credit to the navigational skills of ancient Polynesian voyagers. Experimental research by Lewis (1994) and Gladwin (1970), working with practising Micronesian voyagers, has documented the navigation skills used in long-range return voyaging without instruments.

15 This enigma, and other factors, led Thor Heyerdahl to propose his 'out of America' theory for the origin of many Polynesian cultural traits. As a result of his *Kon-Tiki* raft voyage of 1947, and after conducting archaeological excavations on Easter Island in the 1950s, he published a series of books and articles attempting to prove his theory. Being highly selective in his choice of data, he assembled apparently convincing arguments which unfortunately did not withstand rigorous scientific scrutiny. Nevertheless, he popularized and energized archaeology in the Pacific, and in that respect he performed a valuable service which merits recognition.

16 Pottery has been found in small quantities at four sites in the Marquesas, some with sand tempers from Fiji (Kirch 2000: 258). In the absence of pottery, the archaeologist Yoshihiko Sinoto developed temporal series for Eastern Polynesia using fish hooks.

17 See Spate 1979 and Williams 1997 respectively.

18 This was achieved by John Harrison, who had spent his working life trying to perfect such a timepiece and win the £20,000 prize from the Board of Longitude. Cook took a copy of Harrison's Fourth chronometer, made by Larcum Kendall, on his second voyage (1772–5), when it outperformed all other timepieces.

19 Hawkesworth 1773: I: 208. Wallis's journal has not been published in full. Wallis named Nukutavake 'Queen Charlotte's Island'. The inhabitants had departed in several double-hulled sailing canoes about 30 feet long (about 10 metres).

20 The terms 'artificial' and 'curiosity' did not have negative connotations at this period. Artificial meant manufactured (in contrast to natural history specimens), and curiosity was a term of approbation, implying well made and worthy of attention.

21 Beaglehole 1962; Gascoigne 1994.

22 Adrienne Kaeppler (1978; forthcoming) has endeavoured to trace and document these old collections, notably those deriving from Cook's voyages. For anyone interested in this subject, her work is essential reading.

23 Newell 2005.

24 Forster 2000: 313–14. The Easter Islanders were equally keen on Tahitian and Tongan barkcloth which was being carried on board the *Resolution*.

25 Heyerdahl 1976: pl. 61b.

26 Williams 1837: 106–7. John Williams was one of the main collectors for the LMS museum (see Chapter 3).

27 Moore 1981.

28 Howard Morphy (1991; 1994) has discussed the importance of indigenous aesthetic judgements in assessments of art. See also Morphy and Perkins 2005.

29 For a review of Gell's ideas see Hooper 2000; for Captain Cook 'relics' see Hooper 2003. For an important work on the relation between persons and objects in Melanesia see Strathern 1988.

30 Montgomery 1831: II: 73. The LMS deputation noted that large quantities of barkcloth were also presented on this occasion, much of which was presented in turn to the missionary visitors.

31 Skinner 1974: 181–92. In the early twentieth century a New Zealander, James Robieson, specialized not so much in fakes but in carving objects in his own 'Maori' style, which is readily identifiable. The book *Fake*, edited by Mark Jones (1990), provided a useful overview of the topic.

2

Polynesian Encounters

What was the role and significance of Polynesian objects in their original contexts of use? To help answer this question some background information will be provided on Polynesian religion, chiefship and cultural institutions of the late eighteenth and early nineteenth centuries.[1] In considering indigenous contexts the intention is not to reconstruct some imaginary untainted pre-European Polynesian culture, but to place the manufacture, use and importance of these objects in the context of reciprocal relationships of various kinds, which in the period under review increasingly involved Europeans. Objects were fundamental to relationships, and they did more than symbolize them, they embodied them. This distinction is important because a piece of barkcloth, for example, presented as an offering was not a symbol in the way that the letter 's' is a symbol of the sound 's'. A barkcloth offering can be seen as an embodiment of the women who produced it, and as such it becomes a form of sacrifice, specifically a sacrificial substitute equivalent to their bodies, with all the life-giving potency which that implies.

If we are sensitive to indigenous categories we find that certain things were linked, or were regarded as equivalent: a god image and a chief, for example, or a magnificent feathered cloak and an apparently humble fish hook. All four were regarded, on specific occasions, as vehicles suitable for the physical manifestation of divinity in the mundane world. The cloak and fish hook were also classified as important 'valuables' – objects suitable for ritual presentation. This significance as valuables is separate from, though linked to, their uses as garments and fishing equipment. The role of valuables in exchange will be discussed below, but first some observations will be made on Polynesian religion.

Religion, gods and divinity

Religion in Polynesian contexts was not an aspect of existence which could be separated off from politics, economics or social life. Religion encompassed all these domains of human activity, so that authority, leadership, conflict, the distribution of goods and services, kinship and affinal relations (with those to whom you are connected by marriage) were all aspects of an over-arching religious context. The success or effectiveness of any of these areas of human endeavour was ultimately dependent on having an active and appropriate relationship with god or gods, with divine beings who could affect the mundane world. In this respect, human action or efficiency alone could not guarantee success. Divine favour was also necessary.

The principal way for humans to obtain divine favour was by the establishment of formal exchange relationships based on reciprocal offerings and blessings. To achieve this aim, objects, food, dances, prayers and chants were offered to gods, who were expected to reciprocate by providing health, prosperity and success. During religious procedures at temples (fig. 11) the abstract notion of divinity was materialized or embodied in particular objects – images, relics and 'idols' – or in special people such as chiefs and priests, who became the focus of veneration. Precisely how this human–divine relationship was made manifest, and communication between humans and gods was structured, located and maintained, was what constituted religious practice in any particular cultural context in Polynesia, and for that matter anywhere in the world. At the core, there are broad similarities in religious practices worldwide. Why that might be so need not detain us here, but if we look not at theology, doctrine, faith or belief, but at practice – at what people actually do, how they do it and where they do it – we find many parallels and common characteristics. This distinction between theology and practice is useful when discussing religion because the former tends to be the esoteric province of specialists, whereas the latter is how the great majority of people experience and understand religion – as a system of action, private or public, designed to produce results.[2]

Nevertheless, theological and cosmological understandings frame how religion is enacted as a cultural practice. From a Polynesian point of view, beings called *atua* (Tahiti, New Zealand), *akua* (Hawaii) and various other terms were responsible for the world and the cosmos, and were regarded by humans as divine forces with whom appropriate relationships needed to be maintained. The term *atua* is usually translated as 'god', and this English term is used here, but it needs to be borne in mind when translating vernacular words of this kind that there is no satisfactory equivalent in English. Polynesian gods were conceived of as powerful yet unpredictable, influential yet capricious, potentially benevolent yet problematic. They were responsible for famine and plenty, destructive hurricanes and life-giving rains, health, sickness and recovery. Polynesian islands were potentially hazardous environments: drought, cyclones, sea surges and sickness were all familiar and feared, needed to be explained, and if at all possible prevented. Human ingenuity and planning could ameliorate some of the worst effects of such events, but ultimately the gods were responsible for these phenomena. Likewise, they were responsible for the normal and regular aspects of life and the cosmos, the movement of stars, the cycle of seasons and growth of crops. The most effective way to attempt to exercise control over these things resided in appropriate religious procedures involving offerings to gods in a context of veneration, with the expectation of reciprocal blessings and divine favour.

In most Polynesian communities there was a distinction between remote deities, responsible for the origin of the world and associated with major cosmological domains, and local ancestral deities, who directly influenced the affairs of their descendants, and through whom connections to remote deities might be claimed. In some places there occurred a mythical primordial pair – Rangi and Papa in New Zealand, Wakea and Papa in Hawaii – who were associated with sky and earth, and with male and

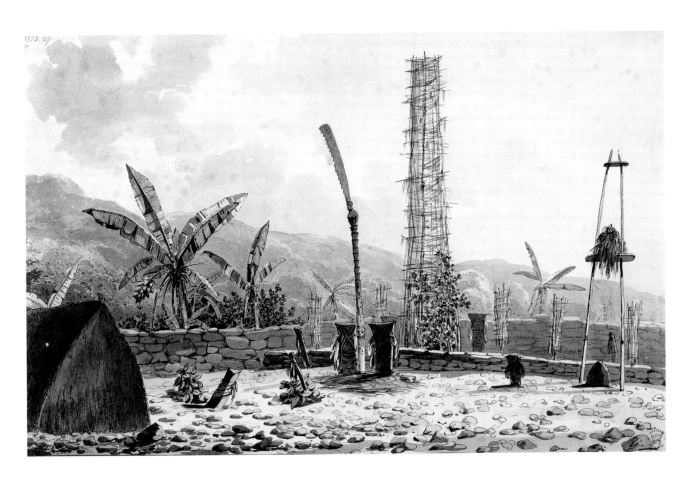

FIG. 11 John Webber, *A 'Morai' at Atooi*, January 1778; pen, wash and watercolour, 31.1 x 49.5 cm. British Library. This view of a temple precinct (*heiau*) at Waimea, Kaua'i, shows boundary walls, an oracle tower, an offering platform and images with barkcloth bindings. The thatched house contained other images bound with barkcloth (Joppien and Smith 1988: 418–21).

female founding elements which gave rise to the universe, the world and all its inhabitants. These foundation myths are as important for their structure as their details because they indicate the deep-rooted significance of complementary pairings in Polynesian cosmology and cultural practice. One such pair concerns the two linked cosmological domains, *po* and *ao*. *Po* was associated with the primeval origin of the gods, with darkness, night and the underworld, and was the location of gods and the place where humans went after death. Its complementary opposite, *ao*, was the place of light and the world above – the mundane world brought into being by the gods from primeval darkness. In some places, including eastern Fiji, the creation of the world of light from primeval darkness was re-enacted every morning during dawn kava-drinking rituals.

Myths widespread in Polynesia also refer to a place of divine and human origin called Hawaiki or Kahiki (Hawaii). Kirch and Green consider this was an actual homeland located in Western Polynesia during the period of early settlement and consolidation prior to the push into Eastern Polynesia.[3] In Eastern Polynesia four major gods were widely recognized. Known as Tangaroa, Tane, Tu and Rongo in New Zealand, and Kanaloa, Kane, Ku and Lono in Hawaii, they formed a pantheon in which each was associated with a particular domain or activity. There were variations in different places, but Tangaroa was generally associated with the sea, Tane with forests, Tu with warfare and Rongo with agriculture.[4]

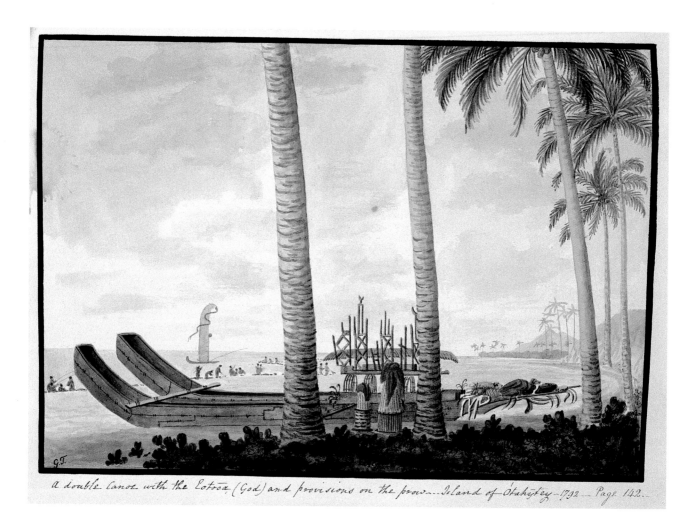

a double canoe with the Eotooa (God) and provisions on the prow...Island of Otahytey-1792 — Page 142.

FIG. 12 George Tobin, *A double canoe with the Eotooa (God) and provisions on the prow...Island of Otahytey*, 1792; watercolour, 16.9 × 24.8 cm. Mitchell Library, Sydney. A canoe consecrated to the deity 'Oro, whose 'house' is mounted on the platform (equivalent to where chiefs stand, fig. 1). Two large drums are shown partially covered in red cloth; food offerings are placed on the prow.

The relationship between myth and history is a complex one in societies with unwritten languages. Many Polynesian myths were recorded after writing was introduced as a result of Christian conversion, and they were subject to tidying-up processes by well-meaning people, locals and Europeans, who wanted to present a coherent picture of Polynesian cosmology. Accounts such as those published by Henry (1928) for Tahiti and Beckwith (1951) for Hawaii (the famous *Kumulipo* chant) remain important early sources, but it is often in the structure of the stories rather than in the incidental details that their importance lies and cross-cultural comparisons can also be made.

Centuries of separation and isolation led to different emphases on and ritual cycles for the major founding deities, and in some places new cults developed in which the major deities did not play a significant role. On Easter Island, Hotu Matu'a, an ancestral deity, became prominent. On Ra'iatea a cult dedicated to 'Oro became very influential in the Society Islands in the eighteenth and early nineteenth century (fig. 12). Like Hotu Matu'a, 'Oro was putatively the child of Ta'aroa, which conferred genealogical legitimacy on 'Oro and on his priests. Another factor which lent great authority to the 'Oro cult was its base on Ra'iatea, and specifically at the great *marae* ('temple') of Taputapuatea

at Opoa. Ra'iatea had long been considered one of the main spiritual homelands of Polynesia, associated with Hawaiki, and Taputapuatea was one of the most famous *marae* in the whole region.[5] This significance has not diminished with time, for the recent *Hokule'a* voyagers from Hawaii made specific journeys there after their landfalls in Tahiti. In 1992 they brought and presented a drum, described as a descendant of an original drum taken to Hawaii from the Society Islands many centuries before. In this way a genealogical link was made through objects as well as through people.

The importance of complementary pairings in Polynesian cosmology and religious practice is reflected in the ritual significance of sea and land. These are the two major domains in which Polynesians lived their lives and which provided the major resources that sustained them. The sea was associated with chiefs, who in most parts of Polynesia were categorized as being of relatively recent foreign origin. This is contrasted with the land, which was associated with non-chiefly ancient autochthonous populations. In eastern Fiji, for example, there was and is an important binary social division, revealed in a range of ritual contexts, between hereditary 'chiefly' clans (plus their specialist associates), deemed to be relatively recent arrivals from overseas, and 'land' clans, deemed to be descended from original inhabitants. In a myth concerning the origin of society, similar to others found widely in Polynesia, the chief of the newcomers, characterized as divine and male, was offered a daughter of the indigenous leader of the land, and together they produced offspring who became great chiefs.[6] Critical to the health and wellbeing of the chiefdom was the effective combination of complementary elements: sea and land, chiefs and people, foreigner and indigene, guest and host, male and female.

Chiefdoms and chiefs

A key relationship in Polynesia was that between chiefs and people – the institution of chiefship was fundamental to Polynesian religious, social, political and economic organization. In the late eighteenth century there were highly centralized chiefdoms in Hawaii and Tonga, with divine kings at the centre (fig. 13), and less centralized chiefdoms in such places as New Zealand, where chiefs were attributed with less absolute authority.[7] A chiefdom may be defined as a named bounded domain and its inhabitants, having a leader with a hereditary title – the chief – who is usually from a clan regarded as originally 'foreign'. Members of a chiefdom belonged to hereditary clans, some of which had special duties requiring specialist skills – carpenters, navigators, priests. These specialists were termed *tohunga, kahuna* and other cognate terms. A large chiefdom might be composed of several smaller ones, each with its titular chief, who recognized the authority of the paramount chief of the greater chiefdom. Chiefdoms could expand by conquest or by absorbing chiefdoms on their borders – persuading them to 'turn', to pledge allegiance, present offerings and contribute resources. Chiefdoms could also wane after defeat in war or after smaller chiefdoms 'turned' away. Besides performing leadership roles, chiefs were the focus of major ritual attention because they were regarded as divine beings, capable of bringing about prosperity and abundance in the

chiefdom. They also played a dual role, on the one hand embodying gods and on the other embodying and representing the entire chiefdom in their person.

When living in eastern Fiji in the 1980s I asked about the defining characteristics of a chief. Contrary to my expectations of comments on hereditary status, leadership, command and authority, I was told that the most important thing about a chief was that he or she should be generous and should look after the people. If the people behaved appropriately to the chief, serving the chief, making presentations and doing the chief honour, then the chief should respond with generosity, creating abundance in the chiefdom for the benefit of the people. This was, of course, a late twentieth-century idealization of the role of the chief, yet at heart it remains true to attitudes which prevailed two hundred years ago. Chiefship implies a profound reciprocal relationship, complementary though not equal, through which the welfare of the whole community can be enhanced. This is at the level of theory. How it works out in practice is sometimes another matter. Chiefship has in it the seeds of autocracy, and some chiefs, such as Kamehameha in Hawaii, Taufa'ahau (later George Tupou) in Tonga, Pomare II in Tahiti and Cakobau in Fiji became individually powerful and wealthy, establishing rulership over whole groups, although it is likely that the wide, probably unprecedented, extension of their power was partly a function of their engagement with Europeans and European resources. On the other hand, the elevation and special treatment of chiefs was something which was done to them and which they endured. It restricted their action, for they were made into objects of veneration and the focus of ritual.

FIG. 13 *Poulaho, King of the Friendly Islands*, engraving by J. Hall after John Webber. The Tongan chief Fatafehi Paulaho is shown in 1777 wearing a feathered headdress. Red feathers obtained in Tonga during Cook's third voyage were taken as exchange valuables to Tahiti, where they were associated with the deity 'Oro.

Chiefs were attributed with divine potency throughout Polynesia. The London Missionary Society inspectors Daniel Tyerman and George Bennet observed that the 'kings' of Ra'iatea 'enjoyed divine honours, and were in fact living idols among the dead ones, being deified at the time of their accession to political supremacy'.[8] In assessing this chief–god equivalence popular Western philosophical notions about gods need to be set aside. Gods in most cultural contexts were not remote omniscient beings, but were 'persons or things with life to give'.[9] 'Life' is the key, and in Hocart's view, the purpose of religion and ritual practice is to achieve 'life' – religious rituals are essentially devices by which people attempt to obtain health, victory and prosperity. Gods were the source of life, and in order for them to be approached a materialization of divinity, a god image, could be created from a person or from other materials by rites of consecration. An installed chief was therefore a specific kind of god image. Etymologically the Polynesian word for chief – *ali'i*, *ariki*, *'eiki* or variants – meant a special kind of priest,[10] and this helps us further understand the role of the chief, for persons referred to as priests were also classified as gods since they too could become

vehicles for divine presence. In short, chiefs were embodiments of ancestral gods, who spoke through them, and for whom chiefs' bodies acted as a kind of shrine. 'Ornaments' worn by chiefs or those of high status, of which there are many in this book made of shell, ivory and feathers, were a means of modifying the body to manifest brightness, vigour and vitality – all divine qualities (figs 13–14).

FIG. 14 *Tanoa. King of Ambau*, 1840, engraving by Rawdon, Wright and Hatch after Alfred Agate. The Vunivalu of Bau, Fiji, Tanoa Visawaqa, has a barkcloth turban and waistcloth, holds a club and staff, and wears shell armlets and a breastplate of pearl shell and whale ivory obtained later by Sir Arthur Gordon (see no. 238).

If a chief in Polynesia was essentially an embodiment of life-conferring power, what was the nature of this power? Divine power in Polynesia was, and in many places still is, referred to by the term *mana* (and in some places by *sau* or *hau*). There is no one single definition of *mana*. It is a term which has undergone shifts in meaning in changing political and religious circumstances. In its widest sense *mana* means efficacy of divine origin, an ability to bring about effects which goes beyond normal human agency. It is not so much a mystical abstract power which people possess, but rather an efficacy manifested in specific outcomes such as fertility, health or success. It is a means by which divinity manifests its presence in the world through particular persons and things. Being of divine origin, *mana* is a problematic potency, dangerous, life-creating and life-destroying, and must be managed with care. Because it is closely associated with installed (consecrated) chiefs, they have to be treated appropriately in order that *mana* can be directed towards beneficial ends. *Mana* is fundamental to chiefship and authority, so much so that Shore claims, in his perceptive review of the topic, that 'without an understanding of *mana* and its related concepts, there is no path into Polynesian worldview'.[11]

The related concepts to which Shore refers are *tapu* (*kapu* in Hawaiian) and *noa*. *Tapu* is a term meaning 'marked', 'contained', 'restricted' or 'set apart'. It could be translated as 'holy' or 'sacred', but one must be wary of oppositions such as sacred/profane, which are inadequate in explaining Polynesian cosmological categories.[12] In one sense *tapu* is the state of a person, a thing, a place or a time period when *mana* is present. In a second sense it means forbidden to certain categories of people in certain contexts. *Tapu* is a relative rather than an absolute term, in that some people/things are *tapu* in relation to others, which are classed as *noa*. *Noa* (*tara* in Fijian) is best translated as 'free', 'unrestricted', and refers to the normal state of human life when the presence of *mana* is not an encumbrance. Certain things – installed chiefs, temple precincts, the head of someone senior to you – are *tapu*, and direct contact, unless ritually sanctioned, must be avoided. Other things may be temporarily *tapu* for time periods when *mana* is present. Shore (1989:

FIG. 15 *A Catalogue of the different specimens of cloth collected in the three voyages of Captain Cook ...,* compiled and published by Alexander Shaw, 1787 (exhibited). One of about forty surviving copies of a book produced in response to the great interest in Polynesian barkcloth. It contains thirty-nine listed samples from Hawaii, Tonga and the Society Islands (one from Hawaii shown), plus a further seventeen samples bound into the back. Pitt Rivers Museum, Oxford.

150) explains that '*tapu* is a state in which *mana* is ritually tied up' in order for its effectiveness to be controlled for human benefit. Conversely, *noa* is a state in which the problematic presence of *tapu/mana* is neutralized to allow mundane life to take place.

A key means of neutralizing *mana* is via female agency. In past studies, women have been characterized as polluting and 'profane' in relation to 'sacred' *tapu*, but this is too simplistic a view of female potency and gender relations. Women had very high status in Polynesia, and continue to do so. Because of their reproductive life-giving power, they were capable of channelling and controlling *mana*, and neutralizing its dangerous effects. This accounts for their key roles, and that of their products – barkcloth and mats especially – in important rituals and in the composition of religious objects. In chiefly consecration/installation ceremonies, often modelled on a re-enactment of the original arrival of the chief from the sea and his incorporation by the land, the role of women and their products was essential. Their barkcloth formed pathways guiding the chief to his appropriate place at the centre of the ceremonial ground, whilst also separating and insulating him from the mundane soil. Barkcloth also formed wrappings and bindings for the chief's body, arms and head: through its ritual application the 'stranger-king' and his associated *mana* was fixed and controlled (fig. 15).[13] Women's bodies directly, via their reproductive powers, were a means by which the external divine *mana* of the consecrated chief was appropriated and domesticated.

Another means of neutralizing and freeing people from *tapu* restrictions was, under approved conditions, to render people or places *noa* by dramatically doing the very thing which was forbidden, and thereby repelling the god, so that normal life could resume. A period of silence could be broken by great noise, restrictions on access to the ceremonial ground by its boisterous invasion, prohibitions on fishing by a major fishing expedition. Even clapping before drinking kava is rooted in a mechanism to drive off the god so that the drink can be consumed. Today in eastern Fiji, at the end of a four-night mourning period, women beat vigorously with barkcloth beaters on a wooden anvil to *vakataratara* ('free') the village from the period of *tabu* restrictions.

Controlling divinity: wrapping, binding, containing and separating

We turn now to the role of objects of the kind illustrated in this book, which were created to perform specific tasks in a variety of contexts. Some were explicitly god images, or 'ornaments' for god images, others had special qualities as exchange valuables and offerings, which, as will be argued, also made them embodiments of divinity in certain respects. First let us consider god images.

For humans to establish productive and mutually beneficial relationships with gods, abstract notions of divinity were given physical form – what we may call god images, or

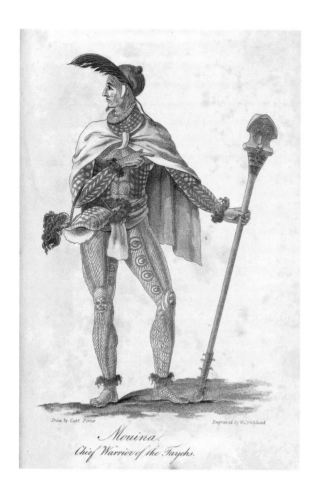

FIG. 16 *Mouina, Chief warrior of the Tayehs*, engraving by W. Strickland after David Porter. David Porter, captain of the US Navy ship *Essex*, visited Nuku Hiva in the Marquesas Islands in 1813–14. His portrait shows Mouina fully accoutred with a complete tattoo, a club, triton-shell trumpet with toggle, sperm-whale tooth necklet, wood and seed necklet, ivory or wood ear ornaments and a feather headdress – all types of item shown in this catalogue.

what the missionaries called idols. Physical manifestations of divinity could be features of the landscape, such as mountains, or stones and shells, but often they were objects manufactured and assembled from raw materials with particular symbolic associations, and often in anthropomorphic form. One such constructed artefact was the chief. At installation/consecration the body of the chiefly candidate, probably already marked and 'wrapped' with tattoos (fig. 16),[14] was transformed by being wrapped and bound. The materials used for this were bark-cloth, mats and cloaks of various kinds, including the magnificent feathered cloaks of Hawaii. The head was encased by a cloth turban, feathered helmet or headdress, and in Hawaii and the Society Islands the waist and loins were bound with a long feathered loincloth.[15] Breastplates and other ornaments of shell, ivory or whalebone were applied to the chief, exotic items from the sea which shimmered and gave off light and vitality. Scented coconut oil was also liberally used, causing the chief's body to glisten with shining health. Thus, at key ritual moments, amongst which were consecration and death, the chiefly locus of divine *mana* was fixed and controlled by the application of elaborate costume.

Not only were paramount chiefs treated in this way, but anyone who was senior in a particular context. The head of a clan, even if not a chief, would be 'chief' relative to juniors in that clan, and would be both *tapu* and *atua* ('god') to them, since these were both relative terms. Therefore a range of senior people could wear ornaments and insignia of various kinds with different symbolic significances. The *taumi* breastplates (fig. 17; no. 141), worn by senior Tahitians, especially warriors, marked them as such, and associated them with sharks' jaws and aggressive power. 'Ornaments' were thus a mechanism to make relatively divine the wearer vis-à-vis non-wearers. They were physical evidence of efficacy, both in their materials, and also in the fact that these materials had to be acquired and the artefacts skilfully assembled, which was evidence of control over resources. Fijian breastplates (nos 238–9) can be viewed in this light. On formal occasions, when people were transformed in this way, offerings were made and benedictions, abundance and prosperity were expected as a consequence.

Related kinds of anthropomorphic god image were made with wood, ivory or coir bodies. If we are willing to follow Gell's (1998) proposition, discussed above, that art objects are persons in artefact form we can see that these objects can be equivalent to chiefs/gods. Evidence from eastern Fiji supports this point, in that forest trees and whale ivory were specifically associated with the body of the chief in an ancient honorific vocabulary.[16] The chief's back was referred to as 'the back of *vesi*', or the *vesi* post, *vesi* being the finest tropical hardwood, used for large double canoes and the posts of temples and chiefly houses. The chief's body was also called 'the skin of the *tabua*', *tabua* being a

sperm-whale tooth. There was an equivalence at the cosmological level between the chief and these products of the deep forest and the deep sea, both dangerous divine domains external to domestic human society. As with the chief's body, these materials were transformed into images through human action, making them suitable vessels for containing and controlling divinity for human ends. This was again done by wrapping and binding. The Rarotongan staff gods (nos 192–5) are a case in point. With their wooden core and massive wrapping of barkcloth – formerly containing feathers and shells – they embodied and combined the productive skills of men and women, and were also effective as a god image via their form as contained *mana*. Most of the anthropomorphic images illustrated here were formerly wrapped and bound in some way; a figure similar to that from Mangareva (no. 118) had a turban-like wrapping round its head when installed in its temple.

The *to'o* images from the Society Islands (nos 130–33) present a well-documented case.[17] They mostly have anthropomorphic characteristics worked into their bindings, which enclose a wood core. They were consecrated by the attachment of feathered bindings and wrappings, red feathers being associated with the essence of divinity. These images were periodically renewed during *pa'iatua* rites, when they were unwrapped and unbound, and their red feathers revitalized by being placed in proximity to the principal god image of 'Oro, prior to being rebound, rewrapped and returned to their particular shrine. Unwrapping was a desecrating act, allowing dangerous *mana* to be uncontained, with problematic consequences. The missionaries realized this and used inappropriate unwrapping of images, without apparent dire consequences, as a means of demonstrating to Polynesians the power of the Christian god (no. 198).

Objects which are not usually regarded as god images are temple drums. Several are included in this volume, most retaining their elaborate bindings, and in the case of the example from the Marquesas (no. 105), barkcloth wrappings. These drums show the combination of wood core and cloth or cord binding which is distinctive of so many objects of ritual importance. Another drum, with a unique pandanus-leaf wrapping of the chamber, is shown in fig. 2, illustrating the high level of skill which was involved in the making of such great ritual objects. In their use drums expressed a particular aspect of divinity, the marking of *tapu* time periods by sound. The drum when sounded indicated the presence of the god while important ritual procedures were underway – as is clear in the 1777 Webber painting of the human sacrifice at Tahiti (fig. 18). Drums were also used to accompany chanting and dances, performed in honour of the gods. A number have anthropomorphic designs applied to them, which could be interpreted as representing dancers (nos 31–2, 161–4). Weapons are a further example of a type of object not normally regarded as a god image. Many were carved and bound in ways which gave them no extra practical efficiency, but which made them suitable vehicles for divine efficacy. They became portable god images.

Procedures of containing and separating were important to how divinity was managed. Chiefs' houses were containers, marked with carvings and elaborate bindings (no. 63, fig. 4). Caskets were used as reliquaries to contain ancestral bones in New Zealand and the Austral Islands (nos 53, 156), while canoes were used for burial in other places. With respect to the bodies and bones of the dead, they could be treated differentially

FIG. 17 John Webber, *A young woman of Otaheite, bringing a present*, September 1777; pen, wash and watercolour, 40.4 x 31.1 cm. British Library. The Tahitian girl, one of two who brought Cook presents from Tu's father, is shown wearing a large roll of barkcloth to which are attached two *taumi* breast gorgets (no. 141; see Beaglehole 1967: I: 207–8). Wrapping barkcloth around the body and unwrapping it before recipients was a widespread form of gift presentation in Polynesia, which continues today in Tonga and Fiji.

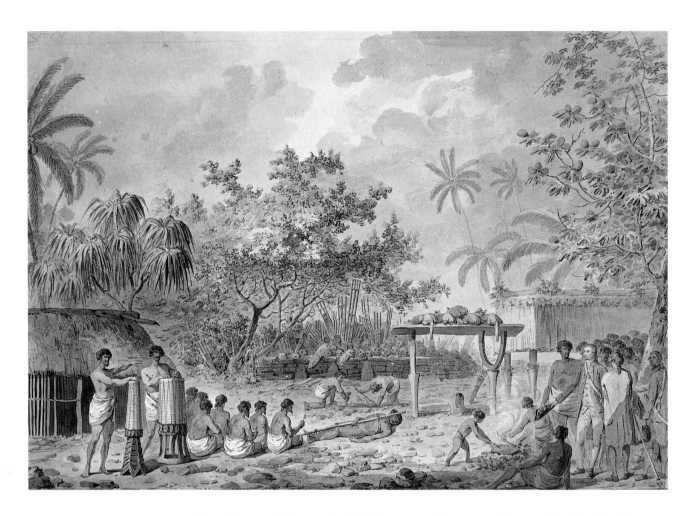

FIG. 18 John Webber, *A human sacrifice at Otaheite*, September 1777; pen, wash and watercolour, 42.2 x 62.5 cm. British Library. On 1 September 1777 Cook visited a *marae* (temple) on Tahiti (probably Utuaimahurau, see Beaglehole 1967: I: 198–205) and witnessed a human sacrifice in the presence of Tu (fig. 21). Offering platforms, an 'altar' and two large drums can be seen, the last possibly imported from the Austral Islands.

depending on their perceived ability to manifest *mana*. The wood casket from Rurutu, for example (no. 156), is a highly elaborate and labour-intensive carving, carefully and extensively hollowed out to receive the skull and long bones of a deceased ancestor.[18] It served both as a 'wrapping' for the divine bones, keeping them in a controlled fixed position, and also as a manifestation of divinity itself, bound as it no doubt was by means of the pierced anthropomorphic lugs which cover its surface. There can be little doubt that it was also wrapped in barkcloth in its original situation – a practice widely reported for god images – and would have been hidden from view except when it was the focus of some public ritual. Both this object, and the 'Family idols of Pomare' (fig. 33), would have been unwrapped as part of the voluntary desecration process undertaken by the former owners, prior to their presentation to the missionaries.

Other bones were differently treated. In Hawaii, arm bones were made into handles for *kahili* sceptres. Captain Clerke, on Cook's third voyage, obtained such a sceptre from the daughter of a chief of Kaua'i. The bone was that of a slain enemy chief.[19] The use of this bone without restriction indicates that it was not attributed with any *mana* in that context. The user did not come within the zone or field of authority of the dead chief to whom it had belonged, and therefore it could do her no harm. This idea of a 'field of authority' is

FIG. 19 John Webber, *Waheiadooa, Chief of Oheitepeha, lying in state*, August 1777; pen, wash and watercolour, 37.5 × 54.3 cm. British Library. This funerary enclosure on Tahiti, seen by Cook on 19 August 1777, shows the chief's body wrapped in layers of cloth and separated from public space by a series of awnings and barriers. Cook, who was not allowed to enter, noted a sheet of red cloth left by the Spaniards (Beaglehole 1967: I: 190–91).

important because it was not just any chief or senior person who could be *mana* in relation to you, but only those in your own chiefdom or polity, whose authority you recognized. Anyone, or any god, outside your own system did not have authority over you unless you chose (or were forced) to acknowledge it, usually by the making of offerings and pledges of allegiance. This is the logic by which Captain Cook's bones were wrapped and treated with reverence by Hawaiians, because those who sacrificed him had consecrated him as an embodiment of the god Lono by making offerings and repeatedly wrapping him in bark-cloth and feathered cloaks (see below, pp. 54–5). His authority had been acknowledged and the dangerous *mana* potential of his relics needed to be managed carefully.

As part of mortuary rites in Tahiti, the dead body of someone in authority in one's own chiefdom was wrapped and segregated off by special screens (fig. 19). A costumed special mourner, brilliant and terrible to behold (no. 140), personated the deceased in a performance of power, brandishing a fearful weapon edged with shark's teeth and going about the district with aggressive attendants who meted out violence to anyone unfortunate enough to come within range.

In Hawaii special bone cases were made of plaited and braided coir cordage (fig. 20). Coir cordage features extensively in Polynesian ritual objects, both as a core material

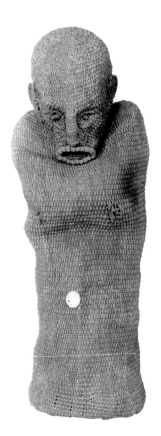

and as a means of binding. Kaeppler has suggested that the acts of making coir cordage and binding god images were accompanied by chanted invocations. These chants were thus 'caught' in the cord and bound into the object – which became an objectification of prayer.[20] The verbal aspects of religious practice must not be neglected, and it is as well to appreciate that many of the things in this book, when in use, were associated with prayers, speeches and songs. Words, especially of chiefs or of those of high status, were *mana*, powerful. Invocations by the people could bring about chiefly benedictions, which in turn could bring about prosperity. Alternatively, the curse of a chief or a senior person could be immensely serious for the recipient.

Boxes were used for storing valuables in New Zealand, Tahiti, and Tonga (nos 58, 138, 243). They were for feathers, shells, ivory and nephrite (in New Zealand), which were regarded as instantiations or particularizations of divinity. Such valuables had specific properties, most likely associated with their external origin and their appearance, which meant that it was appropriate for them to be kept contained in special receptacles. With respect to separation and elevation, in some parts of Polynesia finely carved stools were made for the use of senior people (nos 136, 178). Robertson (1948: 173) noted on Tahiti, during the visit of the *Dolphin* in 1767, that 'a great many of the principle people of the Isld came doun to the River side with servants attending them carrying stools for their masters and mistresses to sit doun on'. In other places fine mats and barkcloth served as special seats, beds, screens and enclosures. Thus we see that many objects and materials were connected to the formation and construction of god images of various kinds, and to the separation, marking and elevation of those of high status who, in relative terms, were *tapu* and *atua* ('gods') to those of junior status.

Exchange, offerings and valuables

Part of the logic of focusing *mana* in particular locations, chiefs and images, was so that reciprocal exchange relations could be established and enacted with them. The enactment of complementary relationships was through offerings of particular kinds – objects, foods, words and dances. These were transferred to the focus of ritual in return for blessings (words) and reciprocal offerings of similar or different things.

Exchanges were more than economic transactions of goods – barkcloth, food and the like – but were couched in religious terms. Such exchanges could be on a modest or major scale, depending on the status and resources of the participants, and on their inclination for competitive gift-giving and displays of abundance. One important type of exchange relationship was that between affinal (intermarrying) groups, whom Hocart characterized as being 'gods to one another'. These exchanges of mutual blessings and often similar goods were addressed to the title of the clan or group, not to the name of the senior person. The title was equivalent to the name of the ancestral god, the forefather of the group, and by addressing that title the presentation became an offering to the god of the other group.

Other exchanges took place between different status groups, between people and chiefs (fig. 21). These again could vary between small private offerings and major public presentations, at which the chief acted as a redistribution agent for those things pre-

FIG. 20 A burial casket (*ka'ai*) made of plaited coir cord, said to contain the skull and bones of Liloa, a sixteenth-century chief of Hawai'i Island. When examined in 1960 it was also found to contain barkcloth and an iron spike in a wood handle. A small pearl-shell disc is sewn onto the front. H. 88.9 cm. Ex. Bishop Museum, Honolulu.

FIG. 21 *Otoo King of O-Taheite*, engraving by J. Hall after William Hodges. Tu was a powerful chief on Tahiti who became Cook's *taio* (exchange partner). He later took the name Pomare and was the father of Pomare II who established control over most of the Society Islands.

sented, and also distributed chiefly valuables made by specialists – such as feathered cloaks, canoes or items of whale ivory. These offerings and blessings cycles were essential to the maintenance and health of the chiefdom, and although chiefs had power to command, they also could be subject to neglect if they were not active in the chiefdom, if their *mana* was not manifested in abundance, fertility of gardens, success in war and other activities. Neglect took the form of the people not 'facing' the chief, not bringing presentations, turning away from the chief (and by implication towards another), and

3

Collecting Polynesia

It is perhaps important to realize at the outset that collecting was not, and is not, an exclusively European activity. The acquisition, retention and high valuation of exotic, strange and/or old things is a human trait which has manifested itself all over the world – in China, Japan, Africa, Central America and, indeed, Polynesia.[1] However, in the second half of the eighteenth century a trend began to develop in Europe, and especially in Britain, of widespread and systematic collecting. This continues to this day, as many thousands of museums and collectors in all parts of the globe vie with one another for specimens and works of art.[2] Polynesia, and Polynesian things, have played no small role in this story of collecting, not least because it was in the eighteenth century that Polynesia, as an intriguing, exciting and exotic place, burst into European consciousness as the result of voyagers bringing back reports, impressions, pictures and objects – curiosities both 'natural' and 'artificial' – to Europe.[3] It is therefore with these voyagers that we shall begin.

Voyagers: Tupaia, Wallis, Cook and their successors

For Europeans, it is tempting to see Polynesians as static recipients of voyaging visits, as European ships traversed the ocean, coming upon fixed populations. But Polynesians were Oceanic peoples, and although by the eighteenth century the great long-distance voyages of an earlier period seem largely to have ceased, voyaging nevertheless continued, focused on local networks of exchange and communication. Open-ocean journeys of several hundred miles were still undertaken in western and central parts of Polynesia, but in Hawaii and New Zealand the local populations explored and exploited their rich environments in relative isolation. Easter Island, too, appears to have become isolated, although the small size and limited resources of that island set different problems for the inhabitants.

The fact that Polynesians retained extensive knowledge of regional geography was exemplified by Tupaia, the priest/navigator from Ra'iatea in the Society Islands who joined Cook's first voyage at Tahiti in 1769 and who piloted the vessel through the Leeward Islands (fig. 22). Tupaia's knowledge of other islands and groups was transferred to a map, the original of which is lost, but a copy of which has caused cartographic confusion because many islands seem to be placed in the wrong positions, often diametrically opposite to where they actually lie. Turnbull (1998) has shown that this is not due to inadequacies in Tupaia's knowledge, but rather to inadequacies in the manner in which

FIG. 22 Tupaia, *A scene in Tahiti*, April–July 1769; pencil and watercolour, 26.7 × 36.8 cm. British Library. This drawing by Tupaia (see fig. 9) shows three canoes, two with fighting platforms and warriors with staff-clubs (no. 155). Among many notable features are the figures drawn in the style of Society Islands' sculptures.

his knowledge and information was transferred to paper.[4] Tupaia appears to have been by no means exceptional in his geographical knowledge: another voyager, Puhoro, who sailed with the Spaniards from Tahiti to Peru and back in 1775, had visited more islands than Tupaia.[5]

Given the likely level of Polynesian voyaging and communication, the visits and 'discoveries' of European vessels need to be seen in a local perspective. Although Wallis on the *Dolphin* in 1767 was the first European to visit Tahiti, it is highly likely that Tahitians, even if they had never seen a European at close quarters, would still have heard about them and their boats with unusual rigs and strange materials on board. Roggeveen not only sighted Borabora and Maupiti in 1722, but his ship was sighted by islanders, since this visit was reported to people on Cook's first voyage some forty-seven years later. Roggeveen also lost a ship in the Tuamotus, and the traumatic visit of Mendaña to the Marquesas in 1595, and those of Quiros and Tasman to various places in the seventeenth century, will have entered local oral traditions and have been transmitted from place to place over generations. Islanders were in many places familiar with metal, even if they had not seen a European, for the men of Nukutavake expressed a strong preference for nails during exchanges with the crew of the *Dolphin* in 1767.

From a European perspective, the 1760s mark the beginning of a period of unprecedented voyaging in the Pacific. Matters started unpromisingly with the voyage of John Byron in the frigate *Dolphin* (1764–6). There were few sightings of land between the Straits of Magellan and the Marianas except in the Tuamotus, where they found parts of

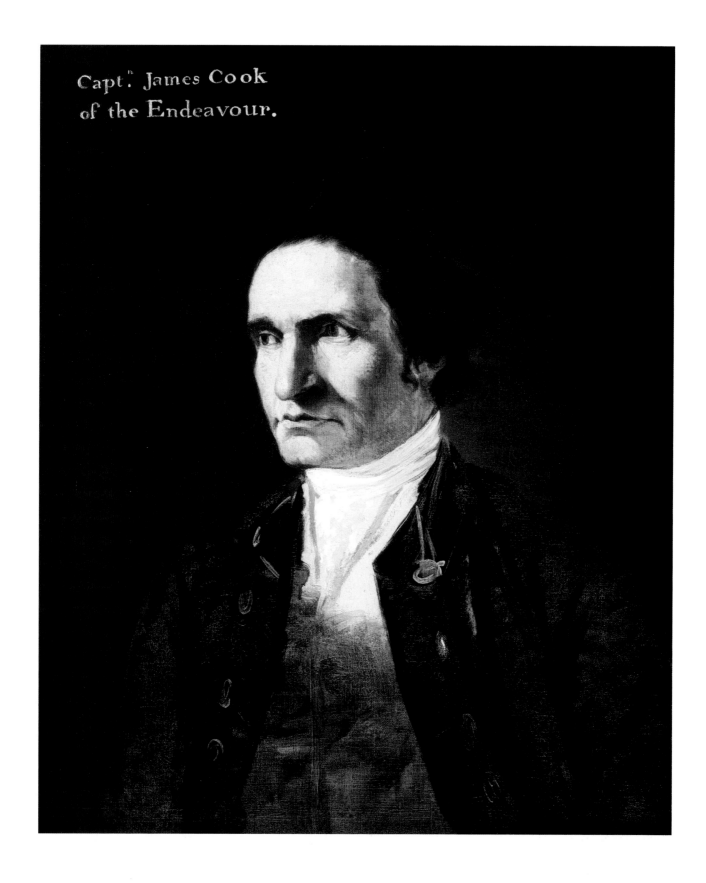

FIG. 23 William Hodges, *Captain James Cook, c.* 1775; oil on canvas, 76.2 x 63.5 cm. National Maritime Museum, Greenwich. Inscribed *Capt. James Cook of the Endeavour.* This portrait, a study from life, reveals Cook's strength of character and determination prior to his third and last voyage.

Roggeveen's *Afrikaansche Galei*, wrecked at Takapoto in 1722, when five sailors deserted – their fate unknown. Almost immediately after the *Dolphin*'s return to England in 1766 she sailed again, this time under the command of Samuel Wallis with instructions to search for the Great Southern Land. The *Dolphin* sailed in the company of the sloop *Swallow*, under Philip Carteret, until they became separated after a terrible passage through the Straits of Magellan. Despite the chronic illness and lack of imagination of Wallis, the *Dolphin* encountered several of the Tuamotus and then, in June 1767, Tahiti, which was 'taken possession of' and named King George the Third's Island. George Robertson, Master of the *Dolphin*, has supplied the best account of this visit to Tahiti, noting that, after initial hostilities in which Tahitians were killed and canoes damaged by naval guns, a great deal of trade and exchange took place at Matavai Bay – for food, water, sex, and also for 'curiosities', mainly shells, shell ornaments, fish hooks, adzes and stone pounders. Many hundreds of nails of all sizes were traded, being in great demand, and these were no doubt adapted quickly for carpentry work, as well as being treated as exchange valuables in their own right. Cloth and suits of clothes were also given as presents or in exchange for food.[6]

Besides the regular bartering for pigs and other supplies, there were also high-level exchanges with local chiefs, including 'Queen' Purea. On one occasion six large bales of barkcloth were presented with feast foods by the islanders. The unwanted bales were initially ignored but were eventually taken after obvious consternation on the part of the Tahitians, who declined to receive a reciprocal gift until theirs had been taken. The Europeans did not understand that to refuse an offering of this kind was publicly to deny an appropriate exchange partnership, because the acceptance of the bales was a way of binding the British into a relationship which they would be expected to reciprocate. A key episode during Wallis's visit was the acquisition by Tahitians, in exchange for food, of the long red pennant which the British set up on land during the act of 'taking possession'. Parts of the flag were eventually incorporated into a long feathered *maro* girdle of the kind worn by chiefs on installation. This was seen and sketched during the visit of William Bligh on the *Providence* in 1792, by which time it had also acquired some auburn hair from Richard Skinner, one of the *Bounty* mutineers of 1789.[7] This event gives us some insight into how Tahitians and their neighbours experienced European visits, attempting to make sense of them in their own cultural terms as they received metal, cloth, diseases and musket balls from these differently costumed and differentially ranked visitors in very large canoes.

George Robertson considered that his commander, Wallis, showed lack of initiative in the search for other islands. This accusation could not be levelled at Lieutenant James Cook, who left England in 1768 in command of the *Endeavour* (fig. 23). Cook's three voyages, which were to change, from both European and Polynesian perspectives, the landscape and seascape of the Pacific for ever, have been the subject of numerous books and studies.[8] Our present brief focus will be on the exchanges between Cook's men and Polynesians. It must be remembered that at this period those on board European ships *had* to trade: their lives depended on it, for without fresh food and water they could not survive long Pacific voyages. However, on Cook's voyages exchange relations

were motivated by more than physical survival, because developing scientific preoccupations meant that opportunities to acquire natural and artificial specimens would not be neglected.

The explicit purpose of Cook's first voyage (1768–71) was scientific, to observe the transit of Venus in 1769 from newly discovered Tahiti. There were also secret instructions, prompted by Wallis's hints at sightings of land, to search for the Great Southern Land and claim it for Britain. In the event Cook completed a circumnavigation via

FIG. 24 Sydney Parkinson, *Portrait of a New Zealand Man*, c. December 1769; pen and wash, 39.4 x 29.8 cm. British Library. This portrait of a man called 'Otegoowgoow, son to one of their chiefs' at the Bay of Islands, shows his facial tattoo (*moko*) and head, ear and neck ornaments of the period (Parkinson 1773: 109).

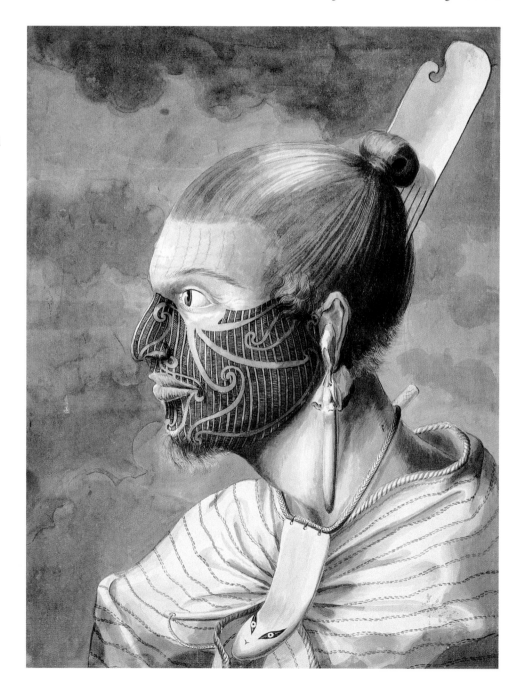

Tierra del Fuego, the Society Islands, Rurutu in the Australs, New Zealand, eastern Australia, Batavia (Jakarta) and Cape Town. On board *Endeavour* were men of science who would record and collect, notable among them the young Joseph Banks, then twenty-five years old, the Swedish botanist Daniel Solander and the astronomer Charles Green. Two artists were also on board, Alexander Buchan (who died before the ship reached Tahiti) and Sydney Parkinson (who died on the way home). Many of the drawings of the latter illustrated his own account of the voyage, prepared for publication by his

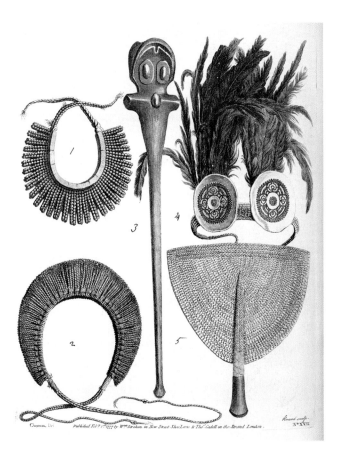

brother (1773). Parkinson was a careful draughtsman who gave accurate renderings of people and objects encountered, notably at New Zealand (fig. 24). Banks was probably the principal collector on board, but regrettably no inventory of his collection from this voyage, or of those things he acquired from third parties on the other two voyages, appears to have been made. Once back in England he distributed several representative collections to friends and institutions, among them Christ Church, Oxford. This collection has only recently been 'discovered' among the holdings of the Pitt Rivers Museum (no. 65).[9] Another recent discovery has been the identity of a first-voyage artist who for some time was thought could be Banks himself. It turns out that this artist was Tupaia, who learned how to paint and produced a number of watercolours. In retrospect, it might seem evident that the way the figures are rendered in the drawing *A Scene in Tahiti* (fig. 22), with squared shoulders and concave backs, would indicate a local hand, since this is the style of figure carving in the Society Islands and not the usual way a European would render the human form in action.[10]

Cook's second voyage (1772–5) was undertaken with the purpose of resolving once and for all the issue of the southern continent. This was achieved when Cook conducted a circumnavigation in high latitudes, with icebergs the only objects of note on the surface of the sea. He called again at the Society Islands and New Zealand, and made other landfalls at Tonga, Easter Island and the Marquesas. Banks had intended to sail on the second voyage, but his retinue was so large that they threatened to destabilize, literally, the *Resolution* when special modifications were made to accommodate them. Cook ordered the modifications to be dismantled, at which Banks protested and took himself off to Iceland. William Hodges was recruited as an artist and Johann Reinhold Forster as naturalist, accompanied by his son George. The elder Forster did not prove a popular shipboard companion, but he and his son were assiduous collectors of specimens natural and artificial, which they documented with thoroughness. The results can be seen principally at Oxford and Göttingen where hundreds of ethnographical objects from the

FIG. 25 *Ornaments and Weapons at the Marquesas*, engraving by Record after Charles Chapman. This plate from the official account of Cook's second voyage shows subjects seen or collected at Tahuata in April 1774, including the feathered headdress now in Oxford (no. 109).

second voyage are now kept.[11] Anders Sparrman, assistant to Forster, also made a collection,[12] as did Cook and other officers. Some of the objects acquired were published in Cook's official account of the voyage in 1777 (fig. 25).

For the first part of the second voyage, until they became separated, the *Resolution* was accompanied by the *Adventure* under the command of Tobias Furneaux. When Furneaux returned to England in 1774 he brought a young man from Ra'iatea, Mai, popularly known as Omai, who spent a year being fêted as a great celebrity – presented at court, hosted by Joseph Banks and painted by the society portraitist Joshua Reynolds. The wood stool he holds in his portrait by Nathaniel Dance (fig. 26) he gave to Furneaux, in whose family it remained until 1986, when it was auctioned and acquired by the Musée de Tahiti et des Iles.[13] Omai was not the first Polynesian to visit Europe: Bougainville had taken a Tahitian named Ahutoru back to France in 1769, but he did not survive the journey home. Omai, on the other hand, returned on Cook's third voyage laden with presents and acquisitions which he had gathered on his travels, including two horses, a suit of armour, muskets and other weapons with which to avenge himself on the Boraborans for the murder of members of his family.

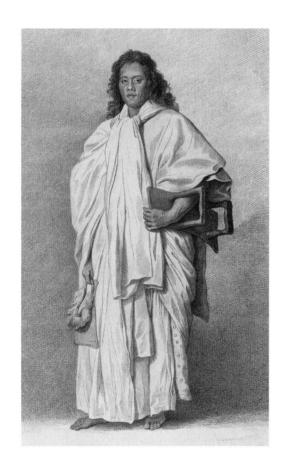

FIG. 26 *Omai, a native of Ulaietea, brought into England in the year 1774 by Tobias Furneaux*, engraving by Francesco Bartolozzi after Nathaniel Dance, October 1774; 54.5 × 33.0 cm. Omai (a combination of the proper article and his name, Mai) is shown during his stay in England robed in barkcloth and carrying a stool which he gave to Furneaux and which in 1986 was acquired by the Musée de Tahiti et des Iles.

By the time of Cook's third voyage (1776–80), the main purpose of which was to search for a northwest passage between the north Pacific and the north Atlantic, interest in artificial curiosities was growing, although still subordinate to the natural variety. Numerous crew members of both ships, *Resolution* and *Discovery*, made more or less systematic collections, bartering in New Zealand, Tonga, the Society Islands, Hawaii and elsewhere for local products in exchange for nails, metal tools, cloth and clothing. The expedition spent several weeks in Tonga, which afforded the crew and Omai the opportunity of acquiring large amounts of red feathers which they knew from experience would be in great demand when they reached the Society Islands, central as these were to the cult of 'Oro. On arrival at Tahiti in 1777 the news of red feathers brought an enormous throng of canoes about the ships, eager for trade. Having settled Omai on Huahine they proceeded north, coming unexpectedly upon Ni'ihau and Kaua'i in the Hawaiian Islands – as far as is known they were the first Europeans to visit there. After a brief stay they headed north again, cruising along the northwest coast of America and into the Bering Sea. Returning south in late 1778 to spend the arctic winter in the Hawaiian Islands, they called at Maui and Hawai'i itself, where Cook's remarkable life was ended by Hawaiians on the beach at Kealakekua Bay on the 14 February 1779.

Prior to this, Cook had been treated with conspicuous honour and received numerous presentations. He had also been consecrated as a temporary embodiment of the god Lono by being wrapped in a feathered cloak by the local chief Kalani'opu'u (fig. 27). This happened because Cook's ships had arrived at a critical juncture in the annual

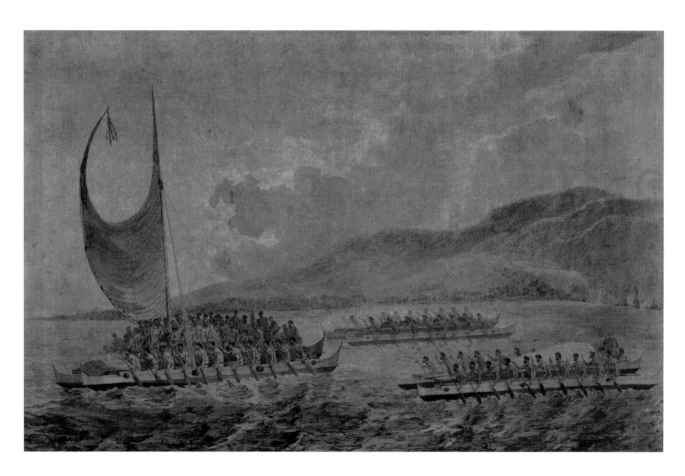

FIG. 27 John Webber, *Tereoboo, King of Owyhee bringing presents to Capt. Cook*, January 1779; sepia and watercolour, 40.0 x 62.9 cm. Bishop Museum, Honolulu.
On 26 January 1779 Kalani'opu'u, chief of Hawai'i, progressed around Cook's ship in three canoes carrying feathered cloaks and images. Cook followed him ashore and was there consecrated as an embodiment of the deity Lono by being robed in a feathered cloak and helmet and presented with other valuables and feast foods (Beaglehole 1967: I: 512).

makahiki ritual cycle linked to veneration for Lono. Cook, the leader of the strange visitors, was identified with Lono, while also being caught unawares in local power struggles between priests of Lono and of Ku, another major deity. The precise reasons for Cook's death have long been debated. Marshall Sahlins has convincingly argued that his identity as Lono and his ritually inappropriate behaviour, returning unexpectedly after damage to the *Resolution*, led to his murder and sacrifice. The fate of Cook, from a Hawaiian point of view, was linked to his status as Lono, an external and potentially problematic source of power which had to be managed by Hawaiians. The rites of consecration were one means of achieving this, as was also his destruction and the local appropriation of his power through sacrifice (fig. 28).[14]

After a period of shock, communications were re-established with the Hawaiians, who returned some of Cook's bones in barkcloth wrappings. The ships then moved north again, taking with them the consecration robes and many other things, including large feathered god images (possibly including nos 1–2) which had also been part of the presentations to Cook. The expedition, having failed to find a northwest passage, eventually returned to England in 1780 minus two other significant collectors who also died on the voyage: Charles Clerke, commander of the *Discovery* and of the expedition after Cook's death, and William Anderson, surgeon. Joseph Banks was the principal recipient of their collections, other material having been left in Kamchatka, presented to the

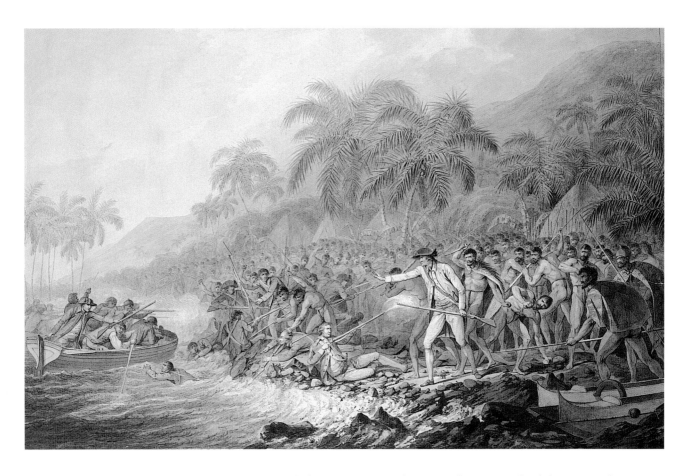

FIG. 28 John Webber, *The death of Captain Cook*, c.1781–3; pen, wash and watercolour, 40.9 x 58.1 cm. Mitchell Library, Sydney. Webber did not witness the death of Cook, but composed this painting from first-hand accounts, showing Cook in a heroic pose, calling for firing to cease as a Hawaiian stabs him in the back (according to some reports with an iron trade dagger).

Russians in gratitude for assistance on the voyage home. Much of this material is now in St Petersburg. The official artist on the voyage, John Webber, made a collection which is now in Bern.[15] Numerous other collections and distributions were made, such as that by James King, who took command of the *Discovery* after the death of Clerke, and who donated material to Trinity College, Dublin. The majority of Cook's own collection appears to have gone to Sir Ashton Lever, Banks's great rival, for his museum the Holophusicon in London.

With respect to voyaging in the late eighteenth century, Britain was not the only European power mounting expeditions to the Pacific, although the British were by far the most active collectors. French expeditions under Bougainville (1766–9), De Surville (1769–70) and Du Fresne (1771–3) visited various parts of Polynesia, but few if any objects are known to have survived from those voyages. Later expeditions under La Pérouse (1785–8) and D'Entrecasteaux (1791–3) left significant records, but again few objects survive.

The Spaniards made three expeditions to Tahiti from Peru in 1772–6, on one occasion leaving Catholic missionaries who encountered little success and were withdrawn. Many Tahitians were keen to embark on the Spanish ships, as had been Tupaia, Hitihiti and Omai with Cook. A navigator, Puhoro, was allowed to make the trip to Lima, returning with an extensive set of carpentry tools, cloth and suits of clothing. On the

way to Peru in 1775 the *Aguila* had stopped at Ra'ivavae – the first European ship to do so – where some minor exchanges took place, but where the visit was notable for pilfering by islanders. From these voyages one remarkable object survives – or at least can be identified. This is a large stone bowl given to the Spanish translator Máximo Rodríguez in 1775 (fig. 29). Made on Maupiti, it was taken to Borabora, to which Maupiti was subject, and then to Ra'iatea. From there it was presented to the Tahitian chief Tu (later called Pomare, fig. 21), who was related by marriage to the island of Ra'iatea. It was kept at the *marae* (temple) Taputapuatea on Tahiti (several *marae* of that name existed, the main one on Ra'iatea), before being given to Rodríguez. Its purpose – for kava or for food – is not known, but it was clearly an exchange valuable of major importance. Bolton Corney stated that it took four men to lift it, but that it was so finely balanced that it tipped easily for pouring.[16] From the voyage of Malaspina to Tonga in 1793 a number of documented pieces survive.

In terms of collecting, the British expedition under George Vancouver (1791–5) followed a similar pattern to those of Cook, with collections being made by a number of people, notably George Hewett (nos 9–11, 30, 42, 48, 153) and Spelman Swaine. Objects can also be documented to William Bligh's voyage in the *Providence* (1791–3), which proved more successful in bringing breadfruit from Tahiti to the West Indies than his first attempt in the *Bounty* (1787–9). A series of objects were collected by Lieutenant Francis Bond, now in Exeter (nos 149–50, 152), and George Tobin made a number of watercolours in a naïve but informative style (fig. 12).[17]

The Napoleonic Wars caused a lull in European naval expeditions during the first two decades of the nineteenth century, with the exception of the Russians, who were interested in annexing Hawaii and who mounted several expeditions which called there and at other places in Polynesia. Von Krusenstern and Lisiansky (1803–6), von Kotzebue (1815–18, 1823–6), Golovnin (1817–19) and Bellingshausen (1819–21) all produced valuable published accounts of their voyages, and a few documented artefacts can be attributed to those voyages, including New Zealand material (Barratt 1988: 156–83) and a Hawaiian feather cape from von Kotzebue's first expedition now in the British Museum (no. 4). The Americans also began to be active in the Pacific, a notable example being the voyage of David Porter in the *Essex* to the Marquesas Islands in 1813, during his cruise in search of British shipping to attack. The major American expedition of the nineteenth century was that under the command of

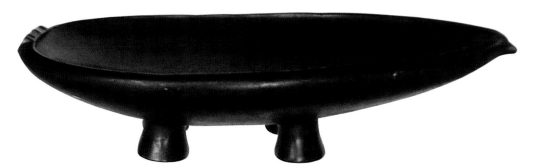

FIG. 29 A massive stone bowl, possibly for kava, given by the Tahitian Tu to Máximo Rodríguez in 1775 (not exhibited). It appears to be the only surviving bowl of its kind (Corney 1919: xxxiv–xli, 156, 169–70). L. 116.8 cm. Museo Nacional de Antropología, Madrid.

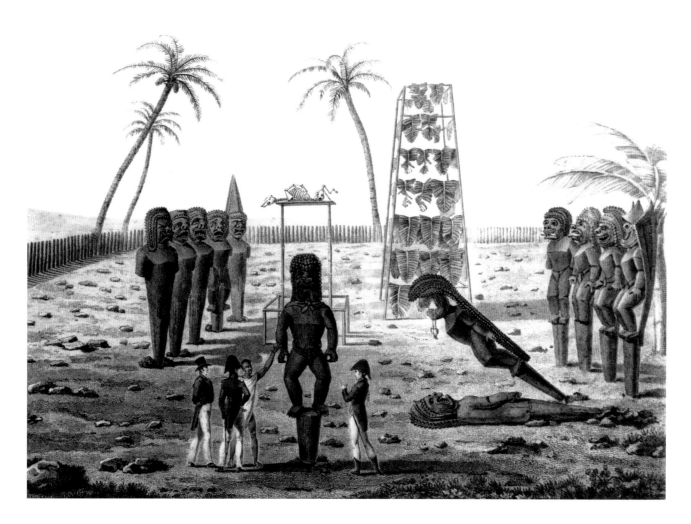

FIG. 30 *Iles Sandwich. Vue du Morai du Roi a Kayakakoua, sur l'Ile Owhyhi*, engraving by Lejeune after Jacques Arago. This depicts a *heiau* (temple) in disrepair at Kailua, Hawai'i, in 1819, with an oracle tower, offering platform and twelve large images. The British Museum figure (no. 20) may have been collected from this *heiau* after its abandonment.

Charles Wilkes, the United States Exploring Expedition of 1838–42. This was a complex multi-vessel undertaking, when extensive scientific and artefact collections were made, much of which was subsequently deposited in the Smithsonian Institution in Washington DC.[18] Alfred Agate, the artist on the expedition, sketched the powerful Fijian chief Tanoa Visawaqa wearing a composite pearl-shell and whale-ivory breast-plate, later almost certainly presented by his son Seru Cakobau to Sir Arthur Gordon, first Governor of Fiji (fig. 14, no. 238).

In terms of state-sponsored voyaging, the French and British navies were most active in the first half of the nineteenth century as early colonial ambitions and rivalries began to develop. French expeditions under de Freycinet (1817–20), Duperrey (1822–5), Dumont D'Urville (1826–9, 1837–40) and du Petit-Thouars (1836–9) produced illus-trated published accounts and some documented collections. The drawing by Jacques Arago of a partly neglected Hawaiian temple (*heiau*), made during de Freycinet's visit in 1819, is a valuable document which shows the arrangement of colossal temple images of the kind made on Hawai'i during the reign of Kamehameha, one of which is now in the British Museum (fig. 30, no. 20).

For Britain, the voyage of George Anson Byron in the *Blonde* (1824–5) was significant in being undertaken to return to Hawaii the bodies of the Hawaiian king and queen, Liholiho and Kamamalu, who had died of measles in London during a state visit to George IV. This service meant that Byron and his crew were offered gracious hospitality and access to things they desired, such as carvings from old temple sites (no. 14). The voyages of Beechey (1825–8), Belcher (1836–42), Erskine (1849) and Denham (1852–61) all resulted in collections which were kept privately or were donated to public institu-

FIG. 31 James Glen Wilson, *Feejean and Tongese Canoes getting under weigh at Levuka, July, 26, 1855*; watercolour, 30.0 x 66.0 cm. Private collection. HMS *Herald* is shown off Levuka, Fiji, in the midst of the great double canoes of King George Tupou of Tonga and of Cakobau, Vunivalu of Bau, who had previously presented one, the *Ramarama*, to King George (David 1995: 85).

tions. Material from the Beechey voyage can be found in Oxford (no. 175) and Exeter (no. 184), and that from the Belcher and Denham voyages in the British Museum (no. 251). James Glen Wilson made an outstanding series of drawings and paintings while on board the *Herald* under Denham (fig. 31).

Collections made on official naval voyages during the period under review are more extensive than those from any other source. The people involved in those voyages were fully aware of their role in representing the interests of their countries and monarchs in their dealings with Polynesians. Given that, in most cases, a local leader with whom to establish relations could be identified, there was perhaps an aspect of international diplomacy about the way in which naval commanders and officers interacted with local chiefs. Exchanges of presents, and bartering or 'trade', were the principal methods by which relationships across beaches and gunwales were initiated and sustained. Although the scouting out of commercial or imperial possibilities was always a factor for voyagers in the developing context of pre-colonial rivalries, financial profit was not the main purpose. Profit was, however, the very specific purpose of a related set of voyagers, the traders and whalers who sailed in the wake of the explorers.

Traders and whalers

Direct European commercial activity in Polynesia did not begin until the 1780s. Members of Cook's third voyage noted with interest the abundance of fine furs, especially that of the sea otter, on the northwest coast of North America. They realized that such furs could fetch high prices in China, where they were a luxury. Although the northwest passage had not been found, and remained a goal of further futile expeditions, if 'the Horn' could be braved, then northwest America provided attractive opportunities to enter a market up till then dominated by the Russians. Nathaniel Portlock and George Dixon, who had both sailed with Cook, mounted successful fur-trading expeditions in 1786–7, using Hawaii as a stopover. For several decades the China trade became a hazardous but highly profitable activity for British and American traders, and one which impacted on several parts of Polynesia. At the heart of this trade was a global fascination with, and high valuation of, exotic goods. It was a triangular trade. Europeans would take metal, cloth, beads and other cheaply acquired goods to the northwest coast of America, where they would exchange them for furs. These they would take, via Hawaii, to Canton in southern China, where they would in turn be traded for silks, tea and porcelain which fetched very high prices back in Europe, and provided massive profits for entrepreneurs.

After numerous expeditions in the 1790s the sea otter, which had the finest quality fur, became scarce and traders turned to sandalwood, the heartwood of which was used for incense and perfume in China. Sandalwood grew in several places in Polynesia, notably Hawaii, the Marquesas and Fiji, and in the first two decades of the nineteenth century the majority of this wood was cut out in those places. After diminishing returns on sandalwood, the Chinese taste for *bêche-de-mer* as a delicacy prompted traders to return to the Pacific, to Fiji in particular, where these 'sea slugs' abounded. Polynesians were interested in metal and cloth as trade goods, but in the sandalwood and *bêche-de-mer* eras other things were in great demand, notably muskets and the teeth of the sperm whale (*Physeter macrocephalus*).

Polynesians had too often had experience of European weaponry and were eager to obtain muskets, and even cannon, for use in their local disputes. If traders were to obtain what they wanted from the islands – food supplies, sandalwood or *bêche-de-mer* – they had to supply what locals were willing to trade for, so they stocked up with cheap muskets, powder and sperm-whale teeth which they obtained from whalers. By the 1830s muskets were plentiful in many parts of Polynesia where traders operated. These had direct and often devastating effects on local politics, but whale teeth were in some places no less valuable and desirable. Due to the pre-existing high value set on whale teeth, which were rare and could only be obtained from stranded specimens since Polynesians did not hunt whales, they were in great demand in Hawaii, the Marquesas Islands, Fiji and elsewhere. Teeth were associated with divine powers from the sea and *mana*, and were used to secure strategic alliances, both marital and military. They were adapted locally for use as new kinds of chiefly regalia. In Hawaii large versions of hook pendants were made (nos 40–41), some of them from walrus-ivory tusks which were brought from the Arctic. Walrus ivory was also incorporated into other high-status

objects, such as *kahili* (no. 8). In the Marquesas large ear ornaments (no. 111) and other pendants were made of ivory in the early decades of the nineteenth century, both for local use and also for trade back to Europeans eager for souvenirs. In Fiji teeth were modified by the attachment of a cord to each end, for use when presented with speeches (no. 237), and other teeth were sawn into sections and assembled as new kinds of composite breastplates and necklaces, worn by chiefs as regalia and also used as exchange valuables (fig. 14, nos 238–40). Many of these were eventually acquired by Europeans in the second half of the nineteenth century from people in the interior of Fiji who had received them from coastal chiefs. Kamehameha I of Hawaii (fig. 32), by controlling the sandalwood trade, was able to acquire European sailing ships in return for 'wood'. He even mounted his own sandalwood trading voyage to China, though with only moderate success. He accumulated enormous quantities of European goods, and he and other chiefs indulged in conspicuous consumption unrivalled in other Polynesian chiefdoms.[19]

Whalers began their operations in Pacific waters in the 1790s – firstly British but then Americans from East Coast whaling ports such as Salem, Boston, New Bedford and Nantucket. For whalers the teeth of the sperm whale were an incidental by-product of their main quest – oil from its blubber and the sperm oil from the chamber in its head, which was so fine as to be in great demand for clocks and industrial machinery.[20] For whalers and for traders Polynesia was a source of labour and of supplies for their long voyages. The Bay of Islands in New Zealand, the Marquesas and Hawaii – notably the port of Lahaina on Maui – were regular stopping places. Herman Melville sailed on a whaler, the *Acushnet*, and the harpooner Queequeg in *Moby Dick* was based on a Marquesan (from the description of his tattoos). Melville's book *Typee* (1846), much more popular at the time, was based on his adventures in the Marquesas.

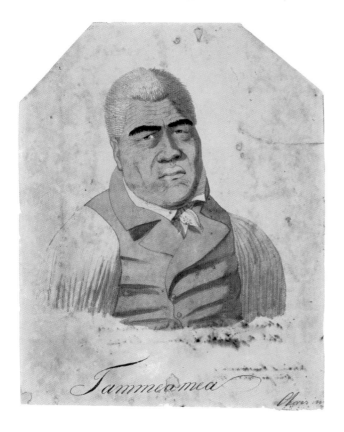

FIG. 32 Louis Choris, *Tammeamea*, 1816–17; watercolour, 22.0 × 18.0 cm. Bishop Museum, Honolulu. The powerful chief Kamehameha I (1753–1819), who unified Hawaii as a kingdom, is shown dressed in European style with a red waistcoat and yellow necktie, reflecting the chiefly colours used in feathered cloaks.

Neither traders nor whalers collected objects in a scientific or systematic way, but some operating from New England brought back souvenirs which now form rare and early collections at institutions such as the Peabody Essex Museum in Salem. A flavour of the time, and of casual collecting, is provided by the following quotation from a letter home from William Winkworth at Tahuata in the Marquesas Islands aboard the whaler *Sir James Cockburn*: 'Musquets are in great requisition on account of the wars they are perpetually engaged in, for one of these we can get 7 or 8 good large hogs, a pound of powder 1 hog; … [they are eager] for muskets and powder finding our mode of weapon much superior to theirs, in fact their own implements of war, viz. clubs, spears, etc. may be procured for a mere trifle. Some of them I have bought as presents for friends at home.'[21]

Another category of visitor to Polynesia played a significant role in local trading and politics – the beachcomber and castaway. These were the first European residents in the region, and by the early nineteenth century many were established on islands throughout the region, usually marrying local women and working in the service of local chiefs as translators, blacksmiths and technicians, notably repairing and operating muskets. The Englishman John Young arrived in Hawaii in 1790 and for almost three decades served Kamehameha I as advisor and military strategist. A few of these men, such as William Mariner on Tonga, Edward Robarts on the Marquesas and William Endicott on Fiji, wrote accounts of their experiences which, when read with caution, are valuable historical documents.[22] Documented collections from beachcombers do not exist, unsurprisingly, and the names of many are now lost, including that of the American whom representatives of the London Missionary Society found in 1822 had been living on Rurutu for seven years. The missionaries, of course, generally disapproved of the behaviour of these men. No doubt the feeling was mutual, and it is to the activities of the missionaries which we now turn.

Missionary enterprise: converting and collecting

European voyagers and traders had few ambitions to change the belief systems or behaviour of Polynesians. Rather, they had to adapt to local conditions during their visits in order to achieve their aims. However, a by-product of these voyages was the impact on intellectual life and philosophical ideas back in Europe when reports were read and pictures and curiosities seen. Many of a philosophical inclination used classical terms to describe Polynesia, following Bougainville who had depicted Tahiti as Nouvelle Cythère, a reference to a classical Greek paradise. These romantic attitudes were fuelled by the charming and exotic behaviour of Omai and Ahutoru during their visits to Britain and France. However, into this celebratory climate came a darker view, founded in stories of murder, cannibalism, infanticide and idolatry. Devout Christians saw not a state of noble dignity but of benighted savagery, and felt impelled, no matter what the hardships, to bring Polynesians from paganism to salvation, from 'darkness' to 'light'. The history of Christianity has been marked by phases of aggressive evangelism towards non-believers, an approach which has had a major impact on Polynesia.

The first missionaries were two Spanish Franciscan Friars who spent an unsuccessful year on Tahiti in 1774–5. Twenty-two years later a more concerted effort was made by Protestants of the newly formed Missionary Society (which became the London Missionary Society in 1818 – hereafter LMS), which was established in 1795 in England and which in 1796 sent out an expedition to the Pacific in the *Duff*, commanded by Captain James Wilson. This was a private, not a state-sponsored venture and four ordained ministers were accompanied by twenty-six laymen, mostly artisans. The missions established in 1797 in Tahiti, the Marquesas and Tonga were conspicuous by their failure, but they persevered in Tahiti and eventually achieved the nominal conversion of Pomare II in 1812 and his baptism in 1819 (fig. 33).[23] Missionary strategy was to concentrate on local chiefs in the expectation, usually well founded, that if chiefs converted the people would follow.

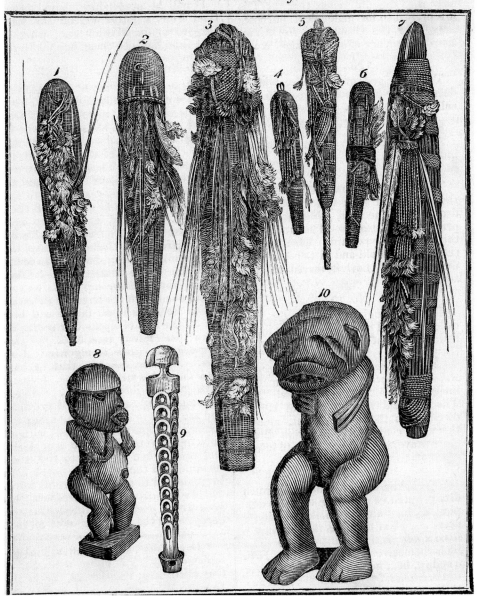

THE FAMILY IDOLS OF POMARE,

Which he relinquished, and sent to the Missionaries at Eimeo, either to be burnt, or sent to the Society.

FIG. 33 The Family Idols of Pomare, *Missionary Sketches*, no. III, October 1818. These objects from Pomare II, son of Tu of Tahiti (fig. 21), were kept by the LMS to publicize their success. The numbers refer to identifications (unreliable) in the text. Nos 8–9 are illustrated below (nos 128, 169).

Chiefs were meanwhile making their own strategic assessments of the new priests and their position in the European scheme of things. Visually, the pious and sober missionaries were unimpressive to Polynesians, who were used to status being reflected in the resplendent costumes of ship's captains. In addition, local priests and guardians of cult objects did not welcome rivals to their territory. On the other hand, islanders who could see advantages in allying themselves with the new religion became pastors and were the main agents through whom conversions were initially achieved, especially in the Cook

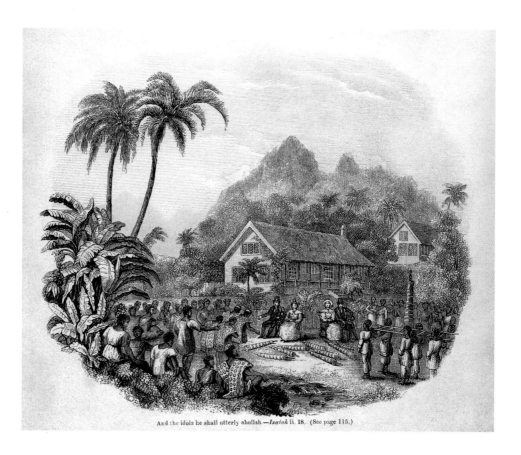

FIG. 34 *And the idols he shall utterly abolish*, engraving by G. Baxter. Reverend John Williams and Reverend Charles Pitman and their wives are shown in 1827 in an idealized scene on Rarotonga in the Cook Islands receiving 'fourteen immense idols' (drawn smaller than life size). Only one large idol complete with its wrapping survives (no. 195).

And the idols he shall utterly abolish.—*Isaiah* ii. 18. (See page 115.)

and Austral Islands. The role of these Society Islands pastors should not be underestimated, not only in central Polynesia but also in Samoa and Fiji – the first Christian missionaries to arrive in eastern Fiji in 1830, five years before the Methodists Cross and Cargill, were Tahitians, though they met with little success. In Fiji Methodist missionaries laboured for almost two decades before the powerful chief Cakobau converted to Christianity in 1854, for reasons which appear to have been more strategic than theological.

The efforts of the LMS were concentrated in the Society Islands, and then extended to neighbouring groups. The establishment of mission schools and of printed versions of the Bible and the prayer book were key mechanisms by which progress was made. William Ellis brought a printing press to Tahiti in 1817. It immediately caused great interest for a variety of reasons. Rivalries developed among the missionaries as to where it should be sited; Pomare insisted on inaugurating its operation, and there was enormous demand for printed texts. It is tempting to view this piece of machinery, in Polynesian terms, as a kind of god image – a composite and impressive object sited in a special restricted place, producing by a mysterious process materials in which god's word and power were said to reside, and which were distributed to regional shrines under the control of priests. This process paralleled in key ways those associated with images of the deity 'Oro in *pa'iatua* rites. It is not surprising that Pomare was insistent on presiding over its first operation, and keen to keep it in his own domains.[24]

When viewed from an indigenous perspective it seems that missionaries were

inclined to take local practice into account in order to keep their congregations. In this regard they sited their chapels on or near old temple buildings and *marae*, and in some cases actually rededicated pagan temples to Jesus Christ, as at Viwa in Fiji. Local god images were sometimes incorporated into chapel architecture, as was the case on Rarotonga in the Cook Islands (fig. 34) and Ra'ivavae in the Australs. The two members of the LMS deputation to Ra'ivavae, Tyerman and Bennet, noted two new chapels there in December 1823. One had pillars opposite the pulpit, 'curiously ornamented with wreaths of human figures, carved out of the solid wood' (cf. drums nos 161–4). Another was described as follows: 'At the several corners … upon suitable platforms, stand four of the deposed idols lately worshipped here. These, which are of large size, are no despicable specimens of rude sculpture; and certainly, as mere statues, they better become the stations which they now occupy, than those which they formerly held in the maraes.' One wonders to what extent the Ra'ivaveans were aware of this fine distinction.[25]

Missions were progressively established in most parts of Polynesia during the first half of the nineteenth century. Samuel Marsden of the Church Missionary Society set up a base at the Bay of Islands in New Zealand in 1814. William Ellis of the LMS and representatives of the American Board of Missions began work in the early 1820s in Hawaii. Methodist missionaries arrived in Tonga in the 1820s, moving across to Fiji in the 1830s. Catholics followed in most areas, often leading to intense interdenominational rivalry to add to that which arose within denominations. Missionaries became intensely involved in local politics as they vied for supplies, converts and success. Reports of baptisms were one measure of success, but one of the other principal ways was the demonstrable overthrow of pagan idolatry. 'Idols' thus became not only a target for iconoclasm – their destruction without bad consequences often serving as 'proof' of Christian superiority – they were also preserved and paraded as 'performance indicators'. Evidence of the triumphs of Christianity through mission work, and of the need for funds to sustain it, were embodied in captured idols which were sent back to Europe for display in mission museums and in fund-raising exhibitions. In this way missionaries became collectors, and an unintended consequence of their actions is the survival of Polynesian sculptures from which we can learn and which we can celebrate. The Tahitian chief Pomare assisted in this process, in 1816 handing over a number of god images to the LMS with the request, 'If you think proper, you may burn them all in the fire; or, if you like, send them to your country, for the inspection of the people of Europe, that they may satisfy their curiosity, and know Tahiti's foolish gods!' (fig. 33).[26]

The LMS Museum was established in London and a catalogue produced (Phillips 1826). A second edition was issued in the 1850s (LMS n.d.), with much additional material deriving from George Bennet, a lay member, who with Reverend Daniel Tyerman had composed the deputation which went on a world inspection tour of missions between 1821 and 1829. Three years (1821–4) were spent in Polynesia. Bennet was an assiduous collector and material deriving from him was deposited in the LMS Museum, in Philosophical and Literary societies in Leeds and Sheffield, and in Saffron Walden Museum. The Reverend John Williams was another active LMS collector (fig. 10) who presided over the offering up of the great god image A'a from Rurutu (no. 156), which

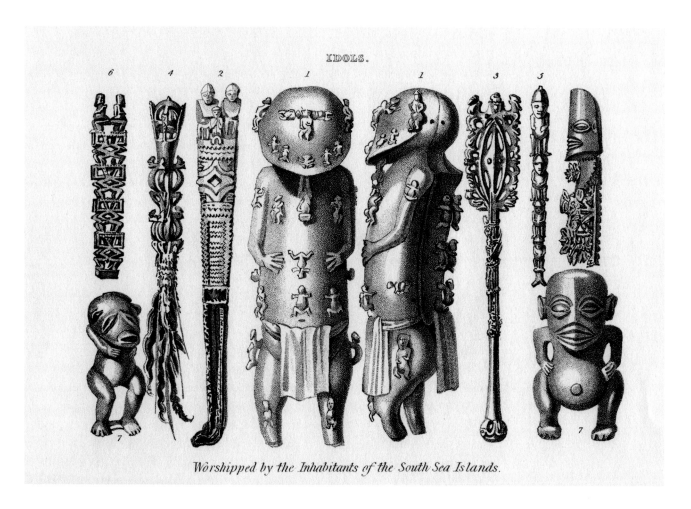

IDOLS.

Worshipped by the Inhabitants of the South Sea Islands.

FIG. 35 *Idols. Worshipped by the Inhabitants of the South Sea Islands*, engraving. A plate depicting objects acquired by the LMS from the Society Islands, the Cook Islands and the Austral Islands (the numbers refer to unreliable identifications in Ellis's text). Nos 1, 3 and 7 are illustrated below (nos 156, 165, 189).

William Ellis described as Tangaroa – the great Polynesian founder god – perhaps in order to enhance the momentous nature of its acquisition (fig. 35).

The Methodist Missionary Society also had a museum and collections which they exhibited periodically. A fine Fijian human-form dish, similar to no. 251 here, derives from their collection and is now in the National Museum of Fiji.[27] Catholic missions also sent material home and many European museums contain objects deriving from these sources, including the Vatican Museum in Rome.

The collecting of objects by missionaries was a conscious act of desecration. They were often stripped of their wrappings and bindings. George Bennet also wrote identifications in large black letters on the faces and bodies of some images (nos 122, 134). The inscribing of objects in this way, especially on the head, was an additional means of disempowering them and bringing them under missionary control.

Provenance, attribution and style

Precise collection documentation has for some time been the concern of the curator – the catalogue section of this book exemplifies that – but this was not always the case.

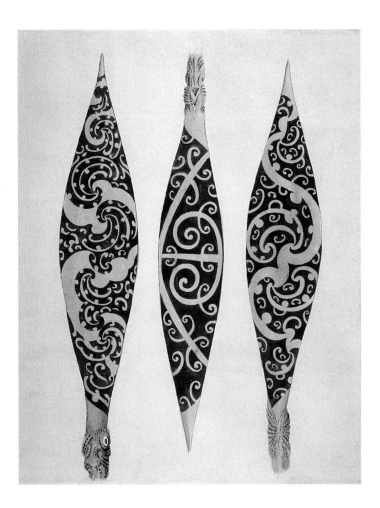

FIG. 36 Sydney Parkinson, *Three paddles from New Zealand,* October 1769; pen, wash and watercolour, 29.5 x 22.8 cm. British Library. Painted from actual examples, illustrations of this kind allow identifications of objects which lack documentation (see no. 66).

The scientific concerns and enthusiasms of the eighteenth and nineteenth centuries did not always extend to rigour in description and documentation, and ethnographical objects were not treated with such classificatory thoroughness as shells, fish or botanical specimens. For example, Cook voyage objects, if they did acquire labels, usually did so back in Europe when collectors' memories proved faulty and the objects had become muddled up in the cramped storage conditions aboard ship and in the confusions of disembarkation. In this way we find that the designation 'Otaheite' became a widespread term to indicate the origin of South Seas specimens. Such errors can be seen in relation to material from New Zealand (no. 83) and Hawaii (no. 33). Otaheite, a combination of the proper article O and Tahiti, misled later scholars as to the origin of many things, but it nevertheless has its significance for research, in that any object which bears such a label can reasonably confidently be ascribed an eighteenth-century provenance.

Joseph Banks, an extremely busy and ambitious man, does not appear to have documented his own ethnographical 'field' collections or those he acquired later from others. We know that he made donations to the British Museum and other places, but these were not, as far as is known, individually listed. Large amounts of very significant material entered the British Museum in the late eighteenth century, but the best efforts of later researchers have not been able to identify them or disentangle them from other collections. In contrast, Johann Reinhold Forster and his son George, who both sailed on Cook's second voyage, were much more thorough and their collections in Oxford and in Göttingen have been mostly identified and published.[28]

The great majority of objects acquired by Europeans in Polynesia in the period in question lack any detailed documentation (fig. 36). We have many accounts of exchanges and gifts, but seldom are specific objects identifiable. Often they have passed through several hands before finding their current locations, and their individual histories have been lost. This situation is one reason why such an emphasis has been placed in this volume on documented and reliably provenanced material – to assist museum curators in comparative work when assessing their own collections. However, even if the time and place of acquisition is known, this is no guarantee that the object was made in that location, or indeed when it was made. Objects acquired on specific dates may literally have been finished the day before the ship sailed, or may have been decades old at that time. Objects may also have been made specifically for the purpose of conducting

exchanges with European visitors – especially when those visitors stayed several weeks, as was the case with many voyages. Such objects should not be construed as 'inauthentic' because exchange valuables were usually made with particular rituals and events in prospect – and interactions with Europeans were numbered amongst these.

With respect to place of manufacture, although craft specialists (sometimes 'foreigners') were working in the service of local chiefs, nevertheless some of the most valuable local objects were exotic imports – much of their power and significance derived from their exotic nature. The pearl-shell elements which are such an important part of 'Tahitian' mourners' costumes (no. 140) were imported from the Tuamotus. The whale-ivory elements in 'Fijian' composite breastplates (nos 238–9) were made by Tongan or Samoan craft specialists using European metal tools and sperm-whale teeth acquired from European traders. None of this makes such objects less authentically Polynesian – indeed it makes them more interesting – but it does pose problems for those who have a simplistic view of what is 'traditional' or 'genuine'. Fijian clubs with New Zealand Maori designs set up intriguing questions about mobility of craftsmen (no. 267), and Austral Island decorated paddles (no. 184), which do not appear to have been made prior to about 1820, indicate innovation and adaptability rather than decadence. The opportunities for Austral Islanders to make desirable exchange goods, and the availability of skilled carvers no longer engaged in 'pagan' drum manufacture, led to an efflorescence of this particular type of carving. The wide variability in the fineness of execution of these paddles indicates that it was a popular and productive activity for a range of carvers. The fact that Australs paddles and bowls (no. 175) were collected in Tahiti also shows the extent to which they were in circulation in the region in the 1820s.

In a large place such as New Zealand, materials, objects and craftspeople moved long distances during the course of inter-tribal exchanges, marriages, alliances and warfare. The capture or destruction of valuables such as canoes, store houses, nephrite weapons and ornaments was a way of disrupting your enemy's prosperity cycle and subordinating them to your power. This is why important carvings have been found in swamps in some parts of New Zealand, hidden there to prevent desecration or capture by an attacking enemy. This mobility and variability creates problems for those who would attempt to be too inflexible in assessing matters of regional style and attribution. There is also the problem of 'received wisdom' being repeated uncritically without examination of evidence. An example of this is exemplified by the large scalloped clubs which for many years have been attributed, including by this author, to Rarotonga in the Cook Islands. There seems little doubt now that they were in fact made on Atiu or another of the central Cook Islands (no. 222).

One aspect to be emphasized is the importance of specialist groups of skilled craftspeople, who did not live on every island in Polynesia. Particular islands possessed particular resources and were home to people who possessed specific skills. The operations of chiefdoms in all parts of Polynesia required specialist objects, such as canoes, and relationships needed to be maintained with their makers, who might be relatively remote. It is thus perhaps helpful to see chiefdoms as composed of networks of relationships, into which materials and objects were drawn from the periphery to the centre. In

this way the chiefdoms of the Society Islands were a focus for material from the Tuamotus, the Australs and even the Cook Islands.[29] One drum (no. 137) perhaps encapsulates the attributional conundrums which such a situation generates. It appears to be 'Tahitian' in general form and in the attachment of the cords to the base, but the binding of the fish-skin tympanum is done in a style familiar from Mangareva, and the row of small figures around the base could be attributed to the central Cook Islands.

Museums and collectors: then and now, here and there

Museums and collectors go together, because without the latter the former would not exist. Whether a museum is a private collection on display, or a major national institution, it is the product of collecting by individuals who had personal motivations in mind. The earlier sections of this chapter have considered the collecting activities of a variety of Europeans – voyagers, traders, missionaries – who either visited or were resident in Polynesia. This section considers what happened to those objects when they arrived back in Europe or America, and how they were re-contextualized in terms of European value systems, institutions and rivalries.

With respect to museums, the late eighteenth century in England was dominated by the British Museum (founded in 1753) and the Holophusicon or Leverian Museum, founded by Sir Ashton Lever in 1771 at Alkrington Hall near Manchester and transferred to London in 1775. These two institutions acquired large quantities of Polynesian material from Cook's voyages and other sources. The British Museum received objects from the Lords of the Admiralty, such as the Nukutavake canoe (no. 121), and also a series of donations from Sir Joseph Banks, who became a Trustee. These donations included material he had collected himself during Cook's first voyage and other things which he obtained from people who sailed on the other two voyages, including the collection of Charles Clerke (no. 24). In the 1890s James Edge-Partington, working with Augustus Franks and Charles Read, catalogued large numbers of early objects which had never been formally accessioned – giving them numerical prefixes HAW, TAH, NZ, to indicate their probable cultural origin. Many of these things are likely to have been part of eighteenth-century donations, but nothing can be proved. In the 1770s and 1780s there appears to have been no-one at the British Museum who was much interested in this material, but the same cannot be said for the Leverian Museum, which existed because of the phenomenal energies, and diminishing fortune, of Sir Ashton Lever. He eagerly acquired what he could from Cook voyagers, including the third-voyage collection of Cook himself, who was an admirer of Lever. However, Lever also failed to keep a proper accessions register, such was the scale, scope and frequency of his acquisitions, but he did employ an artist, Sarah Stone, to make illustrations of objects in his museum in 1783. As far as is known, no drawings exist of the South Seas Room at the British Museum.[30]

For Lever, his obsessive and almost indiscriminate collecting proved his downfall in that it drove him close to bankruptcy and ill health. Having offered to sell his collection to the nation, and receiving no enthusiastic response, he was eventually obliged to sell it by lottery in 1786. 36,000 tickets were issued but only 8,000 were sold. James Parkinson owned the

winning ticket and maintained the museum until 1806, when it was sold at a sixty-five-day auction run by King and Lochee in London. In 1790 Parkinson published a *Companion* to the museum. This document and the sale catalogue of 1806 have allowed later researchers, notably Adrienne Kaeppler, to identify and trace many of the objects from the museum. Before it was auctioned the museum was again offered to the nation, for £20,000, but the offer was declined on the advice of Sir Joseph Banks, who let his rivalrous enmity for Lever cloud his judgement, even many years after Lever's death in 1788. In this way was an extraordinary collection of natural and artificial curiosities lost to the nation.

Buyers at the 1806 auction came from far and wide, and a significant amount of Polynesian material was purchased by Leopold von Fichtel on behalf of the Emperor of Austria – material which is now in the Museum für Völkerkunde in Vienna.[31] William Bullock, who had a museum in Liverpool, which moved to London in 1812, was another major purchaser at the auction. His 'London Museum' was itself sold at auction in 1819 in a twenty-six-day sale and material was further dispersed.[32] William Bullock was following a pattern which had been set by collectors and museum proprietors of an earlier generation who had built up private collections, called museums, which were then sold. Indeed the contents of such museums in those days were often available for sale. George Humphrey sold his Museum Humfredianium in 1779, before the return of Cook's third voyage. He then amassed another collection, much of which was sold to Göttingen in 1782.[33] Daniel Boulter had a Museum Boulterianum at Great Yarmouth and George Allan, who died in 1800, assembled a museum in the northeast of England which was eventually sold to Newcastle Literary and Philosophical Society in 1822. Voyagers such as David Samwell, surgeon on Cook's third voyage, also sold the objects they brought back. Samwell's collection was auctioned in 1781 and some material found its way to the Hunterian Museum at the University of Glasgow (no. 33).

The public excitement and relatively high valuation of Polynesian things of the late eighteenth century did not carry over into the nineteenth century. Material was scattered amongst a relatively limited number of enthusiasts who continued with their private museums, such as that owned by Richard Cuming (no. 32). Most large provincial museums did not become established until later in the nineteenth century. Other types of institution which did hold and keep collections were universities. Banks, the Forsters and others had donated eighteenth-century Polynesian material to colleges at Oxford, Cambridge, Edinburgh and Dublin, and these collections eventually found their way into university museums in the second half of the nineteenth century, or were transferred to national collections. These collections were retained because of their scientific value, rather than any popular appeal, and scientific value was also the motivation for the acquisition of objects by Philosophical, Historical and Literary societies which were formed in England in the early nineteenth century, especially in industrial cities of England such as Leeds, Sheffield, Manchester, Liverpool, Newcastle and Birmingham. Collections at these institutions were later transferred to city museums. George Bennet of the LMS made major donations to the learned societies of Leeds and Sheffield, his home town, but a lack of interest on the part of later curators led to much of this material being transferred to other institutions, such as Cambridge, or sold privately.

FIG. 37 The Museum of the London Missionary Society (*Illustrated London News*, 25 June 1859). A number of objects can be identified in this scene of domesticated idolatry, including the Rarotongan staff god (oversize, no. 195) and the Rurutu casket figure (no. 156) in the cabinet on the left.

The missionary collections themselves – notably of the LMS and the Methodist Missionary Society – were also later dispersed when their effectiveness as fund-raising resources was outweighed by the burden and costs of their care and maintenance. A major portion of the LMS collection was deposited on loan at the British Museum in 1890 and eventually purchased in 1911 (fig. 37). One of the main reasons why the British Museum's collections were enhanced in this and other ways was the energetic presence there of Augustus Franks, who throughout most of the second half of the nineteenth century built up the ethnographical collections. Another remarkable man of the period was Augustus Lane Fox Pitt Rivers, a former military man who assembled a large ethnographical collection in London – acquiring objects at auction and from returning travellers, missionaries and colonial administrators. This collection of some 15,000 items was transferred to the University of Oxford in 1884, where it formed the founding collection of the Pitt Rivers Museum. The donor required that the objects be displayed according to the typological and evolutionary theories which he espoused, and this remains the case today. Pitt Rivers, who inherited a large fortune, went on to make a second large collection which he displayed at Farnham in Dorset until his death in 1900. That collection was later dispersed by private sales around the middle of the twentieth century. The Pitt Rivers Museum at Oxford thrived under the curatorship of Henry

Balfour, while the museum at Cambridge (now the University Museum of Archaeology and Anthropology), also established in 1884, thrived under the curatorship of Baron Anatole von Hügel, who had spent over two years in Fiji in 1875–7.[34]

Between the late nineteenth century and the middle of the twentieth century Polynesian material was little regarded or valued outside of a relatively small number of people – museum curators, private collectors, dealers and, increasingly, artists. The rise of Modernism and modernist critiques of the Victorian art establishment brought Polynesian sculptures within new definitions of art. Artists based in France, such as Pablo Picasso and André Derain, and others in England, such as Henry Moore and Jacob Epstein, were inspired by Polynesian and 'primitive art' as it was then called. This 'appropriation' of non-Western art by European artists has been the subject of political and ethical debate, particularly after the 'Primitivism' exhibition in New York (Rubin 1984), but what cannot be denied is the high cultural value set on such things by these artists.

The relatively low commercial value of Polynesian 'curios' circulating in Britain in the early twentieth century allowed several dedicated collectors to form large private collections of Polynesian material. William Oldman (who began his career as a dealer), Harry Beasley, Alfred Fuller and James Hooper drew on material which was being sold or discarded from private collections and museums, and on the large quantities of souvenirs which had accumulated in the attics of the families of missionaries, travellers and colonial officers, and which was finding its way into street markets and 'junk shops' all over Britain. These men, together with Franks, Balfour and von Hügel, were all acting in the context of what might be called a 'salvage paradigm'. Although they were to a large extent following their own interests, they were also aware of the finite nature of the material they collected, and conjectured that the cultures which had made these things would soon 'die out'.[35] The collection of Hooper has been fully published, those of Oldman, Beasley and Fuller in part. All have been redistributed by sale or gift since their deaths. Beasley's collection was donated after his death in 1939 to major museums in Britain – the British Museum, Liverpool, Oxford, Cambridge and Edinburgh. Fuller's collection was sold to the Field Museum in Chicago in 1958. The majority of Oldman's collection of Polynesian material was sold to the New Zealand government in 1948 and is now mostly in museums in Wellington, Auckland, Christchurch and Dunedin. Portions of Hooper's collection were sold at auction and others sold or donated to the Musée de Tahiti et des Iles and to the National Museum of Fiji.[36]

The discussions surrounding the return of these objects to the Pacific also highlights the linked topics of museums in Polynesia, of repatriation and of cultural heritage. Since the mid-twentieth century the commercial, cultural and political valuations of Polynesian material, both in Polynesia and in the West, have shifted substantially. In certain senses the late twentieth century mirrored the situation in the late eighteenth – high valuation, for a variety of reasons, attributed to these things by both Polynesians and non-Polynesians. It is axiomatic that things in themselves have no intrinsic value or importance, but that it is human attitudes which give them value, and human attitudes change. Thus we have objects which have in turn been important presentation valuables, celebrated curiosities, neglected curios, major works of art and significant cultural

property. The concern of some contemporary Polynesians with objects from the past, with things newly classified as heritage, has brought about a reconsideration of the role of museums in relation to the material they hold. This applies to museums in Europe and America as well as to those in the Pacific. Polynesian countries are relatively well served by museums, many of whose collections began life as European projects around the end of the nineteenth century and in which locals have recently become increasingly involved. Major collections are held at the Bishop Museum in Hawaii, the Musée de Tahiti et des Iles, the National Museum of Fiji and in several museums in New Zealand, including the National Museum, Te Papa Tongarewa, in Wellington. Smaller collections are held in other places, and the notion of the museum as a significant institution in local cultural and political affairs is strengthening. Even on such small islands as Ra'i-vavae people are taking the initiative to establish local museums in order to preserve and display such old things as remain.[37] In the context of a growing appreciation of objects as heritage, museums are seen as important custodians of cultural property, in the affairs of which the descendants of the original makers can have a legitimate say. In New Zealand museums, for instance, Maori people are increasingly involved at all levels in management, curatorship and public education programmes.

Objects now find themselves the focus of ethical and political debates about what they were in the past, about what happened to them, about what is happening to them now, and about who has rights in relation to them. This situation has also stimulated discussion about the intrinsic properties of objects, about the extent to which they embody or enshrine ancestors or ancestral powers. Indigenous concepts, such as *taonga* (treasures, valuables) in New Zealand, are being examined and assessed in an unprecedented way as objects move to the forefront of cultural debates.[38] In some ways it was ever thus, for objects were always important, but in different ways. In the past they were important as strategic gifts, in the present they are also important as strategic possessions. Perhaps, above all this, is their importance as inspired and remarkable creations which have the power to be inspirational still.

1 Collecting is an activity with psychological, social, scientific, commercial, ethical and political implications. Objects collected may relate to, stand for or symbolize the domain from which they come – shells from the Pacific Ocean – or may relate to each other, so they can be ordered into types, sets and series, as a way of classifying, understanding and, to some degree, controlling the world. Objects also relate to the collector and to his or her social milieu. Obsessive behaviour of this kind has certainly been the ruin of many a collector, including Sir Ashton Lever.

2 The success of Ebay on-line auctions shows that collecting grows apace as a global activity. This is separate from what might be called the 'high end' of the market.

3 As stated in Chapter 1, the terms 'artificial' and 'curiosity' had positive connotations in the eighteenth century. In the later nineteenth and twentieth centuries, as value systems shifted, 'curiosities' changed to 'curios', implying odd things of interest but of no great value or status. Such things have, since the mid-twentieth century, been reclassified as works of art, or 'tribal art', with a concomitant elevation in value and status.

4 Islands on Tupaia's map were placed not in the direction in which they lay, but in the direction from which favourable winds would blow to allow a voyage. In this way information about sailing conditions was confused with geographical position. Tupaia's map identified islands in Fiji, Tonga, Samoa, the Cook Islands, the Austral Islands,

the Tuamotus, the Marquesas and possibly New Zealand. Tupaia had not visited the most distant of these islands, but he knew their names and was a bearer of ancient knowledge concerning them.

5 The Spaniards elicited information about islands from Puhoro, but no map appears to have been drawn, or at least survives (Corney 1915). Clearly, navigators existed who had either visited, or knew of, islands and groups at great distances from the Society Islands. It is a puzzling fact that Cook, although interested in Polynesian origins, appeared to show little interest in Tupaia's knowledge or in discussing their respective navigational skills (see Lewis 1994; Durrans 1979; Turnbull 1998).

6 Robertson (1948) gives detailed accounts of interactions. Wallis's journal is unpublished, but a version of it was edited by Hawkesworth (1773, vol. 1).

7 The British pennant and its incorporation into the girdle has been discussed by Robertson (1948: 160–62), Wallis in Hawkesworth (1773: I: 226–8), Rose (1978), Oliver (1988: pl. 16) and Dening (1996: 128–67). The act of 'taking possession' by planting a flag and turning a lump of soil was not to impose rule but to mark a prior claim in relation to other European powers. The French and Spaniards also 'took possession' of Tahiti in 1768 and 1771 respectively. French colonial rule was not established until the 1840s.

8 The literature on Cook is vast. Two recent accounts of the voyages are by Salmond (2003) and Thomas (2003). The original journals by members of Cook's expeditions make for rewarding reading. Although they have to be interpreted with caution from a research point of view, the narrative accounts of events, including trade and exchange, have an immediacy which is often compelling. Several journals have been published in scholarly modern editions, notably the magisterial works edited by Beaglehole (1955; 1961; 1962; 1967) and those written by the Forsters on Cook's second voyage (Forster 1982; 1996; Forster 2000). The definitive biography remains that by Beaglehole (1974).

9 Coote 2004.

10 Tupaia, who died at Batavia on the way to England, was clearly a man of great intelligence and initiative. The identification of him as the mystery artist was made by Harold Carter (1998).

11 The Forster collection at the Pitt Rivers Museum, Oxford, is discussed by Gathercole (1970) and Coote (2005), and is documented on-line at www.prm.ox.ac.uk/forster. The Göttingen collection has been published by Hauser-Schäublin and Krüger (1998).

12 Now in Stockholm (Söderström 1939).

13 Christie's, London (1986: lot 141).

14 Sahlins presented his case for Cook being an embodiment of Lono in *Islands of History* (1985). Obeyesekere (1992) misconstrued both Sahlins' argument and his motives, to which Sahlins responded with his authoritative *How 'Natives' Think* (1995).

15 For the collection in St Petersburg, and some problems of attribution, see Kaeppler 1978a and 1983. For the Webber collection in Bern see Henking 1957 and Kaeppler 1978a.

16 Corney 1919: xxxiv–xli, 156, 169–70.

17 Several are illustrated in Oliver 1988 and Babadzan 1993.

18 Viola and Margolis 1985.

19 Sahlins 1990.

20 From about 1820 onwards whalers began to scrimshaw – to engrave sperm-whale teeth with narrative scenes; see McManus 1997 for a general review of scrimshaw.

21 Phelps 1976: 91. The letter is dated 1 May 1831 and some of the presents were later acquired by James Hooper. One of them, a carved fan handle, is now in the Musée de Tahiti et des Iles (Phelps 1976: no. 427).

22 See Maude 1968 and Dening in Robarts 1974 for studies of beachcombers.

23 Wilson wrote an account of the first missionary voyage (1799). Many of the missionary party were ill-equipped, practically and theologically, for their calling, and some 'went native'. Eleven of the eighteen men left on Tahiti in 1797 were taken off in 1798, to be replaced by twelve others in 1801. George Vason (1810), one of those left on Tonga, recommended that families should be recruited for mission work. The London Missionary Society has been discussed by Gunson (1978), Newbury (1980), Edmond (1998) and Sivasundaram (2005). Davies (1961) provides a contemporary account and Lovett (1899) wrote an official history. The works of Ellis

(1829) and Williams (1837) provide accounts of their own work and that of the mission.

24 Sheets of paper could be interpreted as being equivalent to red feathers: brought to the main shrine, transformed/printed and redistributed. Davies (1961: 197–212) gives an account of the tug-of-war over the printing press.

25 Montgomery 1831: II: 70. Williams (1837: 115–16, 122), Maretu (1983: 65) and Gill (1856: 22) describe the incorporation of Rarotongan staff god 'idols' into chapel architecture.

26 *Missionary Sketches*, III, October 1818, p. 2.

27 Clunie 1986: 85.

28 See endnote 11 above.

29 It is probable that many 'Austral Islands' drums and whisks were collected in the Society Islands, or even made there by resident Austral Islands' or local craftsmen. Further research is needed to clarify these issues of attribution.

30 See Force and Force 1968 for Sarah Stone drawings. The Leverian Museum is the subject of a major study by Kaeppler (forthcoming). For the British Museum see King 1981: 9–15; 1997: 145.

31 Moschner 1955.

32 Bullock 1979.

33 Kaeppler 1978: 44, 47; Hauser-Schäublin and Krüger 1998.

34 For Baron von Hügel see Roth and Hooper 1990 and Herle 2005; for Pitt Rivers see Chapman 1985 and Waterfield 2002; for Franks see Caygill and Cherry 1997.

35 For James Hooper's views see Hooper and Burland 1953: 11–12.

36 For Oldman see Oldman 2004 and 2004a; for Fuller see Force and Force 1971; for Hooper see Hooper and Burland 1953, and Phelps 1976.

37 Maia Jessop, personal communication 2005.

38 For an award-winning book on the subject see *Pukaki: a comet returns* by the Maori scholar Paul Tapsell (2000).

Catalogue

PREPARED WITH
THE ASSISTANCE
OF KAREN JACOBS

The selection of objects for this catalogue has been guided by two main concerns: to provide understandings of Polynesian cultural affairs of the period under review (1760–1860), and to highlight the collection history of these objects in the context of Polynesian and European relations. In selecting pieces which embody and illustrate these themes an attempt has been made to mix well-known objects with others which have rarely or never been published, and to favour examples which have collection data associated with them.

An important criterion for selection has been high level of skill in manufacture. This is easy to find in Polynesian material, and was clearly a concern of the original makers and users. Anyone who looks at a Cook Islands fan, a Hawaiian cloak, a Society Islands fish hook, or at virtually any of the objects shown here, cannot but admire and wonder at the skill, patience and respect with which these things were made. Most were made to be offerings or exchange valuables prior to their more obvious functional uses as religious images, weapons, musical instruments, implements or clothing. In this respect they can be viewed as sacrifices of time, energy and skill, and as manifestations of reverence. The fact of their survival, often so fragile, after the many and various vicissitudes of their existence, must be cause for celebration.

The catalogue is ordered by island group. There is no standard sequence for Polynesian island groups. The three 'points' of the Polynesian triangle are presented here first, beginning with Hawaii, before a largely east to west progression finishing with Western Polynesia.

Attributions of origin and date present particular problems to the cataloguer. Place and date of collection are not proof of place of manufacture or of age. The great extent to which objects and people moved around Polynesia during this period has become increasingly clear. This was especially the case in Western Polynesia and Central Polynesia, where combinations of craft specialization and chiefly patronage, voyaging skills, violent weather, religious change and European intervention meant that 'Tongan' objects were made in Fiji, 'Australs' objects were made – or certainly used – in Tahiti, and raw materials such as pearl shell, whale ivory, red feathers, iron nails and nephrite were transacted and exchanged over long distances. The dating provided in the captions is based on known date of collection, or on strong comparative or circumstantial evidence. However, it is never possible to know if an object obtained on a voyage was made the day before the ship sailed or had been in the local community for generations, or indeed was a local exchange item or trophy acquired from elsewhere.

Care has been taken to provide precise information about the history of each piece. Museum registration numbers often give no clue as to date of acquisition and a *terminus ante quem*. British Museum registration numbers, which feature heavily here, are particularly problematic for British Museum staff and researchers alike (King 1997: 143). In brief, those objects with a date number (such as 1839,4-26,8) were acquired at that time (1839, April 26th, eighth item), and may or may not have previous collection data. Those with simple numbers (up to four digits), or 'plus' numbers (such as +2011), were mostly acquired around 1860–80 using funds provided by Henry Christy, and thus may be referred to as Christy Collection, although he died in 1865. Of importance in this catalogue are those objects bearing HAW, TAH and NZ numbers. These prefixes were given to objects in the 1890s by James Edge-Partington, working with Sir Augustus Franks to register material which had been in the British Museum since the late eighteenth or early nineteenth centuries, and which apparently had never been registered. There is a strong likelihood that many pieces donated by Sir Joseph Banks and others from Cook's voyages are amongst these objects, but if documentation ever existed, it now appears to be lost.

The following information is provided in the catalogue captions: object identification, origin, estimate of date, material, greatest dimension excluding cords, current location/registration number and collection data, followed by discussion with references to evidence and further reading.

The following abbreviations and acronyms have been used for institutions:

Aberdeen, MM: Marischal Museum, University of Aberdeen

Auckland, AM: Auckland War Memorial Museum, New Zealand

Belfast, UM: Ulster Museum, Belfast

Bristol, BCMAG: Bristol City Museum and Art Gallery

Cambridge, CUMAA: Cambridge University Museum of Archaeology and Anthropology

Christchurch NZ, CM: Canterbury Museum, Christchurch, New Zealand

Dublin, NMI: National Museum of Ireland, Dublin

Edinburgh, NMS: National Museums of Scotland, Edinburgh

Exeter, RAMM: Royal Albert Memorial Museum, Exeter

Glasgow, HMAG: Hunterian Museum and Art Gallery, University of Glasgow

Hastings, HASMG: Hastings Museum and Art Gallery

Ipswich, IPSMG: Ipswich Museum and Art Gallery

Kew, EBC: Economic Botany Collection, Royal Botanic Gardens, Kew

Lille, MHN: Musée d'Histoire Naturelle, Lille, France

LMS: London Missionary Society

London, BM: British Museum, London

London, CWM: Council for World Mission, London

London, NMM: National Maritime Museum, Greenwich

Newcastle, HM: Hancock Museum, University of Newcastle

Norwich, SCVA: Sainsbury Centre for Visual Arts, University of East Anglia, Norwich

Oxford, PRM: Pitt Rivers Museum, University of Oxford

Paisley, PMAG: Paisley Museum and Art Galleries, Renfrewshire

Saffron Walden, SAFWM: Saffron Walden Museum

New photographs have been taken of the great majority of objects; photographers are credited and institutional loans listed on p. 288.

Recent general books on Pacific and Polynesian art, which illustrate and/or discuss a range of material, are: Kaeppler, Kauffman and Newton 1997; D'Alleva 1998; Thomas 1995; Meyer 1995; Newton 1999; Notter 1997. Earlier key general works are: Kaeppler 1978; Phelps 1976; Barrow 1973; Musée de l'Homme 1972; Kooijman 1972; Duff 1969; Wardwell 1967; Edge-Partington and Heape 1890, 1895, 1898 (reprinted 1969).

The Hawaiian Islands

At the northernmost point of Polynesia lie the Hawaiian Islands, mostly large fertile lands which provided abundant resources for the first settlers who reached there around AD 700–800. These early voyagers came from the south, probably from the Society Islands area some 2,000 miles away. North–south contact appears to have been maintained during the following centuries, but by the eighteenth century there had not been long-distance voyaging for some time. In isolation the Hawaiian Polynesians had developed distinctive forms of chiefship, religious practices and material culture, yet, as Cook and other early European voyagers noticed, they still preserved linguistic and cultural affinities with other Polynesians as far away as New Zealand and Easter Island.

The populations of the islands of the Hawaiian archipelago remained in regular contact, with chiefdoms established on all the main islands. The first European visitors observed little linguistic or cultural diversity, besides some local stylistic differences in material culture, such as helmet form and construction (see nos 6–7).

For over two centuries Spanish ships tracked back and forth across the Pacific from the Ameri-

can coast to the Philippines and China, passing to the south of Hawaii, but no evidence survives of any visits having taken place until the late eighteenth century. In January 1778 Captain James Cook, heading northwards to the Arctic on his third voyage, called at Kaua'i and Ni'ihau, before proceeding to the northwest coast of America and the Bering Strait. On his return in November he called at Maui and eventually, after contrary winds, anchored in January 1779 at Kealakekua Bay on the west coast of Hawai'i Island.* Here Cook was to die on 14 February in an incident which Sahlins (1985, 1995) has argued convincingly was connected to Cook's Hawaiian status as an incarnation of the deity Lono. Cook had named the group the Sandwich Islands after his patron the Earl of Sandwich, First Lord of the Admiralty, and this name was used into the nineteenth century.

For several years after Cook no European ships visited Hawaii, but towards the end of the eighteenth century the islands began to serve as a revictualling stop for trans-Pacific voyagers taking sea-otter furs from the northwest coast of America to China. In the early nineteenth century sandalwood traders, in league with local chiefs, exploited that local resource for the Chinese market. Local chiefs (ali'i) recruited Europeans such as John Young to work in their service, repairing muskets, organizing campaigns, and negotiating with visiting voyagers and traders. One chief, Kamehameha of Hawai'i, established control over the entire group, eventually in 1810 founding a monarchy which ruled, increasingly nominally, for most of the nineteenth century. On Kamehameha's death in 1819, internal disputes led to the rejection of many of the *kapu* (taboos), or restrictions on behaviour which had been associated with his rule. A year later Christian missionaries arrived from the American Board of Missions, followed in 1822 by William Ellis of the London Missionary Society, who returned in 1823. Whalers had by this time begun to call in great numbers, anchoring mostly at Lahaina on Maui.

After an agreement between Kamehameha and Captain George Vancouver in 1794, Hawaii had maintained closer ties with Britain than with any other power, despite attempts by Russia to extend its influence. In light of this special relationship, Kamehameha's son Liholiho (Kamehameha II) and Queen Kamamalu embarked on *L'Aigle* in 1823 to undertake a state visit to King George IV. Initially successful, the visit became a disaster when both the king and queen died of measles in London in 1824. Their bodies were returned to Hawaii in 1825 aboard HMS *Blonde*, when a number of images and other items were collected from the royal mausoleum at Honaunau, Hawai'i and elsewhere. After the accession of Kamehameha III as a boy, a period of regency ensued when relations with foreign powers were often mediated by gifts of feather cloaks and capes. He died in 1854 aged forty-one, by which time American influence had become increasingly strong.

The objects illustrated in the following pages derive from this dynamic period of intense political and cultural change. Certain things went quickly out of use, such as stone adzes in the face of metal tools. Others, such as feather cloaks and capes, wood images and ivory ornaments, went through changes in form and scale. Kamehameha's expansionist policies led to increases in production of some types of object for conspicuous display and for exchanges with chiefs and visitors alike, crucial to strategic alliances and the maintenance of his dominions.

Further information on Hawaiian art, religion and history may be found in: Buck 1957; Brigham 1899, 1903, 1906, 1911, 1918; Kaeppler 1982, 1985; Valeri 1985, 1985a; Rose 1980; Cox and Davenport 1988; Sahlins 1981, 1981a, 1985, 1995; Kirch and Sahlins 1992; Feher 1969; Ellis 1826; Linnekin 1990; Starzecka 1976; Kamakau 1991; Malo 1951.

* A widely accepted convention for spelling is used here: Hawaii as the political and geographical term for the group; Hawai'i (with the glottal stop) as the name for the Big Island. Owhyhee and variations of that spelling can be found on labels on eighteenth-century artefacts.

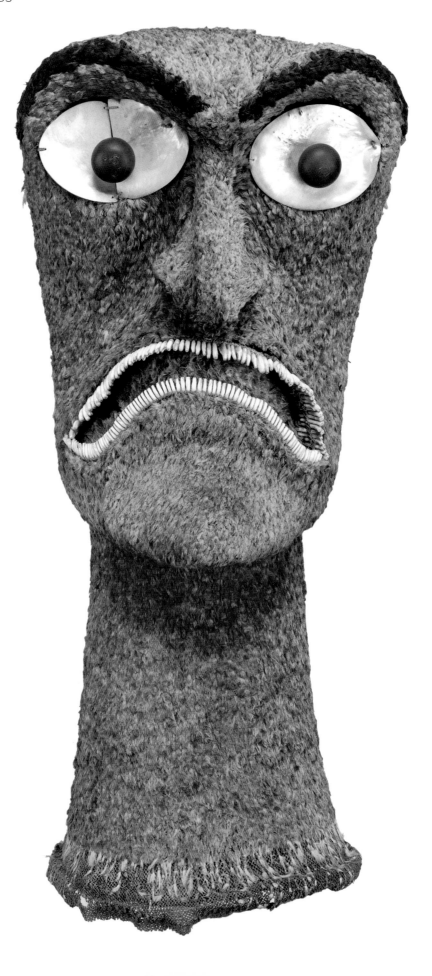

1 Feathered head

Hawaiian Islands

Late eighteenth century

Feathers, basketry, fibre, dog canine teeth, pearl shell, wood

H. 81.0 cm

London, BM: HAW 80

Collection history not known, but registered with material of late eighteenth-century provenance.

A foundation of twined basketry made of the vine-like aerial roots of the *'ie'ie* (*Freycinetia arborea*) has feathered netting tightly attached. The feathers were obtained from honeycreepers unique to the islands, red from the *'i'iwi* (*Vestiaria coccinea*), black and yellow from the *'o'o* (*Moho sp.*). They were gathered and offered as sacrifices and 'tribute' to chiefs, who presided over the manufacture of great ritual objects such as heads and cloaks.

Valeri, in his exhaustive study of Hawaiian religion, states that feathered heads (*akua hulu manu*) were god images carried in procession on important occasions (1985: 204–5, 246–7, 284–5; see also Ellis 1826: 127). A canoe procession carrying heads with barkcloth 'bodies' was made by the powerful chief Kalani'opu'u around Cook's ships on 26 January 1779 (depicted by John Webber; see above, p. 55): 'in the Center Canoe were the busts of what we supposd their Gods made of basket work, variously coverd with red, black, white, & Yellow feathers, the Eyes represent'd by a bit of Pearl Oyster Shell with a black button, and the teeth were those of dogs, the mouths of all were strangely distorted, as well as other features' (King in Beaglehole 1967: 512).

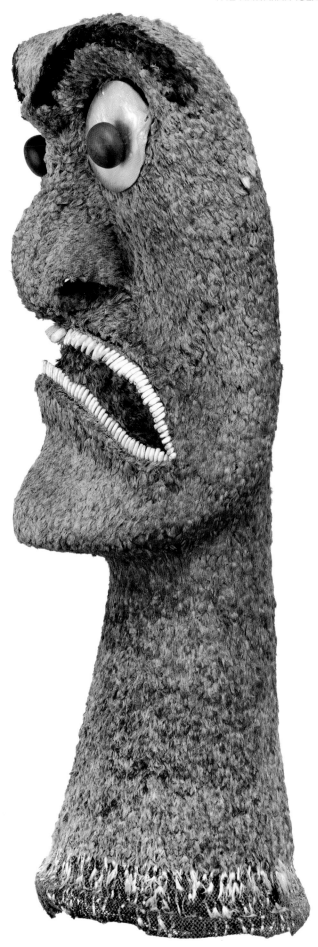

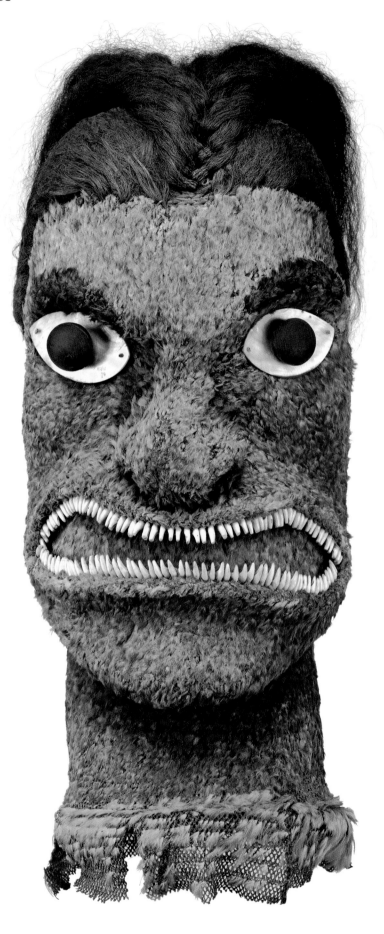

2 Feathered head

Hawaiian Islands

Late eighteenth century

Feathers, basketry, fibre, human hair, dog canine teeth, pearl shell, wood

H. 62.0 cm

London, BM: HAW 78

Collection history not known, but it closely resembles a Cook third-voyage example in Berlin, formerly in the Leverian Museum and depicted there in 1783 by Sarah Stone (Force and Force 1968: 27; Kaeppler 1978: 53, 55).

This example, similar in construction and materials to the previous head (for details see Buck 1957: 503–12), is notable for the attachment of large amounts of human hair, braided at the front. Hair was shaved off as a sign of mourning and sacrifice by relatives at the death of high-status people, to be incorporated into ritually important objects such as god images and necklaces. The pearl-shell eyes are secured with globular blackened wood pegs. It remains uncertain what god was embodied in or represented by these heads. Kaeppler (1982: 104–6) argues that both Ku and Lono were invoked at different times.

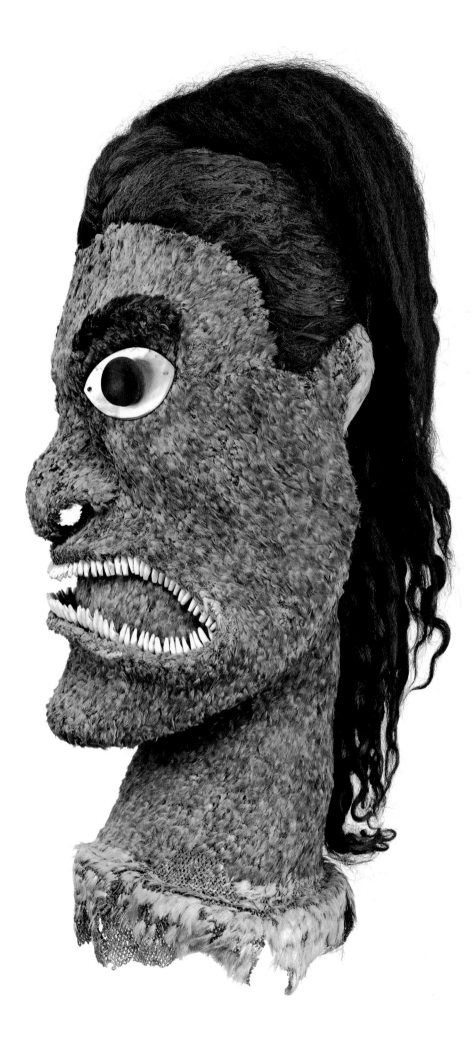

3 Feathered cloak

Hawaiian Islands

Late eighteenth/early nineteenth centuries

Feathers, fibre

W. 242.0 cm

Hastings, HASMG: 919.46.1

Donated 1919 by Lord Brassey; formerly in the Brassey Museum at Durbar Hall, Park Lane, London, 1889–1918.

The history of this cloak is complex. It was acquired by Lord and Lady Brassey in Hawaii in 1876. Previously it had belonged to Queen Pomare of Tahiti, who gave it to Sir Thomas Trigge Thompson in

recognition of his services in resisting French claims to Tahiti in 1842. Thompson presumably returned it to Hawaii. Brigham (1899: 71–2) gives an account of this history and states that Kamehameha III of Hawaii received a present of a coach from Pomare, who may have received this cloak in return.

Magnificent feathered cloaks and capes (*'ahu'ula*) were important exchange valuables in Hawaii, both at the time of first European contact and after (Kaeppler 1970). Captain Cook and his officers were presented with thirty or more in 1778–9.

Numerous examples were later presented to visiting captains, and some taken to London in 1824 when the king and queen of Hawaii paid a state visit to King George IV. Cloaks were worn by those of chiefly status, and were composed of thousands of small feathers, in most cases deriving from honeycreepers (see no. 1). Feathers were knotted into a fibre netting by specialists, most likely women, who were usually responsible for making valuable textile wrappings in Polynesia, but no eye-witness accounts survive.

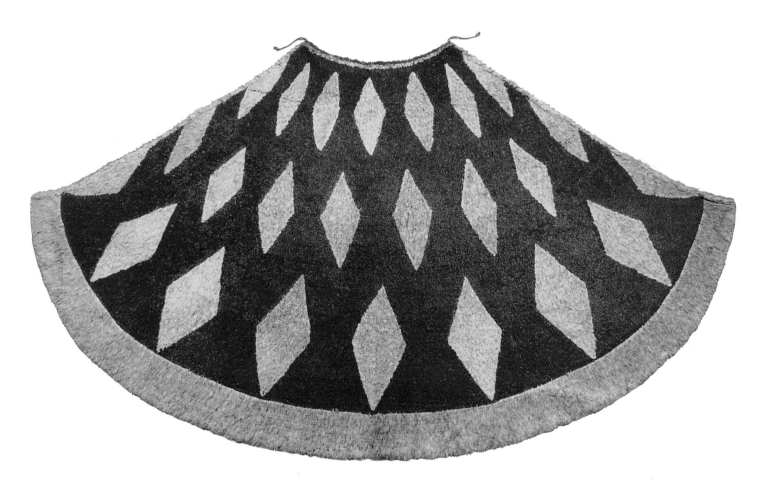

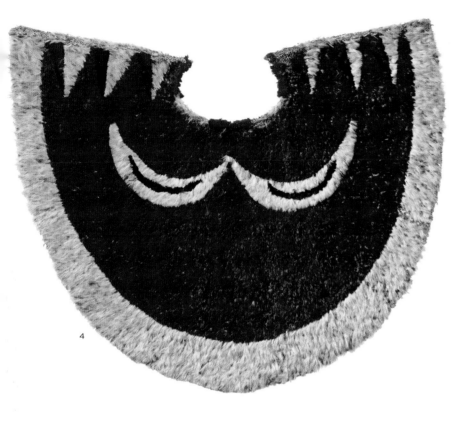

4

4 Feathered cape

Hawaiian Islands

End eighteenth/early nineteenth centuries

Feathers, fibre

W. 82.5 cm

London, BM: 1944.Oc.2.2109

Donated 1944 by Irene Beasley; ex. collection Harry
Beasley, no. 2460; acquired 9 December 1929 from
descendants of the Russian voyager Otto von
Kotzebue (Beasley 1930; Chamisso 1986); given to
von Kotzebue of the *Rurik* by Queen Namahana, one
of the wives of Kamehameha (Linnekin 1990: 64–5).
The *Rurik* was at Hawaii in 1816 and 1817.

This cape (*'ahu'ula*) has a tight rounded
neckline which is probably a stylistic
development dating from the last years of
the eighteenth century, possibly responding
to the form of European officers' jackets, since
no capes or cloaks of this shape were collected
during Cook's third voyage (Kaeppler 1983:
95–6; 1985). The imperial ambitions of
Kamehameha (d. 1819) over the whole Hawaiian
group appear to have led to a temporary
increase and development in cloak and cape
production for use in facilitating strategic and
dynastic alliances.

5 Feathered cape

Hawaiian Islands

Late eighteenth/early nineteenth centuries

Feathers, fibre

W. 65.0 cm

Newcastle, NEWHM: C769

Donated 1834–5 by William Row, son of William Row
(d. 1832), a Newcastle shipowner; acquisition information
not known, but one vessel in which Row had an interest
was the *Three Bs*, which visited Hawaii in 1792–3 (Jessop
forthcoming; Jessop and Starkey 1998: 94).

This cape (*'ahu'ula*), made in a similar way to cloak
no. 3, is in fine condition and has the remains of two
fibre ties at the neck. Brigham (1899; 1903; 1918) and
Buck (1957: 215–31) give detailed information on
featherwork. Capes were worn by those of lesser
status than powerful chiefs who wore full cloaks.

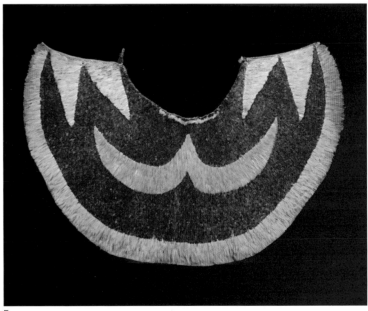

5

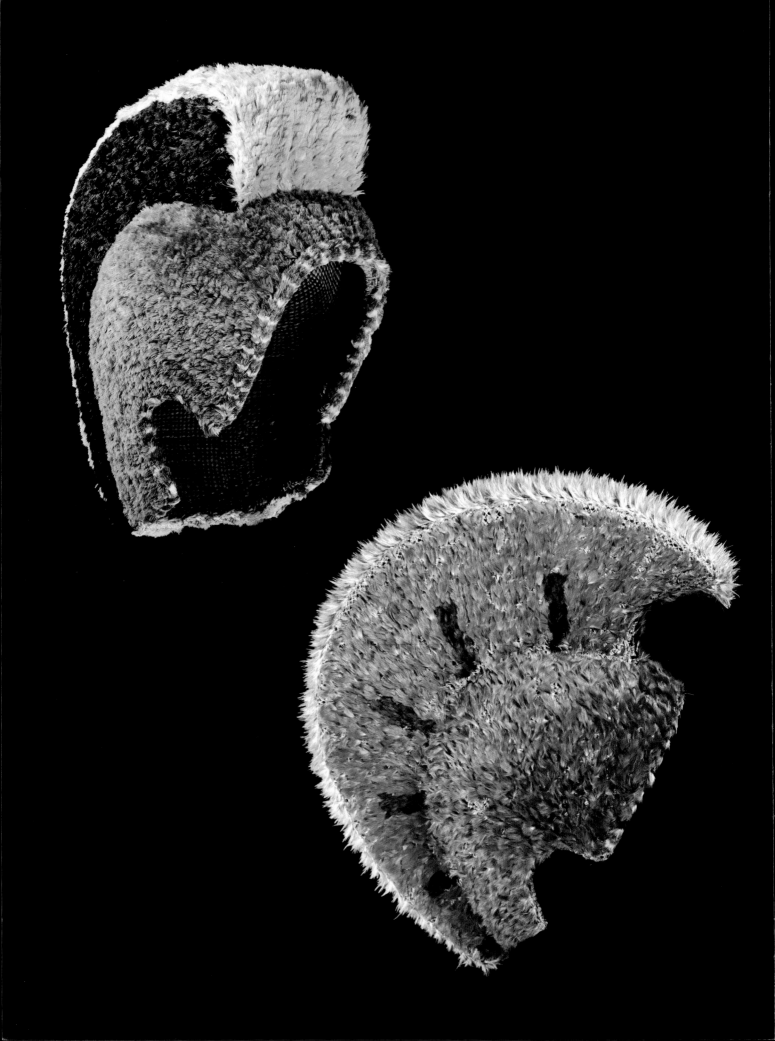

6 Helmet

Hawaiian Islands

Late eighteenth/early nineteenth centuries

Feathers, basketry, fibre

H. 32.0 cm

London, BM: HAW 106

Collection history not known, but registered with material of late eighteenth-century provenance.

A wickerwork basketry base of *'ie'ie* split aerial rootlets is applied with strips of braided fibre with feathers attached. The broad crest and braided strip technique is associated with Kaua'i Island – those from Hawai'i having narrower crests (King in Beaglehole 1967: 626). Helmets (*mahiole*) were worn with cloaks or capes on formal occasions by people of high status. When worn with cloaks the body of the wearer, except for the face, was completely encased with feathers. Helmets were also exchange and presentation items which continued to be made into the early nineteenth century and were regularly presented to visiting dignitaries.

7 Helmet

Hawaiian Islands

Late eighteenth/early nineteenth centuries

Feathers, basketry, fibre

H. 32.0 cm

Newcastle, NEWHM: C770

Donated 1834–5 by William Row, son of William Row (d. 1832), a shipowner from Newcastle; acquisition information not known, but a vessel in which Row had an interest was the *Three Bs*, which visited Hawaii in 1792–3 (Jessop forthcoming; Jessop and Starkey 1998: 94).

This helmet is of the narrow-crested style associated with Hawai'i Island. It is constructed with a wickerwork base of *'ie'ie* split aerial rootlets, covered in feathered netting similar in technique to that used for the feathered heads, cloaks and capes.

8 Sceptre

Hawaiian Islands

End eighteenth/early nineteenth centuries

Walrus ivory, turtle shell, feathers, cloth, wood

L. 159.0 cm

London, BM: 1965

Acquired 1860s; ex. collection Royal United Service Institution Museum, London (donor unknown; the museum was founded in 1831 for naval and military collections).

Feathered sceptres (*kahili*) were noted by the first European voyagers to Hawaii, carried by attendants of chiefs. Early examples sometimes had a handle of turtle-shell discs threaded on human bone (Beaglehole 1967: 577, 1,224; Kaeppler 1978: 76–7). Here the handle is of wood, threaded with walrus-ivory tubes and turtle-shell discs. A small piece of red European cloth is attached at the top of the handle, indicating the high value set on European cloth, especially red, a colour of great ritual importance in Hawaii. Walrus ivory was brought from Arctic waters by the early traders and whalers from the 1790s onwards. It can be recognized from its mottled yellow core, absent in whale ivory, which has 'knots' but no core. During the second and third decades of the nineteenth century very large *kahili*, 8–10 metres tall, were made as staffs of state for the newly established Hawaiian monarchy.

OPPOSITE: 6 above, 7 below

9–11 Three feather ornaments

Hawaiian Islands

Late eighteenth century

Feathers, fibre

L. 40.0 cm, 46.0 cm, 45.0 cm

London, BM: VAN 243, VAN 259, VAN 246b

Acquired 1891; ex. collection George Hewett, surgeon's mate on HMS *Discovery* during Captain Vancouver's voyage; Vancouver was three times at Hawaii in 1792–4. Hewett later acquired objects from Cook's third voyage at the Leverian sale of 1806 (Kaeppler 1979: 177–9).

Beautiful feather ornaments of this kind (*lei*) were made in a great variety of colours and designs; they were worn mostly by women as necklaces or in the hair. Trevenen, with Cook, observed in 1779: 'The fondness of the women for these ornaments was very great even to supercede that which they had for the different articles of our trade, so precious amongst the Men, Whenever a Woman had acquired a large nail or Hatchet she carefully concealed it from the knowledge of her Male friends till an opportunity offered of purchasing one of these beautiful ruffs in the number & variety of which they placed their chief pretensions to finery and ornament' (in Beaglehole 1967: 626n).

12 Barkcloth

Hawaiian Islands

Late eighteenth century

Paper mulberry inner bark, dyes

L. 112.0 cm

Edinburgh, NMS: A.UC406

Acquired 1850s; ex. collection University of Edinburgh; previous history not known, but the University collection contained material of likely eighteenth-century provenance.

Barkcloth (*kapa*) from Hawaii of the late eighteenth century was amongst the most impressive in Polynesia, often employing red and black in bold geometric designs. It was made by women by beating the inner bark of the paper mulberry (*Broussonetia papyrifera*) into sheets, to which dyes were applied (see Brigham 1911; Buck 1957: 166–213). This piece, made of two sections sewn together, was probably originally part of a larger sheet. A smaller section is held in a sample book at the NMS. Alexander Shaw (1787) was the first to produce sample books of Cook voyage barkcloths (see above, p. 38). In local use, *kapa* served as wrapping for important people and objects, and as an exchange valuable.

12

13 Barkcloth mat

Hawaiian Islands

Early nineteenth century

Paper mulberry inner bark, dyes, cotton

L. 100.0 cm

Saffron Walden, SAFWM: 1882.254.2

Acquired 1882; collected 1836 by Revd Daniel Wheeler, Quaker missionary whose travels were published (Wheeler 1842).

This piece of red-and-black dyed barkcloth (*kapa*) most probably dates from the early nineteenth century when barkcloth designs became more detailed and regular, and were applied with stamps and liners (Kaeppler 1979a: 188). It has been mounted on European cotton cloth, possibly as a table mat, indicating the high value set on its preservation.

13

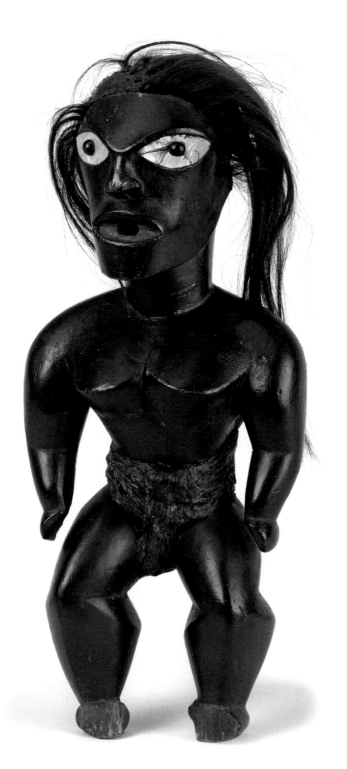

14 Standing figure

Hawaiian Islands

Late eighteenth/early nineteenth centuries

Wood, pearl shell, seeds, hair, barkcloth

H. 41.5 cm

London, BM: 1944.Oc.2.716

Donated 1944 by Irene Beasley; ex. collection Harry Beasley, no. 2630; acquired 18 November 1930 from a descendant of John Knowles, midshipman aboard HMS *Blonde* (Captain Lord Byron), which returned to Hawaii the bodies of the king and queen after they had died of measles during a state visit to Britain in 1824. Beasley (1932), Emory (1938) and others have claimed this figure was taken from the royal mausoleum of Hale-o-Keawe at Honaunau, Hawai'i, but members of HMS *Blonde* collected images at several places.

The figure has lost some of its human hair and a bone or ivory plug from the mouth, representing teeth. Earlier illustrations show the right eye missing, but a replica was inserted at the British Museum in 1967. It is not known with what deity this figure was associated, but it is similar in form and style to two larger female images found in a cave on Hawai'i (Brigham 1906; Cox and Davenport 1988: 160, 166). It has a dynamic flexed posture common to much Hawaiian figure sculpture, probably connected to dance movements, conveying an impression of vigour. The barkcloth loincloth indicates that a male is probably depicted.

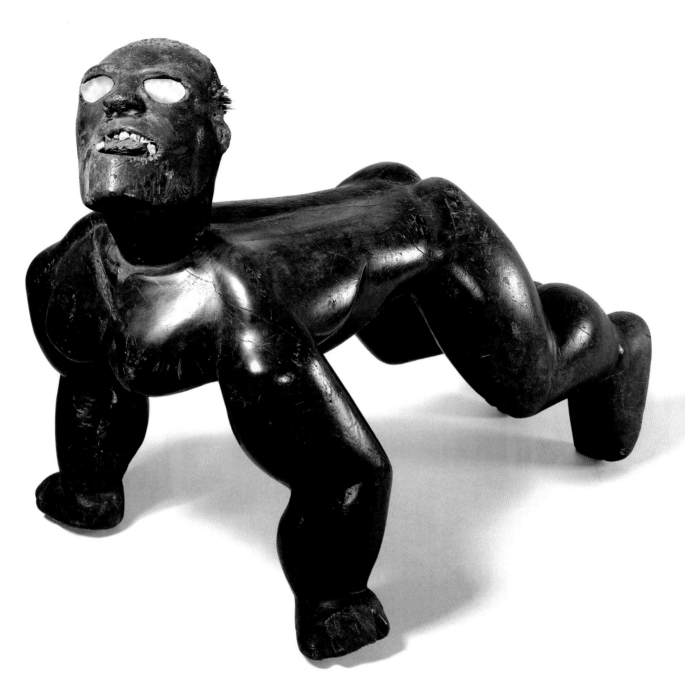

15 Stool/figure

Hawaiian Islands

Late eighteenth/early nineteenth centuries

Wood, pearl shell, human hair, human teeth

L. 66.0 cm

London, BM: 1657

Acquired 1860s; ex. collection Royal United Service Institution Museum, London (donor unknown); Kaeppler (1982: 87) has identified it as having been collected in 1825 at the royal mausoleum Hale-o-Keawe, Honaunau, Hawai'i, by Captain Lord Byron of HMS *Blonde*.

The head has stubbles of human hair – fair rather than grey at the roots, and dyed black – retained by small pegs and wedges. The hair would formerly have cascaded onto the back. The right eye is of pearl shell, the left possibly of nautilus, and therefore a later replacement. The figure has an especially dynamic posture and could have functioned as a stool or as a stand for a bowl or drum. It also stands in balance when placed on its feet, which

may or may not have been the intention of the sculptor. Bloxam, with Byron, stated it was 'the idol upon which all the Kings when they entered the Temple used to rest themselves before sacrifice' (Kaeppler 1982: 87).

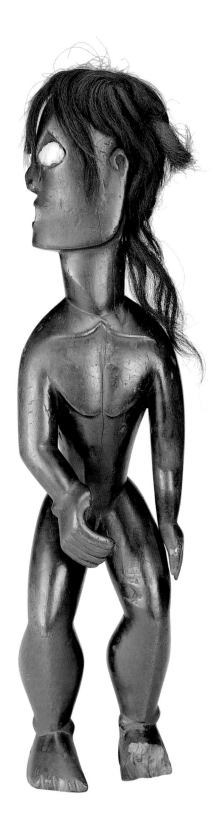

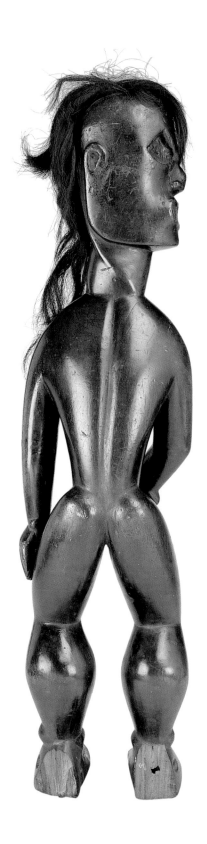

16 Standing figure

Hawaiian Islands

Late eighteenth/early nineteenth centuries

Wood, hair, pearl shell, nails

H. 59.5 cm

Dublin, NMI: 1880.1607

Transferred 1880 from the Royal Dublin Society; the RDS collections contained Polynesian material of probable eighteenth-century provenance (Freeman 1949: 12; Douglas Hyde 1978: 18).

Notable in this sculpture is the twist line at the back of the neck and the tremendous vigour imparted to the image, both in its form and as a result of the attachment of hair (with iron nails) and pearl-shell eyes (the right missing). The figure-of-eight mouth may previously have held inlay. The right thumb is broken and the right hand may formerly have held another object. Holes carved transversely through the feet mean that it was probably originally attached to a frame support. Ellis (1826: 127) records that images of gods were carried by priests in procession and in battle.

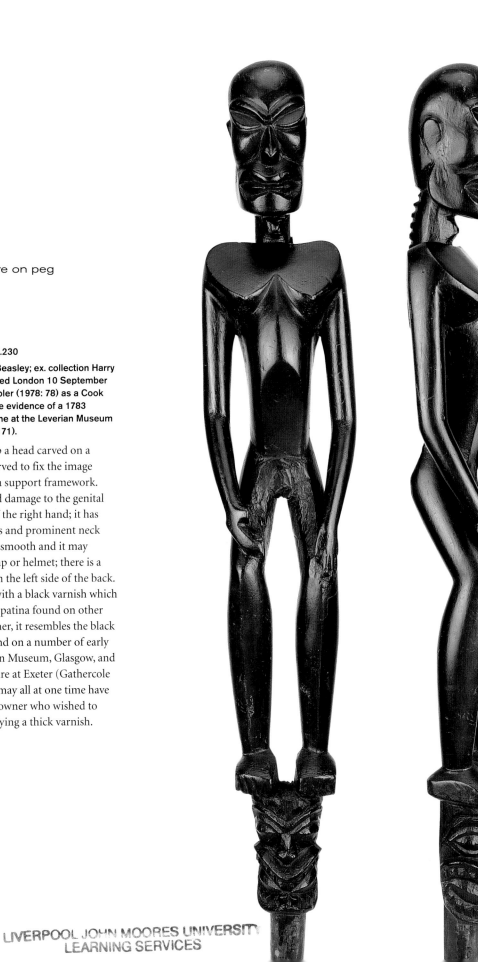

17 Standing figure on peg

Hawaiian Islands

Late eighteenth century

Wood

H. 75.5 cm

Edinburgh, NMS: A.1950.230

Donated 1950 by Irene Beasley; ex. collection Harry Beasley, no. 4557, acquired London 10 September 1937. Identified by Kaeppler (1978: 78) as a Cook third-voyage piece on the evidence of a 1783 illustration by Sarah Stone at the Leverian Museum (Force and Force 1968: 171).

This figure stands atop a head carved on a support peg, which served to fix the image in the ground or into a support framework. The figure has suffered damage to the genital area and the thumb of the right hand; it has strikingly flat pectorals and prominent neck vertebrae. The head is smooth and it may formerly have had a cap or helmet; there is a split in the wood down the left side of the back. The whole is stained with a black varnish which does not resemble the patina found on other Hawaiian figures. Rather, it resembles the black glutinous varnish found on a number of early pieces in the Hunterian Museum, Glasgow, and on a Hawaiian sculpture at Exeter (Gathercole *et al.* 1979: 115). These may all at one time have belonged to the same owner who wished to preserve them by applying a thick varnish.

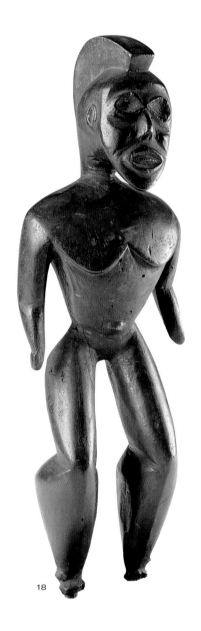

19 Standing figure on peg

Hawaiian Islands

Late eighteenth/early nineteenth centuries

Wood, barkcloth

H. 41.5 cm

Edinburgh, NMS: A.UC384

Acquired 1850s; ex. collection University of Edinburgh; collected by Admiral Beechey during the voyage of HMS *Blossom*. The expedition was at Hawaii in 1826 and 1827.

This figure is likely to have been made some years before Beechey acquired it. There had been a religious crisis in 1819 at the death of Kamehameha I, when the so-called 'kapu [taboo] system' was abolished and many people became nominally Christian (Kaeppler 1982: 102–3). However, indigenous religious practices continued, and images were hidden or remained in old temple precincts such as those of Hale-o-Keawe on Hawai'i. Others were given or sold to visitors such as Beechey, a practice which had occurred since the visits of Cook's ships in 1778–9. This figure is depicted either wearing a narrow-crested helmet or hair cut in that style.

18 Standing figure

Hawaiian Islands

Late eighteenth/early nineteenth centuries

Wood

H. 34.8 cm

Dublin, NMI: 1880.1606

Transferred 1880 from the Royal Dublin Society; the RDS collection contained Polynesian material of probable eighteenth-century provenance.

This dynamic figure may have been broken from a peg support; it is depicted either wearing a narrow-crested helmet or hair dressed in that style. As a sign of mourning and sacrifice, high-status men would cut hair from either side of their head, leaving a central crest. The eyes may formerly have held inlay.

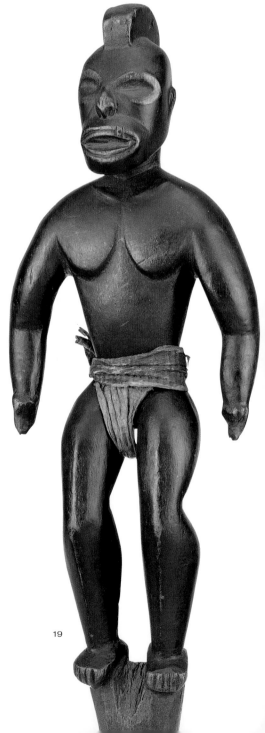

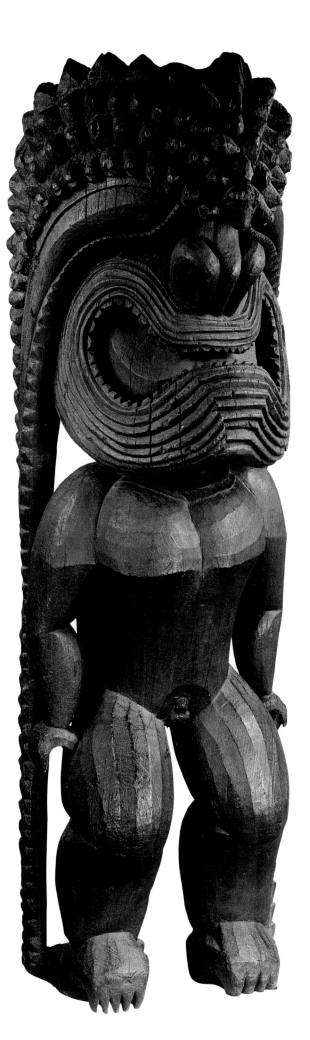

20 Large standing male figure

Hawaiian Islands

Early nineteenth century

Wood

H. 267.0 cm

London, BM: 1839,4-26,8

Donated 1839 by W. Howard; previous history not known.

One of only three surviving colossal images (the others are in Honolulu and Salem), its size was a result of the availability of metal tools and Kamehameha's early nineteenth-century programme of building temples dedicated to Kukailimoku, his tutelary deity (see above, p. 58; Kaeppler 1982: 98–100). Originally based on Hawai'i, Kamehameha extended his rule over the whole group to become the first king of Hawaii and establish a ruling dynasty. A head of a pig or dog, both sacrificial animals, appears above the nose of this image, and the cascading rows of projections may symbolize others. The genitals are disproportionately small, yet the posture is vigorous. The wood has been identified as breadfruit (*Artocarpus sp.*).

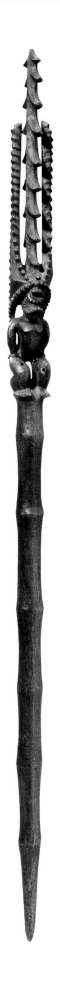

21 Small figure on staff

Hawaiian Islands

Late eighteenth/early nineteenth centuries

Wood, metal

H. 58.8 cm; figure H. 21.6 cm

Oxford, PRM: 1884.65.42

Donated 1884, Pitt Rivers founding collection; exhibited 1879–84 at South Kensington Museum.

Sculpturally similar to the colossal image (no. 20), this small god image has a dynamic posture and notched triangular eye form extending downwards and upwards. It stands atop a fluted columnar stick. It may have been from a domestic shrine, but our knowledge of the use and meanings of Hawaiian figure sculpture is limited (Kaeppler 1979b: 4–5). The three head projections appear to be complete and undamaged, though the figure has been broken across the thighs and repaired with metal pins.

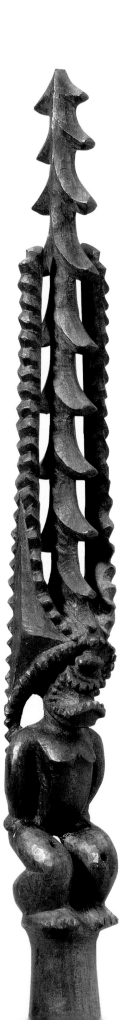

22 Head

Hawaiian Islands

Late eighteenth century

Wood, coir, barkcloth, pearl shell, shark teeth, animal skin

H. 29.0 cm

London, BM: HAW 77

Collection history not known, but registered with material of late eighteenth-century provenance.

This is probably the head of a marionette or puppet used in special *hula* dance performances which did honour to the gods. The head is made of light wood, wrapped in brown and black barkcloth, and bound with brown and black twisted coir cordage. What Europeans identify as brown is usually termed red in Polynesian languages, especially where barkcloth and coir cord colours are concerned. Animal skin (dog?) with traces of fur is applied to the nose and sides of the crest. The pupils of the pearl-shell eyes are made of buttons of barkcloth. The neck is in two pieces, pegged together, with an internal cavity, probably for fixing to a body. A comparable Cook third-voyage example was illustrated by Sarah Stone at the Leverian Museum in 1783, although it is not likely to be this one, as proposed by Luomala (1984: 58) and Cox and Davenport (1988: 193).

23 Arm of an image

Hawaiian Islands

Late eighteenth/early nineteenth centuries

Rushes, barkcloth, fibre, dog canine teeth

L. 39.5 cm

Belfast, UM: 1910.40

Donated 1834 by Revd Professor Edgar; previous history not known (Glover 1994: no. 132). It bears two labels: 'Arm of an Idol. Sandwich Islands' and '354'.

This arm most probably belonged to a marionette or puppet. A complete but very fragile puppet, with arms wrapped in black barkcloth and with dog-tooth 'claws', is in the British Museum (see Luomala 1984: 17–24, pls 6–7). Here, four dog canine teeth are bound with black and pale barkcloth and a stiff reddish wristband of varnished barkcloth or European card. The canine teeth of dogs, a sacrificial animal, were used on a variety of ritually important objects.

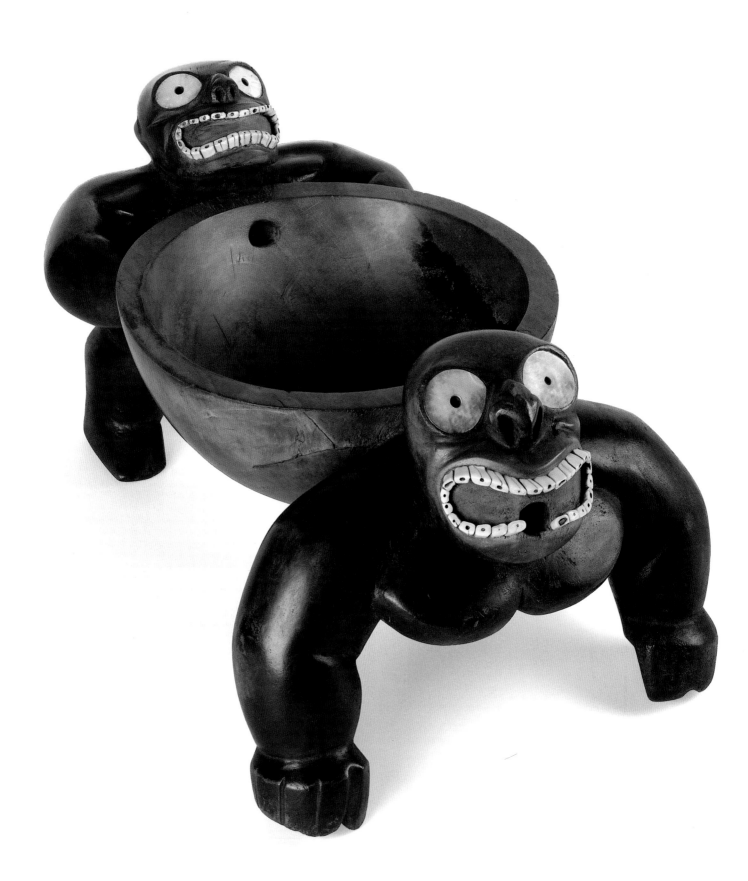

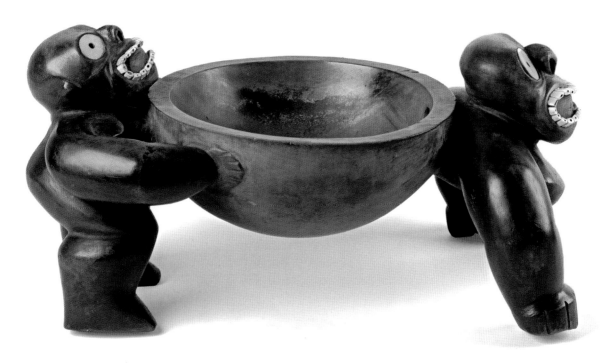

24 Bowl with two figure supports

Hawaiian Islands

Mid-/late eighteenth century

Wood, pearl shell, boars' tusks

L. 46.5 cm

London, BM: HAW 46

Donated 1780 by Sir Joseph Banks; given to Captain Charles Clerke by a chief of Kaua'i on 23 January 1778. Clerke, who became commander of the third voyage after Cook's death in February 1779, himself died in July 1779, leaving his collection to Banks.

A sculptural *tour de force*, probably in highly valued *kou* wood (Jenkins 1989: 63, 71–8), the circular bowl is supported by a complete figure behind and a part figure at the front. The mouths of each figure are furnished with cut sections of boars' tusks (twenty-six at the front, twenty-four at the back). Two channels are carved through the sides of the bowl, one through to the front mouth, the other through the chest of the rear figure and out at the anus. The mode of use of this bowl is not known, but it was almost certainly for *'awa* (kava; see no. 25). Cook recorded that a chief of great sanctity sought out Clerke on the *Discovery* off Kaua'i to present to him 'a large Cava bowl, that was supported by two car[v]ed men, neither ill-designed nor executed'. Bayly added that Clerke gave him in return 'a little piece of red bay's [baize] and some other trifles' (Beaglehole 1967: 281). Whether the bowl was made on Kaua'i is uncertain, since things of value circulated by exchange, as the presentation to Clerke demonstrated.

25 Bowl

Hawaiian Islands

Late eighteenth century

Wood, pearl shell

L. 18.5 cm

Cambridge, CUMAA: 1922.916

Acquired 1922 from Arthur Holdsworth, the Widdicombe House Collection; formerly in the Leverian Museum, auctioned 1806; collected in Hawaii 1778–9 during Cook's third voyage (Kaeppler 1978: 82; Tanner 1999: 49).

A small bowl, probably for the drink *'awa* (kava), carved as a crouching figure with pearl shell eyes; a hole in the side of the bowl emerges at the mouth, through which the drink was probably imbibed. Kava, a drink prepared from the roots of the pepper bush *Piper methysticum* mixed with water, was drunk in ritually prescribed ways in many parts of Polynesia (except temperate New Zealand, where it would not grow). In concentrated form it could lead to trance, and was a means by which chiefs and priests acted as channels of communication with divine powers.

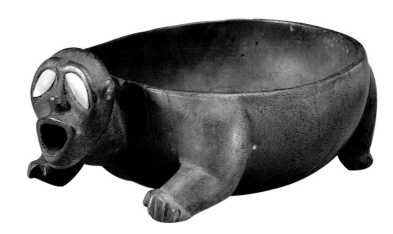

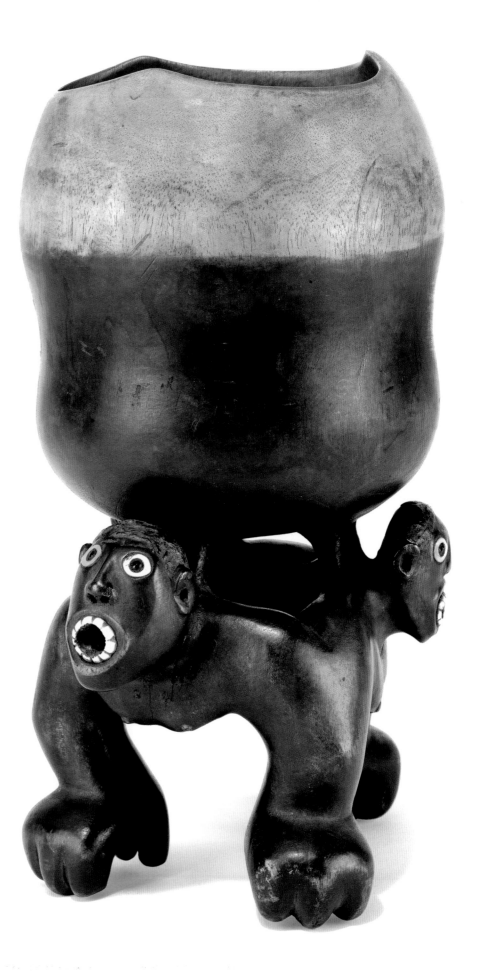

26 Bowl with three figures

Hawaiian Islands

Late eighteenth century

Wood, shell, seeds, bone, fur

H. 30.2 cm

London, BM: HAW 48

Collection history not known, but registered with material of late eighteenth-century provenance.

Three part-figures support a waisted bowl, perhaps based on the shape of a gourd, which could be interpreted as a common body for the figures. The teeth are made from short tubes of bone; traces of fur (dog?) adhere to gum on the back of the heads. Repair pegs to a split on one side of the bowl are of bone or boar's tusk. Kaeppler (1979: 182) considers this to be a possible Cook third-voyage piece on the strength of the similarity of the heads to a head on a bowl in Vienna.

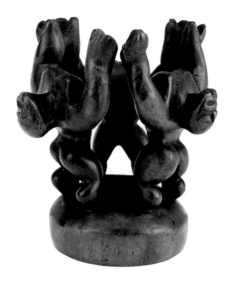

27 Bowl supported by three figures

Hawaiian Islands

Late eighteenth/early nineteenth centuries

Wood

H. 20.1 cm

London, BM: 1854,12-29,119

Donated 1854 by Sir George Grey, Governor of New Zealand 1845–54.

The tripod is formed by three acrobatic figures standing on their hands, their heads thrown back in the manner of the stool figure (no. 15). Previously badly broken, one arm has been replaced by the British Museum. The inside of the bowl appears to have traces of kava. Bowls with figures are rare; Cox and Davenport (1988) illustrate extant examples.

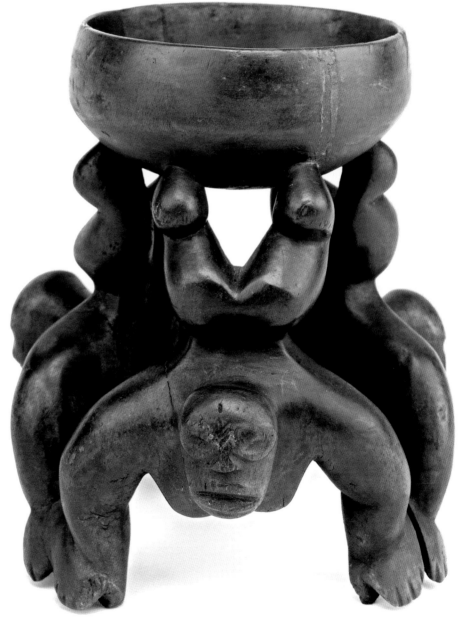

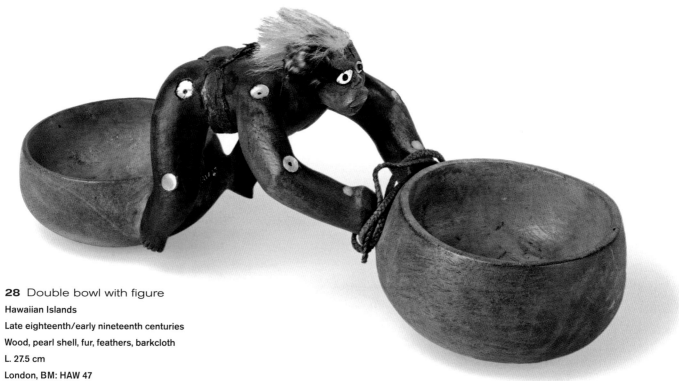

28 Double bowl with figure

Hawaiian Islands

Late eighteenth/early nineteenth centuries

Wood, pearl shell, fur, feathers, barkcloth

L. 27.5 cm

London, BM: HAW 47

Collection history not known, but registered with material of late eighteenth-century provenance.

The small figure has pearl-shell discs at the main joints, except the ankles, and hair of red feathers and fur (dog?). Its sex is ambiguous because despite the male loincloth a vulva is indicated beneath. The purpose of this double bowl is not known.

29 Bowl inset with teeth

Hawaiian Islands

Late eighteenth/early nineteenth centuries

Wood, human teeth

W. 18.0 cm

London, BM: 1920,10-23,1

Acquired 1920 from Miss L.P. Keyworth, who stated it belonged to Kamehameha, first king of Hawaii (d. 1819).

Originally inlaid with fifty-three human teeth (five now missing) this is a scrap bowl or spittoon for the use of a chief to preserve his food scraps and bodily fluids from being taken and used in sorcery. Teeth were removed by the relatives of a deceased chief as an act of sacrifice and mourning; they were also taken from defeated enemies and incorporated into the possessions of the victor. A hole at the side may have been for pouring.

30 Gourd bottle

Hawaiian Islands

Late eighteenth century

Gourd, fibre

H. 37.5 cm

London, BM: VAN 299

Acquired 1891; ex. collection George Hewett, surgeon's mate on HMS *Discovery* during Captain Vancouver's voyage; Vancouver was three times at Hawaii in 1792–4. Hewett later acquired objects from Cook's third voyage at the Leverian sale of 1806 (Kaeppler 1979: 177–9).

This gourd water bottle (*ipu*) retains its original twisted fibre carrying cord and is decorated with four panels of designs. Although the inhabitants of Ni'ihau were particularly famous for gourd bottle manufacture, they were made throughout the Hawaiian Islands (see Jenkins 1989).

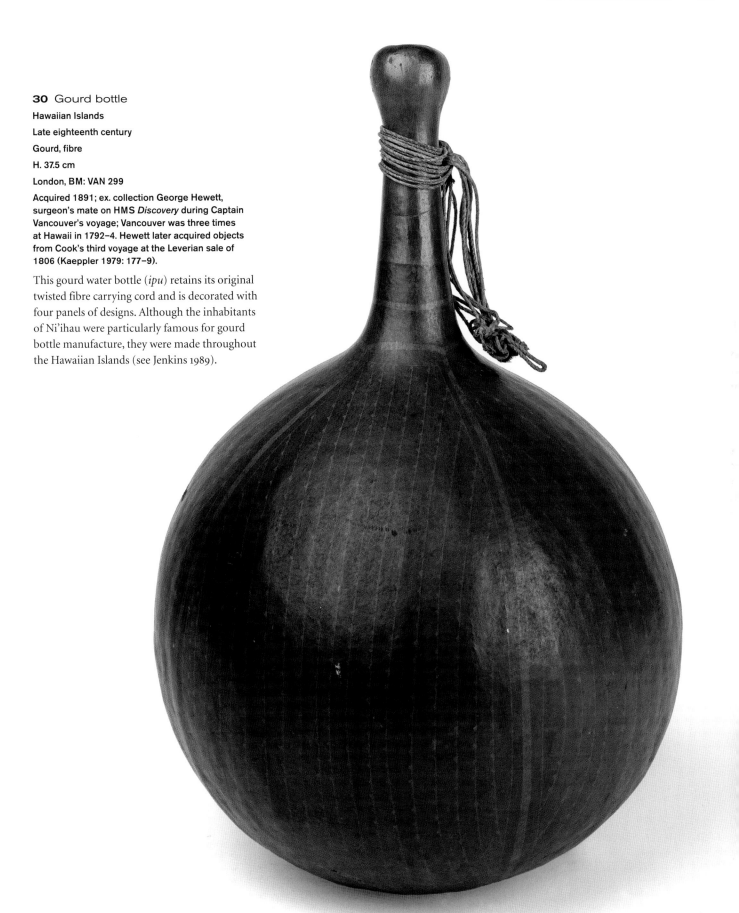

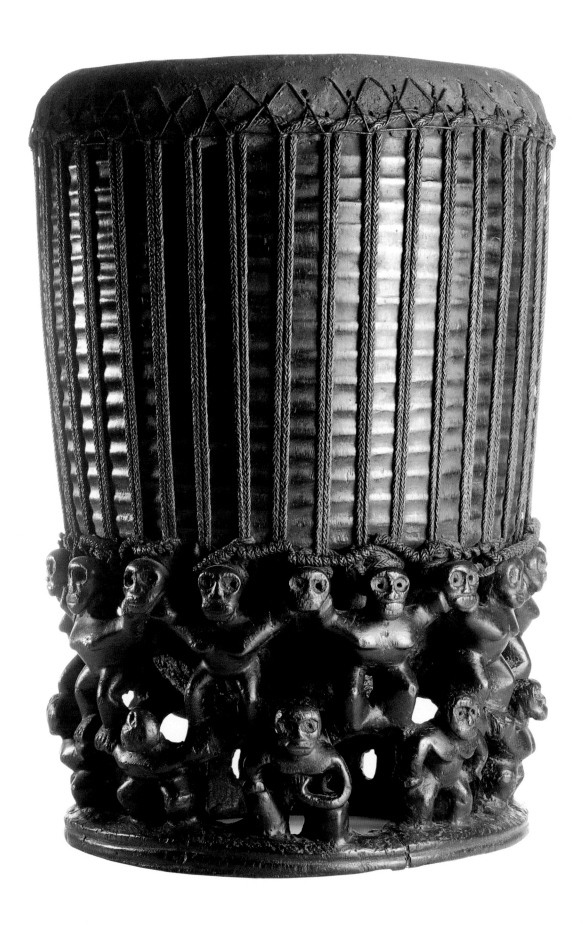

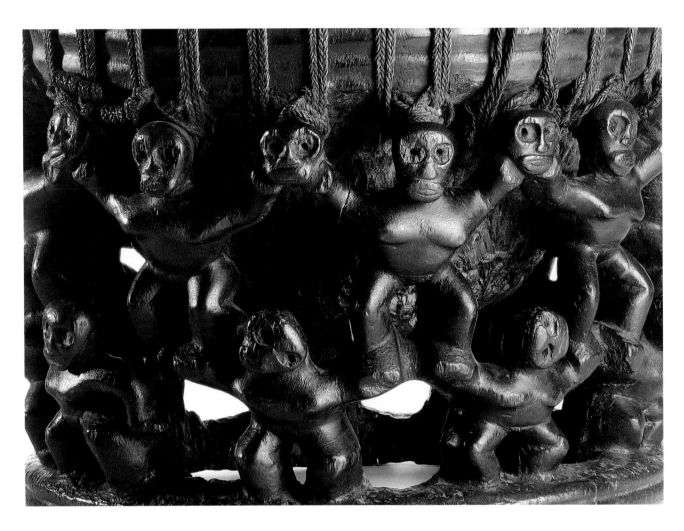

31 Drum

Hawaiian Islands

Late eighteenth/early nineteenth
centuries

Wood, shark skin, coir, fibre

H. 47.0 cm

Christchurch NZ, CM: E.150.1185

Acquired 1948; ex. collection William
Oldman, no. 301 (Oldman 2004: 67,
pl. 123); previous history not known.

One of only two Hawaiian drums
(*pahu*) with figures in the base, this
example has eighteen figures in two tiers, the upper ones
holding a further nine heads in their upraised hands.
These form the cleats by which the coir cords secure
the tympanum. The eyes may formerly have held inlays.
The base of the chamber is convex. The figures appear
in dancing postures, appropriate to a drum which will
have been used to accompany chants and *hula* dance
performances in honour of the gods (Kaeppler 1982: 94).
Drums manifested both aurally and materially the
presence of divinity.

NOT EXHIBITED

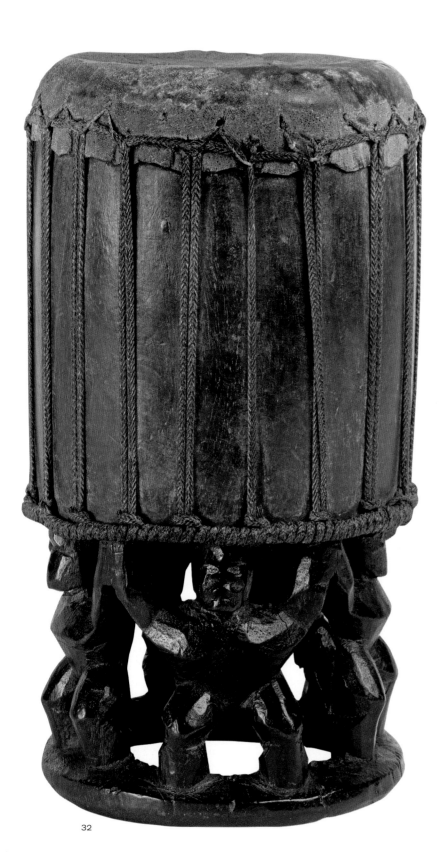

32

32 Drum

Hawaiian Islands

Mid-/late eighteenth century

Wood, shark skin, fibre, coir

H. 29.2 cm

London, BM: 1977.Oc.8.1

Acquired 1977 at Christie's, London; ex. collections James Hooper, no. 272 (Phelps 1976: 72, 416), Richard Cuming, Triphook and Dick; purchased by the last at the Leverian Museum auction 1806; collected during Cook's third voyage (Kaeppler forthcoming).

The second of two surviving drums (*pahu*) with figures, this one has five figures in dancing postures around the base. Two of the faces of the figures have high noses and no mouths; one figure has two breasts while the others have crescent chests. The reasons for these apparently deliberate decisions by the carver are not known. A faint illegible number is painted on one chest. The base of the chamber is solid.

33 Drum

Hawaiian Islands

Mid-/late eighteenth century

Wood, shark skin, coir, fibre

H. 28.2 cm

Glasgow, HMAG: E437

Ex. collection William Hunter; purchased at Samwell's sale, June 1781; collected by David Samwell, surgeon on HMS *Discovery* during Cook's third voyage (Kaeppler 1978: 43, 102; MacKie 1985: 11); it has an old label: 'A drum from Otaheite'.

A well-preserved drum (*pahu*) with two tiers of crescents around the base. The interior is rough but the exterior smooth and covered with a black varnish, congealed around the tympanum binding, typical of many early Hunterian pieces.

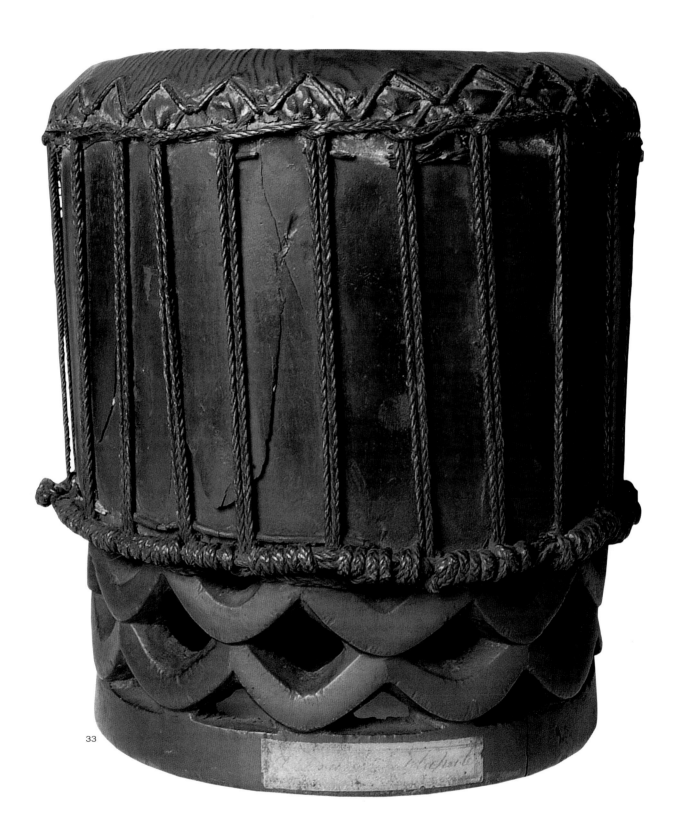

33

34 Dance leglet

Hawaiian Islands

Late eighteenth/early nineteenth centuries

Shells, dog canine teeth, fibre

W. 31.5 cm

London, BM: HAW 160a

Collection history not known, but registered with material of late eighteenth-century provenance.

35 Fan

Hawaiian Islands

Late eighteenth/early nineteenth centuries

Pandanus leaf, human hair, coir, fibre

W. 47.0 cm

London, BM: LMS 200

Ex. London Missionary Society Collection; on loan 1890, purchased 1911.

Fans of this level of refinement were for the use of high-status people. This one may have been acquired in the 1820s by LMS missionary Revd William Ellis.

36 Bracelet

Hawaiian Islands

Mid-/late eighteenth century

Boars' tusks, turtle shell, fibre

L. 14.0 cm

Cambridge, CUMAA: 1922.922A

Acquired 1922 from Arthur Holdsworth, the Widdicombe House Collection; formerly in the Leverian Museum, auctioned 1806; collected during Cook's third voyage (Kaeppler 1978: 96; Tanner 1999: 51).

This bracelet is made of thirty-seven sections of shaped boars' tusks and a single plate of turtle shell threaded onto two fibre cords. Pigs and turtles were important sacrificial animals.

One of a pair, this leglet was worn as a rattle by dancers tied just below the knee (Joppien and Smith 1988: 533–4). In its banding it resembles a Cook third-voyage example in Vienna (Kaeppler 1978: 98–9). At that time both dog-tooth and shell (*Columbella sp.*) leglets were in use, but by the early nineteenth century only dog-tooth ones continued to be made. As canine teeth were used, a very large number of dogs must have been involved, possibly as a result of sacrifices connected to Kamehameha's expansionist policies.

37 Bracelet

Hawaiian Islands

Mid-/late eighteenth century

Turtle shell, bone, fibre

L. 15.5 cm

Cambridge, CUMAA: 1922.922B

Acquired 1922 from Arthur Holdsworth, the Widdicombe House Collection; formerly in the Leverian Museum, auctioned 1806; collected during Cook's third voyage (Kaeppler 1978: 97; Tanner 1999: 51).

Numerous shaped plates of turtle shell and five plates of bone (or possibly boar's tusk) are threaded on two cords of fibre to make an elegant bracelet. Turtle was a high-status creature throughout Polynesia and a sacrificial animal when caught. In Hawaii its carapace was used in a variety of ornaments.

36

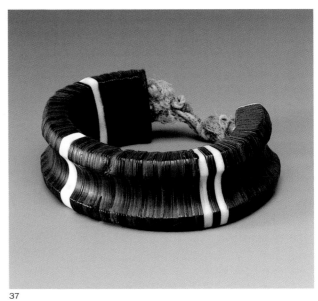

37

38 Bracelet

Hawaiian Islands

Mid-/late eighteenth century

Boars' tusks, fibre

W. 12.5 cm

Cambridge, CUMAA: 1922.919

Acquired 1922 from Arthur Holdsworth, the Widdicombe House Collection; formerly in the Leverian Museum, auctioned 1806; collected during Cook's third voyage (Kaeppler 1978: 95; Tanner 1999: 51).

A bracelet composed of twenty-two boars' tusks, with the points neatly trimmed, of the kind worn by *hula* dancers. The tusks are threaded on two fibre cords, as is usual for Hawaiian bracelets.

39 Turtle pendant

Hawaiian Islands

Late eighteenth/early nineteenth centuries

Whale ivory, turtle shell

L. 2.2 cm

London, BM: 2338

Acquired 1860s; possibly collected on Cook's third voyage (Kaeppler 1979: 181, 194).

A tiny turtle is carved from sperm-whale tooth, the eyes inlaid with pieces of turtle shell and a suspension hole cut into the underside. During the pre-whaling period whale ivory was scarce on Hawaii and items made from it were generally small. This turtle would have had fibre or hair cords attached through the back and been worn as a finger ring or wristlet, similar to an example in the Sainsbury Collection (Hooper 1997: II: 29). Samwell, on Cook's third voyage, observed that women wore 'little Images of turtle made of bone on their Fingers like we do Seals, and some wear them on their wrists' (Beaglehole 1967: 1,180).

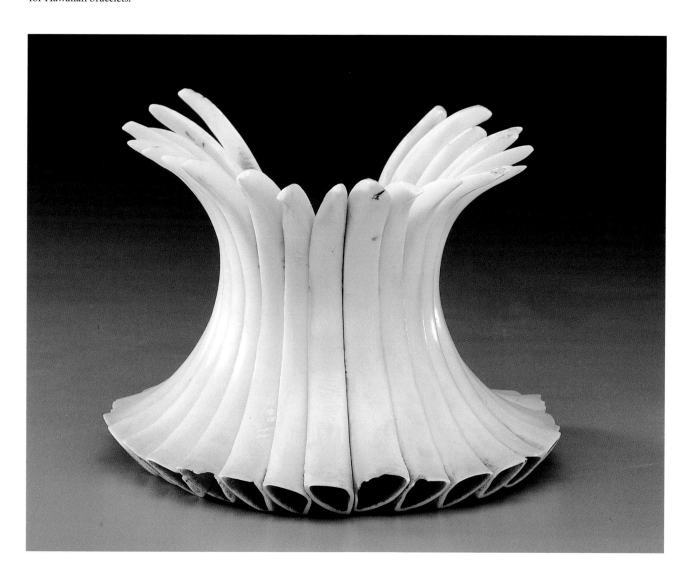

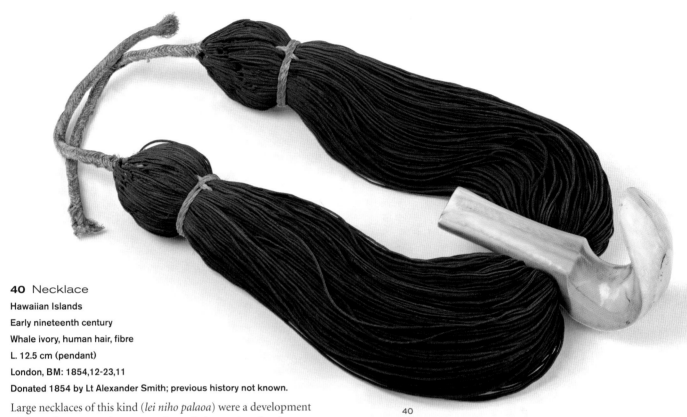

40 Necklace

Hawaiian Islands

Early nineteenth century

Whale ivory, human hair, fibre

L. 12.5 cm (pendant)

London, BM: 1854,12-23,11

Donated 1854 by Lt Alexander Smith; previous history not known.

Large necklaces of this kind (*lei niho palaoa*) were a development of the early nineteenth century, when whalers and traders began to supply sperm-whale teeth and walrus tusks in quantity, allowing craftsmen to create impressive versions of the old smaller hook-shaped pendant. The hair cords are also more substantial, made of fine eight-ply braid. This is a particularly large and handsome example.

40

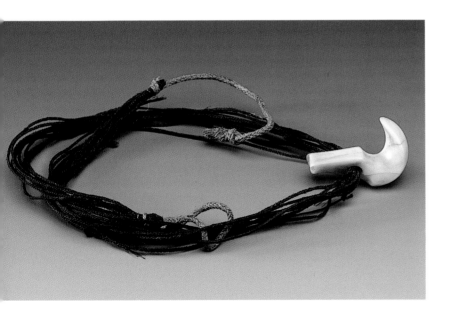

41 Necklace

Hawaiian Islands

Mid-/late eighteenth century

Whale ivory, human hair, fibre

L. 3.4 cm (pendant)

Cambridge, CUMAA: 1922.924

Acquired 1922 from Arthur Holdsworth, the Widdicombe House Collection; formerly in the Leverian Museum, auctioned 1806; collected during Cook's third voyage (Kaeppler 1978: 91; Tanner 1999: 52).

A number of small hook-shaped neck pendants were collected on Cook's third voyage. They are in a variety of materials: whale ivory, bone, stone, wood and shell. This example in ivory is strung on a necklet of braided human hair. Hair was cut off as a sign of mourning and then braided into memorial items such as ornaments of this kind. The significance of the hook shape is not known, though its resemblance to a tongue and a chin has been noted.

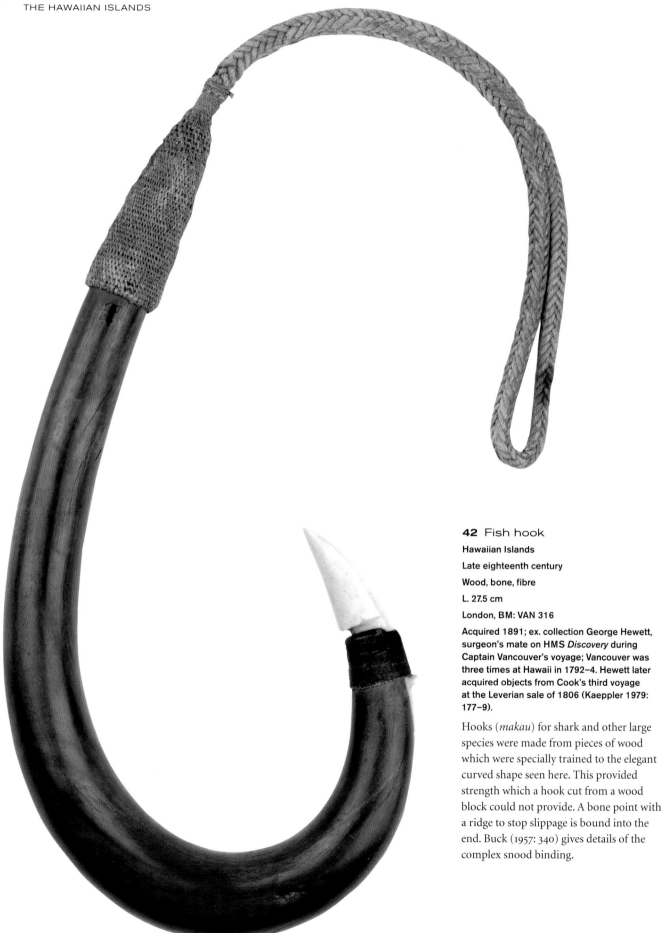

42 Fish hook

Hawaiian Islands

Late eighteenth century

Wood, bone, fibre

L. 27.5 cm

London, BM: VAN 316

Acquired 1891; ex. collection George Hewett, surgeon's mate on HMS *Discovery* during Captain Vancouver's voyage; Vancouver was three times at Hawaii in 1792–4. Hewett later acquired objects from Cook's third voyage at the Leverian sale of 1806 (Kaeppler 1979: 177–9).

Hooks (*makau*) for shark and other large species were made from pieces of wood which were specially trained to the elegant curved shape seen here. This provided strength which a hook cut from a wood block could not provide. A bone point with a ridge to stop slippage is bound into the end. Buck (1957: 340) gives details of the complex snood binding.

43 Fish hook

Hawaiian Islands

Late eighteenth/early nineteenth centuries

Bone, wood, fibre

H. 9.5 cm (excl. cord)

London, BM: 1944.Oc.2.69

Donated 1944 by Irene Beasley; ex. collection Harry Beasley, no. 4322; acquired 21 February 1937 from H.H. Le Mesurier, Guernsey.

This is an unusual example of the composite form of bone hook (*makau*), having three barbs to the point. The binding is made tight by the insertion of small wood pegs. Hooks of this kind have been found as offerings at temples. Harry Beasley published a book on Pacific fish hooks (1928), based on his own extensive collection.

44 Fish hook

Hawaiian Islands

Late eighteenth century

Turtle shell, fibre

H. 7.4 cm

Exeter, RAMM: E1271

Collected by J.W. Scott during Captain Vancouver's voyage; Vancouver was three times at Hawaii in 1792–4.

Turtles were closely associated with chiefs and divinity, and were a highly valued sacrificial offering. The shell of the carapace becomes malleable when heated in water and was adapted to a variety of purposes, including the manufacture of fish hooks.

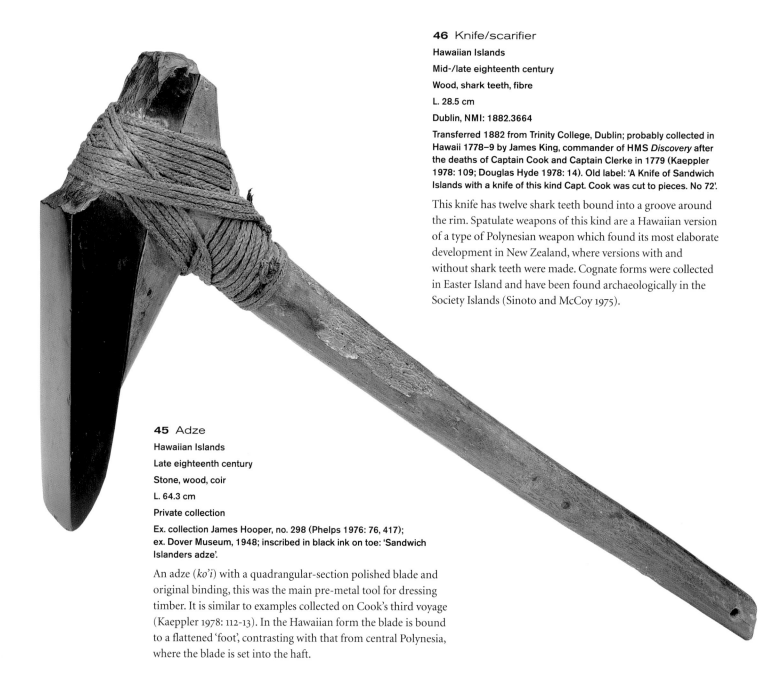

46 Knife/scarifier

Hawaiian Islands

Mid-/late eighteenth century

Wood, shark teeth, fibre

L. 28.5 cm

Dublin, NMI: 1882.3664

Transferred 1882 from Trinity College, Dublin; probably collected in Hawaii 1778–9 by James King, commander of HMS *Discovery* after the deaths of Captain Cook and Captain Clerke in 1779 (Kaeppler 1978: 109; Douglas Hyde 1978: 14). Old label: 'A Knife of Sandwich Islands with a knife of this kind Capt. Cook was cut to pieces. No 72'.

This knife has twelve shark teeth bound into a groove around the rim. Spatulate weapons of this kind are a Hawaiian version of a type of Polynesian weapon which found its most elaborate development in New Zealand, where versions with and without shark teeth were made. Cognate forms were collected in Easter Island and have been found archaeologically in the Society Islands (Sinoto and McCoy 1975).

45 Adze

Hawaiian Islands

Late eighteenth century

Stone, wood, coir

L. 64.3 cm

Private collection

Ex. collection James Hooper, no. 298 (Phelps 1976: 76, 417); ex. Dover Museum, 1948; inscribed in black ink on toe: 'Sandwich Islanders adze'.

An adze (*ko'i*) with a quadrangular-section polished blade and original binding, this was the main pre-metal tool for dressing timber. It is similar to examples collected on Cook's third voyage (Kaeppler 1978: 112-13). In the Hawaiian form the blade is bound to a flattened 'foot', contrasting with that from central Polynesia, where the blade is set into the haft.

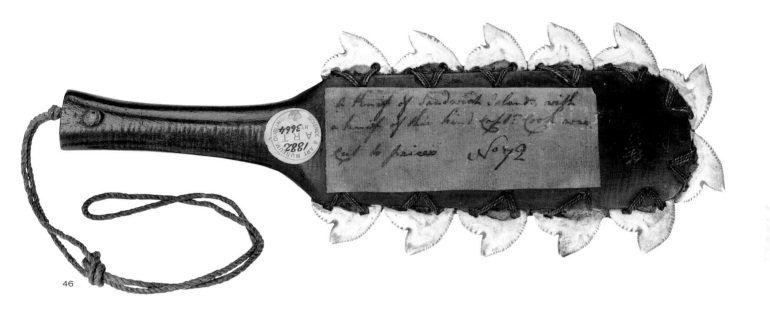

46

47 Knife/scarifier

Hawaiian Islands

Late eighteenth century

Wood, shark tooth, boar's tusk, fibre

L. 13.5 cm

Cambridge, CUMAA: E1920.803

Acquired 1920 by Baron Anatole von Hügel; previous history not known.

A single tooth knife, it is remarkable for the presence of thirty-one black wood discs set into one side (three missing). The other side is inset with three small pieces of boar's tusk. In form it resembles examples collected on Cook's third voyage (Kaeppler 1978: 107–10). The species of shark tooth and the method of lashing differs from the spatulate weapon (no. 46), suggesting that they may be from different parts of Hawaii.

47

48 Club

Hawaiian Islands

Eighteenth century

Stone, wood, coir, fibre

L. 23.2 cm

London, BM: VAN 266

Acquired 1891; ex. collection George Hewett, surgeon's mate on HMS *Discovery* during Captain Vancouver's voyage; Vancouver was three times at Hawaii in 1792–4. Hewett later acquired objects from Cook's third voyage at the Leverian sale of 1806 (Kaeppler 1979: 177–9).

This appears to be the only surviving complete composite club from Hawaii. The four-pointed stone head is lashed with plaited coir cord to a cylindrical wood handle which has a short wrist cord. This may have been for the attachment of a longer cord, allowing the club to have an alternative use as a tripping weapon, thrown at an opponent's legs (Buck 1957: 441, 455–9).

49 Spear

Hawaiian Islands

Mid-/late eighteenth century

Wood

L. 261.5 cm; 24.8 cm (head)

London, BM: 1946.Oc.1.1

Donated 1946 by Miss Upfield-Green; stated by vendor to have been 'Thrown into the boat when Captain Cook was murdered [1779], brought to England by Thomas Bean, whose wife was nurse to Thomas Green, & gave it to her master'; Bean sailed on the third voyage (Kaeppler 1978: 46; 1979: 187).

A finely polished spear with a head composed of five triple-barbed tiers, it has a slender uncarved shaft. Although the Cook death provenance cannot be verified (there are many weapons supposedly associated with Cook's demise; see Hooper 2003), this spear (*ihe*) is nevertheless of a type collected during the third voyage.

50 Knife/scarifier in barkcloth sleeve

Hawaiian Islands

Late eighteenth century

Fish jawbone, barkcloth, fibre

W. 17.0 cm

London, BM: HAW 177

Collection history not known, but registered with material of late eighteenth-century provenance.

Composed of the modified upper palatine jaw of a barracuda (information courtesy of Bishop Museum staff, Honolulu), this scarifier has its own sheath of thick ridged barkcloth, dyed red on the inside. Red was a colour of great symbolic importance, partly associated with the colour of blood. Scarification and blood-letting was an act of sacrifice, especially during mourning, in many parts of Polynesia.

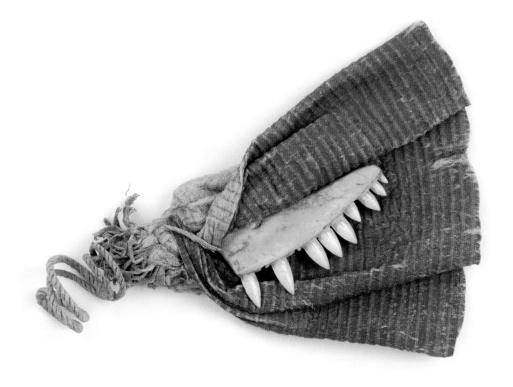

New Zealand / Aotearoa

New Zealand was the last major part of the Pacific to be reached by Polynesian voyagers. This occurred around AD 1100–1200, with the most likely point of departure being somewhere in the Cook Islands, possibly en route from the Society Islands. It is probable that subsequent voyages were made, and these, plus oral accounts of the progressive colonization of New Zealand, became the basis of a myth concerning a 'Great Fleet' of seven canoes (*waka*). This myth became

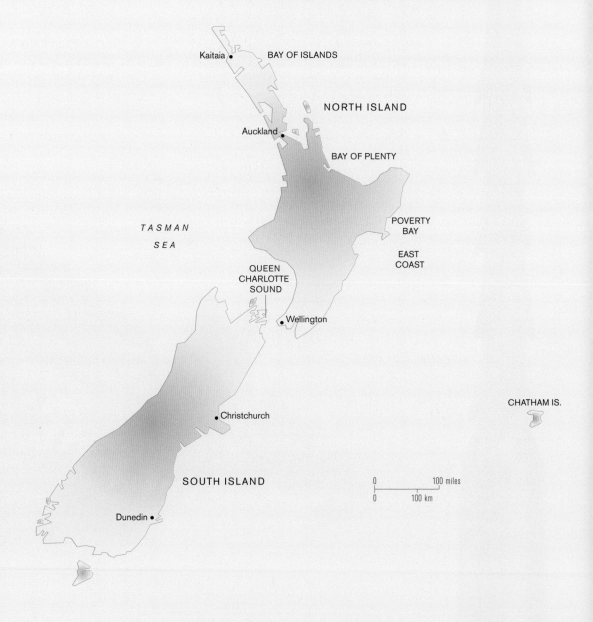

standardized in the late nineteenth century, with the occupants of the canoes being considered ancestral to current Maori people. The term Maori, which means 'local' or 'normal', was not in widespread use until about 1830, there being no indigenous term for people of the whole region. Before then Europeans referred to 'New Zealanders'. Similarly, there was no single term for the whole of New Zealand. The North Island was called Aotearoa ('long white cloud') or Te ika a Maui ('the fish of Maui'); the South Island was Te wai pounamu ('the waters of nephrite/jade'). During the twentieth century Aotearoa was adopted by Maori people as the local term for the whole of New Zealand, hence its use in the context of this catalogue.

The name New Zealand derives from the first European visit, in 1642–3, of the Dutch voyager Abel Janszoon Tasman. The name 'Zeeland' appeared on charts, and was used with the current spelling by the next European visitor, James Cook, who in 1769 made a circumnavigation of the two main islands and produced a map remarkable for its accuracy. Cook called at New Zealand during all three of his voyages, and French and other visitors followed. From the 1790s sealers and whalers called at New Zealand and the Chatham Islands to the east, which are thought to have been colonized either from New Zealand or independently from central Polynesia. Home to the Moriori people, they were named after the visit of one of Vancouver's ships, HMS *Chatham*, in 1791.

The Bay of Islands became one of the main ports of call, and was the location for the first mission, established by the Anglican Samuel Marsden in 1814. It was also a place from where Maori crew were picked up by whalers and traders en route to the islands. Metal, cloth and muskets were the main trade items. The introduction of the last led to an increase in warfare in the North Island in the 1820s, and there was

further fighting both among Maori and against European settlers in the 1840s. In 1840 many chiefs signed the Treaty of Waitangi at the Bay of Islands, ceding sovereignty to Queen Victoria. Cultural misunderstandings about the relationship between sovereignty and ownership have meant that the terms of this treaty have remained in dispute ever since (Orange 1987).

Attempts have been made to attribute precise carving styles to different areas of New Zealand, but this is problematic because although there were regional styles, little reliable information exists about places and dates of manufacture of objects. The movement of objects (by exchange or as war booty) and of specialist carvers (*tohunga whakairo*) also has to be taken into account. The first carver whose identity is clearly known was Raharuhi (Lazarus) Rukupo, born around 1800 in the Poverty Bay area of the East Coast. He carved canoes and then in the 1840s his most famous work, the meeting house Te Hau-ki-Turanga, which is now preserved in the Museum of New Zealand/Te Papa Tongarewa (Kernot 1984). Elaborately carved meeting houses, based on the form of chief's houses and store houses, were a development of that period.

Fine and extensive collections of Maori material are housed in New Zealand museums, including that formed by the Englishman William Oldman, which was purchased by the New Zealand government in 1948. These materials, whether in public or in private hands, are classed as *taonga*, treasures or valuables. Among the greatest *taonga* are flax cloaks and objects made of *pounamu* (nephrite), a type of jade which occurs in several places on the South Island, and which was extensively traded and exchanged.

Further information on New Zealand/Aotearoa art and history may be found in: Mead 1969, 1984; Cooper *et al.* 1989; Davidson 1987; Pendergrast 1987, 1998; Belich 1996; Neich 2001; Hamilton 1896; Webster 1948; Best 1924; Oldman 2004a; Starzecka 1998. For the Chatham Islands see King 1989.

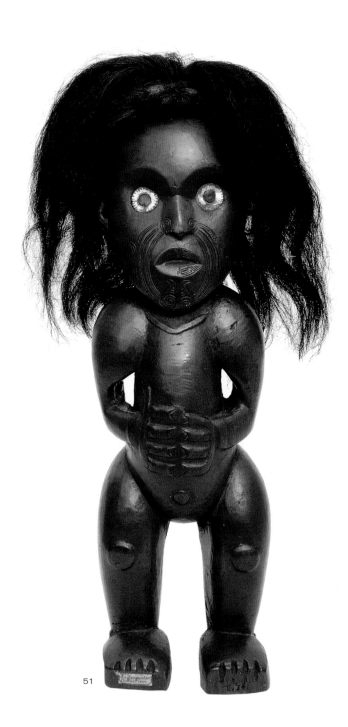

51 Standing figure

New Zealand/Aotearoa

Late eighteenth/early nineteenth centuries

Wood, human hair, haliotis shell

H. 40.0 cm

Glasgow, HMAG: E341

Acquired 1888; ex. collection Andersonian Museum (founded by John Anderson, 1726–96); old label on right foot: 'Andersonian Collection'.

Few free-standing figures of this kind survive; it seems they were not part of architectural structures but probably memorial images of ancestors. The voyager Crozet noted in the Bay of Islands in 1772: 'In their private houses are to be found similar figures like little idols placed in positions of honour' (Roth 1891: 45). Taylor (1855: 62) illustrates a free-standing 'memorial idol' wearing a miniature cloak. The present example has human hair attached to a topknot on the head and bears a partial male facial tattoo; red ochre is found beneath the hair. The eyes are notched rings cut from *paua* shell (*Haliotis iris*). A skin fold below the neck has interesting parallels with that found on an Easter Island figure (no. 91). Barrow (1959) and Hooper (1997: II: 4–6) discuss other examples of such figures.

51

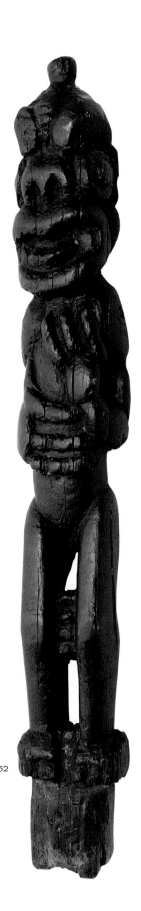

52

52 Standing figure on post

New Zealand/Aotearoa

Late eighteenth century

Wood

H. 54.0 cm

Glasgow, HMAG: E328

Probably ex. collection William Hunter and collected on one of Cook's voyages (MacKie 1985).

A figure with bulbous features and no surface engraving, it stands atop a post by which it was formerly fixed upright, possibly on the fence of a stockade surrounding a *pa* (fort). A lug behind the head may also have served for fixing. Feather or other pendants are likely to have been attached to the spherical topknot. The mid-brown wood is covered with a thick black varnish, similar to that on other Hunterian Polynesian objects, which may have been an early, if misguided, conservation measure.

53 Burial chest

New Zealand/Aotearoa, North Island

Eighteenth/early nineteenth centuries

Wood

H. 93.0 cm

London, BM: 1950.Oc.11,1

Acquired 1950; ex. Bideford Museum, Devon; probably collected by Captain A.J. Higginson during a mid-nineteenth-century visit to New Zealand.

Hollow burial chests (*waka tupapaku*) have mostly been found in the Bay of Islands area; they were for the deposition of ancestral bones in caves as part of secondary burial rites. The decayed left side of this figure suggests that it had fallen and lain on a cave floor for some time before collection. The cavity at the back is rectangular; the cover is lost. The corpus of extant examples, including this one, has been discussed by Fox (1983). Interesting parallels for such reliquary images can be found in the Austral Islands (no. 156), and also among some Hawaiian images (see above, p. 44).

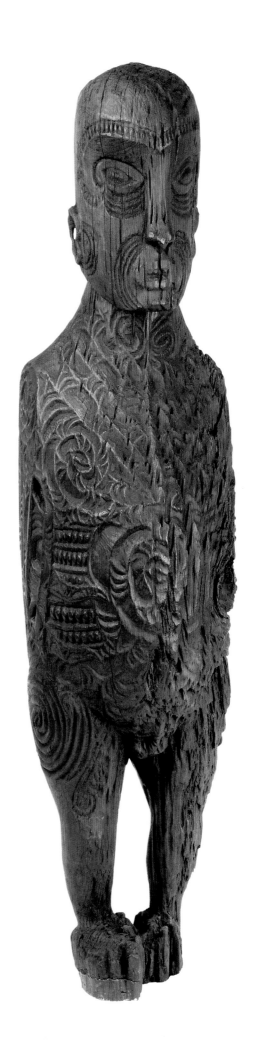

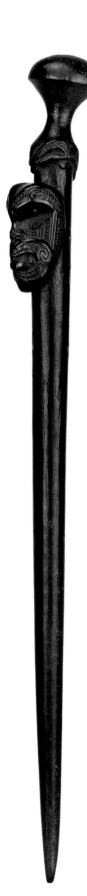

54 Weaving peg/godstick

New Zealand/Aotearoa

Late eighteenth/early nineteenth centuries

Wood

H. 40.8 cm

London, BM: 9357

Purchased 1875 from Revd William Sparrow Simpson; previous history not known.

Weaving pegs (*turuturu*) were used in pairs, pushed into the ground, with flax wefts suspended between them. The finger-weaving of cloaks of various designs was undertaken by skilled women (Pendergrast 1987; 1998). The presence of a head on the side and a four-toothed 'mouth' above suggests that this peg is related to a class of objects known as godsticks. These were used as a way of attracting the gods when being bound with flax cords by priests making ritual invocations (Barrow 1959a; 1961; Hooper 1997: II: 8–9).

55 Bugle-flute

New Zealand/Aotearoa

Late eighteenth/early nineteenth centuries

Wood, haliotis shell, cane, fibre

L. 47.1 cm

London, BM: LMS 142

Ex. London Missionary Society Collection; on loan 1890, purchased 1911.

This bugle-flute (*putorino*) has terminals sculpted in high relief. The head at the top has its tongue held in a bird-like beak; around the central modulating aperture is a female figure in low relief. Made of two perfectly fitting longitudinal sections bound with bands of cane, it was blown at the top end and has a small hole at the bottom. Instruments such as this were used for signalling, for marking *tapu* periods and indicating divine presence.

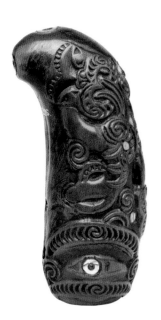

56 Flute

New Zealand/Aotearoa

Late eighteenth/early nineteenth centuries

Wood, haliotis shell

L. 10.8 cm

London, BM: +7926

Purchased 1875 from Revd William Sparrow Simpson; previous history not known.

Blown through the large end aperture, this flute (*nguru*) has two modulating holes on the side and two, with haliotis shell rings, on the curved end. Two contorted figures with extending tongues are carved on the sides; the mouthpiece is shaped as the mouth of a head with haliotis shell eyes. A lug on one side is for a suspension cord, now lost. This type is often referred to as a nose flute, but there is no evidence for this use; the form probably derives from the curved end of a gourd, from which whistles were also made.

57 Shell trumpet

New Zealand/Aotearoa, Queen Charlotte Sound

Mid-/late eighteenth century

Shell, wood, fibre, gum

L. 25.2 cm

Cambridge, CUMAA: 1925.374

Deposited 1912; ex. collections Earl of Denbigh, Thomas Pennant, Joseph Banks; collected during Cook's second voyage on 4 June 1773 at Queen Charlotte Sound (Forster 1777: 277; Kaeppler 1978: 184; Tanner 1999: 3, 31).

This finely preserved *Charonia* shell trumpet (*putatara*) has been discussed in detail by Gathercole (1976). It is very likely to be the one depicted in Cook's second-voyage journal (Cook 1777: pl. 19) and in a drawing by Moses Griffith (Joppien and Smith 1985a: 158). A feature indicating its high value is the fact that a large broken section of shell has been replaced by a carefully shaped wood panel, tied and gummed in place. The ovoid pad made of reddened tightly wrapped flax cloth was probably used as a modulator; the wood mouthpiece is carved in the form of a head with open mouth.

58 Treasure box

New Zealand/Aotearoa

Late eighteenth/early nineteenth centuries

Wood, haliotis shell

L. 47.5 cm

Cambridge, CUMAA: Z6600

Acquired 1886 from Professor Anthony Bevan; previous history not known.

A fine example of a type of box (*waka huia*) which was used to keep feathers, nephrite ornaments and other valuables (*taonga*). Numerous animated figures are carved on the sides and base; the handle of the lid is in the form of two female figures presenting their vulvas towards a male figure with a bird-like head facing the opposite direction. Treasure or feather boxes of various styles were collected during early voyages and continued to be made well into the nineteenth century.

59 Carving

New Zealand/Aotearoa

Late eighteenth century

Wood, haliotis shell

L. 25.3 cm

London, BM: 7361

Acquired 1871 from the London dealer William Wareham.

The original function of this rare type of object remains unclear. Often stated in the literature as being the ends of latrine bars, firm evidence is lacking and they could be from canoe or house architecture. A rectangular recess on both sides of the shaft is pierced with two rectangular holes. The main figure with a large head is female; her feet reach forward to grip the sides of the mouth. The smaller head at the opposite end belongs to a sinuous body carved along the shaft. There are Cook voyage examples in Cambridge (Tanner 1999: 23) and Göttingen (Hauser-Schäublin and Krüger 1998: 107, 302).

60 Feeding funnel

New Zealand/Aotearoa

Late eighteenth century

Wood

L. 22.0 cm

Newcastle, NEWHM: C624

Acquired 1822 by Newcastle Literary and Philosophical Society; ex. collection George Allan (d. 1800); it bears an old oval Allan collection label (stating 'whistle or flute').

Special feeding funnels (*korere*) were used to deliver cooked food directly into the mouths of people in a *tapu* condition, such as when undergoing tattoo or other ritual procedures. In many cultures cooked food is regarded as antithetical and polluting in sacred contexts; today, cooked food should not be taken into a Maori meeting house. This funnel appears to be unfinished – a main figure, partially engraved, is flanked by two smaller figures, with a third in high relief beneath the spout.

61 Ceremonial adze

New Zealand/Aotearoa

Late eighteenth/early nineteenth centuries

Nephrite, wood, fibre, haliotis shell

L. 40.7 cm

London, BM: 1921,10-14,4

Acquired 1921; ex. Yorkshire Philosophical Society Museum; collected 1844 by Revd John Blackburn.

A fine example of a baton called *toki poutangata*, 'the adze which establishes a man in authority'. Adze blades and other objects made of nephrite (*pounamu*) were highly valued. Here a delicate blade, probably an ancient heirloom or trophy, is mounted in a wood handle. This is carved as a figure whose tongue is held in the beak of a bird-like head. Nephrite, a type of jade, was found naturally in remote parts of the South Island, whence it was traded and exchanged throughout New Zealand, being especially valued in the North Island as an exotic valuable.

62 Knife/scarifier

New Zealand/Aotearoa

Late eighteenth century

Wood, haliotis shell, shark teeth, fibre

L. 22.9 cm

Glasgow, HMAG: E352

Probably ex. collection William Hunter and collected on one of Cook's voyages (MacKie 1985).

This knife (*maripi*), armed with what appear to be the teeth of the Sevengill shark or *tuatini*, was most likely used as a weapon and for butchering feast foods. Its ritual importance is attested by the fact that it is elaborately carved beyond any basic practical requirement; the blade is formed of one, or perhaps two, sinuous figures with notched haliotis-shell ring eyes and/or joints. It closely resembles in form two Cook voyage knives in Oxford and the British Museum (Kaeppler 1978: 197–8).

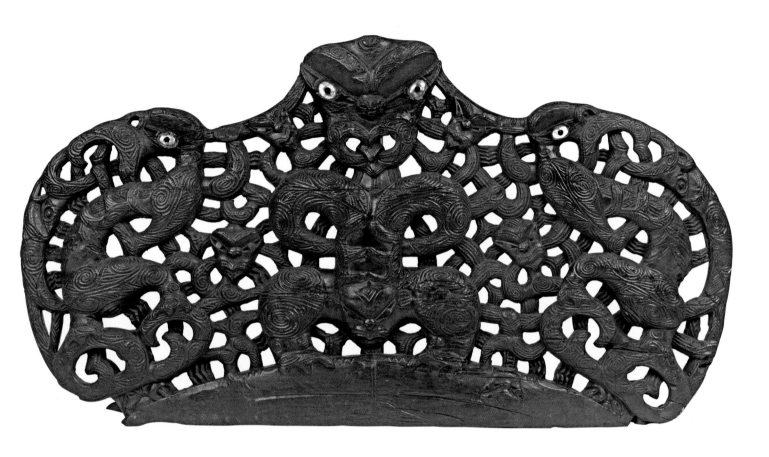

63 Lintel

New Zealand/Aotearoa

Late eighteenth/early nineteenth centuries

Wood, haliotis shell

W. 98.0 cm

London, BM: 1854,12-29,89

Donated 1854 by Sir George Grey, Governor of New Zealand, 1845–54.

A large and complete example of a type of carved panel (*pare* or *korupe*) fitted above the doorway of a chief's house, and later above the doorway of elaborately carved meeting houses (which began to be built around 1840). The entrances of important buildings usually received decorative carving or painting. An analogy could be made between buildings and the human body, whose orifices (ears, eyes, nose and mouth) were also the site of decorative elaboration. Lintels often have a central female figure, as here, which performs a *tapu*-removing function for those entering a house.

64 Canoe prow

New Zealand/Aotearoa

Late eighteenth/early nineteenth centuries

Wood

W. 141.0 cm

London, BM: 1900,7-21,1

Purchased 1900 from Arthur Passmore; formerly in 'the Bennett collection', Farringdon, London.

A large panel-style canoe prow (*tuere*) of the kind seen in the eighteenth century (Joppien and Smith 1985: I: 198–9, 202), but which seems to have been superseded in the early nineteenth century by the type with a projecting figurehead (also present in the eighteenth century). Four sinuous creatures are integrated into the overall design. Canoes (*waka*) were among the most elaborately carved structures made in New Zealand, symbolically and metaphorically important in that they acted as a kind of mobile chiefly house, the chief embodying the whole 'tribe'. Confederations of tribes who traced descent from original voyaging canoes were also called *waka*.

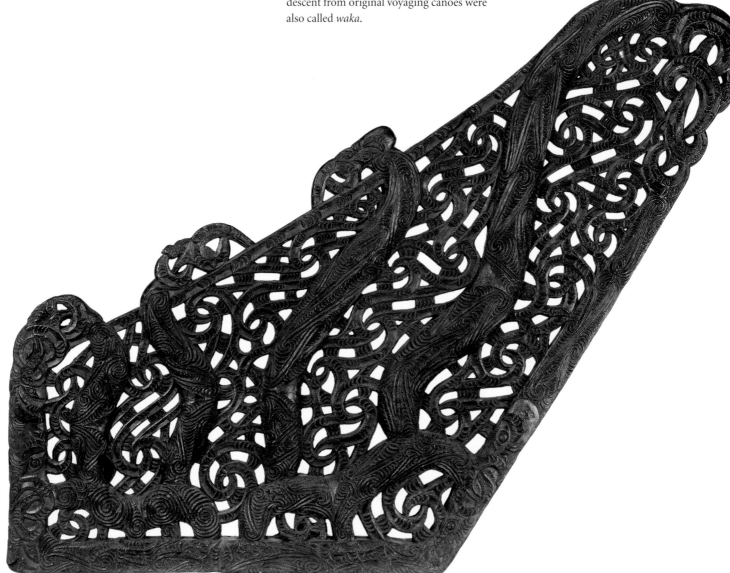

65 Canoe bailer

New Zealand/Aotearoa, East Coast

Mid-eighteenth century

Wood, fibre

L. 50.0 cm

Oxford, PRM: 1887.1.381

On loan since 1886 from Christ Church, Oxford; on loan 1860–86 to Oxford University Museum of Natural History; donated 1771–2 by Joseph Banks to Christ Church; collected 1769 by Banks on Cook's first voyage.

Recently identified as part of a Banks first-voyage collection (Coote 2004: 18), this fine canoe bailer (*tiheru*) has an elegant form highly fit for its purpose. Splits in the wood have received indigenous repairs, the twine neatly inset in order not to be abraded and broken when the bailer was in use; other repairs are more recent.

66 Canoe paddle

New Zealand/Aotearoa

Mid-eighteenth century

Wood, red ochre

L. 179.5 cm

Newcastle, NEWHM: C589

Acquired 1822 by Newcastle Literary and Philosophical Society; ex. collection George Allan (d. 1800; see Jessop 2003).

Several paddles (*hoe*) with carved handles and red ochre designs on the blade were collected during Cook's voyages; three were painted by Sydney Parkinson on the first voyage in 1771 (see above, p. 67). The designs on this example closely resemble the example on the right in the Parkinson painting and it is likely they are the same. The painted curvilinear designs (*kowhaiwhai*) on paddles correspond to those on rafters of important houses, expressing a structural equivalence to houses, with rows of paddles on each side corresponding to rafters sloping from the ridgepole.

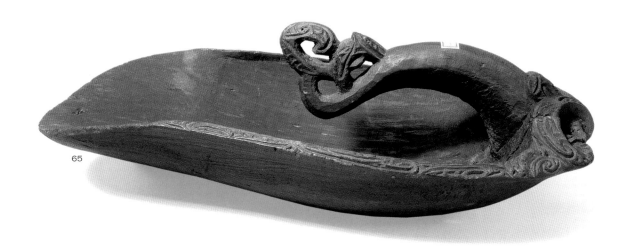

65

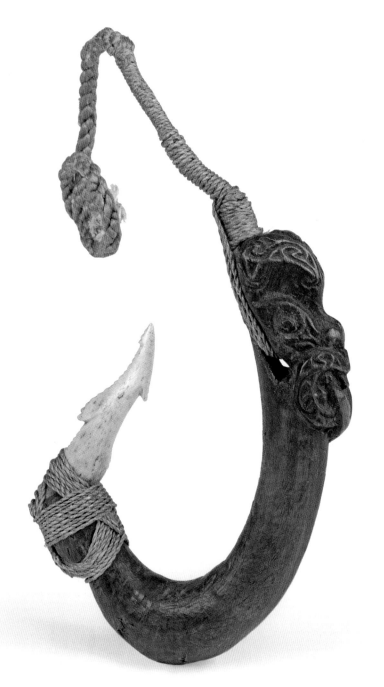

67 Fish hook
New Zealand/Aotearoa
Late eighteenth/early nineteenth centuries
Wood, bone, flax fibre
L. 12.5 cm (excl. cord)
London, BM: 9356
Purchased 1875 from Revd William Sparrow Simpson; previous history not known.

A rare example of a large bait hook (*matau*) with a head carved on the shank. Marks of fish teeth on the shank indicate previous use. A hook of this type, with the head facing sideways, is shown in a Cook first-voyage illustration by Parkinson (1773: pl. XXVI; Joppien and Smith 1985: 227).

68 Fishing lure
New Zealand/Aotearoa
End eighteenth/early nineteenth centuries
Wood, bone, haliotis shell, fibre
L. 10.2 cm
Private collection
Ex. collection James Hooper, no. 17 (Phelps 1976: 35, 411).

A trolling lure (*pa kahawai*) for catching *kahawai*, a schooling fish which was abundant in North Island waters. The lure or spinner was dragged behind a fast-moving canoe, the haliotis shell flashing to attract the prey. No lures of this kind can be traced to Cook voyage collections; the first possible mention of them is in 1793 by Labillardière (1800: 328; Beasley 1928: 16). It is possible that, although spinner shanks have been found archaeologically, this particular form was developed after spinners from tropical Polynesia were seen on European ships.

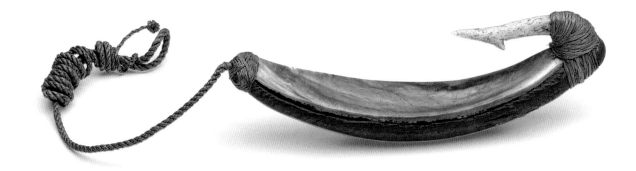

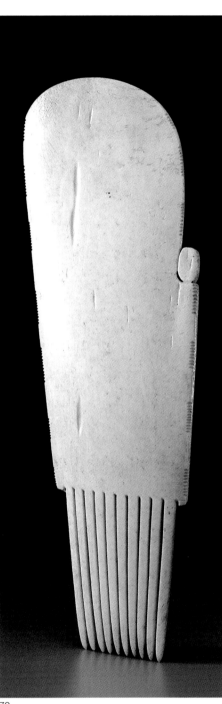

70

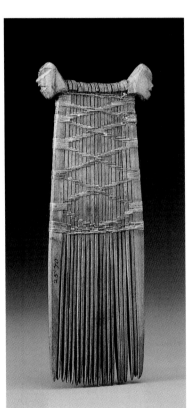

69

69 Comb with small heads

New Zealand/Aotearoa

Late eighteenth/early nineteenth centuries

Wood, fibre

H. 14.2 cm

Cambridge, CUMAA: 1925.70

Acquired 1925 by Louis Clarke; previous history not known.

This finely made comb (*heru*) has decorative binding and small heads carved at the tops of the two end sections. Combs were primarily worn as head ornaments as well as serving to dress the hair.

70 Comb

New Zealand/Aotearoa

Late eighteenth century

Whalebone

H. 28.3 cm

Cambridge, CUMAA: D1933.1

Acquired 1933; ex. collection Jesus College, Cambridge; previous history not known.

A large comb (*heru*) of a type associated with eighteenth-century collections (Kaeppler 1978: 180–81) and also shown in Cook voyage illustrations being worn by men (see above, p. 52; Joppien and Smith 1985: 184–5). There are fine bands of notching around the edge; the side projection represents a head, which is clearer in smaller wooden combs of this general style.

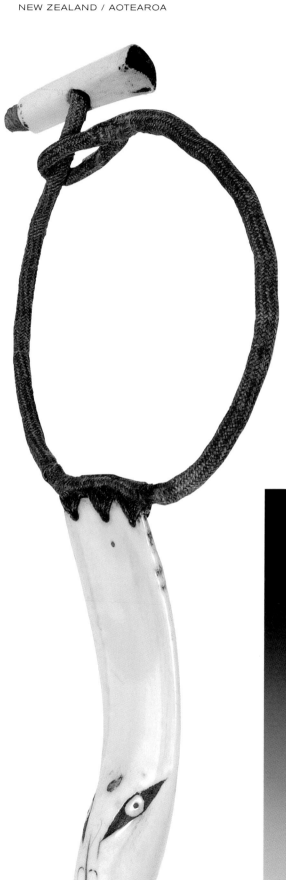

71 Neck pendant

New Zealand/Aotearoa

Mid-/late eighteenth century

Sperm-whale tooth, flax, bird bone

L. 17.0 cm (pendant)

Newcastle, NEWHM: C765

Acquired 1822 by Newcastle Literary and Philosophical Society; ex. collection George Allan (d. 1800; see Jessop 2003).

This rare form of neck pendant (known by its nineteenth-century name *rei puta*) is highly polished, bulbous at the tip and flat at the top, where it is attached to a fine flax neck cord. The cord is composed of a plaited cylindrical sleeve around a flax core, terminating in a bird bone toggle. *Rei puta* were drawn and collected in the eighteenth century (see above, p. 52; Joppien and Smith 1985: 184–5) but they appear to have ceased to be made in the nineteenth century, despite the availability of sperm-whale teeth from whalers and the popularity of the material elsewhere in Polynesia at the time.

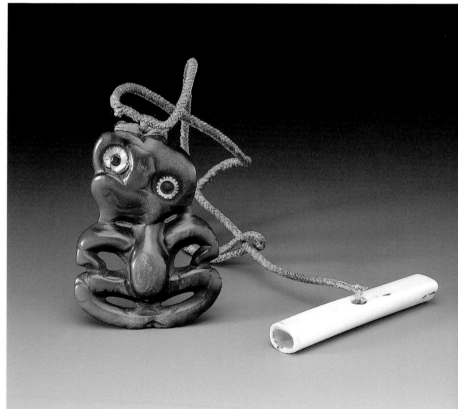

72

72 Neck pendant

New Zealand/Aotearoa

Late eighteenth/early nineteenth centuries

Nephrite, fibre, bird bone, haliotis shell

H. 7.1 cm (pendant)

Cambridge, CUMAA: E1913.293

Acquired 1913 from Professor Anthony Bevan; previous history not known.

This is an example, complete with cord and bird-bone toggle, of the most famous type of Maori neck pendant, the *hei tiki* (necklet figure). Seen by the early explorers, they have continued in popularity to the present day. Many appear to have been made in the nineteenth century when nephrite adzes became redundant in the face of the arrival of metal tools. The adze blade edge can often be seen at the base, although it is likely that the conversion of adzes to *hei tiki* was not a new practice. What they 'represent' remains enigmatic and there is no agreed interpretation. This *hei tiki*, not made from an adze, resembles documented eighteenth-century examples (Kaeppler 1978: 176–7); slender fingers can be seen to grasp the thighs.

73 Neck pendant

New Zealand/Aotearoa

Late eighteenth/early nineteenth centuries

Nephrite, flax, haliotis shell

H. 12.1 cm

London, BM: LMS 141

Ex. London Missionary Society Collection; on loan 1890, purchased 1911.

A fine large *hei tiki* in a more upright style, this example does not appear to have been made from an adze and has saw marks on the back. In pre-metal days the rough nephrite block was ground and sawn with stone and sand abrasives. Webster (1948) illustrated many *hei tiki* and devised a typology according to form and head position.

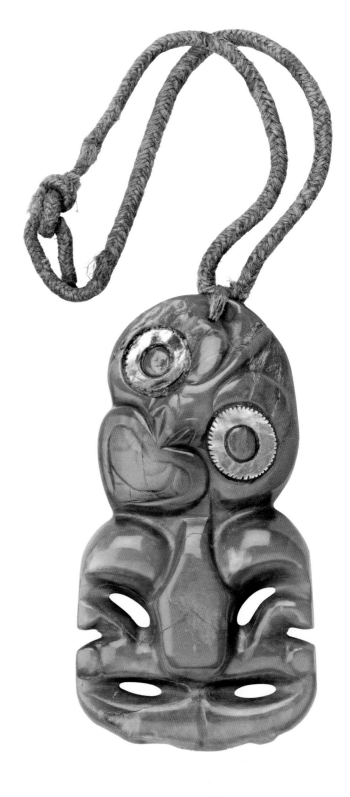

74 Hook-shaped neck pendant

New Zealand/Aotearoa

Eighteenth/early nineteenth centuries

Nephrite

H. 10.6 cm

Cambridge, CUMAA: Z6473

Acquired 1891 from George Brady; possibly ex. collection Revd Daniel Wheeler, a Quaker missionary whose travels were published (Wheeler 1842).

This hook pendant (*hei matau*) is carefully notched on its outside edge and is made from a beautifully coloured type of nephrite named *pipiwharauroa* after the speckled breast of a shining cuckoo (Mead 1984: 189, pl. 30). Notching was a way of marking items which were regarded as special or *tapu* in some contexts; it is regularly found on prehistoric stone and bone objects from New Zealand and elsewhere in Polynesia.

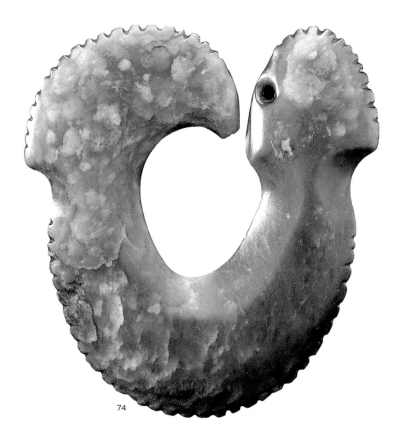

74

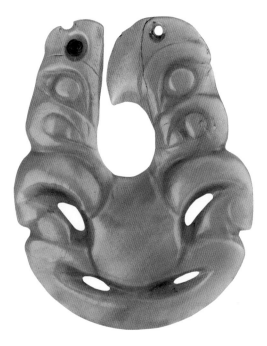

75 Neck pendant

New Zealand/Aotearoa, North Island

Late eighteenth/early nineteenth centuries

Nephrite, fibre

H. 8.5 cm

London, BM: 1896-925

Acquired 1896; given in 1834 to Captain F.W.R. Sadler by the Ngapuhi chief Titore.

A unique combination of *hei tiki* and hook pendant (*hei matau*), this ornament has a beautiful pale green colour. Unusually it has two suspension holes; a now detached short cord and bone toggle (not shown) may not be original. Nephrite (*pounamu*) from several remote western and southern parts of the South Island varied in colour and clarity depending on the source.

76 Pendant

New Zealand/Aotearoa

Eighteenth century or earlier

Nephrite, fibre

L. 14.2 cm

London, BM: 1920,3-17,2

Donated 1920 by Thomas Boynton; previous history not known.

A pale nephrite pendant which has an irregular, possibly humanoid shape found in ancient examples (Skinner 1974: 55). It has notching around the edge. Despite its size it is probably an ear pendant; Parkinson depicted a man at the Bay of Islands in 1769 wearing an ear pendant of this length (see above, p. 52).

77 Parrot leg ring

New Zealand/Aotearoa

Late eighteenth/early nineteenth centuries

Nephrite

H. 3.7 cm

London, BM: 1878,11-1,616

Purchased 1878 from Lieutenant-General Augustus Meyrick; most of the collection was formed by the antiquary Samuel Meyrick prior to 1827 (Starzecka 1998: 152).

A small circular pendant (*poria*) which was also used as a leg ring for captive parrots. An original hole has been broken through and another drilled. This redrilling after breakage can often be seen on old nephrite ornaments, indicating their enduring value.

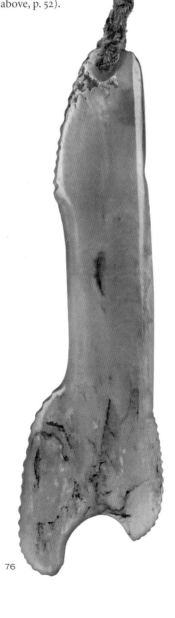

76

78 Gourd bowl

New Zealand/Aotearoa

Late eighteenth/early nineteenth centuries

Gourd

L. 33.0 cm

London, BM: 1977.Oc.8.5

Acquired 1977 at Christie's, London;
ex. collection James Hooper, no. 36; ex.
Penzance Natural History and Antiquarian
Society, 1947; possibly collected by William
Colenso, in New Zealand from 1834 onwards
(Phelps 1976: 40, 411).

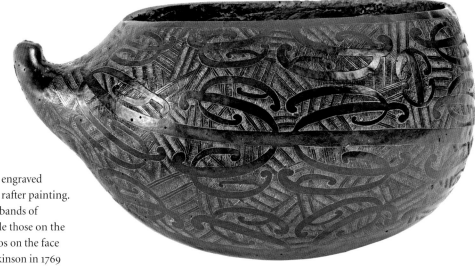

This finely preserved gourd bowl is covered in engraved
designs similar to those found on paddles and rafter painting.
The base of the bowl is left plain. The straight bands of
carving between the curvilinear forms resemble those on the
head of the weaving peg (no. 54) and the tattoos on the face
of the man drawn at the Bay of Islands by Parkinson in 1769
(see above, p. 52; Joppien and Smith 1985: 184–5).

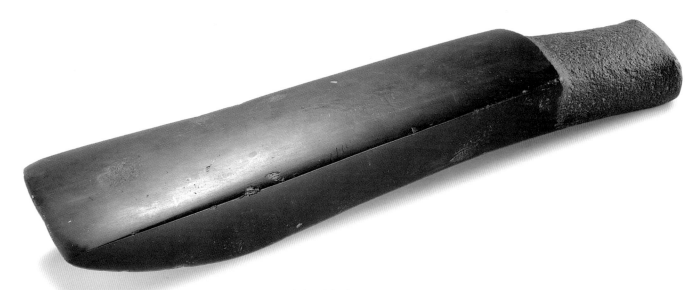

79 Adze blade

New Zealand/Aotearoa

c. fourteenth–sixteenth centuries

Stone

L. 42.6 cm

Edinburgh, NMS: A.1956.863

Donated 1956 by the Society of Antiquaries
of Scotland; acquired 1886 by the SAS.

This massive quadrangular-section adze
(*toki*) is a splendid example of the kind
of tool with which the early Maori carved

large canoes and other sculptures.
It would have been mounted on a
wooden handle not dissimilar to the
manner in which the Hawaiian adze
is hafted (no. 45). Large adzes have been
found in burials and had ritual as well
as technical importance, embodying
gods associated with carpenters and large
public works, such as canoe-building.
This aspect is discussed by Firth (1959)
in relation to adzes from Tikopia.

80 Cloak

New Zealand/Aotearoa

Late eighteenth century

Flax

W. 177.0 cm

Edinburgh, NMS: A.UC830

Acquired 1850s; ex. collection University of Edinburgh; listed in their catalogue in 1785; probably collected during one of Cook's voyages (Idiens 1982: 43).

This cloak (*kaitaka*) is a magnificent early example of the art of flax finger-weaving. The main body of the cloak is intentionally shaped with additional wefts to wrap more effectively around the body of the wearer. The lower and side borders are composed of panels of *taniko*, decorative borders of dyed flax with geometric designs. Cloak-making was the specialist task of women, and a cloak such as this will have been a great *taonga* (valuable), worn by people of high status. Several varieties of cloak were made in New Zealand during the eighteenth century, some with dog-skin and feather decoration. Examples covered with kiwi feathers became popular in the nineteenth century. Mead (1969) and Pendergrast (1987, 1998) have made comprehensive studies of Maori clothing.

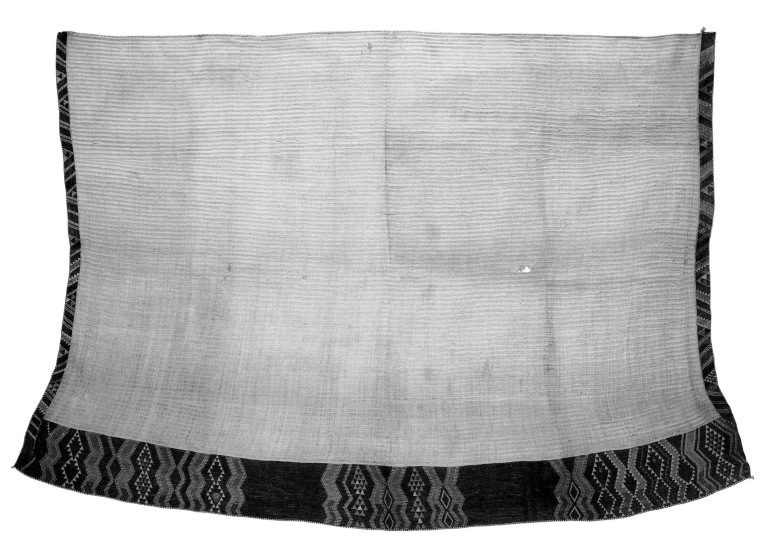

81 Man's belt
New Zealand/Aotearoa
Mid-eighteenth century
Flax
L. 198.0 cm (39.0 cm folded)
Cambridge, CUMAA: D1914.49
Deposited 1914; ex. collection Trinity College, Cambridge; donated 1771/5 by the Earl of Sandwich; collected during Cook's first or second voyage (Kaeppler 1978: 192; Tanner 1999: 26).

A plaited flax belt (*tatua*) with finely plaited ties at each end, coloured with red ochre, it is folded lengthwise and was worn as part of standard male dress in the eighteenth century. Belts were almost certainly made by women, paralleling a situation throughout Polynesia where women made men's clothing of barkcloth or matting.

82 Club
New Zealand/Aotearoa
Late eighteenth/early nineteenth centuries
Nephrite
L. 36.6 cm
London, BM: 1907,12-23,1
Acquired 1907 by Sir C.H. Read; previous history not known.

A rare nephrite club (*mere pounamu*) with a head carved at the butt, this example is made from an especially attractive piece of stone. Short clubs (generally known as *patu*) were both insignia of male warrior status and weapons. They were carried in the belt and had a short wristcord to prevent loss in combat. Nephrite was the most highly valued material in New Zealand, obtained from remote parts of the South Island. Raw stone and finished artefacts moved between groups via exchange relationships or as war trophies; objects made of nephrite were and are classified as great valuables (*taonga*).

83 Club
New Zealand/Aotearoa
Mid-eighteenth century
Wood
L. 39.1 cm
London, BM: NZ 91
Acquisition date not known; collected 1769 during Cook's first voyage; handwriting on label is that of Dr Daniel Solander, who sailed on the first voyage (King 1981: 16).

A unique form of plain spatulate club with a head carved on the butt. The rough square hole for the wrist cord indicates that a stone chisel was used to make it. The old label, 'Wood Bludgeons Otahaiti', shows the widespread error which was made in attributing artefacts to locations in the Pacific during this period. 'Otaheite' and variations approximating to Tahiti were widely used as catch-all terms for objects from many parts of Polynesia, including New Zealand.

84 Club
New Zealand/Aotearoa
Late eighteenth century
Wood
L. 36.5 cm
Newcastle, NEWHM: C636
Acquired 1822 by Newcastle Literary and Philosophical Society; ex. collection George Allan (d. 1800; see Jessop 2003).

A form of short waisted club called *kotiate*, this example has a very finely carved head on the butt and the letter 'F' engraved on one side, the significance of which is not known. Wood clubs of this type seem mainly to date from the eighteenth century; examples in whalebone continued to be made in the nineteenth century.

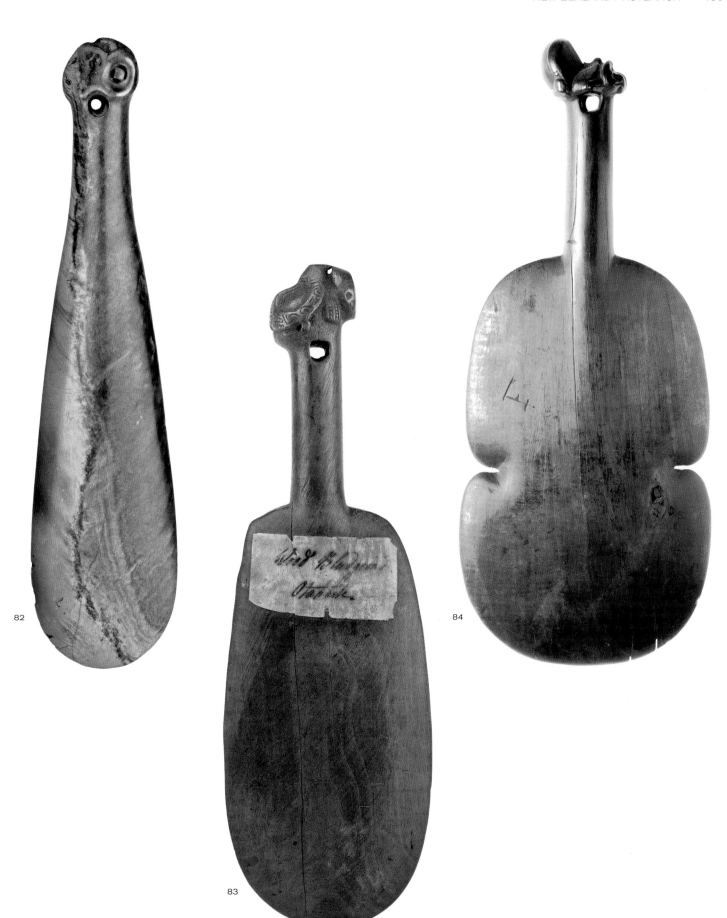

82

83

84

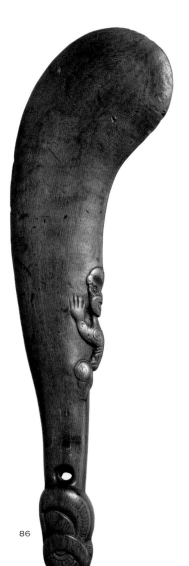

86 Club

New Zealand/Aotearoa

Late eighteenth/early nineteenth centuries

Wood

L. 38.0 cm

Oxford, PRM: 1884.12.282

Acquired 1884, Pitt Rivers founding collection; exhibited 1874–8 at Bethnal Green Museum.

Although without early provenace this club of the *wahaika* form has all the formal characteristics of an eighteenth-century piece. The female side figure is finely carved; the eyes probably once held haliotis shell discs. The wrist cord hole, biconically drilled and gouged from each side, shows no evidence of having been made with metal tools.

85

86

87

85 Club

New Zealand/Aotearoa

Eighteenth/early nineteenth centuries

Greywacke

L. 37.2 cm

Oxford, PRM: 1940.10.04

On loan since 1940 from Queen's College, Oxford; bequeathed 1841 to Queen's College by Revd Robert Mason; acquired by Mason 1822–39.

A simple stone *patu onewa* made of greywacke, a form of indurated sandstone, this club is smoothly and symmetrically finished with regular ridges across the butt. They were produced by grinding, abrading and polishing – the hole for a wrist cord being a particular technical challenge.

87 Club

New Zealand/Aotearoa

Eighteenth century

Whalebone

L. 38.5 cm

Oxford, PRM: 1886.1.1147

Acquired 1886; ex. Ashmolean Museum; donated 1776 by Johann Reinhold and George Forster to Oxford University; collected 1773–4 by the Forsters during Cook's second voyage (Coote *et al.* 2001).

A short club of whalebone (*patu paraoa*), this simple elegant form has ridges carved across the butt and a hole for a wrist cord. It is made from the spatulate section of a whale's jaw. In combat such weapons were for thrusting with the distal end, rather than cutting sideways.

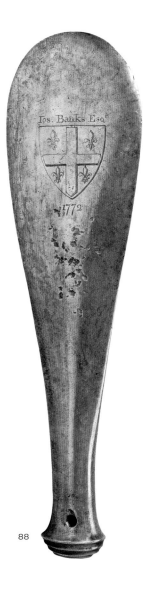

88

88 Replica New Zealand club

England

1772

Brass

L. 36.5 cm

Oxford, PRM: 1932.86.1

Donated 1979; ex. Royal Society collection; on loan since 1932; purchased by F. Ellis in Bristol 1908.

Forty of these replica Maori clubs were cast for Joseph Banks by Eleanor Gyles of London, though few can now be traced. They were engraved with the date and Banks's coat of arms by Thomas Orpin, and Banks intended to take them as presentation items on Cook's second voyage (Newell 2003: 252; 2005: 82–3; Coote 2004: 14). However, after a dispute over the accommodation on board ship for Banks's retinue and equipment, he did not sail. Captain Clerke later took some with him on Cook's third voyage, one of them eventually ending up in inland Oregon (Kaeppler 2005: 152). They are a testament to Banks's admiration for the form of the *patu onewa*, and also his appreciation of the importance of exchange.

89 Long staff/club

New Zealand/Aotearoa

Mid-eighteenth century

Wood, haliotis shell

L. 188.4 cm

Cambridge, CUMAA: D1914.61

Deposited 1914; ex. collection Trinity College, Cambridge; donated 1771/5 by the Earl of Sandwich; collected during Cook's first or second voyage (Kaeppler 1978: 192; Tanner 1999: 34).

This is possibly the earliest example of a *taiaha* quarterstaff to have been collected. The pointed end takes the form of a carved tongue projecting from an open mouth; the eyes of the head are inlaid with oval pieces of haliotis shell. Putting out the tongue was a ritualized challenge given by Maori warriors, and thus the form of the weapon is connected to one of its aggressive functions during combat.

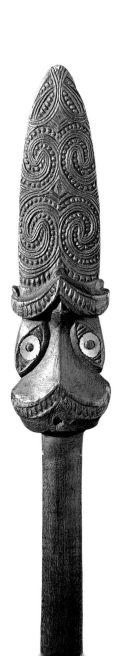

Easter Island / Rapa Nui

The most remote of all Polynesian islands, Easter Island was first settled around AD 700–900 by voyagers from central Polynesia or the Marquesas, probably by stages through the Tuamotus and Mangareva. To what extent there was periodic contact with other islands is unclear, but the remarkable large stone images which were made on the island have given rise to a number of theories about contacts and migrations, the most well-known being that of Thor Heyerdahl, who proposed an American origin

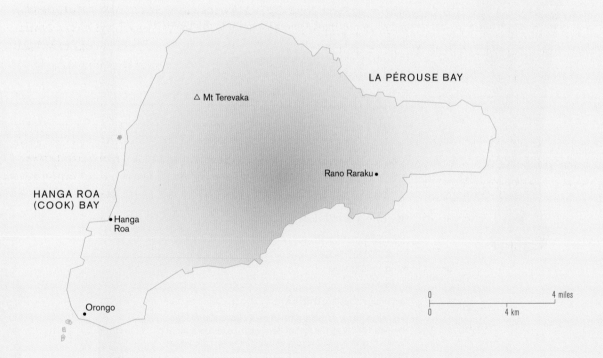

for Easter Islanders and many aspects of their culture. In an attempt to prove his theory he conducted archaeological research on the island in the 1950s with Edwin Ferdon, but he was never able to convince the academic community of the plausibility of his claims.

More recent archaeological research has shown that stone image-making, a Polynesian trait found elsewhere, developed over a period of centuries, with the largest images – some unfinished examples lying in quarries are over 15 m long – being made around the seventeenth century when image-making ceased. Some were made to be erected on *ahu* temple platforms, with separate reddish stone 'hats', others were set up in the landscape. They appear to have been connected to veneration for ancestors, and also to have been an aspect of competitive monument-building between different local groups. In the absence of metal they were laboriously chipped out of the solid rock with stone hand axes and hammers.

The Dutchman Jacob Roggeveen was the first European to visit the island, arriving on Easter Day, 1722, hence the name. The local name for the island was and has remained Rapa Nui (Great Rapa; there may be a remote historical connection with Rapa Iti, Small Rapa, in the Austral Islands). The Spaniard Gonzalez was next to call at Easter Island in 1770, followed by Cook during his second voyage in 1774 and La Pérouse in 1786. Most visitors during the first half of the nineteenth century were traders, many of them unscrupulous, who carried off as slaves large numbers of islanders to work on the guano islands off Peru. 1862 saw a major depredation of the already declining population, and those who returned later from South America brought smallpox with them. Catholic missionaries established themselves in 1866 and by 1868 most of the by then much diminished population was baptised. The island was annexed by Chile in 1888.

The main artistic legacy of the late eighteenth and first half of the nineteenth centuries is wood carving in the local species of mimosa, *toromiro*. Figures and dance paddles, seen during Cook's visit, developed stylistically during the following decades when metal tools allowed refined work. A variety of forms survive, several of which are included here. Kaeppler (2003) has undertaken a study of images, about which reliable information is scarce. It appears they were worn and danced with during rituals involving feasts. Kaeppler considers them to have been objectifications of prayers and intoned texts which gave permanent form to transient ritual activities. By the end of the nineteenth century large and clumsily carved figures were being made for sale to visitors.

Further information on Easter Island/Rapa Nui art and history may be found in: Kjellgren 2001; Van Tilburg 1992, 1994, 2004; Thomson 1891; Metraux 1940; Routledge 1919; Heyerdahl and Ferdon 1962, 1966; Heyerdahl 1976; Lee 1992; Fischer 1993, 2005.

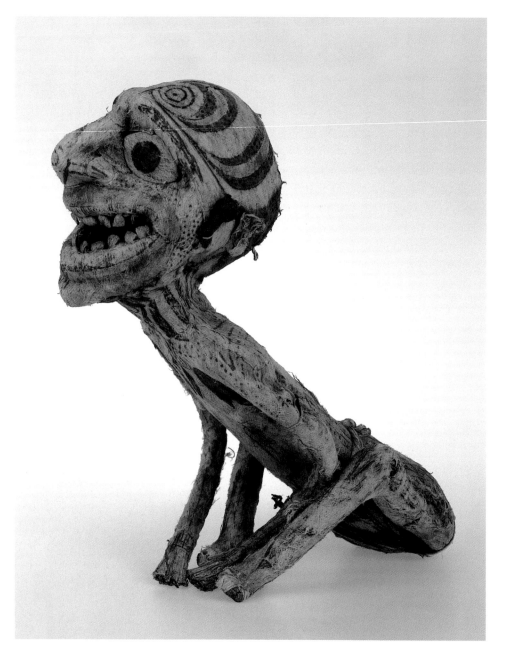

90 Seated figure

Easter Island/Rapa Nui

Early nineteenth century

Barkcloth, rushes, red cloth, fibre

H. 47.5 cm

Belfast, UM: 1910.41

Ex. Belfast Natural History and Philosophical Society, donated 1843; collected by Gordon Thomson while travelling in the Pacific 1836–40 (Glover 2001: 209).

A framework of folded rushes is covered in whitish barkcloth, painted in black designs with orange/red on the face and head. The figure has a plain barkcloth loincloth and the remains of a twisted cord tie through the back of the head, by which it was probably suspended. Coarse red European cloth is folded and stitched on to form ears; the teeth are barkcloth pads. Objects made of barkcloth from Easter Island are extremely rare and only two other figures of this kind exist, both in the Peabody Museum at Harvard (Kjellgren 2001: 58–60). Little is known of their use and significance, but the paper mulberry did not grow well on Easter Island and barkcloth was highly valued, especially that brought by visitors from Tahiti on European ships. Kaeppler (2001; 2003) has discussed the type most recently.

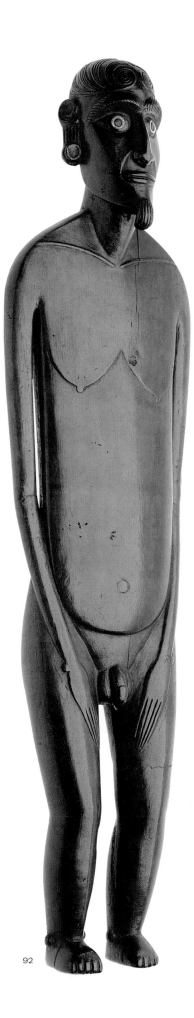

91 Standing male figure

Easter Island/Rapa Nui

Early/mid-nineteenth century

Wood, bone, obsidian

H. 45.0 cm

Edinburgh, NMS: A.1954.100

Donated 1954 by Irene Beasley; ex. collection
Harry Beasley, no. 3751, acquired 7 May 1935
in London (Idiens 1982: 25).

A finely carved male figure (*moai tangata*)
with ankle and wrist joints clearly marked,
it has a skin fold shown beneath the neck.
A ring is carved at the lumbar region and
three heads in low relief on top of the head
(partial because of a natural flaw in the
wood). The eyes are composed of bone rings
(probably fish) inset with obsidian discs.
There are traces of red pigment in the nostrils
and on the teeth.

92 Standing figure

Easter Island/Rapa Nui

Early/mid-nineteenth century

Wood, bone, obsidian

H. 67.5 cm

Belfast, UM: 149.1927

Donated 1927 by R.J. Evans; previous history not
known (Glover 1994: 45).

A large figure with hermaphrodite features:
the flat form and pendent breasts are usually
associated with female images (*moai papa*),
but this also has male genitals. The clavicles
and wrist and ankle bumps are clearly shown;
scrolling patterns are carved in relief on top
of the head. The eyes are composed of bone
rings (probably fish) inset with obsidian
discs. There is no suspension lug at the nape
of the neck. A pale patch on the left shoulder
blade is the site of an old label, now lost.

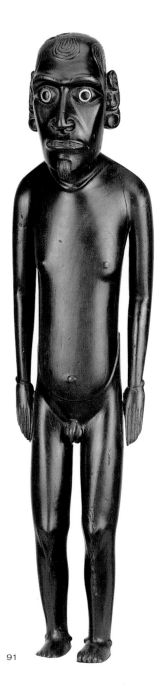

91

92

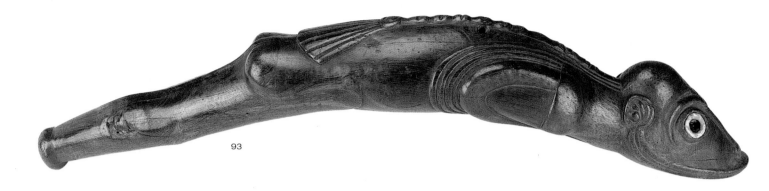

93

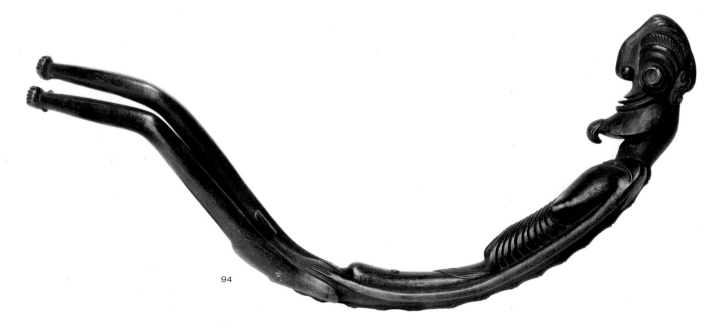

94

93 Man/lizard figure

Easter Island/Rapa Nui

Late eighteenth/mid-nineteenth centuries

Wood, bone, obsidian

L. 42.0 cm

Dublin, NMI: 1880.1603

Transferred 1880 from the Royal Dublin Society; donated by Arthur Huband (probably on 30 December 1853 as one of 'two idols'; Douglas Hyde 1978: 16).

This male figure (*moai moko*) has head and body characteristics which are usually considered lizard-like, particularly the large long mouth. The arms are contorted, with slender fingers reaching under the chin. Whether a lizard is intended in this sculpture is uncertain; it has a prominent spine ending in a fan-like form above the buttocks. The spine is also pierced in the centre for suspension; obsidian inlay is missing from the left eye.

94 Cadaverous male figure

Easter Island/Rapa Nui

Late eighteenth/early nineteenth centuries

Wood

L. 39.4 cm

Private collection

Acquired 1984 Christie's, New York; possibly collected in March 1774 on Easter Island by the Boraboran Hitihiti (Mahine) during Cook's second voyage (Attenborough 1990).

This slender curved male figure resembles an example possibly collected on Cook's second voyage, now in St Petersburg (Joppien and Smith 1985a: 264). This form may be the predecessor of the more upright and conventional form of cadaverous figure, but any art-historical sequencing remains speculative in the absence of secure data. This figure has finely carved features and fingers; the head is distinctive, with the bulbous eyes low behind the nostrils and a nine-tentacled cephalopod in low relief on the head. A small hole is cut between the body and the right arm, which would allow the figure to hang in balance, suggesting that it could have functioned as a chest pendant.

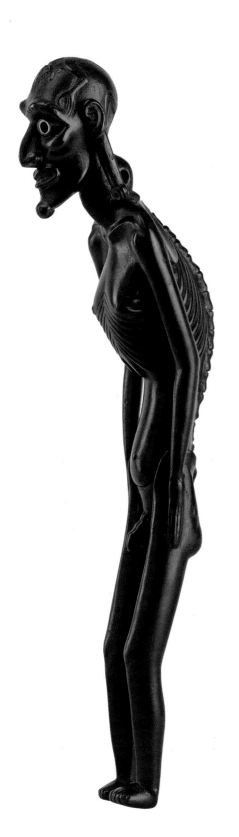

95 Cadaverous male figure

Easter Island/Rapa Nui

Late eighteenth/mid-nineteenth centuries

Wood, bone

H. 43.0 cm

London, BM: +2595

Acquired 1885; previous history not known.

This is a finely carved example of perhaps the
most well-known type of wooden image from
Easter Island called *moai kavakava*. The hips,
spine, upper body and head have cadaverous
characteristics which have given rise to much
speculation about emaciation and famine.
Polynesian sculpture does not generally attempt
naturalistic representations of the human form,
even though in the wood sculpture of
Mangareva and Easter Island there are stronger
elements of naturalistic representation. Rather
than emaciation, the figures may portray the
cadavers of deceased ancestors, manipulated
in secondary burial rites. This figure, as most
of this type, has a suspension lug carved at the
nape of the neck. On top of the head is a figure
in low relief with outstretched arms. There is red
ochre in the nostrils; obsidian inlay is missing
from both eyes.

96 Staff

Easter Island/Rapa Nui

Late eighteenth century

Wood, obsidian

L. 175.0 cm

Exeter, RAMM: E1216

Donated 1868 by James Vaughan; formerly in the
Leverian Museum, auctioned 1806; collected March
1774 during Cook's second voyage (Kaeppler 1978:
169).

This bifacial staff (*ua*) has obsidian inlay in the
eyes of both faces. Staffs served both as weapons
and as insignia of high status, but, as with
anthropomorphic weapons and staffs generally in
Polynesia, they could also be regarded as portable
god images, embodiments of ancestors who are
watchful over their descendants.

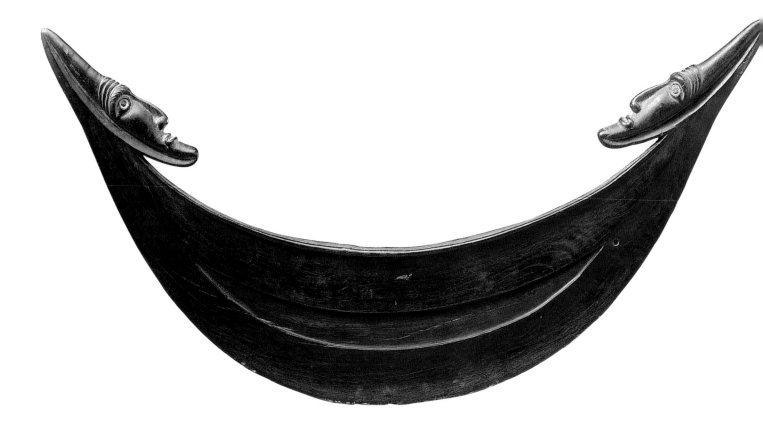

97 Gorget

Easter Island/Rapa Nui

Late eighteenth/mid-nineteenth centuries

Wood, bone, obsidian

W. 40.4 cm

Cambridge, CUMAA: 1920.801

Purchased 1920 by Baron Anatole von Hügel; previous history not known.

Gorgets (*rei miro*) were worn on the chest, suspended around the neck from two lugs on the upper edge of the back. The front has a crescent-shaped recess and a fine ridge along the upper edge. The heads, modelled more fully on the front than the back, have bone ring and obsidian eyes on the front. A crescentic line beneath the heads recalls rare gorgets which have the terminals carved in the form of shells. An anthropomorphic association with sea shells may be intended. The crescent gorget form is found elsewhere in Polynesia, notably the Society Islands *taumi* gorget (no. 141) and the wood breastplate of the Tahitian mourner's costume (no. 140).

98 Dance paddle

Easter Island/Rapa Nui

Late eighteenth/mid-nineteenth centuries

Wood

L. 81.8 cm

London, BM: +2600

Acquired 1885; previous history not known.

These bifacial anthropomorphic dance paddles (*rapa*) are carved from a single piece of *toromiro* wood (*Mimosa sp.*). A head with nose, brows and ears is discernible in the upper part, while the lower terminates in a phallic point. In this example the phallic terminal is a very carefully constructed replacement, socketed into the 'body' and secured with five small wooden pins. It is likely to be a European repair, though not done to deceive because the pins are clearly visible. In the twentieth century dance paddles became much admired among Modernists for the elegance of their sculptural form. A smaller example was collected on Cook's second voyage (Kaeppler 1978: 170, 285).

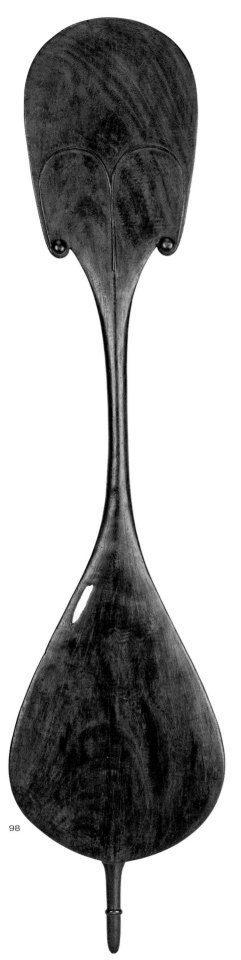

98

99 Headdress

Easter Island/Rapa Nui

Late eighteenth century

Feathers, rushes, fibre

W. 37.0 cm

Oxford, PRM: 1886.1.1528

Acquired 1886; ex. collection
Ashmolean Museum; donated
1776 by Johann Reinhold and
George Forster to Oxford
University; collected March 1774
by the Forsters during Cook's
second voyage (Kaeppler 1978:
160, 169; Coote *et al.* 2001).

This is a remarkably well-preserved example
of a rare headdress for which we have first-hand
information from the collectors, the Forsters,
father and son. Johann Reinhold observed in his
journal: 'Some of them wear a kind of round
ring plaited of a tough kind of Grass, with white
or sometimes with black Feathers of the Man of
warbird' (Forster 1982: III: 470). On 15 March
1774 they met a chief wearing 'a Diadem of black
shining Feathers' (ibid.: 472), which may well be
this one. The Man-o-War bird is another name
for the frigate bird, whose black plumes, wavy
when split down the centre, were used widely
in Polynesia. It is an aggressive bird whose
presence indicates shoals of fish and which
harries other seabirds into giving up caught fish.
The feathers here are secured with fibre to a
continuous six-band coil of rushes.

The Marquesas Islands

The earliest dates for settlement of the Marquesas Islands have recently been revised upwards to around AD 700–800 (Allen 2004). It is probable that after initial settlement there was periodic contact with nearby Polynesian groups such as the Tuamotus and Society Islands.

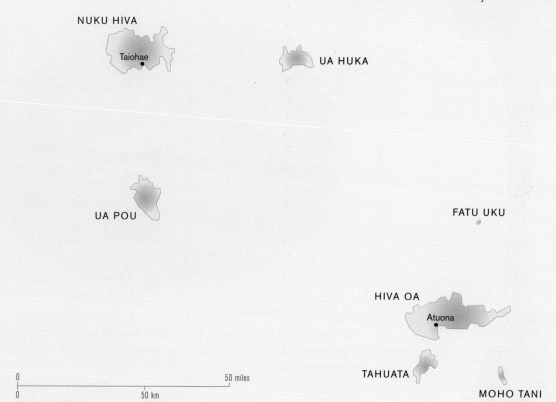

NUKU HIVA

Taiohae

UA HUKA

UA POU

FATU UKU

HIVA OA

Atuona

TAHUATA

MOHO TANI

0 50 miles
0 50 km

FATUIVA

The first European sighting of a major Polynesian group of islands took place in 1595 when the Spaniard Alvaro de Mendaña visited the southeastern group and named them Las Marquesas de Mendoza, after his patron the Viceroy of Peru. There was a violent encounter which cost the lives of some 200 Marquesans and the islands were not visited again until Cook arrived at Tahuata (Santa Christina) in 1774. The northwest group was not seen until 1791, when the American Ingraham and later the Frenchman Marchand arrived. In 1797 several members of the London Missionary Society were left at the Marquesas, but this first attempt to establish a mission was a failure. A good account of this period was written by the beachcomber Edward Robarts.

During the first part of the nineteenth century the islands were exploited by sandalwood traders who cut out the timber in a few years, as they did elsewhere. The Marquesas was also a favourite revictualling station for whalers. Whales' teeth, cloth, metal and muskets were the principal items traded for sandalwood and food supplies. Catholic missionaries arrived in the 1830s and in 1842 the islands were annexed by France along with other parts of French Polynesia. Herman Melville visited in the early 1840s aboard a whaler, the *Acushnet*. His first novel, *Typee* (1846) – a mixture of close observation and fantasy named after Taipi valley on Nuku Hiva – became a popular book.

The Marquesas are rugged mountainous islands without fringing reefs. The local stone was carved into large figures which were erected at *me'ae*, the local version of temple precincts known elsewhere as *marae*. This stonework is related to that found on Easter Island, the Australs and Society Islands. Whale ivory was scarce and highly valued, although after it was acquired in quantity during the first three decades of the nineteenth century demand for it was superseded by that for muskets and gunpowder. Europeans were struck by the wide variety of personal ornaments worn by men and women, using a range of land- and sea-derived materials – including feathers, wood, coir, barkcloth, pigs' tusks, whale ivory, shell and turtle shell. Extensive tattooing was also practised. Men received full-body tattoos administered by *tuhuna*, specialists who, as in New Zealand and elsewhere, performed a priest-like function. There was originally no local name for the whole group, but the islanders now refer to the Marquesas as Te Henua 'Enana or Te Fenua 'Enata, meaning 'the Land of the People' in the northern and southern dialects respectively.

Further information on Marquesas Islands art and history may be found in: Kjellgren and Ivory 2005; Thomas 1990; Von den Steinen 1925-28; Panoff 1995; Robarts 1974; Dening 1980; Linton 1923; Ottino-Garanger 1998.

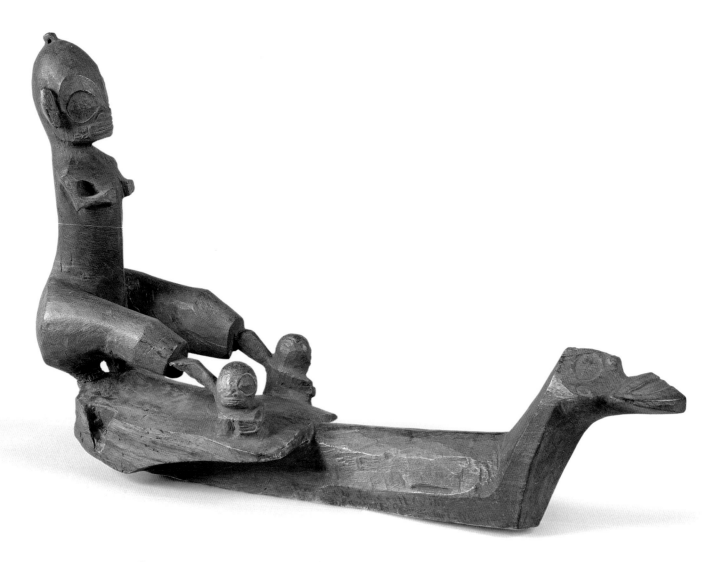

100 Canoe prow

Marquesas Islands, Fatuiva

Late eighteenth/mid-nineteenth centuries

Wood

L. 44.5 cm

Paisley, PMAG: 1941.6e

Donated 1941 by Louis Gow; previous history not known; a faded ink inscription on one side: 'April 1852 [or 1882]. Taken from I. of Magdalena, Pacific Ocean. Presented to J.S. Scott by the ... Commandant, Marquesas.'

This prow is similar in general form to the following example, but the upper body of the main figure is smaller and its legs are touched by an outstretched arm from each of the two smaller figures. The front projection is carved with a face and the head of the main figure has a single topknot, pierced laterally. The rear corners of the platform upon which the main figure sits have been broken off through the holes which were used for attachment. La Magdalena was the name given to the island of Fatuiva by Mendaña in 1595. If the inscription is reliable this style of figure sculpture may originate from that island. A similar example is in the Musée d'Ethnographie in Geneva (Musée de l'Homme 1972: no. 135).

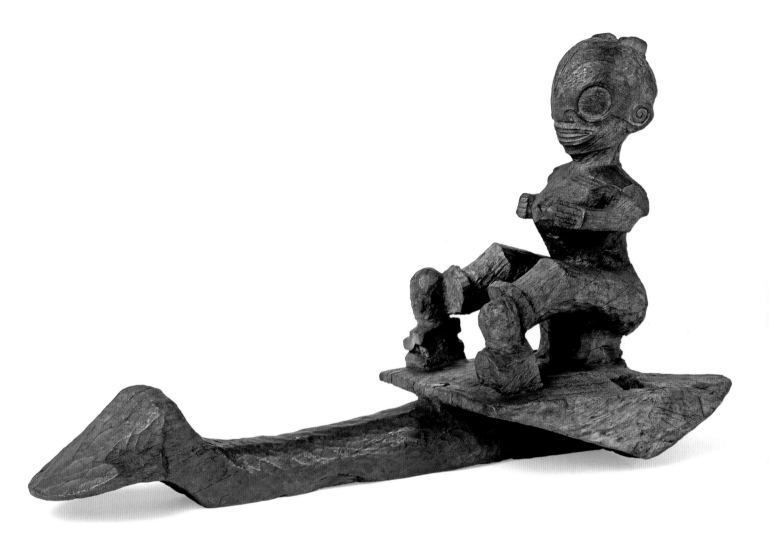

101 Canoe prow

Marquesas Islands

Early nineteenth century

Wood

L. 48.0 cm

London, BM: LMS 194

Ex. London Missionary Society
Collection; on loan 1890, purchased
1911.

This prow sculpture was fixed to the forepart of a canoe by means of two irregular square holes, one on either side of the figure's seat. The feet rest upon the heads of two squatting figures, one of which appears unfinished; there is some surface grooving to the chest and shoulders; the two projections on the head represent a male hairstyle. This prow resembles very closely another formerly in the collection of the Leeds Philosophical and Literary Society, acquired by them in 1858 (Phelps 1976: 98, 419).

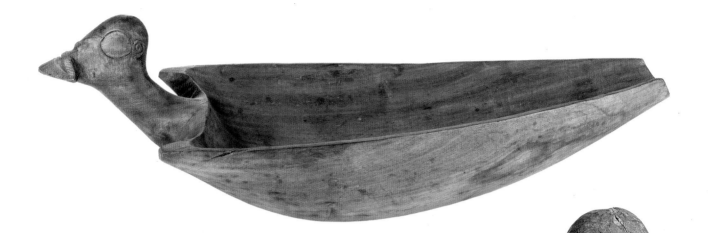

102 Bowl

Marquesas Islands

Early nineteenth century

Wood

L. 47.0 cm

London, BM: LMS 195

Ex. London Missionary Society Collection;
on loan 1890, purchased 1911.

The distinctive handle on this bowl has
a head with a wide crescentic mouth
reminiscent of the spatulate terminals on
canoe prows. The pouring spout is similar
to that found on bowls from the Society
and Austral Islands. The bowl may have
been used as a scoop, or more likely for
kava, the drink prepared from the roots
of the pepper bush *Piper methysticum*.
Any kava residue has gone due to heavy
cleaning in the past, leading to depatination;
it may once have been much darker.

103 Figure on post

Marquesas Islands, Nuku Hiva

Early nineteenth century

Wood

H. 50.2 cm

Norwich, SCVA: UEA 192

Robert and Lisa Sainsbury Collection,
acquired 1952 from John Hewett, who
acquired it from Kenneth Webster; ex.
collection Leeds Museum and Leeds
Philosophical and Literary Society, acquired
1881/2; collected by W.H. Eyres 'during a
voyage round the world' (Hooper 1997: II:
25); an ink inscription on the back of the
head: 'Nukahiva, Marquefas Island'.

This figure was probably fixed into
an altar-like platform by means of the
tapering post. This is reminiscent of
the form of the large stone image from
Ra'ivavae in the Austral Islands (no. 158).
In common with a range of Polynesian
images, this figure has one hand
extended and raised to the mouth,
a gesture of unknown significance.
The power of speech, when of divine
origin and channelled through chiefs,
priests and ancestors, may be associated
with this sculptural form.

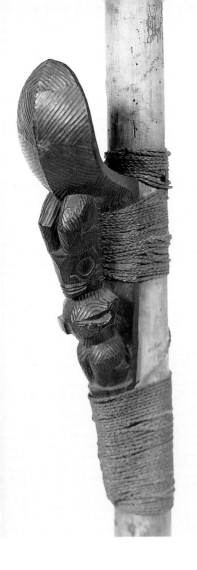

104 Stilt step
Marquesas Islands
Early nineteenth century
Wood, coir
H. 134.0 cm
Saffron Walden, SAFWM: 1835.262 (E88)
Donated 1835 by Richard Norris.

Among the earliest documented stilts from
the Marquesas, the step (*tapuvae*) of this
example has an unusual form with a pair of
legs above the head of the principal figure.
Stilt races and contests took place as
celebratory parts of mortuary rituals on
stone paved areas (Langsdorff 1813: I: 168–9).
The earliest record of a stilt appears in the
publication of Marchand's 1790–92 voyage
(Fleurieu 1801: pl. V). Steps detached from
stilt shafts are quite numerous; it is likely that,
being exotic, attractive and portable, they
were made during the early/middle decades
of the nineteenth century to supply a demand
from traders, whalers and other visitors.

105 Drum
Marquesas Islands
Early nineteenth century
Wood, barkcloth, coir, skin, fibre
H. 112.0 cm
Lille, MHN: 990.2.1141
Acquired 1850; ex. collection Alphonse Moillet
(Notter *et al.* 1997: 57–64).

An extremely rare example of a drum with full
wrapping and binding. Eleven vertical sheets of
plain barkcloth encase the chamber, with designs
formed by irregular 'weft' bindings of black and
brown/red plaited coir cords. A 'belt' and 'skirt'
consists of six vertical sheets of barkcloth. The eight
legs have coir bindings at the base and a retaining
wood hoop beneath the skirt, to which are bound
the hidden vertical cords attaching the fish-skin
tympanum. There is a hole between the chamber
and the hollowed base. The anthropomorphism
of the drum is evident here, encouraging the
hypothesis of seeing a drum as a sound-making god
image. A similar though partly decayed example is
illustrated by Panoff (1995: 124).

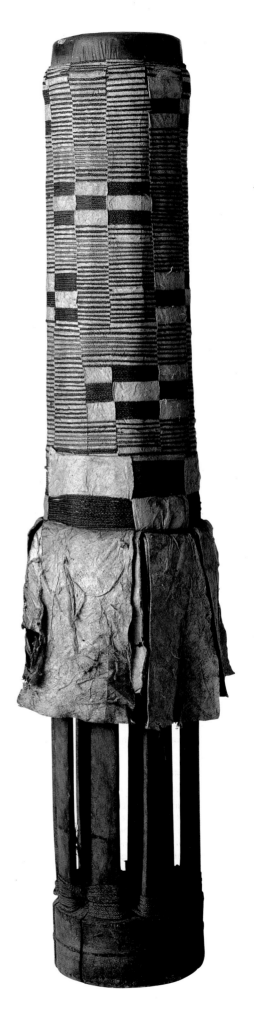

106 Head ornament

Marquesas Islands

Early/mid-nineteenth century

Turtle shell, triton shell, pearl shell, coir

L. 47.5 cm

London, BM: 1934-3

Purchased 1934 from Paul Nordmann, Paris.

Head ornaments of this kind (*pa'e kaha*) were worn, according to nineteenth-century sources, with the shell plates sloping downwards over the brow. The seven turtle-shell plates show a central figure in low relief, flanked by two smaller profile figures. Some examples have numerous small pearl-shell and turtle-shell discs on the outside of the headband, others have European shell buttons. A very similar ornament is illustrated in Kjellgren and Ivory (2005: 67).

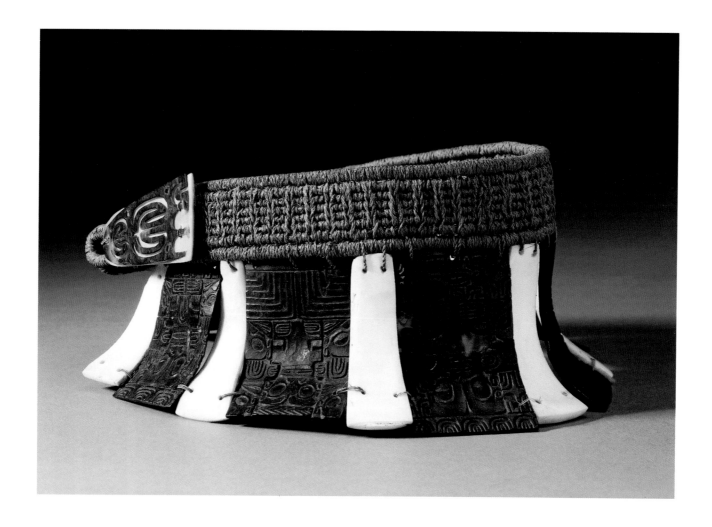

107

107 Neck pendant

Marquesas Islands, Tahuata

Mid-/late eighteenth century

Shell, barkcloth

L. 8.5 cm (pendant)

Oxford, PRM: 1886.1.1540

Acquired 1886; ex. collection Ashmolean Museum; donated 1776 by Johann Reinhold and George Forster to Oxford University; collected April 1774 by the Forsters during Cook's second voyage (Kaeppler 1978: 167; Coote *et al.* 2001).

Several shell pendants in the form of whale teeth were collected during the visit of Cook's ships (Hauser-Schäublin and Krüger 1998: 325). With virtually no fringing reefs, the Marquesas experienced few strandings of sperm whales, which occurred elsewhere in Polynesia. However, the importance of whale ivory is revealed in this skeuomorph – an object made from one material in the form of another. The shell is from the mouth of the helmet shell (*Cassidae*).

108 Breast ornament

Marquesas Islands

Late eighteenth/early nineteenth centuries

Wood, abrus seeds, fibre

W. 24.5 cm

Lille, MHN: 990.2.2692

Acquired 1850; ex. collection Alphonse Moillet (Notter *et al.* 1997: 57–64).

Breast pendants of this U-shaped form were seen at Tahuata during Cook's second voyage in April 1774 (Joppien and Smith 1985a: 206), but are rare in collections. They were not worn as a collar but on the chest. A base of whitened light wood (which in some examples is in sections) has hundreds of red and black abrus seeds gummed to the upper surface.

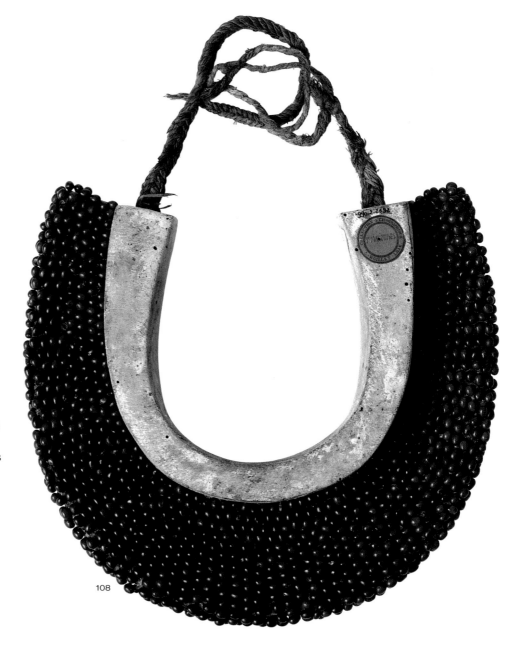

108

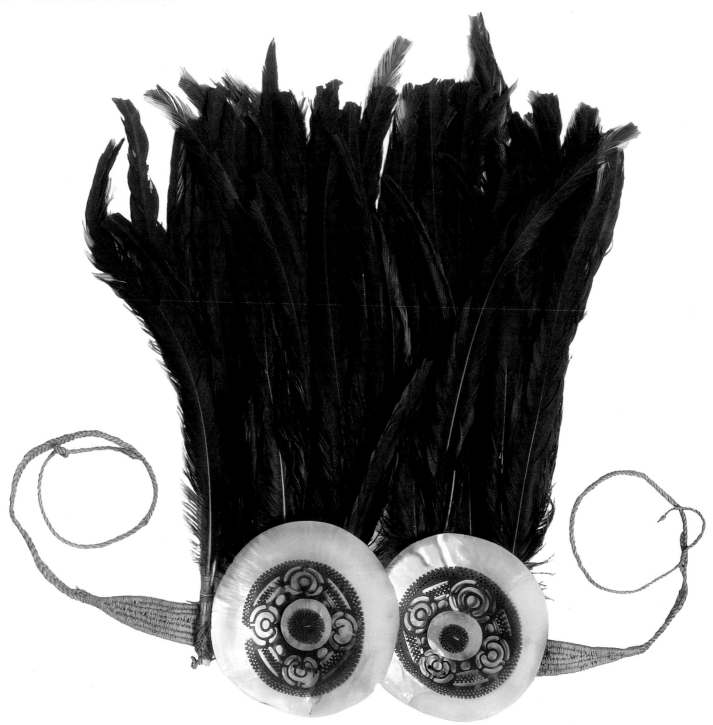

109 Headdress

Marquesas Islands, Tahuata

Mid-/late eighteenth century

Feathers, pearl shell, turtle shell, coir, fibre

H. 42.0 cm

Oxford, PRM: 1886.1.1340

Acquired 1886; ex. collection Ashmolean
Museum; donated 1776 by Johann Reinhold
and George Forster to Oxford University;
collected April 1774 by the Forsters during
Cook's second voyage (Kaeppler 1978: 165;
Coote *et al.* 2001).

This magnificent and finely preserved
headdress is composed of two pearl-shell
discs upon which are mounted two filigree
discs of turtle shell. The whole is fixed to a
headband of plaited coir, above which are
two clumps of black cock tail feathers.

This is almost certainly the example
depicted in the publication of Cook's
second voyage – the turtle-shell discs are
identical (see above, p. 53; Joppien and
Smith 1985a: 207; Cook 1777: pl. 17).
As Cook only called at Tahuata, it must
have been collected there.

110 Women's ear ornaments (pair)

Marquesas Islands

Early nineteenth century

Boar's tusk, conus shell, pith

L. 5.8 cm

Belfast, UM: 1910.309b

Ex. Belfast Natural History and Philosophical Society, donated 1843; collected by Gordon Thomson while travelling in the Pacific 1836–40 (Glover 1994: 35).

These delicately carved ear ornaments (*pu taiana*) were worn through the earlobe with the pith-lined conus-shell cap forwards and the figures to the outside. Each shaft has a vertical hole for a pin to hold the ornament snug to the earlobe. Often referred to as made from whale ivory or bone, close inspection of these ornaments usually shows them to have been made from boar's tusk, which has a shiny white outer 'skin', visible in places on these shafts. Larger and more elaborate examples were made from imported whale ivory.

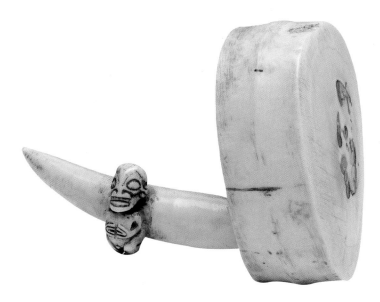

111 Man's ear ornament

Marquesas Islands

Early nineteenth century

Whale ivory, wood

L. 11.1 cm

Private collection

Ex. collection James Hooper, no. 405; acquired 1947 or 1951 from Kenneth Webster (Phelps 1976: 101, 419).

The arrival of whalers in Pacific waters at the end of the eighteenth century resulted in the trade of sperm-whale teeth to Marquesans, among whom it was highly valued. This allowed the development of chiefly regalia, such as large ivory ear ornaments (*hakakai*) for men. Another type was made of whitened wood. This example is in two parts – a spur with a tiny male figure is inserted into an oval fluted disc and secured with a hardwood pin. This ornament would have been for the right ear, with the disc facing forwards and the figure facing outwards. A vertical hole through the base of the spur is for a pin to keep the disc snug against the earlobe.

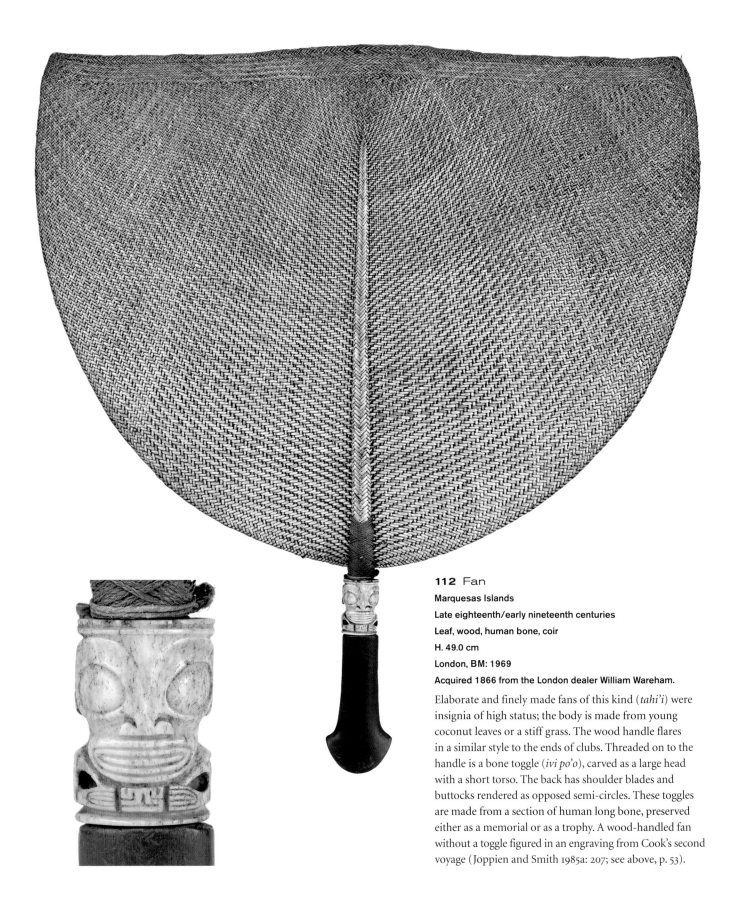

112 Fan

Marquesas Islands

Late eighteenth/early nineteenth centuries

Leaf, wood, human bone, coir

H. 49.0 cm

London, BM: 1969

Acquired 1866 from the London dealer William Wareham.

Elaborate and finely made fans of this kind (*tahi'i*) were insignia of high status; the body is made from young coconut leaves or a stiff grass. The wood handle flares in a similar style to the ends of clubs. Threaded on to the handle is a bone toggle (*ivi po'o*), carved as a large head with a short torso. The back has shoulder blades and buttocks rendered as opposed semi-circles. These toggles are made from a section of human long bone, preserved either as a memorial or as a trophy. A wood-handled fan without a toggle figured in an engraving from Cook's second voyage (Joppien and Smith 1985a: 207; see above, p. 53).

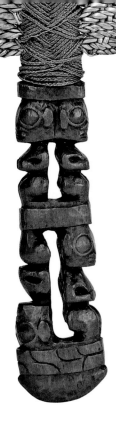

113 Fan

Marquesas Islands

Early nineteenth century

Leaf, wood, coir

H. 42.0 cm

London, BM: LMS 199

Ex. London Missionary Society Collection; on loan 1890, purchased 1911.

This fan (*tahi'i*) has the more usual style of handle with two pairs of superposed figures. Interestingly, and for an unknown reason, one of the figures is carved upside down. Such a composition is likely to be intentional, rather than an absent-minded carver's error. Fan-making was a specialist craft on Tahuata, although they were used in all the islands of the group.

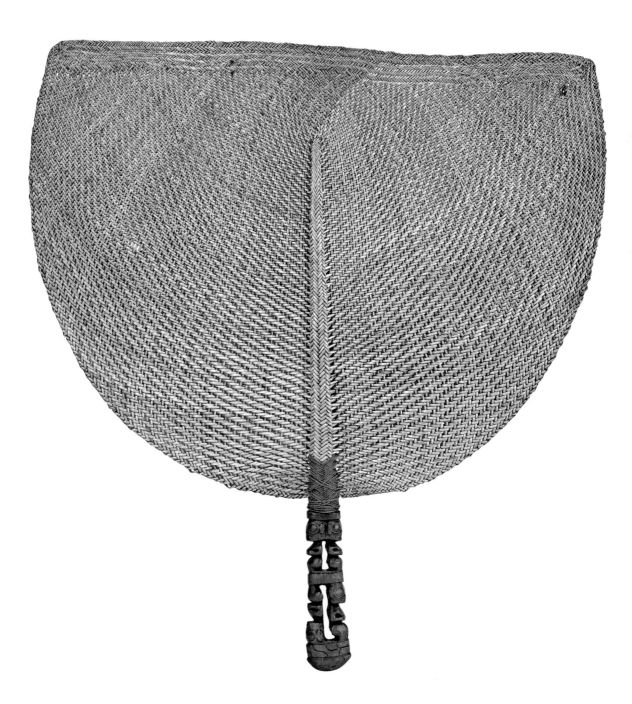

114 Shell trumpet

Marquesas Islands

Late eighteenth/early nineteenth centuries

Triton shell, human hair, bone, coir, gum

L. 37.5 cm

Cambridge, CUMAA: 1922.1166

Donated 1922 by Louis C.G. Clarke; possibly from the Widdicombe House collection (also acquired by Clarke in 1922), and of Cook second-voyage provenance.

This side-blown triton-shell trumpet (*putoka*) is in exceptional condition, missing only the wood mouthpiece which was formerly gummed to the circular aperture. A bone toggle (*ivi po'o*) secures a large bunch of human-hair tassels (see the Porter engraving of Mouina, p. 39). The hair may have functioned as a muffle, as well as a sacrificial memorial to a deceased relative – hair being cut off as a sign of mourning. Trumpets were used to summon, to signal and to mark specific ritual time periods. In eastern Fiji, now as in the past, triton-shell trumpets are sounded continually during the taboo mourning period for high chiefs, when normal keening is not permitted.

115 Sling and toggle

Marquesas Islands

Late eighteenth/early nineteenth centuries

Coir, bone, seed, hair

L. 263.0 cm; bone toggle H. 3.4 cm

Edinburgh, NMS: A.UC353

Acquired 1850s; ex. collection University of Edinburgh; previous history not known.

This sling has a beautifully plaited oval panel for the slingstone and a finely carved bone toggle (*ivi po'o*) with dog-hair tassels at one end. A black seed secures the cord above the toggle. It very closely resembles a Cook voyage example in the British Museum (Kaeppler 1978: 167–8).

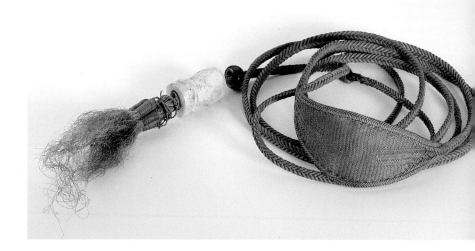

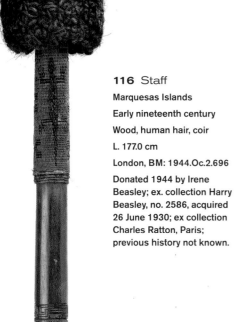

116 Staff

Marquesas Islands

Early nineteenth century

Wood, human hair, coir

L. 177.0 cm

London, BM: 1944.Oc.2.696

Donated 1944 by Irene Beasley; ex. collection Harry Beasley, no. 2586, acquired 26 June 1930; ex collection Charles Ratton, Paris; previous history not known.

Staffs with hair pommels (*tokotoko pio'o*) are not rare in collections, but this example has three pairs of figures carved at intervals down the upper part of the shaft, the central pair rotated at 90 degrees to the other two. Each pair also has a face carved to the side of their legs. The coir and hair sleeve binding reveals two lizards and several quatrefoil designs, one recognizably a figure. Human hair on artefacts is usually that cut off by relatives as a sign of mourning for a deceased elder, the sacrificed hair then serving as an artefactual memorial and sign of appropriate respect.

117 Club

Marquesas Islands

Late eighteenth/early nineteenth centuries

Wood, coir, hair

L. 138.5 cm

London, BM: 1920,3-17,1

Donated 1920 by Thomas Boynton; previous history not known.

A fine and complete example of a type of bifacial club (*'u'u*) that was collected in relatively large numbers in the first half of the nineteenth century – some two hundred survive. They appear to have been the standard weapon and staff of warriors. The form was recorded during Cook's second-voyage visit and nineteenth-century engravings often show them (Porter 1815: II: fp. 32; see above, p. 39). Both sides of the clubhead are carved similarly, with minor differences, showing a series of faces of different kinds looking in all directions. Gell (1998: 191) argues that these designs, on human bodies as tattoo, or on objects, represent *atua* (gods) in a tutelary and watchful guardian mode. The club is made from tough and heavy ironwood (*Casuarina equisetifolia*), called *toa*, also the name for warrior. The rich dark patina was achieved by steeping the club in taro swamps and by polishing with coconut oil.

116

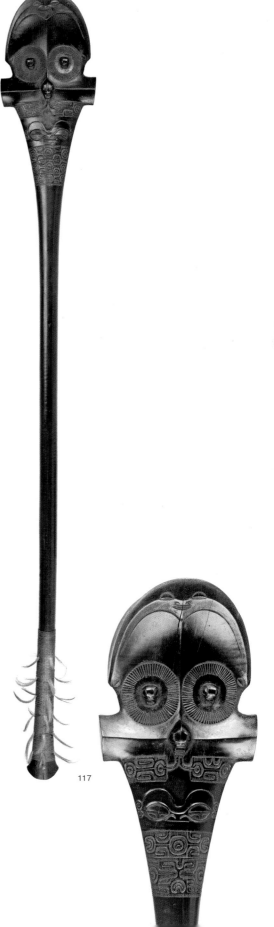

117

Mangareva and Tuamotu Islands

Mangareva is the principal island of a small and remote volcanic group called the Gambier Islands, named in 1797 by Captain Wilson of the *Duff* after Captain James Gambier, a supporter of Wilson's London Missionary Society expedition. Although linked here with the Tuamotu Islands, Mangarevan culture of the early nineteenth century was distinct, with affinities culturally to

NAPUKA

TAKAPOTO

RANGIROA

FANGATAU

RAROIA

FAKARAVA

TUAMOTU ARCHIPELAGO

MARUTEA

TATAKOTO

ANAA

ME'ETIA

TAHITI

RAVAHERE

HAO

VAHITAHI

NUKUTAVAKE

MURUROA

TUBUAI

MANGAREVA

RA'IVAVAE

GAMBIER ISLANDS

0	300 miles
0	500 km

the inhabitants of the Marquesas. The earliest archaeological evidence gives a settlement date of *c*. AD 1100, but human occupation may well have been earlier, colonists coming from the Tuamotus or Marquesas. As was the case for Easter Island, there seems to have been significant environmental degradation as a result of population pressure on local resources. The first significant European visit was by HMS *Blossom* in 1825–6, when Frederick Beechey and Edward Belcher made detailed observations (Beechey 1831). Father Honoré Laval and other Catholic missionaries arrived in 1834 and swiftly set about the destruction of indigenous culture, effectively setting up a theocracy under Laval. The few objects which remain from this period of iconoclasm testify to a thriving tradition of wood sculpture. As elsewhere in Polynesia, the local population suffered a severe decline in the nineteenth century as a result of introduced diseases.

The Tuamotu Islands, with Mangareva now part of French Polynesia, number dozens of atolls stretching more than 1,000 miles in a northwesterly direction from Mangareva. Those islands in the north and centre of the group were most densely settled – their proximity to the Society Islands and the Marquesas in a favourable sailing direction suggests that they will have been visited not long after settlement of those groups in the second half of the first millennium AD. The resources of the Tuamotus are limited, but fish were in abundance, as was pearl shell, which was a highly valued material in the adjacent Marquesas, Society and Austral Islands. In the eighteenth century the Tuamotuans, who were skilled navigators, were in regular contact with Tahiti and other Society Islands, supplying shells and specialist canoe builders. Scarcity of wood led to the development of a sophisticated technique of canoe assembly involving tied planks (see no. 121). It is likely that the builders of the magnificent *pahi* keeled double canoes in the Society Islands were Tuamotuan carpenters. Since the voyage of Magellan in 1521 European ships had entered the Tuamotus but seldom lingered as the waters were dangerous. Robertson (1948) left an account of the visit of the *Dolphin* to Nukutavake and other islands in 1767. In the early nineteenth century the lure of pearls brought European traders to what were then called the Low Islands or the Paumotus. This latter name, deriving from the Tahitian for 'conquered islands', was replaced in the 1850s by Tuamotu, meaning 'islands out in the ocean'.

Further information on Mangareva and Tuamotu Islands art and history may be found in: Buck 1938; Emory 1934, 1939, 1947, 1975; Stimson 1933; Robertson 1948; Beechey 1831.

118 Figure

Mangareva

Late eighteenth/early nineteenth centuries

Wood

H. 115.0 cm

London, BM: LMS 99

Ex. London Missionary Society Collection; on loan 1890, purchased 1911.

This impressive figure in heavy wood is one of few which survived the iconoclasm of the conversion period on Mangareva in the mid-1830s. Several were sent back to Europe by Father Caret with a numbered list that has helped identify them (Buck 1938: 460–67; 1939). This figure is not among them, having been acquired by the LMS. The forearms are broken, possibly as a result of casual attempts to move it, which may account for similar damage to other examples. The left upper side of the head has a carefully made replacement panel of the same wood, pegged in with wood dowels, probably made to cover a flaw in the original block. Little is known of the role in indigenous religion of figures of this kind, but in a temple in 1826 Belcher saw a platform 'elevated about three feet from the ground; in the centre of which was an idol three feet high, neatly carved and polished; the eyebrows were sculptured but not the eyes' (Beechey 1831: I: 122–3). Belcher also noted that it had a turban of barkcloth and was surrounded by offerings.

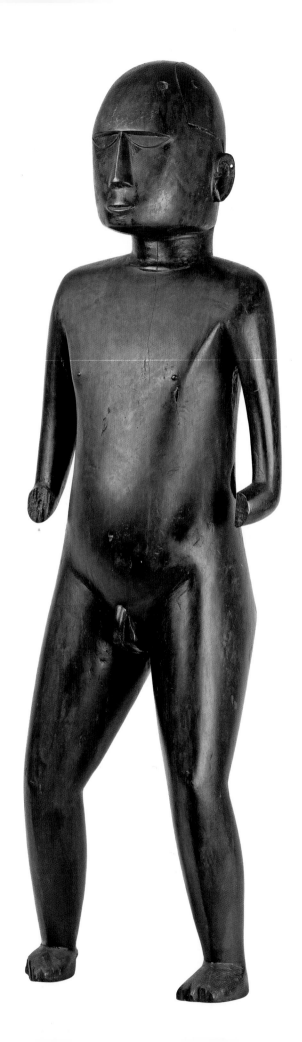

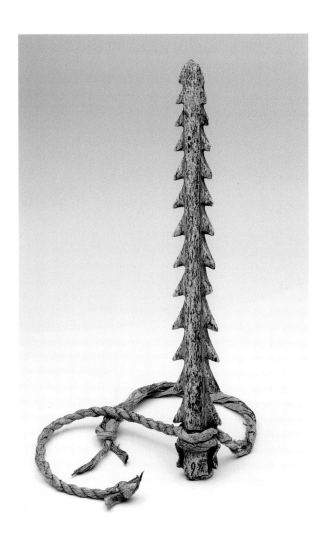

119 Spear head

Mangareva

Early nineteenth century

Whalebone, barkcloth

L. 27.3 cm (excl. cord)

Private Collection

Ex. collection James Hooper, no. 921 (Phelps 1976: 205, 208); ex. collection Leeds Philosophical and Literary Society, no. 46: 'Head of war spear of sperm whale jawbone. George Bennet, 1831–2'; collected 1821–4 by George Bennet of the LMS.

This spear head is of a type distinctive to Mangareva – several were collected there by Beechey in 1825–6 (Buck 1938: 190–91). However, George Bennet did not visit Mangareva so must have obtained this object elsewhere. It has a twisted barkcloth cord which is unlikely to be the binding for a spear; it may have been worn as an ornament and used as an exchange valuable. Beechey (1831: I: 143) observed that spear heads were removed from their shafts when not required. The form of the flange, broken here, resembles that on detachable spear heads from the Austral Islands (no. 166).

120 Fish hook

Tuamotu Islands, Fangatau or Napuka

Early nineteenth century

Pearl shell, fibre, bristles

L. 13.2 cm (excl. cord)

London, BM: TAH 148

Donated by Hugh Cuming, a naturalist who travelled to Polynesia in 1827–8.

An elegant trolling lure or spinner, this hook was not used with bait but towed behind a fast-moving canoe. It has a distinctive form located to Fangatau and Napuka in the north central Tuamotus (Emory 1975: 211–12). Short bristles or hairs are tied crosswise across the end of the shank to cause turbulence and attract predatory fish.

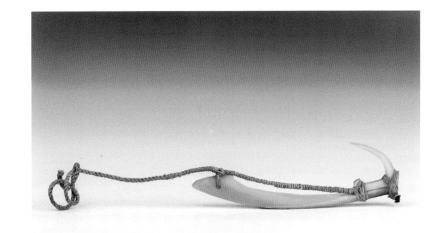

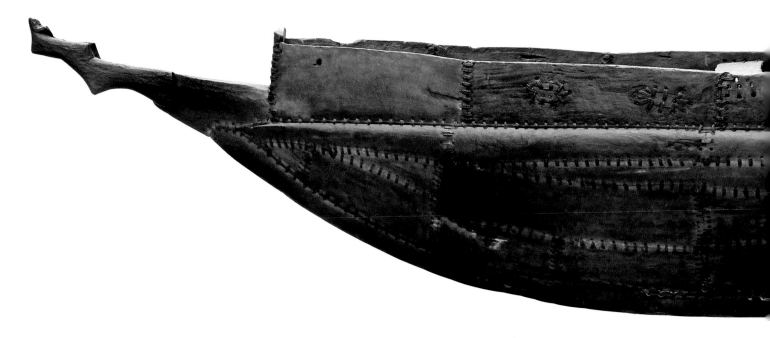

121 Canoe

Tuamotu Islands, Nukutavake

Mid-eighteenth century

Wood, coir, coconut leaf midrib, fibre

L. 387.0 cm

London, BM: 1771,5-31,1

Donated 1771 by the Lords of the Admiralty; collected at Nukutavake on 8–9 June 1767 by Captain Samuel Wallis during the voyage of HMS *Dolphin*, though no account of its acquisition was given by either Robertson (1948) or Wallis (Hawkesworth 1773: vol. I).

This is one of the earliest documented surviving artefact collected from Polynesia (see above, pp. 22–4). It is in astonishingly good condition considering its long voyage to England lashed to the deck of the *Dolphin*. The hull is composed of forty-five wood sections bound together with continuous lengths of plaited coir cordage covering battens of split coconut leaf midrib. There is a pointed prow, a broken stern and a single plank seat amidships. There is no step for a mast, and it is likely to have been an outrigger paddling canoe, as suggested by Hornell, who gives an exhaustive account of its construction (1936: 63–8). Missing are the head rails, which would have reached from the gunwales on each side to the ends of the prow and stern, as shown in Emory (1975: 166). No commentator has remarked on the broken figure, whose flattened legs are carved on either side of the stern. Sheared off at the waist, the figure would have faced into the canoe. This may have been a local break, or the result of the canoe being upside down on the *Dolphin*'s deck. Grooves on the port gunwale – burn marks from fishermen's hand lines – testify to the canoe's former successful use.

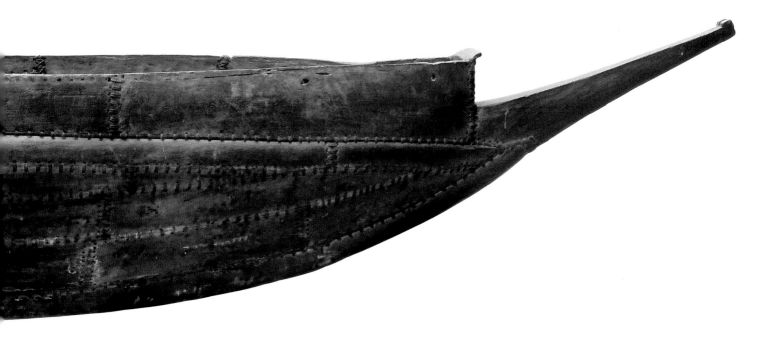

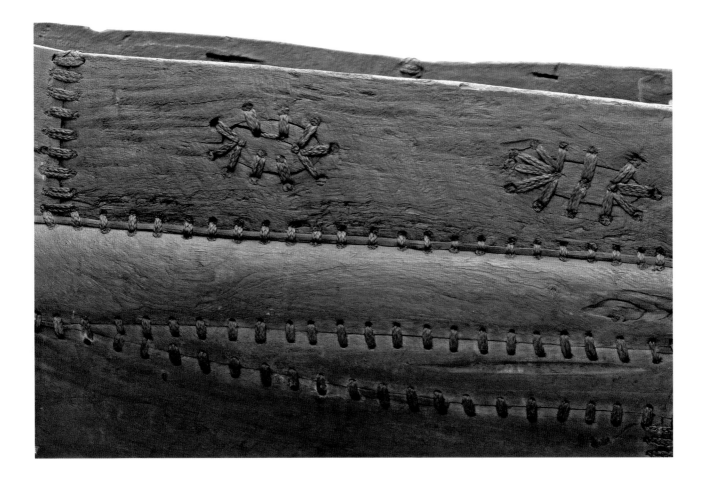

The Society Islands

It remains unclear when the Society Islands were first settled by early Polynesians moving eastwards from Western Polynesia, although it is likely to have been around AD 600–800. Prevailing southeast trade winds would have pushed voyagers northeast towards the Marquesas but, as Irwin (1992) has shown, voyagers will have waited for periodic westerlies to assist their eastward probings, knowing they could return once the trade winds returned. After settlement the Societies are likely to have become a crossroads for population movements in Polynesia. The excavation of whale-ivory pendants at Maupiti, similar to examples found in New Zealand and the Marquesas, point to early links, as does the discovery of a flat whalebone club at Huahine, dating

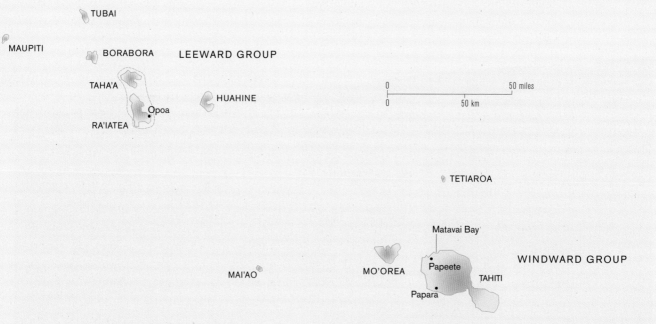

to *c.* AD 1000 (Sinoto and McCoy 1975), which has related forms among eighteenth-century New Zealand and Hawaiian clubs and scarifiers. Short hand clubs ceased to be used in the Society Islands some time before the eighteenth century.

The Society Islands are composed of two main groups, referred to as the Windward (east) and Leeward (west) Islands, some 100 miles apart. Tahiti, the principal island of the Windward group, has become synonymous with the group and in the nineteenth century became the centre of government. Ra'iatea in the Leeward group is the location of Taputapuatea, one of the great temple sites and ritual centres in Polynesia. As a kind of spiritual homeland, it is to Taputapuatea that modern voyagers from all over Polynesia have come on reconstructed canoes for dedication ceremonies, such as that in 1995 (Finney 2003). In the eighteenth century Ra'iatea was the centre of a developing religious cult linked to the deity 'Oro, which was becoming influential in the Windward group when Wallis (1767), Bougainville (1768) and Cook (1769) arrived. Cook, encouraged by Banks, took on board at Tahiti a Ra'iatean priest named Tupaia, whose linguistic and navigational skills proved of great value on the first voyage before his death at Batavia in 1770.

Maupiti and Borabora had been sighted by Roggeveen in 1722, but the visit to Tahiti by Wallis was the first substantial European contact – by turns cordial, violent and cordial again (Robertson 1948). Wallis named Tahiti George the Third's Island. Cook named the Leeward group the Society Islands because of their contiguity (not in honour of the Royal Society, see Beaglehole 1955: 151), and this name is now used for the entire group.

Cook visited the Society Islands on all three voyages, and many other visitors followed before the end of the eighteenth century – French, Spanish and British – including Bligh (twice) and Vancouver. A Tahitian chief, Tu (later called Pomare), nurtured his relationship with European visitors and began to extend his power throughout the group, eventually establishing a dynasty which 'ruled' the Society Islands for much of the nineteenth century. Pomare and his son cultivated an alliance with missionaries of the London Missionary Society, eighteen of whom arrived in the *Duff* in 1797 (eleven of them departed in 1798). After intense local warfare Pomare II, who had been supported by the missionaries, converted to Christianity and was finally baptised in 1819. He had previously renounced his 'idols' and given them over to the LMS (fig. 33). Catholic missionaries made an unsuccessful attempt to establish themselves on Tahiti in the 1830s, but in 1842 the Society Islands were claimed by France in the face of British opposition – a situation ultimately recognized in 1847.

Both before and after European arrival in the 1760s the Society Islands were a dynamic place of developing religious cults, chiefly rivalry and population movements. This makes confident attribution of objects to any particular place difficult. Island styles within the group have not been established, if indeed such styles existed. The importation of objects from the Australs and elsewhere, and of specialist carpenters from the Tuamotus, makes the notion of a Society Islands style problematic. Certain objects, such as no. 137, appear to embody several techniques and styles, making it almost impossible to give them a provenance other than central Polynesia. Formal analysis of all extant figure sculpture remains to be done.

Further information on Society Islands art and history may be found in: Oliver 1974, 1988; Henry 1928; Ellis 1829; Williams 1837; Montgomery 1831; Newbury 1980; Davies 1961; Handy 1930, 1932; Lavondès 1968; Barrow 1979; Corney 1913, 1915, 1919.

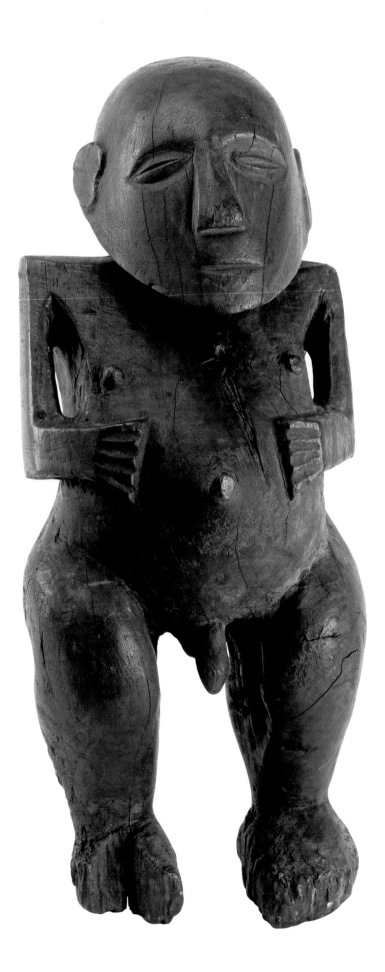

122 Standing figure

Society Islands, Tahiti

Late eighteenth/early nineteenth centuries

Wood, nails

H. 52.5 cm

London, BM: 7047

Acquired 1871 from Sheffield Literary and Philosophical Society; collected 1821–4 by George Bennet of the LMS.

This large male figure may formerly have been fixed to a post or to a canoe prow or stern. It exhibits sculptural features of Tahiti or Society Islands style: squared shoulders, concave back, protruding abdomen and bulky legs. Single figures are sometimes referred to as sorcery figures, but the precise meaning of such a designation is unclear, since propitiating an image for religious purposes may not involve sorcery (the use of images/materials to harm people). There are old nails and square nail holes in the buttocks and left knee. Associated with the figure is a much decayed 'costume' of fine matting, barkcloth and feather ornaments. The figure has been transformed into a missionary trophy by faded black ink inscriptions (probably in Bennet's hand) written on the back, across its cheeks and on its forehead. On the back can be made out: 'Ti'i Tane [male figure or figure of Tane] Orofena ... Tahiti'.

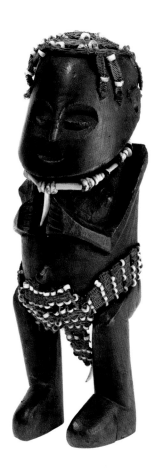

123 Figure with Tongan dress

Society Islands

Late eighteenth century

Wood, coir, shell beads, tooth, feather, nails

H. 21.0 cm

London, BM: TAH 63

Acquisition date not known, but registered with material of known eighteenth-century provenance.

This female image, in Society Islands style, is remarkable for the Tongan coir basketry and necklace with which it is decorated. Red feathers were highly valued in the Society Islands; when Cook's ships arrived there on the second and third voyages, the Tongan feathered basketry they had on board was greatly coveted. It is likely that the basketry on this figure derives from that time – one small red feather remains on the cap. The figure's effectiveness was enhanced by the addition of two powerful exotic materials – feathered basketry and the small iron nails with which it is fixed to the head and waist. A vulva is clearly indicated beneath the apron.

124 Standing figure

Society Islands

Mid-eighteenth century

Wood

H. 30.0 cm

Oxford, PRM: 1886.1.1424

Acquired 1886; ex. Ashmolean Museum; donated 1776 by Johann Reinhold and George Forster to Oxford University; collected by the Forsters in 1773–4 during Cook's second voyage (Kaeppler 1978: 136; Coote *et al.* 2001).

A female figure in very heavy wood, it has an asymmetrical hand position unusual in Society Islands sculpture. The second-voyage ships visited several places in the group and, given that no specific island style has yet been identified, this figure may be from an island other than Tahiti or Ra'iatea. It has rounded shoulders, a vulva, a 'cap' and a distinctive straight brow line. The feet are damaged, suggesting a previous use as a canoe prow or stern figure.

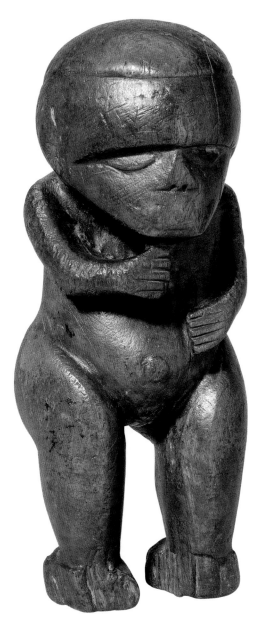

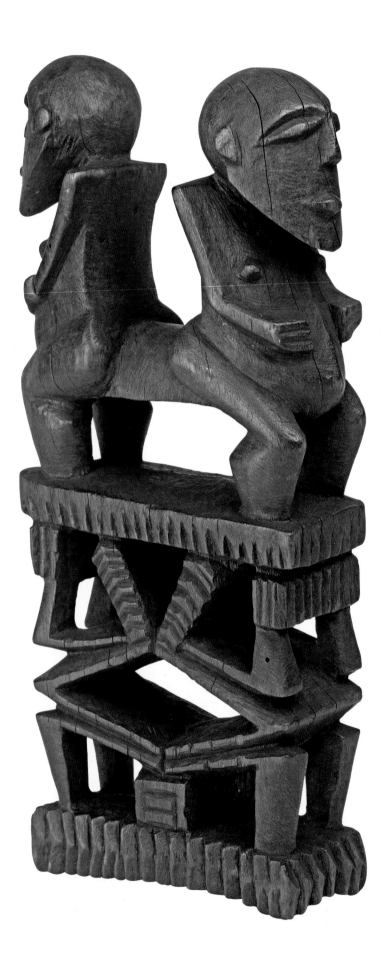

125 Double figure
Society Islands
Late eighteenth/early nineteenth centuries
Wood
H. 32.5 cm
London, BM: TAH 60
Acquisition date not known, but registered with material of known eighteenth-century provenance.

The double figures sit atop two other stylized seated headless figures whose forearms reach up to the platform. The underside of the base is smooth and slightly concave, suggesting that this sculpture was formerly attached to a large curved mount, possibly at a canoe prow or stern. The protruding mouths are distinctive. A probable Cook voyage image in Dublin (Kaeppler 1978: 138, 142) is almost certainly a fragment of a double-figure carving of this type, since it retains an upward-reaching forearm below one foot.

126 Whisk handle

Society Islands

Late eighteenth/early nineteenth centuries

Wood

H. 15.5 cm

London, BM: TAH 138

Acquisition date not known, but registered with material of known eighteenth-century provenance.

A small female figure stands above a broken zigzag shaft, where a small hole through the break indicates an old indigenous repair. The form of the shaft closely resembles the broken zigzag handle of a coir whisk in the Cook voyage collection in Vienna (Kaeppler 1978: 224–5; Moschner 1955: 223–4). That whisk appears to have Tongan and Society Island characteristics, and it is possible that these are two parts of the same object.

127 Whisk handle

Society Islands

Late eighteenth/early nineteenth centuries

Wood, coir

L. 39.0 cm

London, BM: TAH 137

Acquisition date not known, but registered with material of known eighteenth-century provenance.

An exceptional miniature sculpture with slender arms held to the chin, this figure is tied with coir binding on one side to a flat zigzag shaft. Two biconically drilled holes at the end would have been for the attachment of a coir whisk, now lost. The two components fit together well, but they may originally have been from two separate objects.

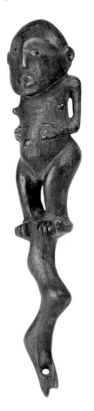

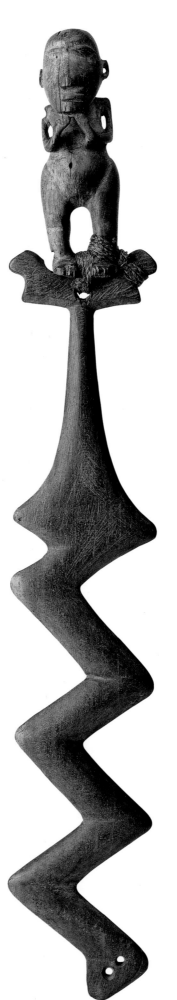

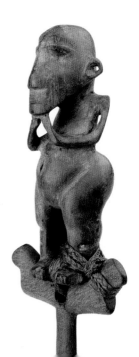

129 Baton

Society Islands

Late eighteenth century

Wood

L. 47.5 cm

Glasgow, HMAG: E438/2

Probably ex. collection William Hunter and collected on one of Cook's voyages (MacKie 1985).

This baton, pierced on each of its four sides with twenty holes, is of unknown use, although it is likely that it formerly had bindings and attachments. The two figures are carved in Society Islands style, but the piercing technique is associated with objects probably made in the Austral Islands (nos 168–70). The whole object has received a black varnish at some time in the past.

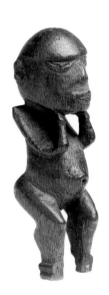

128 Standing figure

Society Islands

Late eighteenth/early nineteenth centuries

Wood

H. 10.5 cm

London, BM: LMS 98

Ex. London Missionary Society Collection; on loan 1890, purchased 1911.

A small figure with hands to the chin, this may have been a whisk handle or the end of a baton similar to no. 129. Called Tii Vahine (female figure/figure of Vahine) in British Museum documentation, it was supposedly collected by George Bennet in October 1823 at Papara, Tahiti, in association with the god house (no. 134). However, this figure is illustrated as no. 8 in *Missionary Sketches* no. III of October 1818 (see p. 63), where it is called a 'family Tii', so it must have been collected by then. The association of the two objects, already doubted (Hooper 2005: 95), is therefore false and Tii Vahine ('a female fiend, hideously mis-shapen', Montgomery 1831: II: 58) must be sought elsewhere. She was possibly connected to Ti'i Tane (no. 122).

130 God image

Society Islands

Late eighteenth/early nineteenth
centuries

Coir

H. 38.6 cm

London, BM: TAH 67

Acquisition date not known, but
registered with material of known
eighteenth-century provenance.

This form of god image (*to'o*)
is clearly anthropomorphic, with
eyes, nose, navel, arms and hands
indicated. It is not known if it
encases a wood core. Cook in 1777
described this type of image as
a 'sacred repository ... shaped
somewhat like a large fid or
sugar-loaf' (Beaglehole 1967: 203).
Babadzan (1993) has discussed
their role in *pa'iatua* rituals
associated with the cult of 'Oro,
when wrappings and bindings of
feathered cords were removed and
replaced. The god house (no. 134)
was probably designed to contain
a wrapped image of this kind
(Hooper 2005: 95–7).

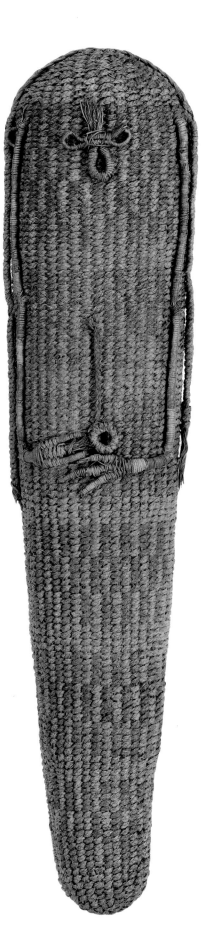

131 God image

Society Islands

Late eighteenth/early nineteenth centuries

Coir, wood, feathers

H. 45.0 cm

Lille, MHN: 990.2.2108

Acquired 1850; ex. collection Alphonse Moillet
(Notter *et al.* 1997: 57–64).

This *to'o* image is one of the few which retain
some original feathered bindings attached to the
anthropomorphic features, including eyes, nose,
mouth, navel and what may be a vulva. A scan
has shown that it has a wood core. Highly
valued red feathers were scarce in the Society
Islands, and some were probably obtained from
the Cooks and Australs. Those brought from
Tonga in Cook's ships were seized upon locally,
in preference to metal and other goods.

132 God image
Society Islands
Late eighteenth/early nineteenth centuries
Wood, coir, cane, feathers
L. 85.0 cm
London, BM: LMS 102
Ex. London Missionary Society Collection; on loan 1890, purchased 1911.

Another type of god image, this is composed of a wood spearhead encased in thick hanks of plaited coir cordage, bound in turn with cane slatting and feathered coir cords. It is possibly the one illustrated as no. 7 on the right in *Missionary Sketches* no. III of October 1818, among 'The family idols of Pomare' (see p. 63), where it is called Tiipa, a god of Otaheite. Pomare, the most powerful chief on Tahiti, espoused Christianity in 1812, and gave up images and ritual paraphernalia as proof of his conversion (see Davies 1961 for mission history).

133 God image
Society Islands
Mid-/late eighteenth century
Wood, coir
L. 61.9 cm
London, BM: TAH 64
Collected 1769 during Cook's first voyage (Kaeppler 1978: 136); drawn by J.F. Miller in 1771 (Joppien and Smith 1985: 217).

God images took various forms in the Society Islands, including one in which a wood shaft is tightly bound with coir cordage. These can have an anthropomorphic form, as here, where knots of coir are positioned as breasts, navel and penis; the crossed cords are probably arms. In ritual use it is likely to have had feathered binding attachments. Images made of coir bound around or containing wood are called *to'o* (staff), and are associated with the worship of the deity 'Oro, whose priests in the late eighteenth century were based at Opoa, Ra'iatea.

133

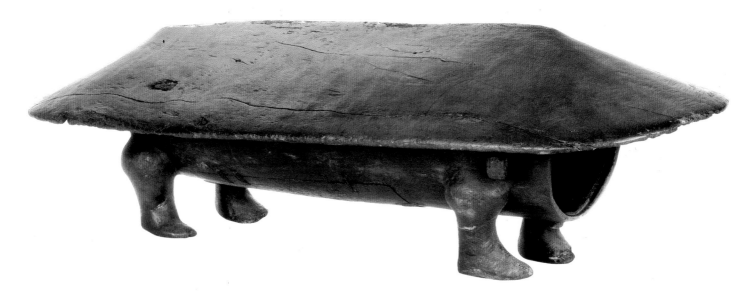

134 God house

Society Islands, Tahiti

Late eighteenth/early nineteenth centuries

Wood, coir

L. 87.0 cm

London, BM: LMS 120

Ex. London Missionary Society Collection; on loan 1890, purchased 1911.

This remarkable one-piece sculpture with animal/humanoid features was acquired by George Bennet on 1 October 1823 at Papara, Tahiti. Bennet noted that after the 'overthrow of idolatry' in 1815 the house was kept in a cave in the mountains, before being 'brought to market and sold, not for its value, but for its curiosity' (Montgomery 1831: II: 58). It is likely to have served as a portable shrine (*fare atua*) for a *to'o* image similar to nos 130–31, which would have been kept in the cylindrical chamber (Hooper 2005). The cover for the front of the chamber is lost.

135 Headrest

Society Islands

Late eighteenth/early nineteenth centuries

Wood, coir

L. 24.0 cm

London, BM: 574

Acquired 1860s; previous history not known.

This is one of the most finely carved headrests known, the careful coir repair to a crack on one side adding an intimate charm – someone had taken such trouble to preserve a delicate possession. It is carved from one block with great skill. The Revd William Ellis recorded that people slept on the bare wood 'as soundly as the inhabitants of more civilised parts would do on the softest down' (1829: II: 182).

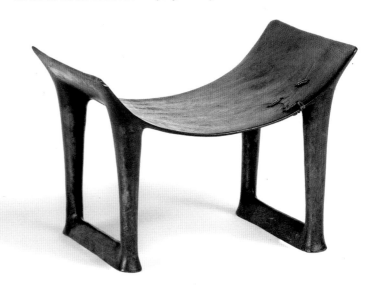

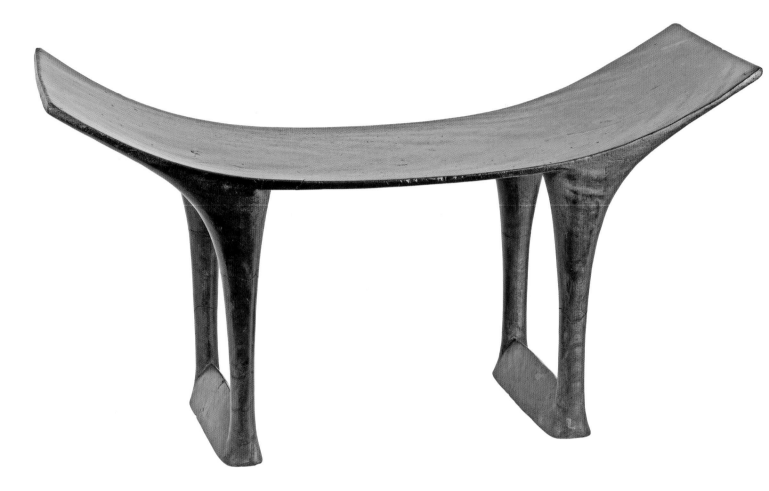

136 Stool

Society Islands

Late eighteenth/early nineteenth centuries

Wood

L. 98.8 cm

London, BM: 1982.Oc.3.1

Acquired 1982, Christie's auctioneers, London.

The word stool does not do justice to this throne-like seat, which must have been for a person of very high status. Carved from one massive block of wood, probably breadfruit, the seat is extremely thin. The triangular-section bars between the feet, typical of the Society Islands, give structural strength, allowing the legs to be slender.

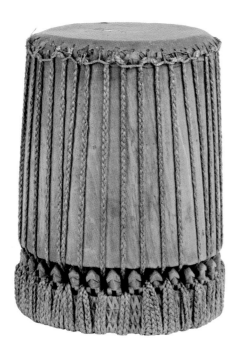

137 Drum

Society Islands (?)

Late eighteenth/early nineteenth centuries

Wood, shark skin, coir, fibre

H. 33.2 cm

London, BM: LMS 82

Ex. London Missionary Society Collection; on loan 1890, purchased 1911.

This is another object whose form and decoration make it difficult to provenance. Its shape and method of binding around the base is that associated with Society Islands drums (Kaeppler 1978: 140, 143), but the encircling figures resemble more the style of the central Cook Islands. The matter is further complicated by the fact that the binding of the tympanum is in a style known from Mangareva, where drums also have zigzag engraving at the base (Buck 1938: 401). The figures are headless, inviting an interpretation that the chamber forms a common head for all.

138 Box

Society Islands

Late eighteenth century

Wood, coir

L. 106.0 cm

London, BM: TAH 13

Acquisition date not known, but registered with material of known eighteenth-century provenance; possibly collected during one of Cook's voyages (Kaeppler 1978: 135).

A large box in three parts, the hollowed tubular chamber has a panel bound on at each end, carved with zigzags. The rectangular aperture is flanked on each side by four small figures; whether these served as lugs for securing a cover is not clear, but other examples have figures in low relief which could not have had such a function. These boxes were used for valuables, including feathers and pearl shells.

139 Breastplate

Society Islands

Late eighteenth/early nineteenth centuries

Pearl shell, human hair, coir

W. 22.9 cm (shell)

London, BM: LMS 72

Ex. London Missionary Society Collection; on loan 1890, purchased 1911; inscribed on back: 'The Royal Breast Plate of Tamatoa King of Raiatea. G. Bennet'; collected 1821–4 by George Bennet of the LMS.

This rare type of breast ornament can be localized to Ra'iatea on the strength of the inscription. However, the black-lipped pearl shell may have been an import from the Tuamotus; location of collection does not prove location of manufacture. That it was a very high-status object is evident from its association with Tamatoa, the title of the senior chief of Ra'iatea. The human hair and coir collar is attached through eleven conical holes drilled from the back.

140 Mourner's costume

Society Islands, Tahiti

Late eighteenth century

Barkcloth, wood, pearl shell, turtle shell, coconut shell, feathers, hair, fibre

H. 214.0 cm

London, BM: TAH 78

Acquisition date not known, but registered with material of known eighteenth-century provenance; probably the one presented to Captain Cook at Tahiti on 7 May 1774 (Beaglehole 1961: 392).

Spectacular costumes of this kind (*heiva tupapa'u*) were witnessed during Cook's voyages as being worn by a 'chief mourner' as part of funerary and mortuary rituals, when he would terrorize the locality accompanied by a troupe of assistants. The costume forms a complete body mask made of a dazzling combination of highly valued materials; the panel suspended beneath the wood gorget is composed of hundreds of carefully cut and drilled slivers of pearl shell which rippled and flashed in movement. When conserved at the British Museum the costume was found to be mounted upon an eighteenth-century easel with a hitherto unknown wooden figure supporting the headdress (Cranstone and Gowers 1968). Teilhet (1979) and Jessop (2002) have discussed their significance. With respect to exchange, Cook wrote that during a visit from 'the Royal Family', Tu's father 'made me a present of a compleat Mourning dress, curiosities we most valued, in return I gave him what ever he desired and distributed red feathers to all the others' (Beaglehole 1961: 392).

NOT EXHIBITED

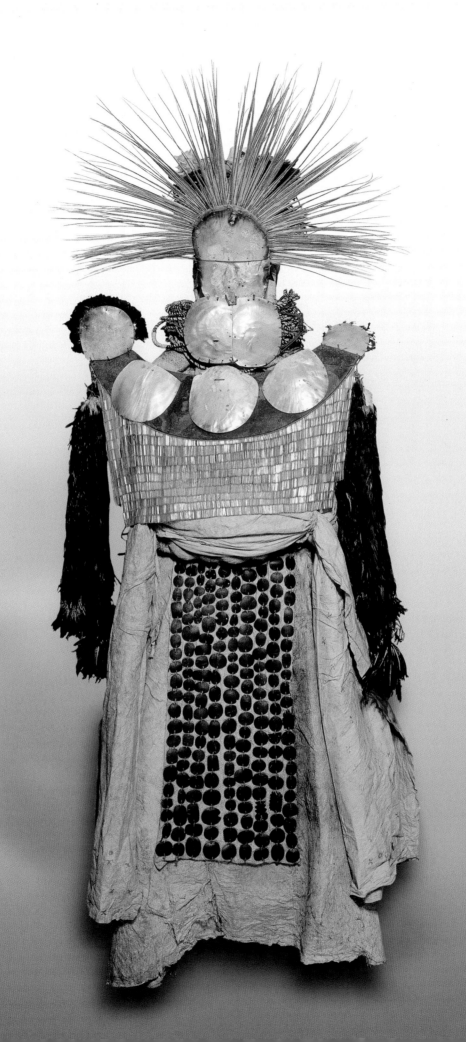

141 Gorget

Society Islands

Late eighteenth century

Cane, coir, feathers, dog hair, shark teeth, barkcloth, fibre

H. 61.0 cm

London, BM: TAH 57*

Acquisition date not known, but registered with material of known eighteenth-century provenance.

Usually called military breast gorgets, these U-shaped objects (*taumi*) are shown in a 1769 drawing by Sydney Parkinson in which men in a Ra'iatean canoe wear them on both the chest and the back (Joppien and Smith 1985: 154). Their association with warriors could support an interpretation that these gorgets represent the jaws of a shark, with the wearer taking on the qualities of a shark. John Webber made a watercolour in 1777 of a girl bringing a large roll of barkcloth and two *taumi* 'as a present', suggesting that they may have belonged in pairs (see above, p. 40). They were made of a combination of highly valued materials and have a complex structure; this example is probably the best preserved in existence.

142 Cloak

Society Islands, Ra'iatea

Early nineteenth century

Barkcloth

L. 245.0 x 155.0 cm

Saffron Walden, SAFWM: 1835.254 (E58)

Collected 1821–4 by George Bennet of the LMS; formerly owned by Mahine Vahine, daughter of Tamatoa, chief of Ra'iatea (Pole 1987: 12, no. 65).

Barkcloth was exclusively produced by women throughout Polynesia. It was used for bedding and clothing, for screens and for wrapping important objects and people when female agency was required in religious contexts. The pressed fern-leaf designs in red on this cloak (a detail is shown) may have been a development of the late eighteenth century, since no examples appear to have been collected during Cook's voyages.

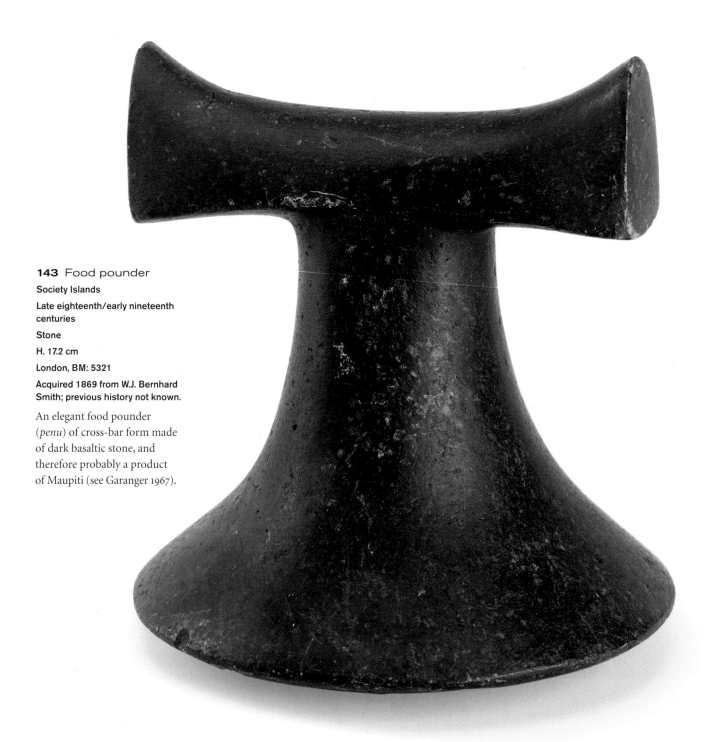

143 Food pounder

Society Islands

Late eighteenth/early nineteenth centuries

Stone

H. 17.2 cm

London, BM: 5321

Acquired 1869 from W.J. Bernhard Smith; previous history not known.

An elegant food pounder (*penu*) of cross-bar form made of dark basaltic stone, and therefore probably a product of Maupiti (see Garanger 1967).

144 Food pounder

Society Islands

Mid-/late eighteenth century

Stone

H. 20.5 cm

Glasgow, HMAG: E430

Probably ex. collection William Hunter and collected on one of Cook's voyages (MacKie 1985).

This is an elegant forked-top pounder used for preparing *poi* and other mashed vegetable foods on a wood-pounding table. Pounders were used throughout the group, but most of those of dark basaltic stone were made by specialists on Maupiti, an island subject to Borabora.

145 Food pounder

Society Islands

Mid-/late eighteenth century

Stone

H. 15.5 cm

London, NMM: L15/94/A

Probably collected during one of Cook's voyages; said to have been acquired from the great granddaughter of Cook's sister Margaret (Kaeppler 1978: 149).

A rare form of pounder in polished stone which appears to be a version of the forked-top type (no. 144).

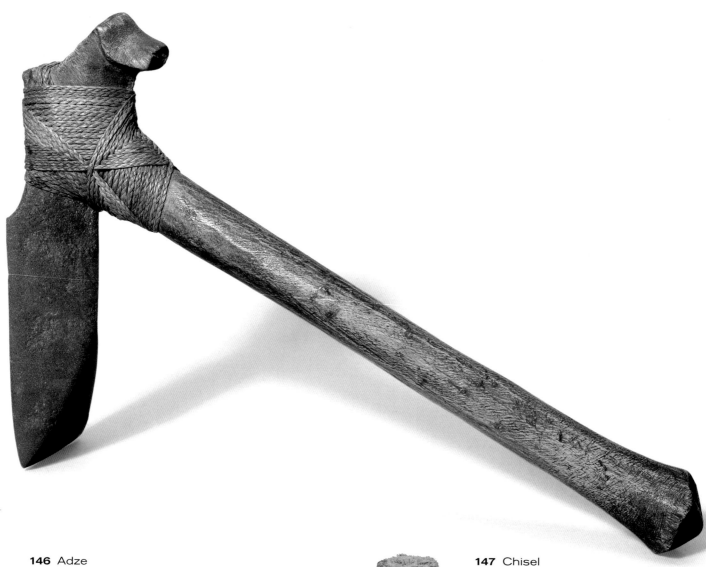

146 Adze

Society Islands

Mid-eighteenth century

Stone, wood, coir

L. 60.0 cm

Oxford, PRM: 1886.1.1334

Acquired 1886, ex. Ashmolean Museum; donated 1776 by Johann Reinhold and George Forster to Oxford University; collected 1773–4 by the Forsters during Cook's second voyage (Kaeppler 1978: 152; Coote *et al.* 2001).

A massive adze (*to'i*) of the kind used by carpenters to dress timber for canoes and houses. Accomplished voyagers for millennia, Polynesians depended on specialist carpenters for creating the vessels in which they conducted their voyages. Experience led to a range of perfectly balanced and elegantly proportioned tools, notably the adze, of which this example is among the most superb. It has the distinctive Society Islands block at the heel, which does not appear to have had any practical function, except perhaps to provide balance. By the end of the eighteenth century stone-bladed adzes had been replaced by ones fitted with metal blades obtained from Europeans.

147 Chisel

Society Islands

Late eighteenth/early nineteenth centuries

Wood, bone, coir

L. 17.5 cm

London, BM: TAH 121

Acquisition date not known, but registered with material of known eighteenth-century provenance.

A chisel used for carpentry work, made from a piece of bone, possibly human, set into a wood haft bound with plaited coir. A wood wedge is inserted between the blade and the haft to give rigidity. Very similar chisels were collected on Cook's voyages (Kaeppler 1978: 154).

148 Barkcloth beater

Society Islands

Late eighteenth century

Wood

L. 38.5 cm

Dublin, NMI: 1882.3687

Transferred 1882 from Trinity College, Dublin; possibly collected by James Patten or James King on Cook's second or third voyage respectively (Kaeppler 1978: 160; Freeman 1949).

Barkcloth was made by women from the inner bark of the paper mulberry (*Broussonetia papyrifera*), soaked and then beaten on a wooden anvil with mallets (*i'e*) of this kind. The four sides have different densities of lines, used at different stages of the beating. Two old paper labels, partly legible, attribute the beater to 'Otatheiti' and 'Otaheite'.

149–50 Tattoo adze and spatula

Society Islands

Late eighteenth century

Wood, bone, fibre

L. 16.9 cm, 41.4 cm

Exeter, RAMM: E1760, E1895

Ex. Devon and Exeter Institution; probably collected 1792 by Lt F.G. Bond of HMS *Providence*.

Tattooing was practised in all Polynesian societies. Men were tattooed more extensively than women in the Society Islands. Designs were applied with a dye made from baked candle-nuts and oil. A miniature adze was dipped in the dye and tapped into the skin with a spatula, which was also used to wipe away dye and blood during the painful process. Tattooing was done by *tahu'a*, priest-like specialists, and the practice was discouraged by missionaries. It has, however, recently enjoyed a revival throughout the Pacific. Gell (1993) has made an exhaustive study of Polynesian tattoo, analysing it as a way of 'wrapping' the body.

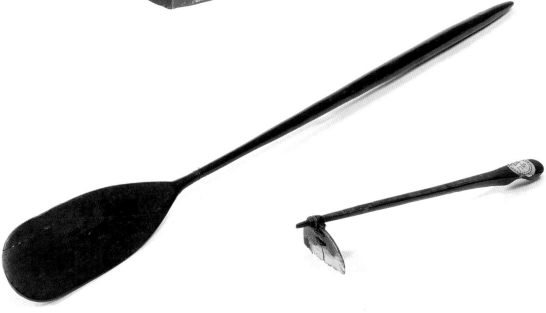

The Austral Islands

The Austral Islands have been settled since about AD 800–900 and have probably had an interactive relationship with the Society Islands to the north ever since. The main islands of Rurutu, Tubuai (also known as Tupua'i) and Ra'ivavae are fertile islands with good stands of hardwood. They became home to specialist carpenters who by the eighteenth century were making important ritual equipment for chiefs of the Society Islands. The

RIMATARA

RURUTU

TUBUAI

RA'IVAVAE

| 0 | | 100 miles |
| 0 | 100 km | |

island of Rapa (or Rapa Iti, Small Rapa) far to the southeast is outside the tropics and seems to have had less regular contact with the larger groups to the north. Its connection, if any, to Rapa Nui (Great Rapa or Easter Island) is not known.

Cook visited Rurutu (then called Oheteroa) in 1769 and Tubuai in 1777, but landed on neither occasion. Ra'ivavae was first visited by Thomas de Gayangos in 1775 and was later sighted by Vancouver, who was also the first European to visit Rapa. Little is known of Austral Island affairs between the 1770s and 1819, when Pomare II of Tahiti paid a state visit to Tubuai and Ra'ivavae, establishing them as part of his domain of authority. In 1789 the Bounty mutineers had made a bloody and unsuccessful attempt to settle on Tubuai, but other information is lacking. During the early nineteenth century a series of epidemics afflicted the vulnerable populations, one of them giving rise to an expedition from Rurutu which arrived in 1821 at Ra'iatea, where a base for the London Missionary Society had been established. Sailing back to Rurutu with local pastors, the Rurutuans then returned to Ra'iatea with offerings for the new priests, including the famous hollow sculpture (no. 156), named A'a by Reverend John Williams who received it. Reverend William Ellis and George Bennet visited Rurutu in 1822, and Bennet visited Ra'ivavae in 1823–4, where he and his delegation were presented with large quantities of barkcloth and saw finely carved paddles (no. 184). On Rurutu they met an American who had been living on the island for seven years, a reminder of the relatively large number of beachcombers and runaways who moved around the islands at this time. Most left no trace of their activities except in the writings of those who saw them and the memories of those amongst whom they lived.

The attribution of objects to islands is made difficult by the absence of contemporary first-hand accounts, and by movements of objects and craftspeople. Such stylistic features as rosettes appear to be associated with Ra'ivavae, but the design is also found on Tubuai. The necklaces with seat, balls and pig pendants would appear to originate from Rurutu, but the balls pendants are also known from the Cook Islands in the early nineteenth century. The fifty years between 1769 and 1819 was doubtless a period of great activity in the region, of which we know little.

Further information on Austral Islands art and history may be found in: Aitken 1930; Vérin 1969; Morrison 1935; Hanson 1970; Marshall 1962; Barrow 1979.

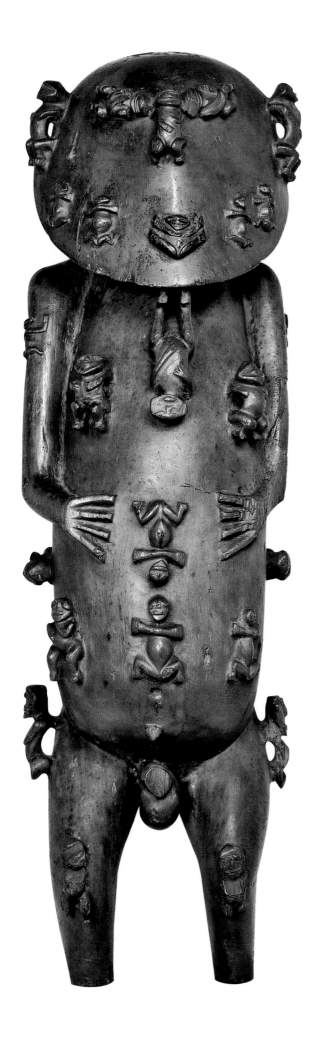

156 Standing casket figure

Austral Islands, Rurutu

Late eighteenth/early nineteenth centuries

Wood

H. 117.0 cm

London, BM: LMS 19

Ex. London Missionary Society Collection; on loan 1890, purchased 1911. Presented by Rurutuans in August 1821 to Revd John Williams at Ra'iatea, Society Islands.

This figure has a hollowed body and head, covered at the back by a detachable carved panel. It has thirty small figures distributed over its surface forming facial and other features. Referred to by Williams (1837: 43–4) as 'Aa, the national god of Rurutu', it contained at the time of presentation twenty-four 'smaller gods', now dispersed and unidentifiable. The carefully shaped excavation of the head and body indicates that it was most likely used originally as a reliquary for the skull and bones of a deified ancestor, wrapped and bound with feathered cords (Hooper 2001a). It became the prize trophy of the London Missionary Society, being featured on the front of *Missionary Sketches* XXIV, January 1824, and on the frontispiece of volume II of William Ellis's *Polynesian Researches* – on both occasions with a modest waist wrap, even though it had been emasculated (see above, p. 66). Ellis (1829: II: 220) referred to it as 'Taaroa, the supreme deity of Polynesia', but on what evidence is unclear. In indigenous use it was likely to have had more substantial wrappings and bindings.

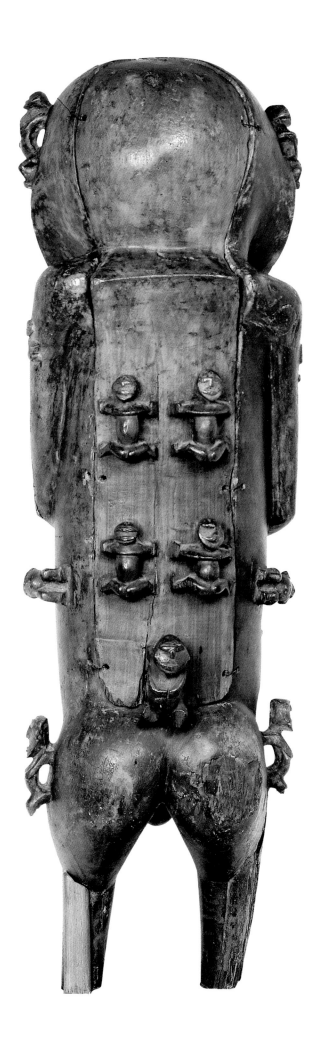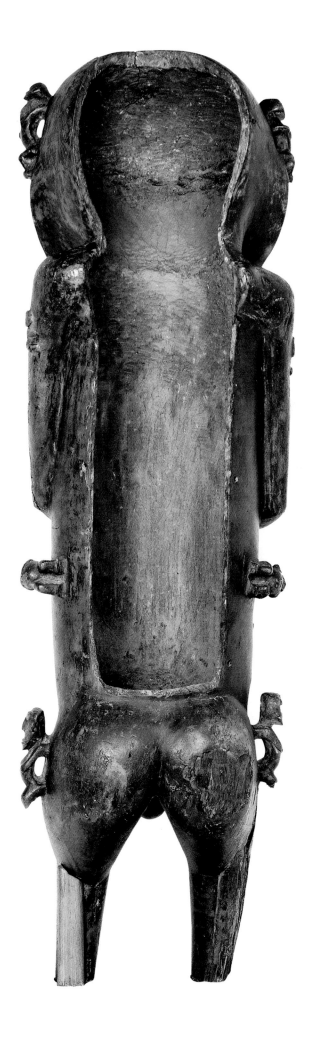

157 Standing figure

Austral Islands, Ra'ivavae

Late eighteenth/early nineteenth centuries

Wood

H. 66.0 cm

Auckland, AM: 31499

Acquired in 1948; ex. collection William Oldman, no. 413 (Oldman 2004: 21, pl. 35); collected by Revd John Williams of the LMS.

This female figure is extensively covered in engraved designs of rosettes and triangular notching typical of Ra'ivavae. A circular headdress appears to be depicted and there is a raised ridge down the spine, also covered in designs. Its function and identity is not known, but an old document preserved with it stated that it was an 'Indian God Brought to England by the Revd. John Williams ... by the consent of the natives for the purpose of illustrating his lectures to procure funds on behalf of the Mission to the islands' (Oldman 2004: 21, pls 35–6). Several large cracks and a broken right elbow have been filled and repaired since 1948.

158 Standing figure

Austral Islands, Ra'ivavae

Late eighteenth/early nineteenth centuries

Stone

H. 160.0 cm; figure H. 99.0 cm

Oxford, PRM: 1886.1.1427

Acquired 1886, ex. Ashmolean Museum; donated 1827 by G.W. Featherstonhaugh; collected 1826 on Ra'ivavae by Samuel Stutchbury (Stutchbury 1996).

A massive figure standing atop a high rectangular-section base, it formerly would have fitted into a platform on a *marae* or temple precinct. It is carved from a reddish volcanic stone found on Rai'vavae, and has sustained some damage to the arms (repaired) and losses to the hands. Stutchbury records seeing this figure on 8 July 1826 and arranged for Captain Samuel Henry to transport it for him. Despite its apparently female appearance, he noted that it was a male god named 'Aroonoona, and considered the watch-god of the Marae' (Pitt Rivers Museum website). Large stone figures and structures were made in many parts of Polynesia, a tradition which found its most dramatic expression on Easter Island.

159 Panel of figures

Central Polynesia, Austral Islands (?)

Mid-eighteenth century

Wood

L. 53.5 cm

Cambridge, CUMAA: D1914.34

Ex. collection Trinity College, Cambridge, deposited 1914; donated 1771 by the Earl of Sandwich; collected during Cook's first voyage (Kaeppler 1978: 159).

The purpose and origin of this bold sculpture remain enigmatic, but its Cook first-voyage provenance seems certain. Variously attributed to the Society Islands, the Cooks and the Australs, specifically Rurutu, which was visited briefly on Cook's first voyage, it bears no close formal resemblance to any known style in the region. Certain features, such as zigzags, back-to-back figures and pigs, do occur, but the style of the figures and their faces is without parallel. It is made from a heavy, wide-grained wood, and analysis of this could lead to identification – even to a surprise attribution, such as New Zealand. It seems to have been hacked off, rather than broken away, at one end; the form of the loose arms and the absence of evidence of feet would seem to discount a missing pig or dog to balance the composition. In the eighteenth century it could already have been an antiquity from somewhere in the Society Islands or Australs; the chunky zigzags most closely correspond to those on the tall drum (no. 160).

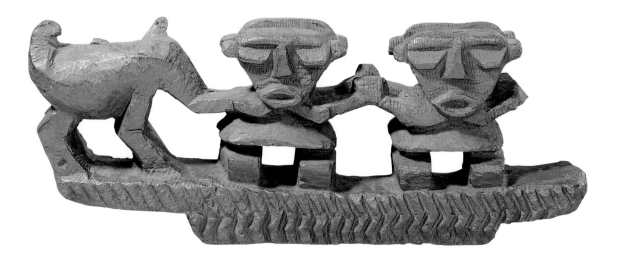

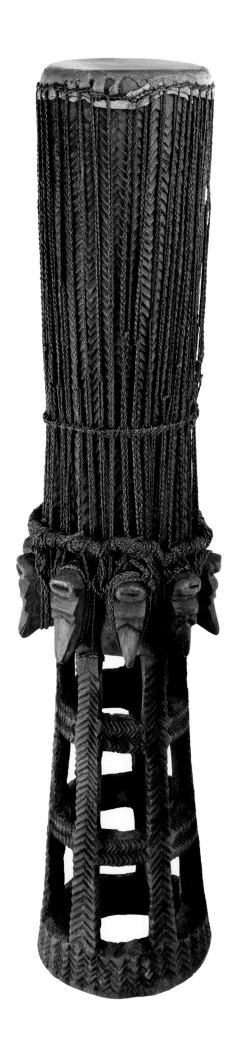

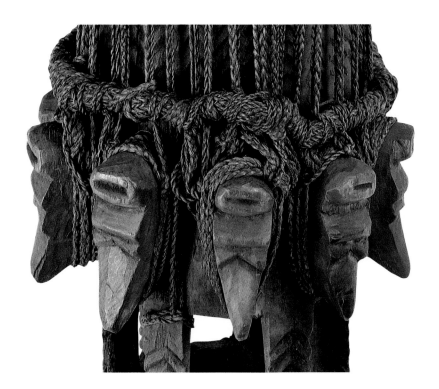

160 Tall drum

Austral Islands, Tubuai (?)

Late eighteenth/early nineteenth centuries

Wood, fish skin, coir

H. 121.0 cm

London, BM: LMS 94

Ex. London Missionary Society Collection; on loan 1890, purchased 1911.

A unique drum, it has nine triangular projections around the waist serving as cleats for the coir cords which secure the fish-skin drumhead or tympanum. The chamber and six legs have chevron engraving, with a horizontal black/red dyed sequence just discernible. A rough hole is cut between the chamber and the base. The cleats resemble encircling heads on whisk handles from Tubuai or Rurutu (nos 171–4) and on sacred spear heads collected by George Bennet (Phelps 1976: 153). The drum has the appearance of great antiquity; it may be the kind depicted at a *marae* in Tahiti in 1777 by Webber during Cook's third voyage (see p. 42), and thus an import from the Australs.

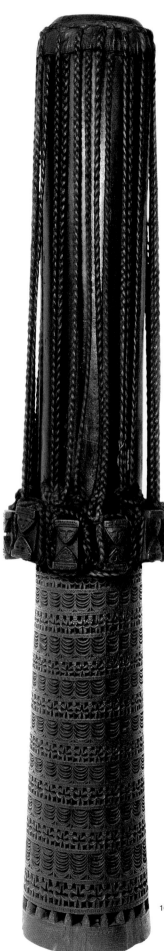

161 Tall drum

Austral Islands, Ra'ivavae

Late eighteenth/early nineteenth centuries

Wood, coir, fish skin

H. 134.6 cm

Oxford, PRM: 1954.4.34

Donated 1954 by Irene Beasley; ex. collection Harry Beasley, no. 2441, purchased 10 October 1929 from the Royal United Service Institution Museum, London, no. 2954; presented 1881 to the RUSI by Sir Alexander Malet, originally owned by Lord Lytton.

A finely preserved example of a tall drum with twelve cleats around the waist, one a modern replacement. The base is carved in distinctive openwork Ra'ivavae style, with eight horizontal rows of linked figures separated by seven bands of crescents. Such drums were probably used locally and also exported to the Society Islands. Drums were beaten as accompaniment to religious activities at temple precincts, signalling the presence of divine powers and marking *tapu* time periods. As the 'voice' of the gods, they could also be regarded as a form of god image.

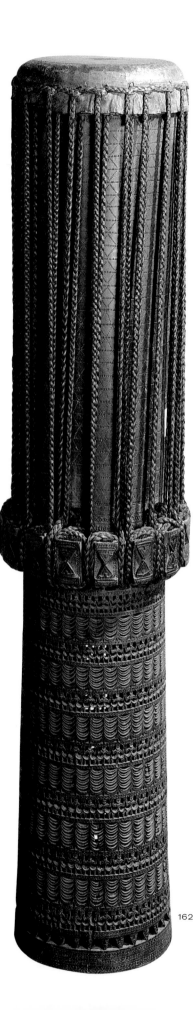

162 Tall drum

Austral Islands, Ra'ivavae

Late eighteenth/early nineteenth centuries

Wood, coir, fish skin

H. 128.0 cm

Cambridge, CUMAA: E1904.459

Acquired 1891; ex. collection Revd Daniel Wheeler, a Quaker missionary whose travels were published (Wheeler 1842).

A drum with sixteen cleats, it has a wide chamber engraved in triangular patterns, similar to those on another example in Edinburgh (Idiens 1982: 31). The fineness and intricacy of the openwork carving on these drums suggests that they were made between the time metal tools arrived in the Australs (probably via the Society Islands in the late eighteenth century) and the conversion period of the 1820s.

161

162

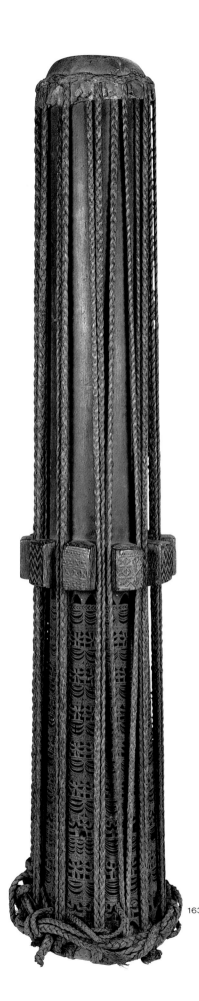

163 Tall drum

Austral Islands, Ra'ivavae

Late eighteenth/early nineteenth centuries

Wood, fish skin, coir

H. 127.0 cm

Dublin, NMI: 1882.3636

Transferred 1882 from Trinity College, Dublin; reputed to have been collected by James Patten or James King on Cook's second or third voyage respectively (Kaeppler 1978: 160; Freeman 1949).

The bindings on this example, which are very thick, are tied not to the ten cleats but to the base, after the manner of the Society Islands. This supports the hypothesis that Australs drums were imported to the Society Islands, and that when this one needed rebinding it was done in the local style. The highly crisp and controlled post-metal carving of the base would argue against this being a Cook voyage object, dating rather to the turn of the nineteenth century.

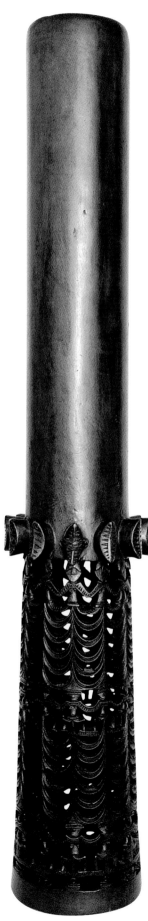

164 Tall drum

Austral Islands, Ra'ivavae

Late eighteenth/early nineteenth centuries

Wood, coir

H. 130.0 cm

Glasgow, HMAG: E567

Acquisition date not known.

This drum, which lacks binding and tympanum, is another variety that has a base carved with three rows of large linked figures separated by panels of swags. The chamber and base form a hollow tube unlike nos 160–63, which are solid at the bottom of the chamber. Two of the twelve oval cleats have been broken and repaired with coir cordage. Rows of figures on Ra'ivavae carvings are usually described as dancing females because of their wide stance and breasts.

163

164

165 God image/baton

Austral Islands (?)

Late eighteenth/early nineteenth centuries

Wood, coir

L. 80.7 cm

London, BM: LMS 168

Ex. London Missionary Society Collection; on loan 1890, purchased 1911.

This baton has an openwork panel to the handle of which are bound two short sticks; one corner figure is missing. It was illustrated, complete, alongside other central Polynesian 'idols' by William Ellis (1829: II: frontis; see above, p. 66) and was described in the LMS museum catalogue (n.d.: 7, no. 23) as: 'Another form of Taaroa, left as his representative at the great marae, in the district of Natipaki'. Previously classified as a Tahitian *to'o* image (Buck 1944: pl. 16a), the figures on the panel more closely resemble those on Rurutu sculptures such as the casket figure (no. 156) and whalebone bowl (no. 176).

The end of the handle has a distinctive acrobatic backward-arching figure, also found on whisk handles (nos 169–70).

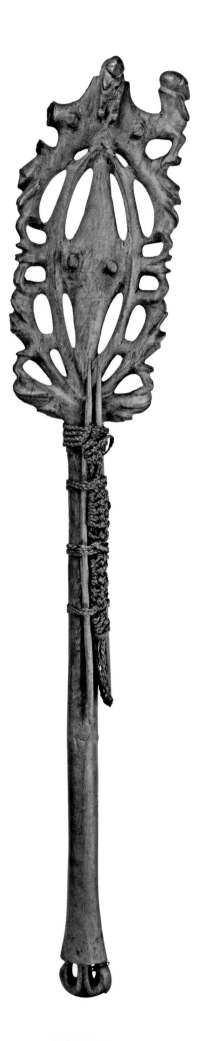

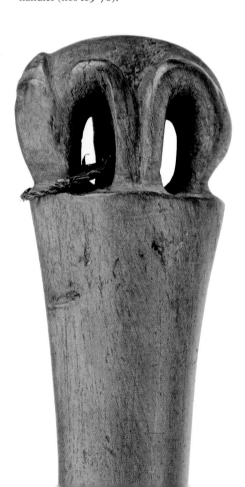

166 Spear head

Austral Islands, Ra'ivavae (?)

Late eighteenth/early nineteenth centuries

Wood

L. 48.7 cm

Cambridge, CUMAA: E1906.150

Acquired 1906; previous history not known.

This spear head has a collar of eight flaring spikes and a flanged end for binding to a shaft. Its rosette engraving is in Ra'ivavae style; other examples with differently shaped collars, some with small 'pigs', are more likely to have come from Tubuai or Rurutu (Gathercole *et al.* 1979: 158). When the famous Rurutu casket image was opened at Ra'iatea it was reported to contain 'the family gods of the old chiefs, the points of spears' (Montgomery 1831: I: 508), signifying that spear heads were important objects.

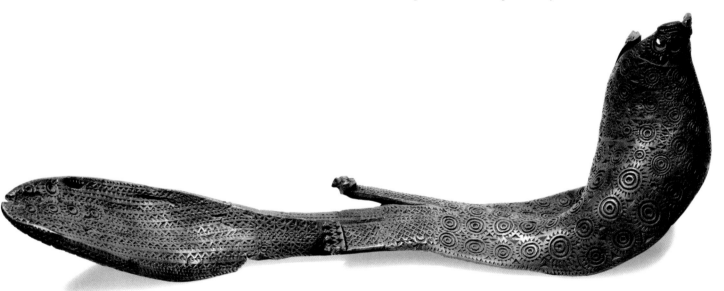

167 Carving

Austral Islands, Ra'ivavae

Early nineteenth century

Wood

L. 45.0 cm

Bristol, BCMAG: E1187

Probably collected on Ra'ivavae by Samuel Stutchbury, 1826.

This unique and little-known object has no known function. It appears to be a natural piece of wood which has been modified and carved over its entire surface with rosettes and other geometric designs. The cavity at one end had six encircling 'dancing' figures, two of which remain; the 'legs' are carved with small friezes of birds, some broken. The cavity is unlikely to have been used to hold kava because the rim figures are pierced. Its resemblance to a bird may be fortuitous.

168 Whisk handle/baton

Austral Islands (?)

Late eighteenth/early nineteenth centuries

Wood, coir

L. 19.7 cm

Auckland, AM: 31894

Acquired 1948; ex. collection William Oldman, no. 389 (Oldman 2004: 5, pls 6, 9); previous history not known.

This object is related in form to the Society Islands baton (no. 129), but the figure is carved more in the style of Rurutu. The irregular nature of the pierced holes may indicate that it predates no. 129. These two objects may be part of the complex exchange relationship between the Society and Austral groups in this period, which makes attributions difficult. The shaft has been broken and has a tight coir-cord repair; the end is also broken.

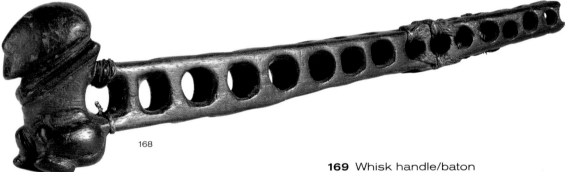

168

169 Whisk handle/baton

Austral Islands (?)

Late eighteenth/early nineteenth centuries

Whalebone

L. 24.2 cm

London, BM: LMS 57

Ex. London Missionary Society Collection; on loan 1890, purchased 1911.

Pierced with multiple holes, this handle has a finial carved as a contorted backward-arching figure. The function, if any, of the painstakingly drilled holes is not known, but the importance of the piece is attested by its inclusion among 'The family idols of Pomare' of Tahiti as no. 9: 'Tahivi Anunaehau, the handle of the sacred fan with which the priest drove away the flies, while about his prayers and sacrifices' (see p. 63). It may well have been an exotic import, the finial figure suggesting an Australs origin (see no. 165).

170 Whisk handle/baton

Austral Islands (?)

Late eighteenth/early nineteenth centuries

Whale ivory, coir, fibre

L. 30.2 cm

Aberdeen, MM: ABDUA 4024

Donated 1823 by Christopher Nockells; collected 1818–22 in the Pacific (Hunt 1981: 3).

This handle has a complex backward-arching finial figure holding a smaller figure across its chest. The carving on the shaft also appears to represent stylized figures. The two upper sections are tightly bound together with coir cord; the lower of these is broken and has been repaired with white (European?) fibre. A further section is attached to the end with the same material, but this appears not to belong, and to be from a different, if similar, object. This handle closely resembles an example in New York (MMA: 65.80) which was presented to Revd Thomas Haweis by Pomare of Tahiti in 1818 (Gathercole *et al.* 1979: 148). Another unpublished handle in Dublin (NMI: 1889.103) has feathered cords attached to the bottom. Possibly made by Australs craftsmen, several of these handles had gravitated to the most powerful chief in the region by about 1815.

171 Whisk handle

Austral Islands, Rurutu or Tubuai

Late eighteenth/early nineteenth centuries

Wood, coir

L. 28.2 cm

Ipswich, IPSMG: 1938-1.52

Acquired 1860s, ex. Ipswich Literary Institute; donated 1810 by Admiral B.W. Page, an associate of John Hatley who sailed on Cook's third voyage (David Jones, personal communication 2005).

Whisks with handles of this kind were long assumed to be from Tahiti, but research by Rose (1979) has shown that they were made on the Austral Islands of Rurutu and Tubuai. Details vary, but all have a finial of back-to-back figures and a raised disc at the bottom of the handgrip with a rim of triangular faces, fifteen on this example. At least one similar whisk was collected on Cook's first voyage and drawn by Miller in 1771 (Kaeppler 1978: 39, 162).

172 Whisk handle

Austral Islands, Rurutu or Tubuai

Late eighteenth/early nineteenth centuries

Wood

H. 21.4 cm; carved part 14.4 cm

Auckland, AM: 31925

Acquired 1948; ex. collection William Oldman, no. 387 (Oldman 2004: pls 11–12); previous history not known.

This whisk handle has a handgrip carved with deep chevron designs rather than the more usual multiple discs. The lower ring has ten small heads. Note the similarity in certain key features between this whisk and the tall drum (no. 160).

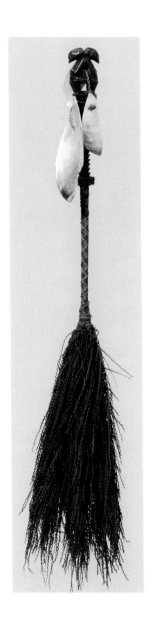

173 Whisk

Austral Islands, Rurutu or Tubuai

Late eighteenth/early nineteenth centuries

Wood, coir, fibre, pearl shell

L. 54.5 cm

Oxford, PRM: 1906.20.6

Donated 1906 by Mrs S.W. Silver; ex. collection Steven Silver, Letcombe Manor (listed in his printed catalogue, 1876).

Complete with black and red coir-cord binding and coir whisk, this example also has three pieces of pearl shell attached through the hole in the body of the figures. One of these, tied on with European string, has two holes and appears to be a separate object, a broken neck pendant of the kind shown in no. 182. Pearl-shell pieces are found on several eighteenth-century whisks, leading to the suggestion that they may have functioned as rattles, used not to deter flies but to be shaken during religious performances (Hooper 2001). In 1769 the Ra'iatean Tupaia drew two girls dancing with a whisk in each hand (Joppien and Smith 1985: 150).

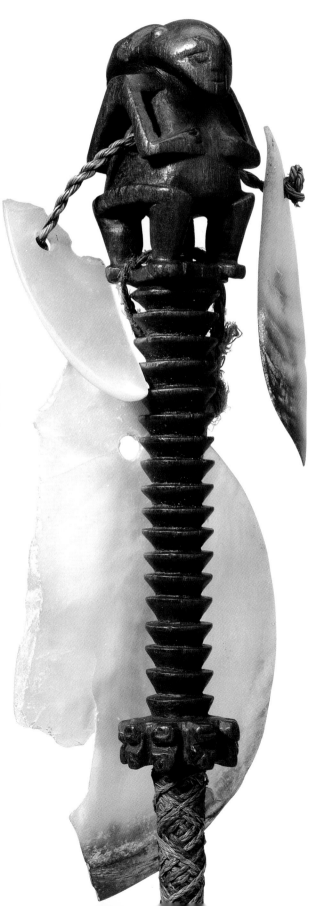

174 Whisk

Austral Islands, Rurutu or Tubuai

Late eighteenth/early nineteenth centuries

Wood, coir

L. 82.0 cm

Edinburgh, NMS: A.UC403

**Acquired 1850s, ex. collection University
of Edinburgh; previous history not known.**

This large type of whisk with highly refined
figures and wide lower disc may be a later
development of the more compact form.
It differs in that it lacks a hole through the
shared body and has paired heads around the
lower disc, rather than a single head with an
oval. It remains unclear whether all whisks
were made on the Australs and exported to
the Society Islands, or whether Austral Island
craftsmen settled in Tahiti and elsewhere to
practise their skills in the service of local chiefs.

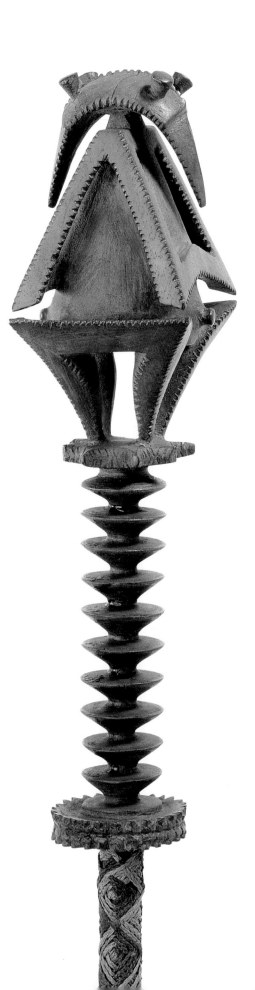

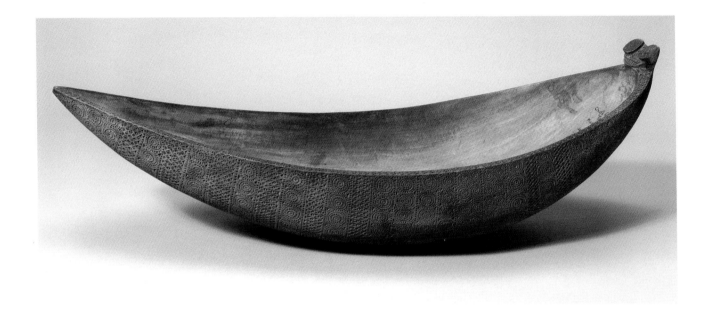

175 Bowl

Austral Islands, Ra'ivavae

Early nineteenth century

Wood

L. 61.5 cm

Oxford, PRM: 1886.1.1366

**Acquired 1886, ex. Ashmolean Museum; collected
1826 on Tahiti by Frederick Beechey during the
voyage of HMS *Blossom*.**

The undersurface of this wood bowl is entirely
engraved with bands of rosettes and geometric
designs. It was most likely used for kava, but a
copy of Beechey's original label states: 'Island
of Tahiti Manufactured by the Natives of Livivai
... A bowl in which the meals are served up to
the Chiefs'. Beechey did not visit Ra'ivavae and
this bowl shows that such things were finding
their way to Tahiti.

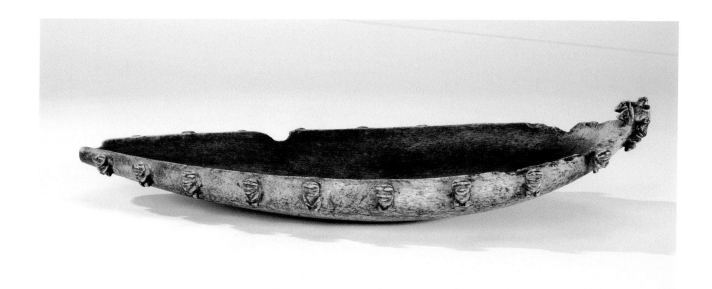

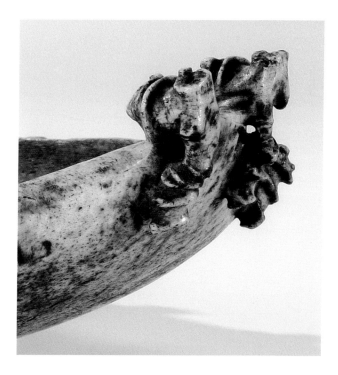

176 Bowl

Austral Islands, Rurutu

Late eighteenth/early nineteenth centuries

Whalebone

L. 36.8 cm

Auckland, AM: 31542

Acquired 1948; ex. collection William Oldman, no. 476 (Oldman 2004: 11, pl. 22); ex. collection James Hooper, acquired 1931; ex. collection Sir Thomas Brooke, Huddersfield.

Cut from the jawbone of a whale, this unique bowl has twenty small figures carved in high relief around the rim, two of them supporting two pig-like creatures which face into the bowl and provide holes for the attachment of a cord. The figures closely resemble several of those on the surface of the casket image (no. 156) and therefore locate this bowl to Rurutu (Buck 1944: 440). The pig figures are very similar to those that appear on necklaces with whale-ivory and bone 'seat and balls' pendants (see no. 179), suggesting that they too originated in Rurutu. The oval bowl form with pouring spout was widespread in central Polynesia (see the massive stone example from the Society Islands, p. 57). This example was almost certainly used for the preparation of kava.

177 Cup

Austral Islands, Ra'ivavae (?)

Late eighteenth/early nineteenth centuries

Coconut shell

L. 13.4 cm

Private collection

Ex. collection James Hooper, no. 626; ex. Dover Museum, 1948 (Phelps 1976: 148, 424); inscribed in black: 'sacred vessel used by the priests in offering to their idols South Sea'.

Almost certainly for serving kava, this cup has a neatly notched rim under one end of which is a band of small crescents, suggesting a Ra'ivavae origin. Kava was drunk by chiefs and priests, and poured as a libation to the gods.

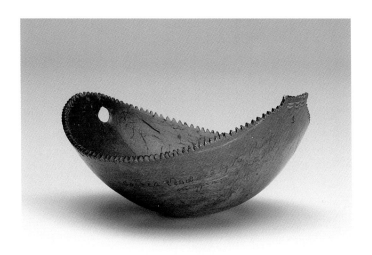

178 Stool

Austral Islands, Rurutu

Early nineteenth century

Wood

L. 48.8 cm

Private collection

Collected 1822 on Rurutu by George Bennet of the LMS; inscribed in black ink under seat: 'Geo Bennet Oct 6 1822 Rurutu made'.

The inscription confirms a Rurutu origin for stools of this form. George Bennet visited Rurutu on 30 September/1 October 1822 and will have made the inscription on his return to Huahine, where he arrived on 4 October. Cut from a solid block, the legs have hemispherical feet, and the ends of the seat have an elegant everted curve. Stools were reserved for those of high status and would have been an appropriate present for a visiting Mission representative.

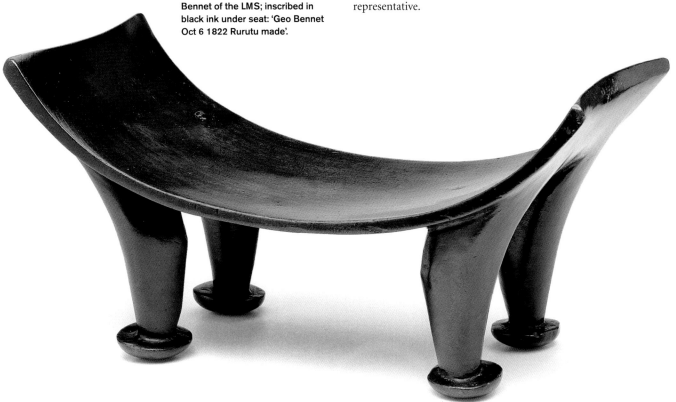

179 Necklace

Austral Islands

Late eighteenth/early nineteenth centuries

Whale ivory, coir, hair

L. (curved) 22.5 cm

London, BM: LMS 34

Ex. London Missionary Society Collection; on loan 1890, purchased 1911.

A number of necklaces of this kind are documented to the early nineteenth century but their provenance has remained unclear. The 'seats' with everted rims and the pig figures, which appear on some, point towards a Rurutu origin, but the twin-balls pendants have been found in the Cook Islands (see no. 218). The small ridged panels can also find parallels in Tongan ornaments. The fact that many of the twenty or so necklaces in existence seem to be rather flimsily put together suggests that they may have been assembled as a new kind of necklace combining disparate elements in circulation in central Polynesia. The seats signifying status and the balls signifying potency, combined with the materials of whale ivory (and in some case bone), will have made them a valuable ornament and gift.

180–81 Two ornaments

Austral Islands, Ra'ivavae (?)

Late eighteenth/early nineteenth centuries

Whale ivory, hair, coir

W. 8.2 cm, 7.0 cm

Lille, MHN: 990.2.2062, 990.2.2063

Acquired 1850; ex. collection Alphonse Moillet (Notter *et al.* 1997: 57–64).

These are probably ear ornaments, formed of ten and thirteen elements respectively. Each pendant is shaped as a pig-like creature, longer than those from Rurutu (see bowl no. 176), and with a distinctive Ra'ivavae rosette engraved on the 'tail'. The binding is a combination of human-hair braid and coir, a technique widespread in central Polynesia

182 Necklace

Austral Islands, Rurutu

Late eighteenth/early nineteenth centuries

Pearl shell, hair, coir, fibre

W. 13.0 cm; total l. 69.0 cm

Lille, MHN: 990.2.1477

Acquired 1850; ex. collection Alphonse Moillet
(Notter *et al.* 1997: 57–64).

Made from a polished valve of black-lipped
pearl shell, this pendant is attached with fibre
to a large hank of braided human hair which
has distinctive looped terminals. A similar
example, given by George Bennet to the Leeds
Philosophical and Literary Society in 1831
(now in the Musée de Tahiti et des Iles), has the
following description: '52. Necklace of human
hair with pearl shell ornament worn by female
chiefs at Rurutu. G. Bennet' (Phelps 1976: 146,
425, no. 653).

183 Headdress

Austral Islands, Rurutu

Early nineteenth century

Cane, coir, barkcloth, pearl shell, feathers, hair

H. (total) 115.0 cm; W. 29.0 cm

London, BM: +2011

Acquired 1882 by exchange with Sheffield Museum;
ex. collection Sheffield Literary and Philosophical
Society; probably collected 1821–4 by George
Bennet of the LMS (Woroncow 1981: 54).

An impressive headdress made of multicoloured
feathers from a variety of birds, this resembles
several other examples attributed to Rurutu in
the British Museum, the National Museums of
Scotland and Bristol Museum. Beneath the red
feather pompoms are folds of barkcloth
decorated in bands of black crescents of a kind
found on a piece of Cook voyage barkcloth in
Cambridge (Tanner 1999: 17). Joseph Banks
reported that barkcloth was collected at Rurutu
in 1769 (Beaglehole 1962: 331). William Ellis
(1829: II: 498–9) gave a very precise description
of a headdress of this kind from Rurutu, stating
that he sent it home for the LMS museum.

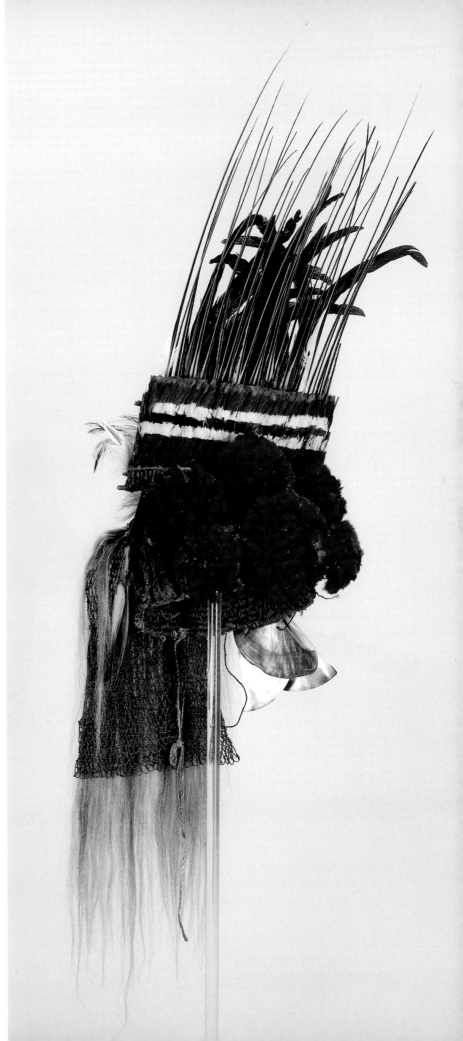

184 Paddle

Austral Islands, Ra'ivavae

Early nineteenth century

Wood

L. 139.2 cm

Exeter, RAMM: 51/1916/1

Collected 1826 (probably in Tahiti) by George Peard, First Lt on HMS *Blossom* during the Beechey expedition; an old label on butt: 'Paddle from chief's canoe carved with very imperfect tools by natives of islands in North Pacific. Brought home by Capt Peard RN 1828'.

Paddles of this highly decorated kind were perhaps the most collected objects in the Pacific in the first half of the nineteenth century. Well over one thousand exist in collections, and research by Rhys Richards (n.d.) has shown that they were made during a dynamic period of activity by Ra'ivavae carvers around 1820–40. None can be reliably dated to earlier than this period. The back of the blade of this fine example has a raised ridge and is covered in rosettes; the front has bands of rosettes and geometric carving. It is possible, after conversion to Christianity and the cessation of manufacture of drums and other religious objects, that carvers turned their hand to paddles to supply a local demand for exchange valuables and a European demand for curios.

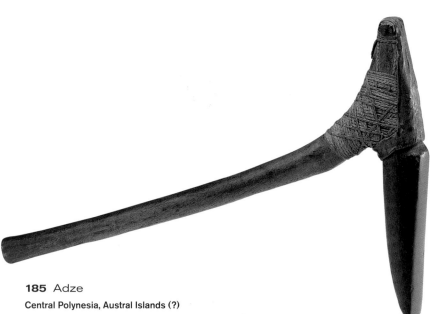

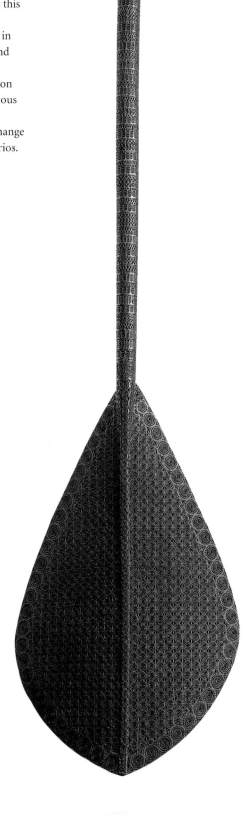

185 Adze

Central Polynesia, Austral Islands (?)

Late eighteenth century

Wood, stone, coir, fish skin

L. 59.0 cm

Private collection

Ex. collection James Hooper, no. 588; possibly ex. Dover Museum, 1948 (Phelps 1976: 135, 138, 423).

An adze of this size was for heavy timber work. The fish-skin pad which protects the binding from abrasion during use is folded and tied in a distinctive manner. The form of the blade resembles archaeological examples from Tubuai (Duff 1959: fig. 5f), although the adze could also originate from the Cook Islands.

186 Barkcloth beater

Austral Islands

Early nineteenth century

Wood

L. 45.1 cm

Private collection

Ex. collection James Hooper, no. 604 (previous no. 1192); purchased 1930 from John Williams' granddaughter; collected by Revd John Williams, LMS missionary stationed in the Pacific 1817–39; old label: 'Mallet used ... beating cloth, South Sea Islands, John Williams' (Phelps 1976: 140, 424).

Carved with grooves of different densities on each surface, this tapa beater is attributed to the Austral Islands on formal grounds (Buck 1944: 430; Aitken 1930: pl. VII, c.3). It was used to beat the inner bark of the paper mulberry into thin white sheets, the most finely grooved side being for the final beating.

187 Staff

Austral Islands, Rurutu or Tubuai

Late eighteenth/early nineteenth centuries

Wood

L. 274.3 cm; figure H. 5.8 cm

London, BM: LMS 96

Ex. London Missionary Society Collection; on loan 1890, purchased 1911.

A rare form of staff with a finial of the kind found on whisk handles (nos 171–3), it has in addition a short vertical shaft between the platform and the body. Near the lower end of the pole is a small roundel with double faces on the rim, again similar to that on whisk handles, flanked by oval designs in low relief. In general form it resembles an enormously elongated whisk handle.

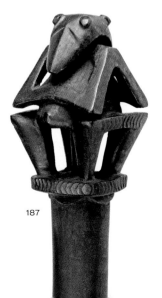

187

188 Spear club

Austral Islands, Rurutu

Late eighteenth/early nineteenth centuries

Wood, coir

L. 292.0 cm; 123.0 cm (head)

Aberdeen, MM: ABDUA 4158

Donated 1823 by Christopher Nockells; collected 1818–22 in the Pacific (Hunt 1981: 3); inscribed in ink on blade: 'New Zealand spear'.

This long club has a double collar with V-shaped engraving. At the end is a ball of tightly bound coir cord. Joseph Banks in 1769 observed weapons at Rurutu 'well polishd and sharpned at one end into a broad point' (Beaglehole 1962: 333). The provenance is confirmed by an example at Saffron Walden which was collected on Rurutu by George Bennet in 1822 (Pole 1987: 7, no. 7). William Ellis, on the same visit, celebrated the fact that the polished railings on the steps to the pulpit in the new church were made of 'the handles of warriors' spears' (1829: II: 520).

The Cook Islands

The Cook Islands in their current political status are formed of two groups: the Northern Cooks, a few remote atolls, and the Lower or Southern Cooks (shown here) with which this catalogue is mainly concerned. The Lower islands are here divided into the 'central islands' (Aitutaki, Manuae, Takutea, Atiu, Mitiaro, Mauke) and the southern islands of Rarotonga and Mangaia. It is

AITUTAKI

MANUAE

TAKUTEA

MITIARO

ATIU

MAUKE

Avarua

RAROTONGA

0		50 miles
0	50 km	

MANGAIA

probable that Pukapuka in the Northern Cooks was settled some 2,000 years ago, but the Lower Cooks may not have been colonized until about AD 800–900, probably from the Society Islands, although contact with Samoa may have occurred at some stage. It is highly likely that the place of departure, around a thousand years ago, for the first voyagers to New Zealand was somewhere in the Lower Cooks.

Tupaia, the navigator/priest from Ra'iatea in the Society Islands who joined Cook's first voyage, had extensive knowledge of islands in the central Pacific, including the Cook Islands, which shows that periodic contact was maintained between groups in the region. Rarotonga and Ra'iatea are connected in myth, and when Cook visited Atiu in 1777 he found several people from the Society Islands who hade drifted there some years before. Cook had been the first European to sight one of the Lower Group when in 1773 he passed Manuae, calling it Hervey Island, a name which for a long time was used for the whole group. The name Cook Islands was given to the Southern group by the Russian voyager and cartographer von Krusenstern in 1824.

Rarotonga, the largest island, was first visited briefly in 1789 by the *Bounty* mutineers and later by the *Cumberland* in 1814, looking (unsuccessfully) for sandalwood. Aitutaki was visited by the *Bounty* in 1789 before the mutiny. In 1821 it became the first base in the Cook Islands for pastors of the London Missionary Society, sent from the Society Islands. When John Williams of the LMS visited there in 1823 he returned in triumph with thirty-one newly-surrendered 'idols' (1837: 106–9), many of which are now in the British Museum but whose identifications have become detached or lost. Conversions were achieved swiftly on Atiu and its subject islands of Mauke and Mitiaro, and pastors were left on Rarotonga and Mangaia, later to be succeeded by English missionaries. The Cook Islands are now self-governing, linked to New Zealand.

Local iconoclasm associated with conversion, and loss of documentation for those objects taken as trophies and souvenirs, means that precise attributions of material to the central islands is at present not possible. It is, however, clear that many fine things were made there – for local use and for export to regional ritual/political centres such as Rarotonga and even Ra'iatea. The Rarotongan asymmetrical eye form appears to be distinctive to that island (nos 189–93), but Rarotonga was divided into three chiefdoms at that time and it is possible that other as yet unrecognized styles existed.

Further information on Cook Islands art and history may be found in: Buck 1927, 1934, 1944, 1993; Maretu 1983; Gilson 1980; Gill 1876, 1894; Buzacott 1866; Williams 1837; Barrow 1979; Idiens 1982.

189 Figure, 'fisherman's god'
Cook Islands, Rarotonga
Late eighteenth/early nineteenth centuries
Wood
H. 44.0 cm
London, BM: LMS 36
Ex. London Missionary Society Collection;
on loan 1890, purchased 1911.

A massive emasculated image, this is
almost certainly the one illustrated by
Williams (1837: 116–17) and described
by him as 'An idol … placed upon the fore

part of every fishing canoe; and when the
natives were going on a fishing excursion,
prior to setting off, they invariably
presented offerings to the god, and
invoked him to grant them success'. Its
weathered condition is consistent with
prolonged exposure to the elements. It
was also illustrated by Ellis on his plate
of 'idols' (1829: II: frontis), and resembles
an example in the Sainsbury Collection
(Hooper 1997: II: 18–21).

190 Figure, 'fisherman's god'
Cook Islands, Rarotonga
Late eighteenth/early nineteenth centuries
Wood, paint
H. 32.5 cm
London, BM: 9866
Acquired 1876 from the London dealer William
Wareham.

Another image in similar style, this one
has black painted designs on its body that
almost certainly represent tattoos, and
which also correspond to the form of the
designs on the large sheet of barkcloth
(no. 194). The ears are pierced, as is usual,
and also notched around the rim.

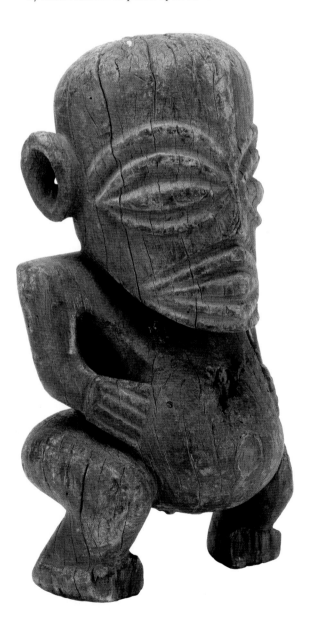

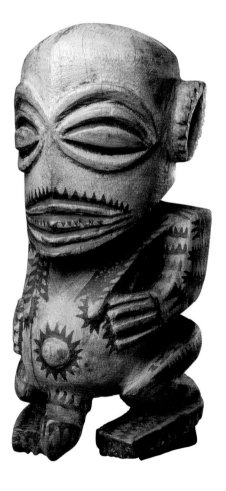

191 Standing figure

Cook Islands, Rarotonga

Late eighteenth/early nineteenth centuries

Wood, coir, feathers, barkcloth

H. 69.8 cm

London, BM: LMS 169

Ex. London Missionary Society Collection; on loan 1890, purchased 1911.

This large male figure has three smaller ones in high relief on the chest, plus two further figures in low relief on each arm, all male. Coir arm bindings cover traces of barkcloth and feathers. It is extremely heavy, probably made of ironwood (*Casuarina equisetifolia*) which takes a high polish. No information is known about its original use, but it is attributed to Rarotonga on the basis of its distinctive eye form (an eye, two lids and one brow), similar to that on the staff gods (nos 192–3). It has escaped being emasculated, despite its missionary collectors; only one other comparable example is known (Ortiz 1994: no. 274). A formal relationship with the Rurutu casket image (no. 156) has been widely noted.

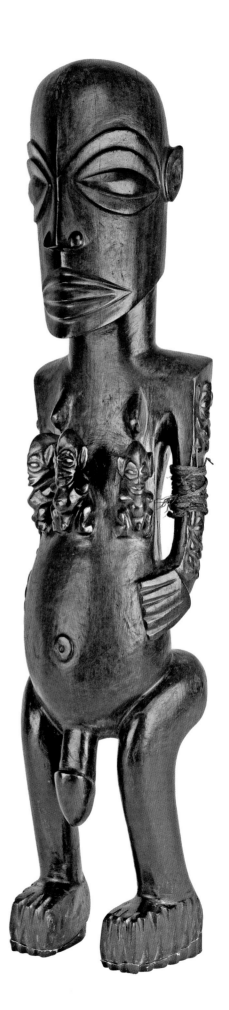

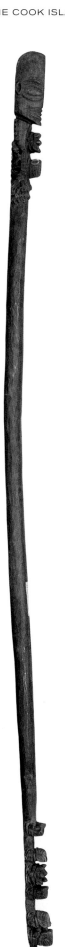

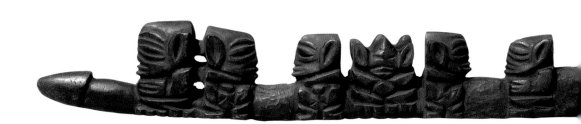

192 Staff god

Cook Islands, Rarotonga

Late eighteenth/early nineteenth centuries

Wood

L. 232.2 cm

Oxford, PRM: 1884.62.31

Acquired 1884, Pitt Rivers founding collection; exhibited 1874–8 at Bethnal Green Museum and 1878–84 at South Kensington Museum.

A medium-size image without barkcloth wrapping, this example shows the complete form of the distal end with a naturalistic penis. There is notching along the back at the top and bottom. Images were made in a range of sizes, and a contemporary account records that in about 1823–4 (the time the first native Christian pastors arrived) ten large images were consecrated (Maretu 1983: 59–60). After conversion, those images not destroyed were given away or incorporated into church architecture (Gill 1856: 22).

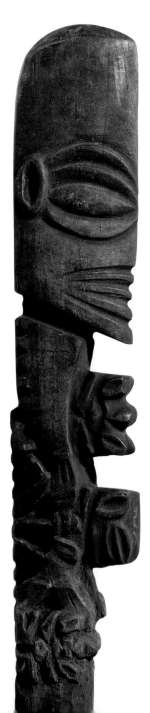

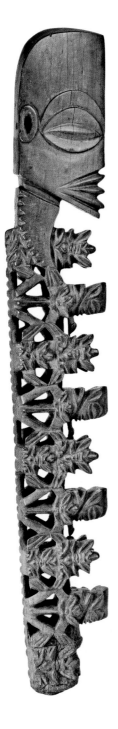

193 Head of a staff god

Cook Islands, Rarotonga

Late eighteenth/early nineteenth centuries

Wood

L. 111.0 cm

London, BM: 1919,10-14,1

Purchased 1919 from Jessie Barnes; previous history not known.

This is the largest surviving staff god head. If in proportion to no. 195, it will have come from a staff god over 6 metres in length. The four small figures in profile are explicitly male; a figure in low relief is carved at the top of the notched spine; the ears of the main figure are pierced. Most staff gods which were not burned were hacked apart and only the top ends kept as religious trophies or curios.

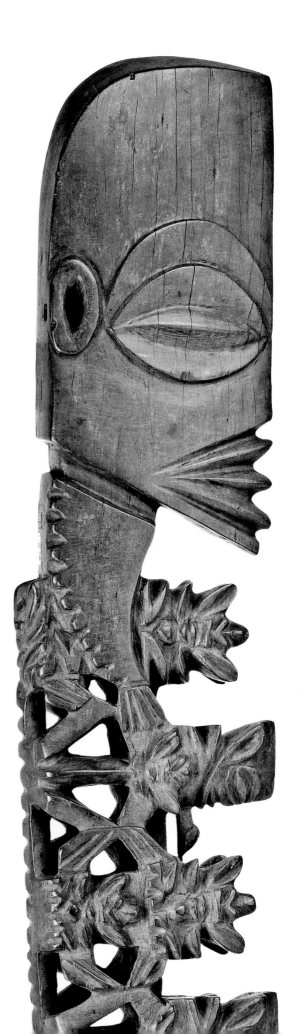

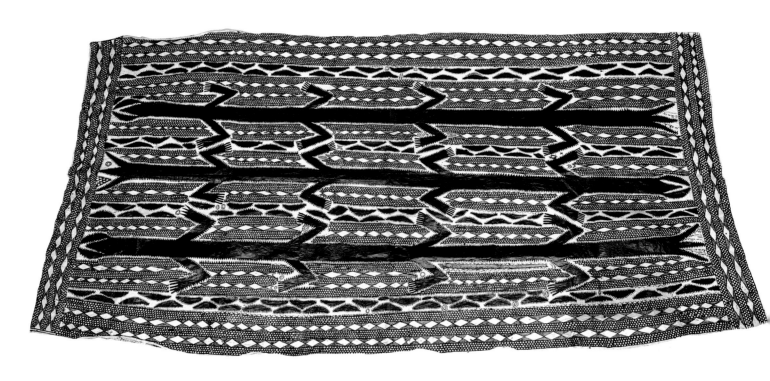

194 Barkcloth

Cook Islands, Rarotonga (?)

Early/mid-nineteenth century

Barkcloth, dye

347.0 x 165.0 cm

Kew, EBC: EBC42953

Donated 1850 by William Miller Christy; previous history not known.

Few barkcloths survive with this distinctive design incorporating multi-legged creatures, and none has a clear provenance. A similar example in Exeter has been ascribed to one of Cook's voyages (Kaeppler 1978: 160, 164; Pole and Doyal 2004: no. 51), but that attribution is challenged by this cloth, which bears written inscriptions in the same dye as the designs and which must therefore be contemporary with them. Several of the words are in a Cook Island language (Aaron Marsters, Marjorie Crocombe, personal communication), which supports Kooijman's suggestion for their provenance (1972: 59). Cook Island languages only began to be written in the 1820s, which dates this cloth to that period at the earliest. The matter would appear to be resolved by the similarity of the border of this cloth to the black-and-white chequer border of the roll of barkcloth on the large Rarotongan staff god (no. 195).

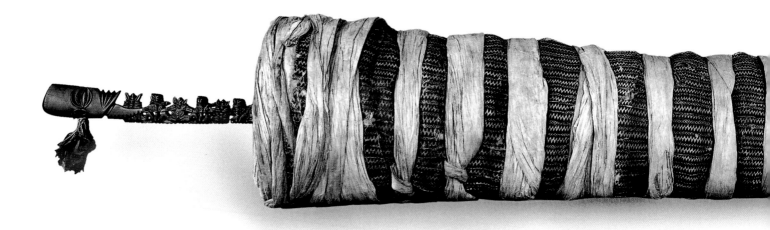

195 Large staff god

Cook Islands, Rarotonga
Late eighteenth/early nineteenth centuries
Wood, barkcloth, feathers
L. 396.0 cm
London, BM: Q78.Oc.845
Ex. London Missionary Society Collection; on loan 1890, purchased 1911.

The only surviving wrapped example of a large staff god, this impressive image is composed of a central wood shaft wrapped in an enormous roll of decorated barkcloth. The shaft is in the form of an elongated body, with a head and small figures at one end. The other end, composed of small figures and a naturalistic penis, is missing, but its original form can be seen in no. 192. This image was among fourteen presented to Revd John Williams at Rarotonga in May 1827. After describing them he noted that 'Near the wood were red feathers, and a string of small pieces of polished pearl shells, which were said to be the manava, or soul of the god' (Williams 1837: 115–16; see above, p. 64). The shaft has been cut into three sections, two of which remain; a feathered pendant is in one ear. It was exhibited as a centrepiece in the LMS museum (see above, p. 71). Little is known of the function or identity of these images. Duff (1969: 61) speculated that they represent Tangaroa the creator god, but without evidence. What is clear is that in their materials they combine the results of the skilled labour of men and women. They also have an explicit sexual aspect, thus embodying male and female productive and reproductive qualities (Hooper 1997: II: 17).

NOT EXHIBITED

196 Canoe stern board (?)

Cook Islands, Rarotonga
Late eighteenth/early nineteenth centuries
Wood
H. 68.5 cm
London, BM: 2086
Acquired 1860s; previous history not known.

No old Rarotongan canoes survive or were depicted, so it is not certain if this is a canoe carving. The three fixing holes at the bottom suggest such a use. Carved in Rarotonga style, it has a plain back with a curved section at the top.

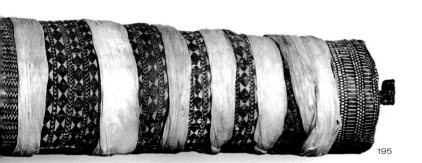

195

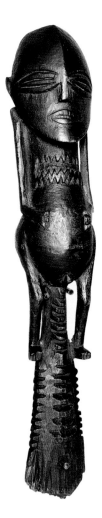

197 Canoe stern figure (?)

Cook Islands, Aitutaki (?)

Late eighteenth century

Wood

H. 39.5 cm

Glasgow, HMAG: E360

Acquisition date unknown; possibly ex. collection William Hunter.

The raised zigzag engraving on the chest and the form of the head suggest that this figure is from Aitutaki in the central Cooks (Buck 1944: 341–2). It has some black painted chevrons and bands on the body and legs, but these are not clear because, like many early objects in the Hunterian Museum, it has received a coating of black varnish. It is most likely to have been cut from the prow or stern of a canoe; Hornell (1936: 173) shows an early twentieth-century canoe from Atiu with similar notching down the inside of the stern post.

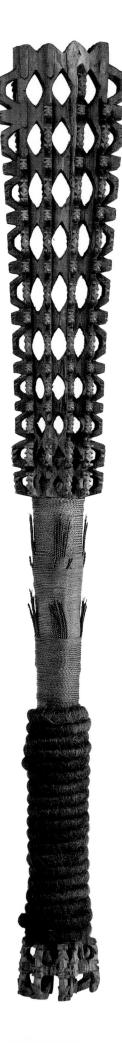

198 Mace god

Cook Islands, Mangaia

Late eighteenth/early nineteenth centuries

Wood, coir, hair

L. 91.4 cm

London, BM: LMS 42

Ex. London Missionary Society Collection; on loan 1890, purchased 1911.

One of three mace gods in the British Museum which were among eleven taken from the god house at Kei'a on Mangaia and surrendered to the pastor Davida (from Taha'a in the Society Islands) in the mid 1820s: 'The bark cloth wrappings were cast away and in this way the gods were desecrated' (Buck 1993: 18). The missionaries John Williams and George Platt later took them for the LMS museum. Its openwork head was probably once covered with feathers. The handle is bound with coir and a thick rope of human hair.

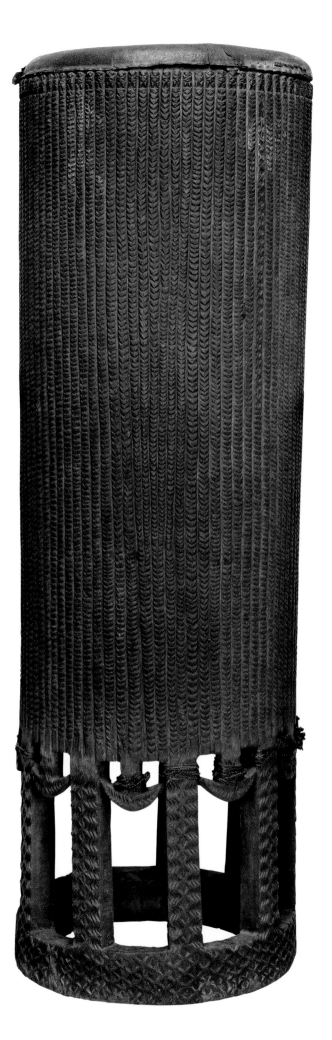

199 Tall drum

Central Polynesia, central Cook Islands (?)

Late eighteenth/early nineteenth centuries

Wood, fish skin, coir

H. 150.1 cm

London, BM: LMS 80

Ex. London Missionary Society Collection; on loan 1890, purchased 1911.

This is one of three similar massive drums presented by George Bennet to the LMS museum, but of uncertain origin. The chamber, which has a solid base, shows traces of red ochre. The crescent-shaped cleats are distinctive, as is the row of stylized figures around the top and the lozenge-shaped engraving on the nine legs. These last two features link this tall drum to a gong drum, also of uncertain provenance (no. 200). The combination of iconographic elements makes their origin a puzzle, although the stylized figures would point towards the central Cooks as the place of manufacture. Related design elements involving lozenges and zigzags can be found on a variety of objects from central Polynesia, so the question must remain open for the present.

200 Gong drum

Central Polynesia, central Cook Islands (?)

Late eighteenth/early nineteenth centuries

Wood

L. 92.0 cm

London, BM: LMS 54

Ex. London Missionary Society Collection; on loan 1890, purchased 1911.

Gongs are beaten on the side with wood mallets; wear marks on this example show it has seen heavy use. The row of small figures and panels of carving on each side very closely resemble the style of carving on the massive tall drum (no. 199), indicating that both types were made at the same location. It remains uncertain precisely where, though it was probably the central Cooks because gongs are not known from the Australs. The sound of gongs travels great distances, and they continue to be used in Tonga and Fiji for signalling, on formal ritual occasions and for summoning the congregation to church.

201 Ceremonial adze

Cook Islands, Mangaia

Early nineteenth century

Stone, wood, coir, fish skin

L. 74.5 cm

Private collection

Ex. collection James Hooper, no. 561 (Phelps 1976: 13, 423); almost identical to an example depicted by Revd John Williams (1837: 262).

Adzes of this elaborate kind were a form of god image, possibly related to Tane-mata-ariki. Stone blades served as exchange valuables as well as tools, and could also serve as shrines for gods. This blade almost certainly pre-dates the handle. The making and binding of coir cord was a specialist ritual activity. In their combination of elements, these adzes enshrine the finest of woodwork, binding and stonework. After the population's conversion to Christianity in the 1820s adzes were widely collected and local craftsmen began to make them for sale as curios (Buck 1944: 380–81).

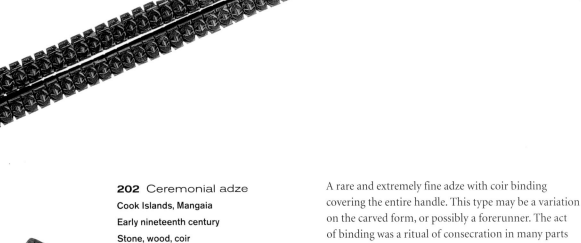

202 Ceremonial adze

Cook Islands, Mangaia

Early nineteenth century

Stone, wood, coir

L. 62.5 cm

London, CWM: no number

Ex. London Missionary Society Collection.

A rare and extremely fine adze with coir binding covering the entire handle. This type may be a variation on the carved form, or possibly a forerunner. The act of binding was a ritual of consecration in many parts of Polynesia, and surface carving can be understood as a kind of binding with carved patterns. The end of the handle of this adze is marked with a number of shallow circular depressions.

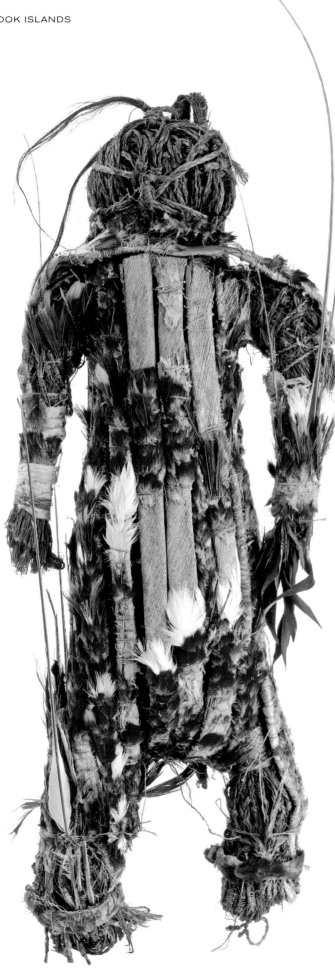

203 Humanoid god image

Cook Islands, Atiu (?)

Late eighteenth/early nineteenth centuries

Coir, hair, palm spathe, feathers, barkcloth, fibre

H. 57.0 cm

London, BM: LMS 170

Ex. London Missionary Society Collection; on loan 1890, purchased 1911.

An anthropomorphic image composed of hanks of coir bound with feathers from a variety of bird species. At the back are thick cords of hair and further long panels of palm spathe fixed with feathers. An old label attributes it tentatively to Atiu. Nothing is known of its identity or function in indigenous religion, but its materials are a testament to the importance and value of coir, feathers, hair and barkcloth in constructing images of divinity. Anderson, during Cook's third voyage visit to Atiu in 1777, remarked on the red feathers worn by chiefs and women dancers (Beaglehole 1967: 840).

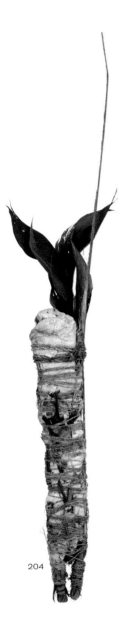

204

204 Humanoid god image

Cook Islands

Late eighteenth/early nineteenth centuries

Coir, barkcloth, feathers, fibre

H. 38.0 cm

London, BM: LMS 104

**Ex. London Missionary Society Collection;
on loan 1890, purchased 1911.**

An anthropomorphic image of coir
wrapped in bark cloth, it has feathers
secured by twisted fibre cords. This type
of image has been attributed to Mangaia
on the strength of a label to that effect on
a similar one in Cambridge (Buck 1944:
366), but certainty is not possible.

205 God image

Cook Islands, Atiu (?)

Late eighteenth/early nineteenth centuries

Coir, barkcloth, feathers, fibre

H. (inc. feathers) 52.5 cm

London, BM: LMS 53

**Ex. London Missionary Society Collection; on loan
1890, purchased 1911.**

Thick folded cords of coir are tightly bound
with black barkcloth, small red and green
feathers and flat-plaited red and natural coir
cords. Longer feathers, probably of the frigate
bird and tropic bird, are fixed into the top.
This image is considered by Buck (1944: 397)
to be from Atiu.

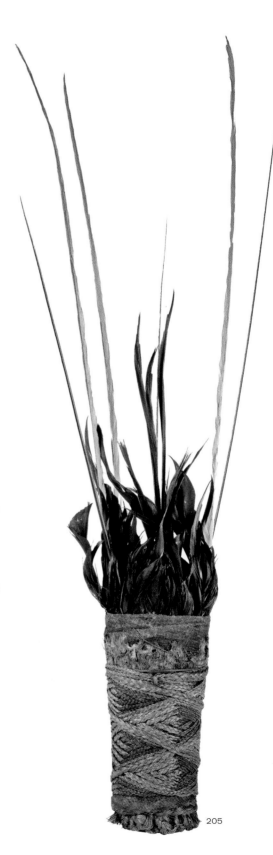

205

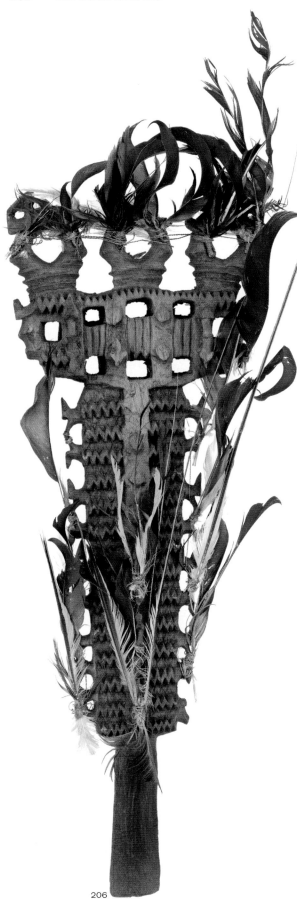

206

206 God image plaque

Cook Islands, Aitutaki (?)

Late eighteenth/early nineteenth centuries

Wood, feathers, fibre

H. 58.0 cm

London, BM: LMS 45

Ex. London Missionary Society Collection; on loan 1890, purchased 1911.

This plaque retains many of its original feather attachments. It has raised zigzag elements characteristic of Aitutaki, and arched cleats (many broken) resembling stylized figures of the kind found on openwork images attributed to Mitiaro (nos 207–8). At the top are three projections composed of back-to-back stylized figures with hands to chin. Unfortunately, as with most Cook Islands god images, we have no information about its manner of use.

207 God image

Cook Islands, Mitiaro (?)

Late eighteenth/early nineteenth centuries

Wood, fibre

H. 39.3 cm

London, BM: Q82.Oc.121

Ex. London Missionary Society Collection; on loan 1890, purchased 1911.

A type of openwork image normally attributed to Mitiaro on the basis of old LMS labels (Buck 1944: 351). However, it has zigzag elements and stylized figure cleats which resemble those on Aitutaki carvings. The central Cook Islands were in regular and close contact, and the present state of knowledge does not permit firm island attributions.

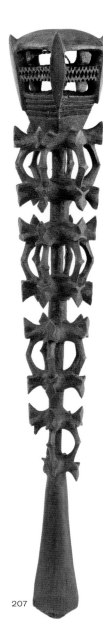

207

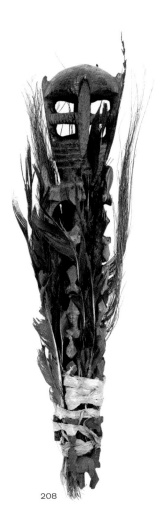

208 God image

Cook Islands, Mitiaro (?)

Late eighteenth/early nineteenth centuries

Wood, coir, fibre, feathers, barkcloth

L. 30.5 cm

London, BM: LMS 48

Ex. London Missionary Society Collection; on loan 1890, purchased 1911.

This example retains some of its feather and coir attachments bound to the openwork sculpture. The base is broken.

209 God image

Cook Islands, Atiu (?)

Late eighteenth/early nineteenth centuries

Wood, fibre, feathers

L. 40.6 cm

London, BM: LMS 49

Ex. London Missionary Society Collection; on loan 1890, purchased 1911.

This image is localized to Atiu in LMS documentation. It is a variation of the domed Mitiaro form, but has rows of complete figures, with hands to chin. Thick ropes of coir, some retaining red feathers, are tied between the figures. Their length suggests that there was at least one further section of six figures beneath the broken base.

208

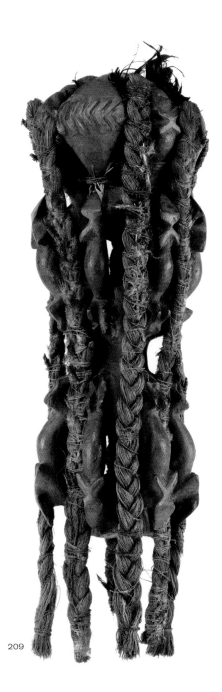

209

210 Fan handle/god image

Cook Islands, central islands

Late eighteenth/early nineteenth centuries

Wood, barkcloth, feathers, fibre

L. 46.0 cm

London, BM: LMS 131

Ex. London Missionary Society Collection; on loan 1890, purchased 1911.

Fans were not only practical means of keeping cool but were important ritual objects. The special value placed on their handles is attested to by their use as god images, wrapped and bound with barkcloth and feathers. This handle has a pierced terminal with finely carved chevron engraving. A similar style of handle is shown in a 1777 drawing by William Ellis of a complete fan from Atiu (Joppien and Smith 1988: 294).

211 Fan handle/god image

Cook Islands, central islands

Late eighteenth/early nineteenth centuries

Wood, feathers, hair, fibre

L. 40.0 cm

London, BM: LMS 128

Ex. London Missionary Society Collection; on loan 1890, purchased 1911.

Another fan handle converted into a god image by the binding on of feathers and hair. It has a lozenge-shaped terminal.

211

212 Fan handle/god image

Cook Islands, central islands

Late eighteenth/early nineteenth centuries

Wood, feathers, fibre

L. 53.0 cm

London, BM: LMS 124

Ex. London Missionary Society Collection; on loan 1890, purchased 1911.

This handle has a simple spatulate form with two short oval projections at the sides, similar to those on the complete fan (no. 216). One side of the upper end of the shaft has a precise zigzag design.

212

210

213 Fan handle/god image

Cook Islands, central islands

Late eighteenth/early nineteenth centuries

Wood, barkcloth, hair, feathers, fibre

L. 47.0 cm

London, BM: LMS 78

Ex. London Missionary Society Collection; on loan 1890, purchased 1911.

Two figures, one with a missing head, form the terminal of this fan handle, which has been converted into a god image by being bound with a bundle of black barkcloth and feathers. The end of the shaft is notched.

214 Fan handle

Cook Islands, central islands

Late eighteenth/early nineteenth centuries

Wood

L. 18.7 cm

Lille, MHN: 990.2.2103.2

Acquired 1850; ex. collection Alphonse Moillet (Notter *et al.* 1997: 57–64).

Almost certainly the handle of a fan, the stick part has broken away from the bottom. There are design elements usually associated with three islands: a finial of heads with hands to chin (Aitutaki or Mitiaro), a scalloped central section (Rarotonga) and a lower section with raised zigzags (Aitutaki). As is indicated for no. 222, the scalloped form is more likely to be of Atiu origin, so a central islands provenance for this handle seems certain; it is probably from Aitutaki.

215 Fan handle

Cook Islands, central islands

Late eighteenth/early nineteenth centuries

Wood

H. 43.5 cm; H. of figures 12.0 cm

David King Collection

Ex. collection George Ortiz, Sotheby's, 29 June 1978; formerly in the British Museum, obtained 1971 by Ralph Nash by exchange; ex. London Missionary Society Collection; on loan 1890, purchased 1911.

This finely carved fan handle has paired male figures rendered in a more detailed and naturalistic manner than in other examples. The form of these figures may be compared to those on the god image from Atiu (no. 209). There are circular projections below the feet for securing the body of the fan, as seen in no. 216, but the end of the stick is plain. This fan handle can be identified in the Anelay portrait of John Williams (fig. 10, p. 26 above)

213

214

215

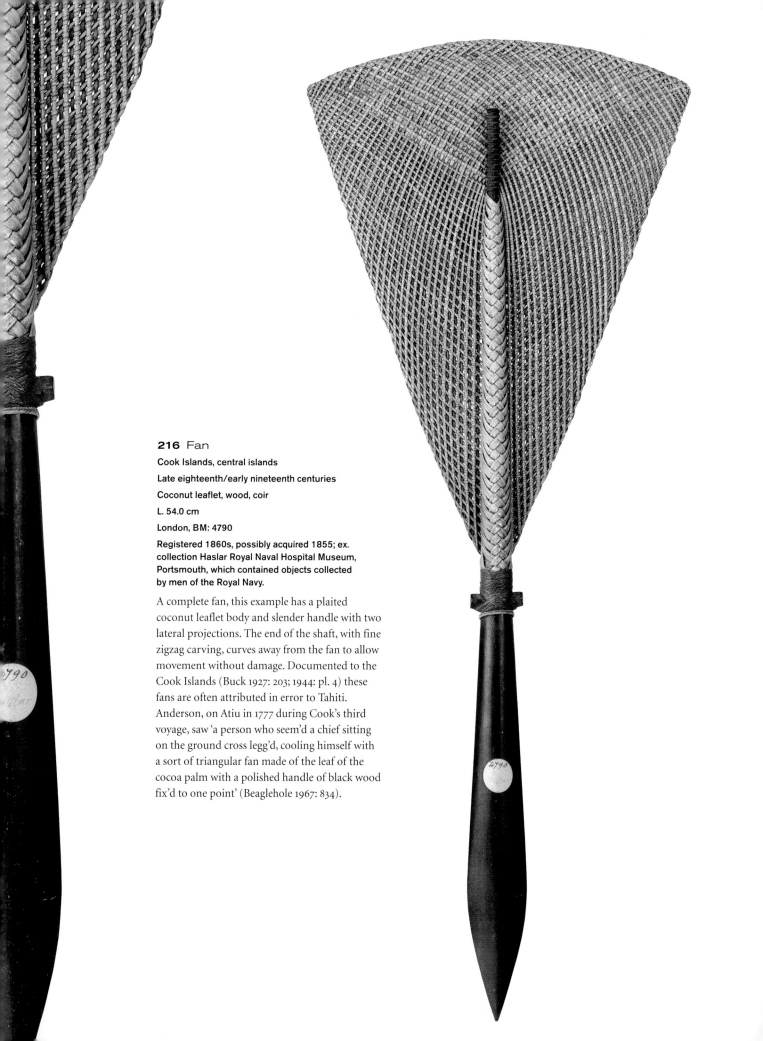

216 Fan

Cook Islands, central islands

Late eighteenth/early nineteenth centuries

Coconut leaflet, wood, coir

L. 54.0 cm

London, BM: 4790

Registered 1860s, possibly acquired 1855; ex. collection Haslar Royal Naval Hospital Museum, Portsmouth, which contained objects collected by men of the Royal Navy.

A complete fan, this example has a plaited coconut leaflet body and slender handle with two lateral projections. The end of the shaft, with fine zigzag carving, curves away from the fan to allow movement without damage. Documented to the Cook Islands (Buck 1927: 203; 1944: pl. 4) these fans are often attributed in error to Tahiti. Anderson, on Atiu in 1777 during Cook's third voyage, saw 'a person who seem'd a chief sitting on the ground cross legg'd, cooling himself with a sort of triangular fan made of the leaf of the cocoa palm with a polished handle of black wood fix'd to one point' (Beaglehole 1967: 834).

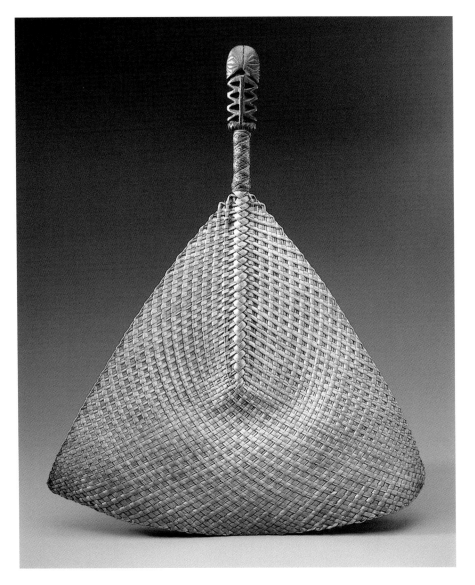

217 Fan

Cook Islands, Rarotonga

Late eighteenth/early nineteenth centuries

Coconut leaflet, wood, coir

L. 49.5 cm

Cambridge, CUMAA: Z6102

Acquired 1891 from George Brady; probably ex. collection Revd Daniel Wheeler, a Quaker missionary whose travels were published (Wheeler 1842).

A very finely preserved fan with two stylized figures on the handle with Rarotongan features. Two-tone coir binding secures the handle to the body; the end of the shaft is plain.

218 Balls pendant

Cook Islands, Atiu

Late eighteenth/early nineteenth centuries

Whale ivory

W. 6.8 cm

Cambridge, CUMAA: 1923.12

Acquired 1923 by Louis Clarke from Llewelyn Hutchin; given to Revd John Hutchin (resident in Rarotonga 1882–1912) by Ngamaru, an Atiu chief, husband of Takau, the Makea (chief) of Rarotonga.

This pendant can also be localized to Atiu on the strength of observations made by Anderson in 1777 during Cook's third voyage. He noted that 'Some who were of a superior class, and also the chiefs, had two little balls with a common base made from the bone of some animal which was hung round the neck with a great many folds of small cord [probably human hair]' (Beaglehole 1967: 840). This example is pierced through the sides of the notched projection and retains some old coir binding. Smaller examples can be found on Australs necklaces (no. 179).

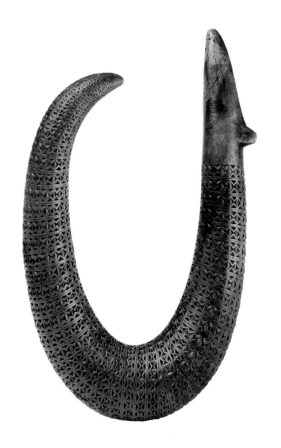

219 Hook
Cook Islands, Mangaia
Late eighteenth/early nineteenth centuries
Wood
L. 29.3 cm
London, BM: LMS 30
Ex. London Missionary Society Collection; on loan 1890, purchased 1911.

In the form of a large fish hook, this object shows no sign of use and is covered in engraved designs characteristic of Mangaia. Buck (1944: 242) mused that it might have had a symbolic function and it is likely he was right. As was the case with certain 'sacred' adzes, this may have been an object for use in ritual procedures, in this case connected to fishing.

220 Fish hook and line
Cook Islands, Mangaia (?)
Late eighteenth/early nineteenth centuries
Wood, coir, stalagmite
H. (hook) 22.7 cm; total L. 798.0 cm
London, BM: 1903-18
Acquired 1903; ex. Wallace Collection, Whitehaven Museum, Cumbria.

A complete hook and line for catching shark or other large species, in form it resembles no. 219 and so is probably Mangaian. It also has patterned coir binding on the snood which is typical of Mangaia. It shows much sign of use and has a stalagmite sinker bound on to the line about 90 cm down from the hook.

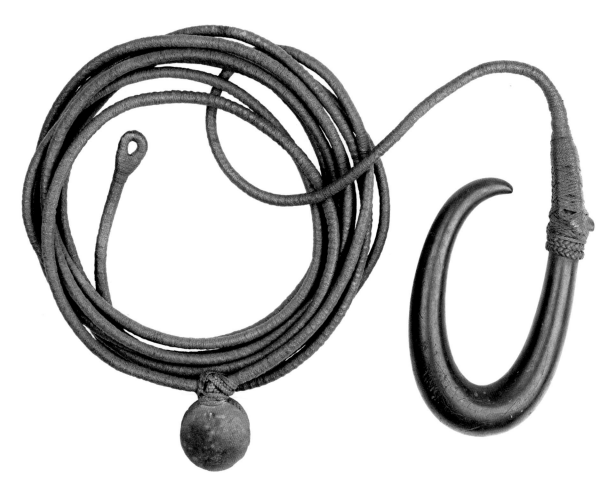

221 Staff

Cook Islands, Rarotonga

Late eighteenth/early nineteenth centuries

Wood

L. 248.0 cm

Edinburgh, NMS: A.1968.406

Registered 1968; previous history not known.

One of only two such staffs known (the other is in the museum in Angoulème, France), this one has a finial carved as a turtle above four Rarotongan-style figures with large ears. The upper part of the shaft is cut with V-shaped designs and has notching of the kind seen on the spines of staff god figures (nos 192–3); the lower part is plain.

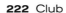

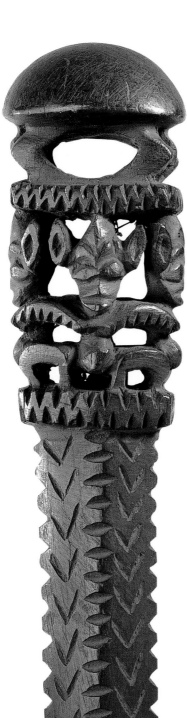

222 Club

Cook Islands, Atiu

Late eighteenth/early nineteenth centuries

Wood

L. 282.0 cm

London, BM: 7205

Donated 1871; previous history not known.

Large scalloped clubs of this kind, common in collections, have long been attributed to Rarotonga, but evidence for this assumption is hard to find. Formal analysis and an eye-witness account suggest that these were originally made on Atiu, though they may have found their way to Rarotonga and elsewhere. A number of them (Oldman 2004: pl. 31, no. 445c; Phelps 1976: pls 77–8, nos 606, 610; Buck 1944: fig. 179r–s) have collar designs as small figures of the central Cook Islands kind, and where they have 'eye' designs they are of eye and lids, with no additional brow line, which is characteristic of Rarotonga. Others, including this example, have a fine tip which is carved in exactly the same way as the tips of fan handles of central Cooks origin (no. 216). One variation of these clubs, unpointed with a saw-tooth edge, is likely to be the Rarotongan form, for the collar design is consistently of the eye, lids and single brow type (Buck 1944: 286; Phelps 1976: pl. 77, no. 618), but the more common scalloped type is most probably from Atiu. When Anderson was there in 1777 during Cook's third voyage, he noted: 'The clubs were about six feet long or more, made of a hard black wood launce shap'd at the end but much broader, with the edge nicely scollop'd and the whole neatly polish'd' (Beaglehole 1967: 841).

221

222

Western Polynesia

Western Polynesia is treated here as a 'culture area', following Burrows (1938). It is made up of a number of groups and nation states which are in close proximity – Fiji, Tonga, Western Samoa, American Samoa, Niue and Wallis ('Uvea) and Futuna, the last two part of French Polynesia. The region may be expanded to encompass the small Polynesian populations of Tokelau and

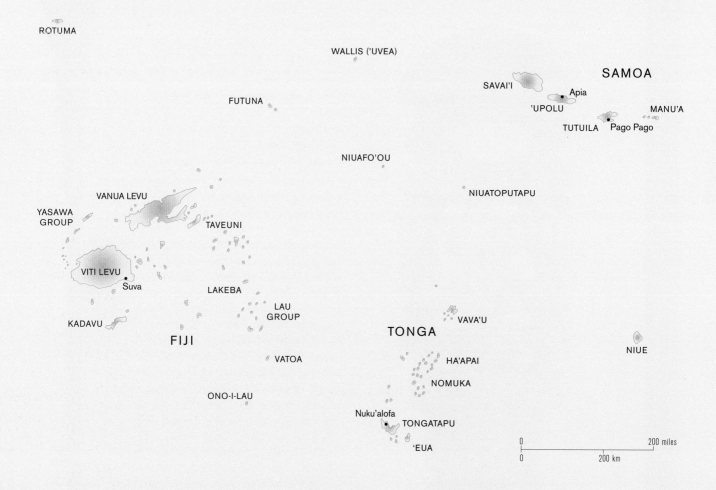

ROTUMA

WALLIS ('UVEA)

SAMOA

SAVAI'I

Apia

'UPOLU

MANU'A

FUTUNA

TUTUILA Pago Pago

NIUAFO'OU

NIUATOPUTAPU

VANUA LEVU

YASAWA
GROUP

TAVEUNI

VITI LEVU

Suva

LAKEBA

LAU
GROUP

VAVA'U

KADAVU

TONGA

NIUE

FIJI

VATOA

HA'APAI

NOMUKA

ONO-I-LAU

Nuku'alofa

TONGATAPU

'EUA

0 200 miles

0 200 km

Tuvalu, and those of the so-called Polynesian Outliers, islands such as Nukuoro, Kapingamarangi, Rennell, Bellona, Sikaiana, Nukumanu, Tikopia and Anuta. These now fall geographically within Micronesia or Melanesia, but have populations linguistically and culturally related to those of Western Polynesia, whence they originated several centuries ago in a Polynesian migratory 'backwash' westwards.

The earliest dates for human settlement of Western Polynesia suggest that some time around 1000 BC voyagers crossed the 700-mile divide between the main Melanesian islands and Fiji. These people made a distinctive dentate-stamped form of pottery called Lapita, named after the site on New Caledonia where it was first identified. These 'Lapita Peoples', who no doubt made return voyages, were the ancestors of modern Polynesians. After their arrival they appear to have consolidated in the region, prior to a further eastward exploratory push during the second half of the first millennium AD. Archaeological evidence indicates dynamic periods of cultural change around AD 1000–1200, and a period of fort-building in the fourteenth to sixteenth centuries.

By the eighteenth century chiefdoms were established throughout the region, their relative strengths waxing and waning as alliances and conflicts affected their relationships. An extensive exchange network existed between Fiji, Tonga and Samoa (Kaeppler 1978b). Tongan influence was increasing in eastern Fiji, and specialist carpenters were constructing large double canoes with efficient Micronesian rigs which allowed great manoeuvrability and maritime supremacy. Into this dynamic situation arrived Cook during his second and third voyages in the 1770s, and other Europeans such as Malaspina and D'Entrecasteaux followed. Cook named Tonga the 'Friendly Islands' and Bougainville in 1768 called Samoa 'Navigator's Islands'. Information about the first decades of the nineteenth century derives from the remarkable account by William Mariner of his four-year stay in Tonga between 1806 and 1810 (Mariner 1827), and from accounts of visits of sandalwood traders such as Lockerby to Fiji (Im Thurn and Wharton 1925).

Bêche-de-mer traders and missionaries of the London Missionary Society and the Methodist Mission arrived in the 1820s. Chiefs in Tonga were converted around 1830 but it was not until 1854 that Cakobau, Fiji's most powerful chief, converted to Christianity after a prolonged period of warfare between the major chiefdoms of Bau and Rewa (Sahlins 2004). Meanwhile Tongan expansionist policies, personified in the Christian warrior Ma'afu, were affecting eastern Fiji, a process only stopped by the cession of Fiji to Britain in 1874. Fiji became independent in 1970. Tonga, under the long-lived King George Tupou and his successors, has maintained its independence. Samoa fell increasingly under German influence in the late nineteenth century, before being split into two – Western Samoa (independent in 1962) and American Samoa.

The immense amount of activity in the region during the period under review means that the attribution of objects is often difficult. Samoan-Tongan carpenters were settled in eastern and coastal Fiji, working in the service of local chiefs to produce canoes and regalia made of shell and ivory. Their presence is manifested in the large amount of whale-ivory inlay which can be found in artefacts from this period. This was a result of the increased availability of whales' teeth and metal tools through trade with Europeans, and a cultural situation in which ivory was highly valued and strategically important.

Further information on Western Polynesian art and history may be found in: Clunie 1977, 1986; Williams 1858, 1931; Derrick 1950; Kaeppler 1999; St Cartmail 1997; Campbell 2001; Mallon 2002; Wilkes 1845; Huntsman and Hooper 1996.

223 Standing female figure

Tonga, Ha'apai, Lifuka

Late eighteenth/early nineteenth centuries

Wood

H. 37.5 cm

Auckland, AM: 32651

Acquired 1948; ex. collection William Oldman, no. 530 (Oldman 2004: 29, pl. 45); collected 1830 by LMS missionary Revd John Williams; old label on back: 'Goddess of Lefuga hung by Taufaahau on embracing Christianity, Hapai, July, 1830'.

A figure with sharply angled shoulders and pointed buttocks and calves, its feet are damaged and set into wax in a circular wood base. It has traces of dark red dye on the front. This image is illustrated by Williams (1837: 319–20) who described the occasion it was presented to him by Taufa'ahau, later to become King George Tupou of Tonga: 'On observing five goddesses hanging by the neck, I requested this intrepid chief to give me one of them, which he immediately cut down and presented to me. I have brought it to England, with the very string around its neck by which it was hung'. Although present when published by Oldman, the string has since disappeared. Hanging may not have been the act of desecration Williams imagined, since Taufa'ahau did not convert to Christianity until the following year (Kaeppler 1999: 21).

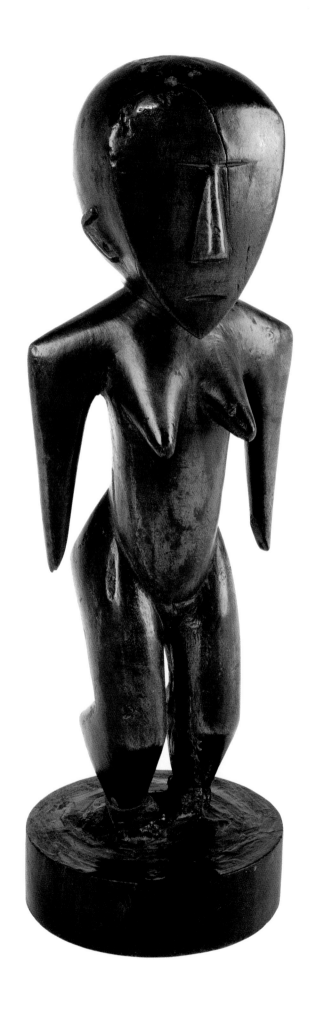

224 Standing female figure

Tonga, Ha'apai, Lifuka

Late eighteenth/early nineteenth centuries

Wood

H. 33.0 cm

Auckland, AM: 32652

Acquired 1948; ex. collection William Oldman, no. 531 (Oldman 2004: 29, pl. 46); previous history not known.

Similar to no. 223 but shorter and broader, with the same V-shaped ear form, this image has marks of rough treatment to the head and traces of red dye on the body. It is likely to have been one of several presented by Taufa'ahau in 1830 to Revd John Thomas and other missionaries (Larsson 1960: 59–60), possibly as a kind of tactical test for the priests of the new religion, prior to his decision about conversion.

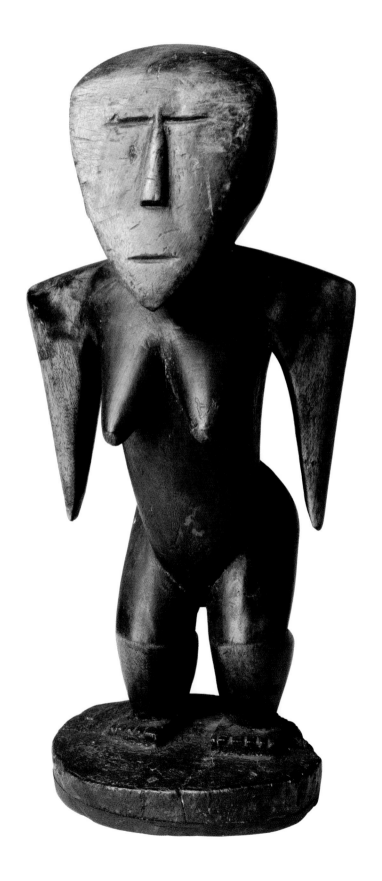

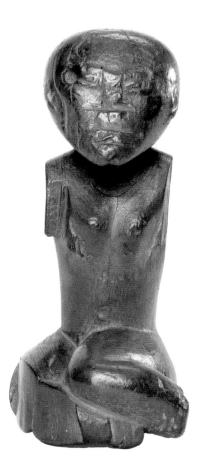

225 Seated female figure
Tonga
Late eighteenth/early nineteenth centuries
Wood
H. 19.1 cm
Auckland, AM: 32650
Acquired 1948; ex. collection William Oldman, no. 532
(Oldman 2004: 29, pl. 47); ex. collection O. Belsham,
acquired *c.* 1846.

This unique and sadly much mutilated figure
retains a certain dignity from the seated posture
which is still usual for women in the region today.
A cavity beside the right eye may be a flaw in the
wood or an intentional drilled hole. The ears are
naturalistically rendered. A detached label reads:
'Household Goddess of the Emperor of Tonga',
which refers to King George Tupou.

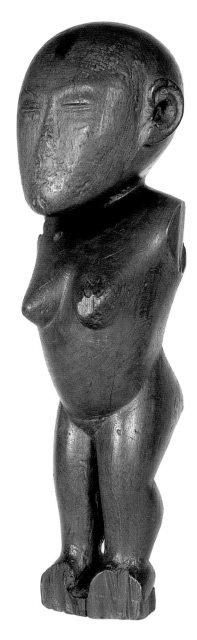

226 Standing female figure
Tonga
Late eighteenth/early nineteenth centuries
Wood
H. 36.5 cm
Aberdeen, MM: ABDUA 63365
Acquisition date not known (Hunt 1981:
no. 21); old label on back: 'Sakaunu a great
Tonga goddefs'.

Both arms are broken; at the right
shoulder there are traces of four holes
showing where the right arm was
previously reattached. The figure has
a disproportionately large head with
well-formed ears, thus contrasting in
style with nos 223–4, which are usually
attributed to Ha'apai. Figures may have
been made elsewhere in Tonga, as
visitors to Tongatapu during Cook's
second and third voyages saw images
at burial places there (Beaglehole 1961:
251; 1967: 139, 904; Forster 1777: 451–2).
'Sakaunu' is identified in an old Tongan
tradition as 'a goddess of the
underworld' (Kaeppler 1999: 21).

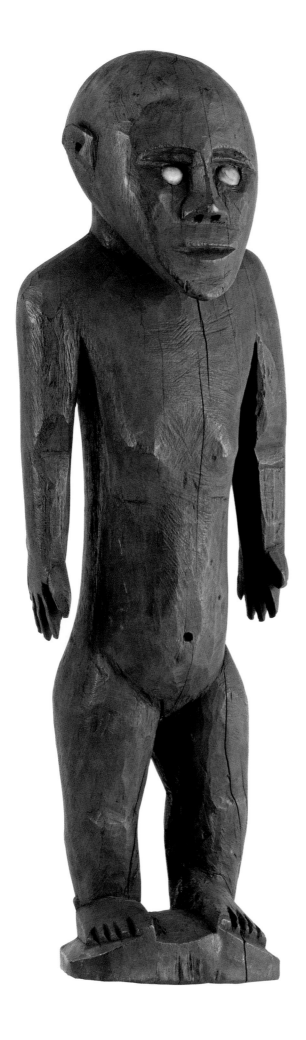

227 Standing figure
Samoa, Upolu Island
Early nineteenth century
Wood, opercula
H. 69.0 cm
London, BM: 1841,2-11,52
Donated 1841 by Queen Victoria; collected 1839 at Amaile, Aleipata district, Upolu Island, by LMS missionary Revd Thomas Heath.

This figure, documented as having been acquired in Samoa, has some formal similarities with the previous Tongan figures, although the facial features are closer to some Fijian images. Lines at the genitals indicate that a female is represented. The eyes are inlaid with opercula from a gastropod; nostrils and navel are deeply drilled. Davidson (1975) has discussed how this figure was associated with the preserved bodies of two chiefs, which parallels the association between images and burial places at Tongatapu (see no. 226). There was no established figure sculpture tradition in Samoa, so the origin of this image remains unclear (Mallon 2002: 88–91).

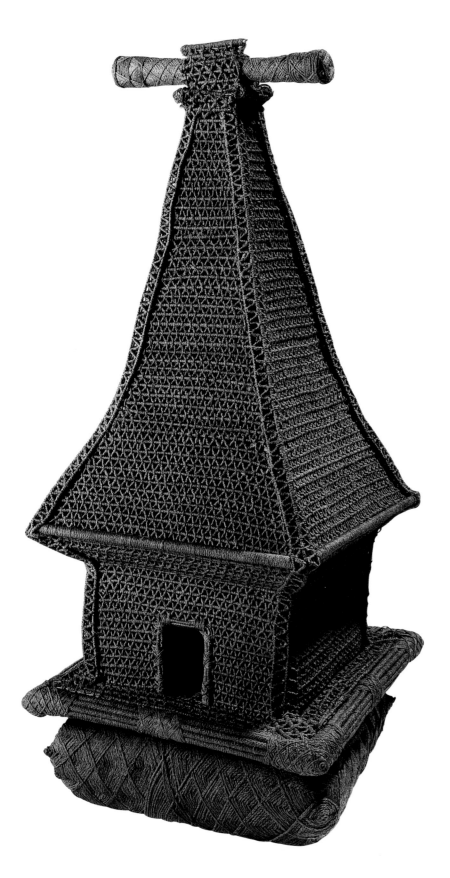

228 God house

Fiji

Early/mid-nineteenth century

Coir, reed

H. 108.5 cm

Edinburgh, NMS: 1868.79.2

Acquired 1868 from John W. Bradley (together with figure 1868.79.5).

A highly elaborately bound portable temple or shrine (*bure kalou*), it consists of a foundation of reeds wrapped in complex bindings of plaited coir cords. Many hundreds of metres of coir cord will have been used to construct it. The small figure (no. 229) is likely to have been associated with it (Clunie 2000); no. 231 was reportedly housed in a similar temple. The form is a miniature version of the full-size Fijian temple which had a tall roof, short ridgepole and elaborately bound timberwork and door frame.

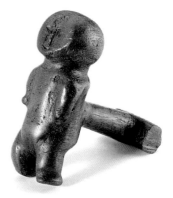

229 Figure with back projection

Fiji

Early/mid-nineteenth century

Wood

H. 12.5 cm

Edinburgh, NMS: 1868.79.5

Acquired 1868 from John W. Bradley (together with god house 1868.79.2).

This small figure and the coir god house (no. 228) may well belong together (Clunie 2000). An old museum catalogue entry reads: 'Idol of carved wood taken from a heathen temple. Fiji'. It has a partly broken T-shaped projection emerging from the back, purpose not known.

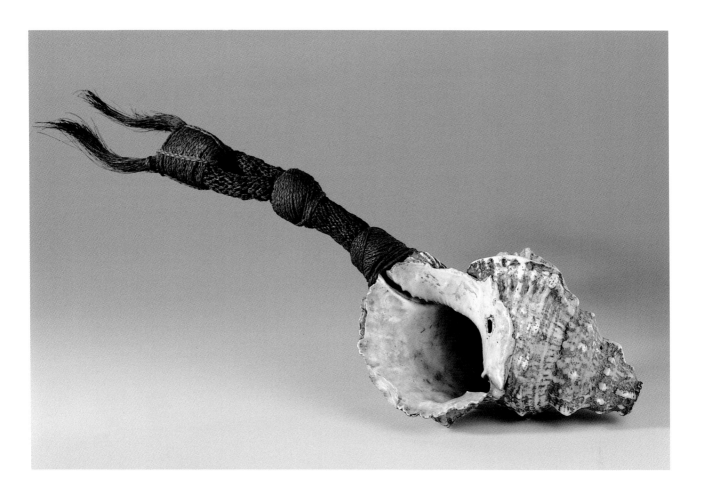

230 Shell trumpet

Fiji

Early/mid-nineteenth century

Bursa shell, coir

L. 60.5 cm

Cambridge, CUMAA: Z2886

Acquisition date not known; likely to have been collected by Baron Anatole von Hügel or an associate in 1875–7.

An end-blown trumpet (*davui*) of *Bursa lampas* shell with a modulating hole and elaborate coir bindings, it was used for signalling and sounding on important occasions – consultation with the gods, the death of a chief or return of a successful war party. Acquired by exchange with coastal people, shells were transformed into trumpets and kept in temples in the interior of Viti Levu (see Larsson 1960: 121–47). They were regarded as the shrine or voice of a god and are clear examples of how an object can be consecrated by being elaborately bound.

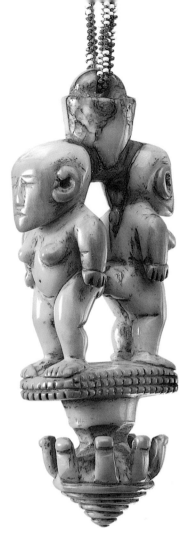

231 Double-figure hook

Fiji/Tonga

Eighteenth/early nineteenth centuries

Whale ivory, glass beads, fibre

H. 12.2 cm

Cambridge, CUMAA: 1955.247

Acquired 1955; collected by Sir Arthur Gordon, first Governor of Fiji, 1875–80.

Similar in general form to no. 232, this double-figure sculpture has a lug at the top for suspension by a fibre cord with coloured trade beads. Sir Arthur Gordon wrote a note about it: 'Tavita to-night produced and gave to me the "Nadi Devil," the idol of the Nadi district [western Viti Levu]. It consists of an ivory – cut out of whale's tooth and representing two women back to back with nine hooks below also of ivory. This figure represents Na Lila Vatu …' (Larsson 1960: 27). Gordon goes on to describe how it was kept in a small temple (possibly similar to no. 228) inside a larger one, and would speak, move around and demand offerings.

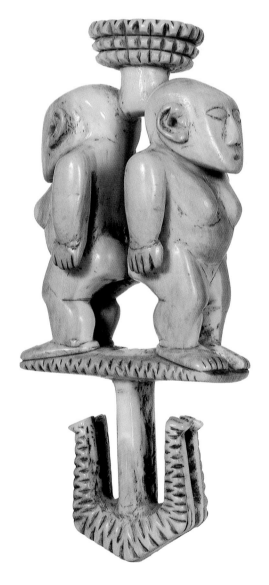

232 Double-figure hook

Fiji/Tonga

Eighteenth/early nineteenth centuries

Whale ivory

H. 14.5 cm

Aberdeen, MM: ABDUA 4651

Acquired 1899; ex. collection William MacGregor, chief medical officer in Fiji, 1875–88, given to him by Ro Matanitobua of Namosi, Viti Levu (Larsson 1960: 25).

This is one of four female double-figure hooks (one lost) which were collected in Fiji in the 1870s. Carved from a single sperm-whale tooth it has two angled holes forming a lug for suspension in the top. The ears have small deeply drilled holes. The similarity between these figures and the Tongan wood figures, especially no. 226 (note the ears) is clear, and there is no doubt that this double hook was made either in Tonga or by Tongan craftsmen resident in Fiji and working in the service of Fijian chiefs. MacGregor was told in the 1870s that it was venerated and had been in the possession of its previous owner's family for seven generations. These hooks may be of eighteenth-century date, but are more likely to be the product of the early nineteenth-century period when large whale teeth and metal tools became available.

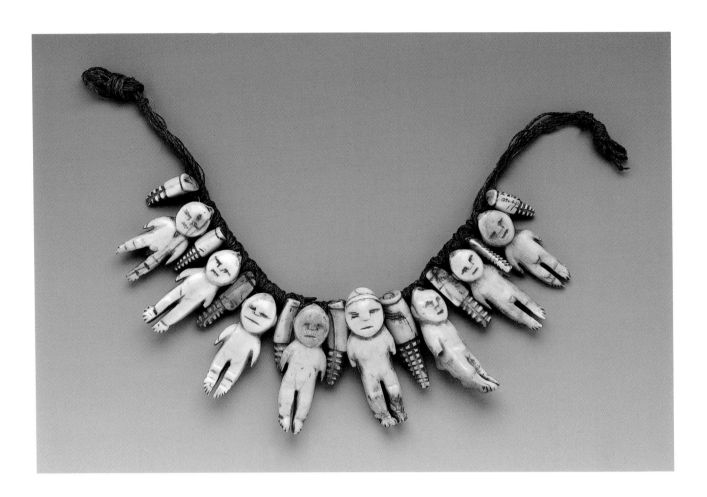

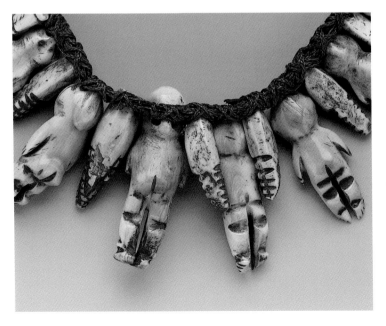

233 Figure necklace

Fiji/Tonga

Eighteenth/early nineteenth centuries

Whale ivory, coir

L. 52.0 cm; figure H. 9.6 cm (largest)

Cambridge, CUMAA: Z2752

Acquisition date not known; reportedly presented to Lady Gordon, wife of Sir Arthur Gordon, first Governor of Fiji, 1875–80.

This unique necklace is composed of eight figures and nine other pendants. All the figures are pierced for suspension at the back of the head; it is not known what the other pendants represent, but the distinctive notching is paralleled in nos 231–2 and Tongan food hooks of Cook voyage vintage (Kaeppler 1974: 79). The main figure appears to be carved in a Fijian style, with a band across the forehead. The darker honey colour of the back of the pendants is the result of contact with scented coconut oil.

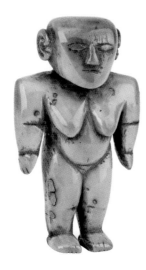

234 Female figure pendant
Tonga
Late eighteenth/early nineteenth centuries
Whale ivory
H. 6.2 cm
London, BM: 1954.Oc.2.1
Donated 1954 by Dorothy Oldman; ex. collection
William Oldman; previous history not known.

This female figure pendant has its original beautiful honey colour, resulting from smoking, rubbing and oiling, and being kept from bright light. The ears are well formed and a broken lug at the back of the head shows it was once worn as a pendant. It closely resembles in form and size a Cook second- or third-voyage example in Vienna (Kaeppler 1978: 207; Moschner 1955: 228–9; Gathercole *et al.*: 1979: 177).

235 Female figure pendant
Tonga
Late eighteenth century
Whale ivory
H. 3.3 cm
Norwich, SCVA: RLS 35
Given 1991 to Sir Robert Sainsbury by John
Hewett; possibly collected during Cook's
second or third voyage (Kaeppler 1978: 207).

Another very small pendant figure, it has a lug at the back of the head and a deep navel. It was stated by John Hewett to have come from the Colonial and Indian Exhibition held in London in 1886 and therefore to have a Cook voyage provenance (Kaeppler 1978: 281).

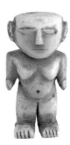

236 Female figure pendant
Tonga
Late eighteenth/early nineteenth centuries
Whale ivory
H. 3.4 cm
London, BM: TAH 134
Acquisition date not known, but registered
with material of known eighteenth-century
provenance.

A very small pale ivory figure with toes and fingers clearly marked, it has a broken suspension lug at the back of the head. It was catalogued in the nineteenth century as being from Tahiti.

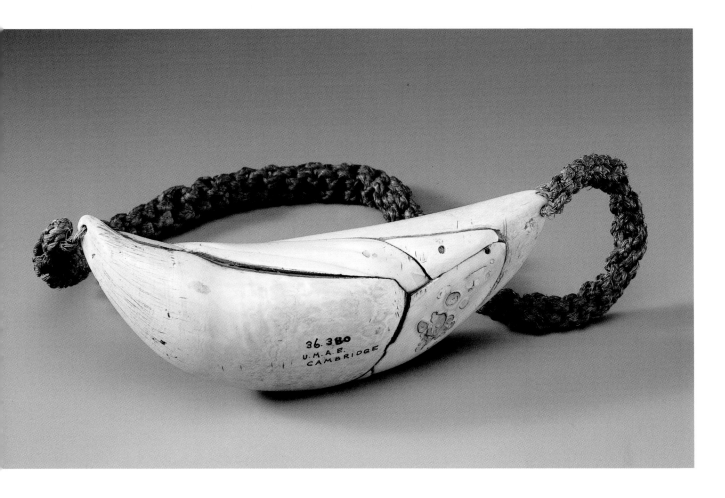

237 Composite presentation tooth

Fiji

Early/mid-nineteenth century

Whale ivory, coir

L. 27.2 cm

Cambridge, CUMAA: 1936.380

Donated 1936 by Alys Thurston, daughter of Sir John Thurston, Fiji resident and Governor, 1888–97; given to him by Ratu Peni Tanoa who took it from a temple in Naitasiri, Viti Levu.

This 'tooth' is composed of nine pieces of sperm-whale ivory – two whole teeth and seven other sections – assembled by a technique which renders the coir cords virtually invisible. A hole is pierced at each end for a braided coir cord.

Single whale teeth, called *tabua* (pronounced 'tambua'), held by a coir cord, were and are used in Fiji as presentation items at weddings, funerals and other important occasions. Acquired by chiefs from European traders in the early nineteenth century, they became highly important in strategic and dynastic exchanges by which chiefs increased their power and influence (Hooper 1982: 84–9). They also acted as shrines, as was the case with this unique composite example (see Roth 1937 for full discussion). As with other composite ivory work, it was probably assembled by Tongan/ Samoan craftsmen working in the service of Fijian chiefs.

238 Breastplate

Fiji

Early nineteenth century

Whale ivory, pearl shell, fibre

W. 26.7 cm

Cambridge, CUMAA: Z2730

Acquired 1918; collected by Sir Arthur Gordon, first Governor of Fiji, 1875–80.

This large composite breastplate (*civavonovono*) is of the kind which began to be made in the early decades of the nineteenth century by Tongan/Samoan canoe builders working in the service of Fijian chiefs. The techniques of manufacture of breastplates and canoe hulls are similar, with binding on the inside invisible from the outside. Clunie (1983a) has identified this as the breastplate worn by Tanoa Visawaqa, Vunivalu of Bau and father of Seru Cakobau, when he was sketched by Alfred Agate during the Wilkes expedition's visit to Fiji in 1840 (see p. 37). Gordon most likely received it as a 'royal' gift from Cakobau.

239 Breastplate

Fiji

Early nineteenth century

Whale ivory, coir, fibre

W. 23.5 cm

Cambridge, CUMAA: Z2749

Collected on 27 June 1875 by Baron Anatole von Hügel at Nakorovatu, interior Viti Levu, Fiji (Roth and Hooper 1990: 36).

Seven flat sections of whale ivory are butted together and secured by paired holes cut at an angle into the edge of each section. This Tongan/Samoan canoe builders' technique means that no bindings show on the front. Neck cords of coir are attached through nine holes drilled through the top. It is not clear if these rare ivory breastplates (*civatabua*) were forerunners of those incorporating pearl shell, but the Tongan chief Ma'afu told von Hügel in 1875 that it was an 'antique' from Tonga. He said his first visit to Fiji 'was caused by a similar ornament and he eventually bought a large canoe with it' (Roth and Hooper 1990: 144–5).

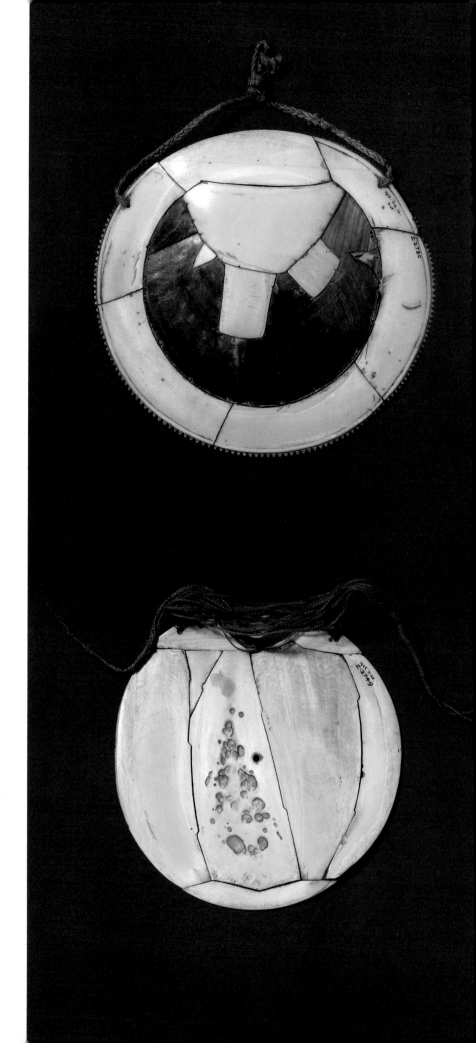

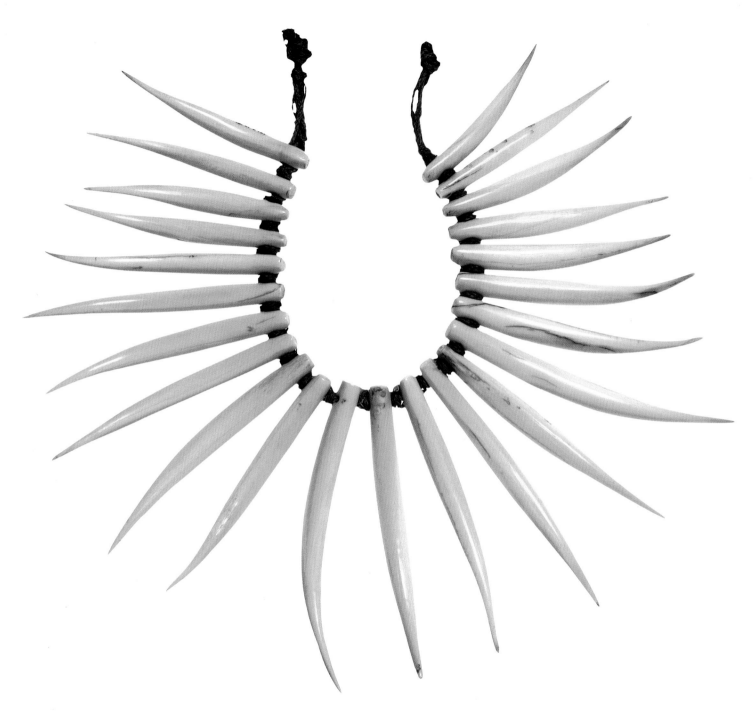

240 Necklace

Fiji

Early/mid-nineteenth century

Whale ivory, coir

L. 16.5 cm (longest tooth)

Oxford, PRM: 1940.10.54

Donated 1940 by Gladys Calvert; collected by her grandfather Revd James Calvert, Methodist missionary in Fiji, 1838–55, 1861–5; stated to have been given to Calvert by Seru

Cakobau, Paramount chief of Bau, in whose conversion to Christianity Calvert was instrumental.

This form of necklace (*waseisei*), also found in Samoa (Mallon 2002: 175–7), has long pendants cut from sperm-whale teeth. A refinement of the 1820–50 period, these necklaces were made by Tongan/Samoan craftsmen in relatively large numbers as chiefly regalia and strategic gifts for interior chiefs of Viti Levu, for whom whale-ivory objects were great valuables. Necklaces of modified teeth, 1–4 inches long, described by Mariner (1827: 250) as being made with rough metal tools in Tonga in 1806–10, are not likely to be this type, but rather the small-tooth type illustrated by Clunie (1986: nos 108–9).

241

241 Massive breastplate

Tonga

Late eighteenth century

Whalebone, coir

W. 71.8 cm

London, BM: Q82.Oc.874

Acquisition date not known, but similar to two large Cook second-voyage examples in Oxford and Göttingen (Kaeppler 1978: 211; Hauser-Schäublin and Krüger 1998: 318).

This enormous plate of whalebone, most likely a shoulder blade, has the remains of coir-cord neck ties secured through seven unevenly drilled holes along the top edge. On Cook's third voyage at 'Eua in 1777, Anderson saw a man at a demonstration club fight with 'a very large thick semicircular breast plate made of one piece of bone hung round his neck' (Beaglehole 1967: 964). Clunie (1986: 161) considers them to have served as a form of body armour against Fijian arrows.

242 Breastplate

Tonga

Late eighteenth/early nineteenth centuries

Whalebone

W. 16.4 cm

Private collection

Ex. collections Nelly van den Abbeele, 1999; George Ortiz, 1978; Robert Ramsden (d. 1865), Carlton Hall, Worksop.

A smaller breastplate, this example has a neat raised rim around the edge and three unevenly drilled suspension holes along the top edge. The type is possibly a forerunner of the composite breastplates, several of which also have rims around the edges (see no. 238).

242

243 Bucket with lid

Tonga, Tongatapu

Mid-/late eighteenth century

Wood, coir, shell beads

H. 44.5 cm (excl. cords)

London, BM: Q78.Oc.836a-b

Donated either in 1775 by Tobias Furneaux via the Admiralty or in 1778 by Sir Joseph Banks; collected 1773 during Cook's second voyage (Kaeppler 1978: 221); brought back on HMS *Adventure*.

This bucket has two hollowed wood semi-cylindrical sections, bound together with coir and encased in a tight sleeve of black and red coir decorated with tiny white and brown shell beads. The separate wood lid has a coir cover in black and red concentric circles. The base has the same concentric designs as the lid. Such receptacles were for storing valuables – ornaments, feathers, whale ivory – and appear to be a combination of the skilled labour of men and women. The bucket would not have been easy to excavate, and the coir wrapping is superbly executed and preserved. This piece was drawn by John Cleveley in 1774 shortly after the premature return of HMS *Adventure* from Cook's second voyage (Joppien and Smith 1985a: 156, 189).

245 Basket

Tonga

Late eighteenth century

Coir, shell beads

W. 17.0 cm

Edinburgh, NMS: A.UC473

Acquired 1850s; ex. collection University of Edinburgh; previous history not known.

This small basket (*kato*) decorated with white and brown shell beads has the character of a purse compared to the larger baskets and buckets, several of which were obtained on Cook's second and third voyages (Kaeppler 1978: 219–20).

244 Comb

Tonga

Early/mid-nineteenth century

Coconut leaflet midribs, coir

L. 18.6 cm

Exeter, RAMM: E1918

Collected 1865 by John Veitch, botanist during the voyage of HMS *Curaçoa* (Brenchley 1873).

This is a comb (*helu*) and hair decoration of the kind collected in large numbers in the 1770s and which continued to be made well into the nineteenth century. Thought to be the work of women, single strands of black and natural coir tie the midribs together in geometric patterns.

246 Basket

Tonga

Mid-/late eighteenth century

Cane, creeper, coir

L. 50.5 cm

London, BM: Q77.Oc.7

Ex. Leverian Museum 1806; collected during Cook's second or third voyage (Kaeppler 1978: 217–18).

Another type of Tongan basket (*kato*) made from coconut leaf midribs bound with black-dyed creeper. It has a coir-cord handle and the outer surface is decorated with fine flat-plaited coir cordage in triangular patterns; the base has well-preserved rectangular patterns, also in coir.

247 Mat in frame

Samoa, Upolu island

Mid-/late nineteenth century

Pandanus leaf, feathers; in a glazed frame

L. 98.5 cm (in frame)

Oxford, PRM: 1948.12.1B

Acquired 1948; given to Arthur Mahaffy (in Samoa 1896–1914) by chief Salanoa, nephew of Mata'afa, sometime 'king' of Samoa.

Mats (*'ie toga*) such as this, made in Samoa, were and are esteemed great valuables in the region and especially in Tonga. They were decorated with red feathers mostly obtained from Fiji. The Methodist missionary Revd Thomas Williams, referring to a place on Taveuni famous for its feathers, noted in 1844 that 'The Tonguese [Tongans] used to visit it in former days to procure these feathers which they conveyed to Samoa and exchanged for the fine mat dresses of that people' (in Clunie 1986: 150). See Schoeffel (1999) and Kaeppler (1999a) for full discussions.

247

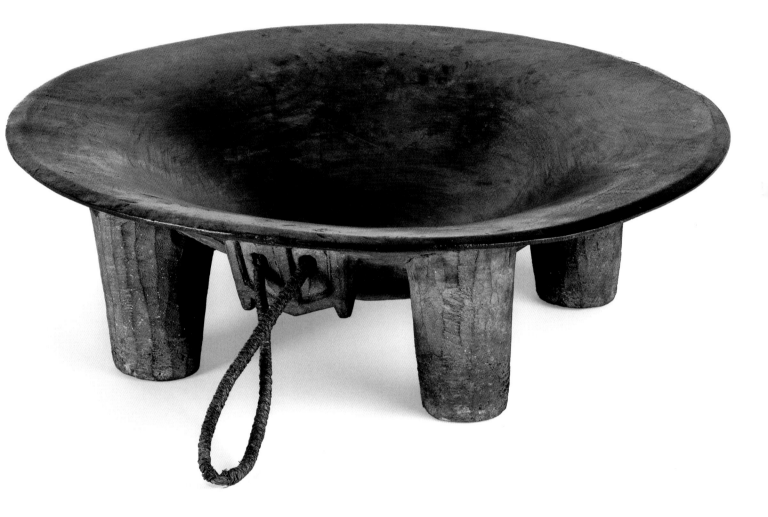

248 Kava bowl

Tonga/eastern Fiji

Eighteenth century

Wood, coir

W. 48.8 cm

London, BM: 1971.Oc.5.1

Purchased 1971; probably formerly in the
Leverian Museum and collected during Cook's
second or third voyage (Kaeppler 1978:
226–7).

Large bowls of this kind (*tanoa* or *kumete
ni yaqona*), cut from a single block, were
for the mixing of kava (*kava* in Tongan;
yaqona, pronounced *yanggona*, in Fijian),
a drink made from the roots and stems of
the pepper bush *Piper methysticum*, mixed
with water. In the eighteenth century the
Tongan style of kava preparation – a public
chiefly ritual (see above, p. 17) – was
spreading into eastern and coastal Fiji.
Specialist carpenters of Samoan descent,

the Lemaki, settled in Kabara in southern
Lau to make canoes and bowls from the
fine stands of *vesi* (*Intsia bijuga*) which
existed there (Clunie 1986: 168–75; Hooper
1982: 53–63). These bowls were distributed
by exchange throughout the region. This
bowl has kava deposits inside and closely
resembles one presented to Malaspina at
Vava'u in 1793 (La Caixa 2001: no. 101).

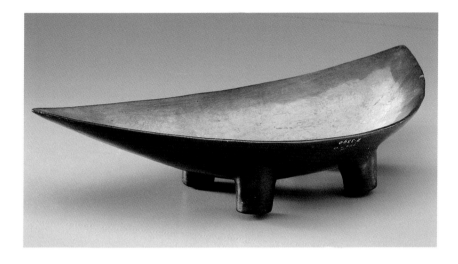

249 Kava bowl
Fiji
Early/mid-nineteenth century
Wood, coir
L. 44.0 cm
Cambridge, CUMAA: Z3390
Collected by Baron Anatole von Hügel in Fiji, 1875–7.

This semicircular bowl with four legs relates to the priestly, non-public form of kava preparation which occurred in Fiji at the time when the Tongan-style 'state' kava rituals were being introduced. The priestly *burau* procedure involved kava being mixed in concentrated form in a shallow bowl and being sucked through a tube (Clunie 1986: 168–9). In trance as a result, the priest would communicate with the spirits and convey medical diagnoses, advice or instructions. This bowl has a distinct patina of kava on the inside. It has a lug and coir cord by which it was hung up when not in use.

250 Kava bowl in duck form
Fiji
Early nineteenth century
Wood, shell
L. 46.3 cm
Norwich, SCVA: UEA 912
Robert and Lisa Sainsbury Collection; acquired 1985 from John Hewett; ex. collection Harry Beasley, no. 354, purchased Canterbury, Kent, 1908; probably collected in Fiji in 1849 by Captain John Erskine (Hooper 1997: II: 32–5).

This duck-shaped bowl is another used in the priestly *burau* form of kava drinking (see no. 249). Cut from one block, the legs connect to a circular base and the eyes have shell ring inlay (the left missing). Bowls in duck form are extremely rare; two are in the Fiji Museum (Clunie 1986: 169), another in Tasmania (Ewins 1982: 60).

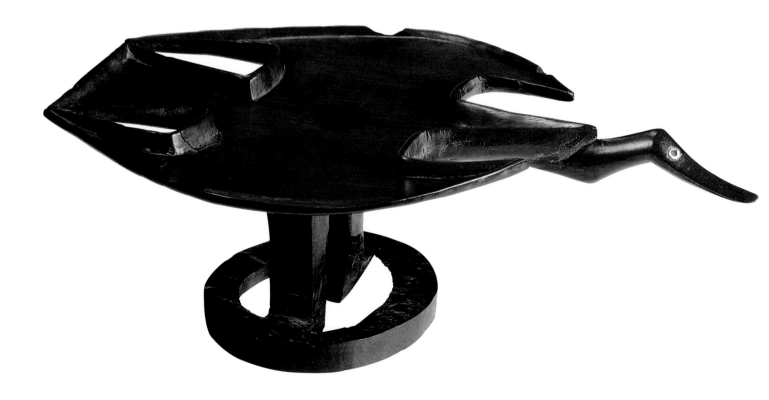

251 Bowl as a figure

Fiji

Early nineteenth century

Wood

H. 26.8 cm

London, BM: 1842,12-10,127

Acquired 1842; collected 1841 by Edward Belcher during the voyage of HMS *Sulphur*.

Bowls carved as a shallow figure (*daveniyaqona*) are rare and were used for priestly *burau* kava drinking rites. This example has extensions to the heels which balance the bowl when it is placed flat; a lug at the back of the head is for a suspension cord when not in use. Similar examples, and the *burau* method of use, are discussed in detail by Clunie (1986: 168–9; 1996).

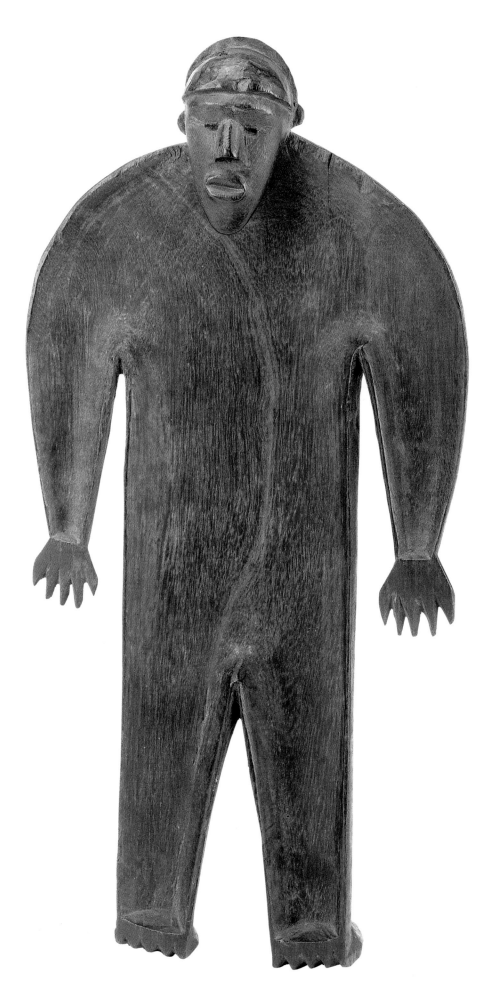

252 Whisk

Tonga

Mid-/late eighteenth century

Wood, coir

L. 45.0 cm

London, NMM: L15/94/C

Probably collected during Cook's second or third voyage; said to have been acquired from the great granddaughter of Cook's sister Margaret (Kaeppler 1978: 224).

Whisks (*fue*) were used as insignia of status and as orators' accessories. Some collected on Cook's second and third voyages have carved handles with ivory inlay. This example appears to have been made from a modified spear point, possibly of Fijian origin. Spears which had done injury in battle were consecrated; this whisk may be from such a spear and have had a priestly owner.

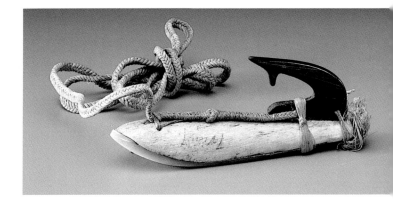

253 Fish hook and line

Tonga

Late eighteenth/early nineteenth centuries

Whalebone, pearl shell, turtle shell, fibre

L. 15.7 cm

Cambridge, CUMAA: Z3322

Acquired 1912; ex. collection Sir Arthur Gordon, first Governor of Fiji, 1875–80; presented to him by the Tongan chief Ma'afu.

Large composite trolling hooks of this kind were collected in the eighteenth century and were still in use as exchange valuables in August 1875, when this example was presented by the Tongan chief Enele Ma'afu'otu'itoga to the newly arrived Governor of Fiji, Sir Arthur Gordon. Baron von Hügel recorded that Ma'afu presented 'a splendid large fish hook made of tortoiseshell, pearl and sinnet. "You have got the land. I bring you the water, as land without water is useless. Here it is with all the fish and living creatures in it." It was a most characteristic offering, for the Tongans are great sailors and fishermen' (Roth and Hooper 1990: 120).

254 Fish hook and line

Tonga

Mid-/late eighteenth century

Pearl shell, turtle shell, coir, fibre

L. (hook) 6.2 cm

Edinburgh, NMS: A.1956.1010

Ex. collection Society of Antiquities of Scotland; donated 1781 to the SAS by Sir John Pringle; given to Pringle by Captain Cook's widow; collected during Cook's second or third voyage (Kaeppler 1978: 43, 235–6).

This smaller type of trolling hook is of simpler construction than no. 253, but has a similar manner of attaching the point to the shank and line. It may once have had a white feather hackle to cause turbulence in the water and attract fish to bite.

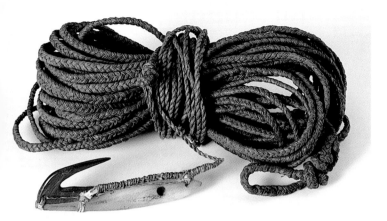

255 Headrest

Tonga

Mid-/late eighteenth century

Wood

L. 56.0 cm

Oxford, PRM: 1886.1.1418

Acquired 1886, ex. Ashmolean Museum; donated 1776 by Johann Reinhold and George Forster to Oxford University; collected 1773–4 by the Forsters during Cook's second voyage (Kaeppler 1978: 228; Coote *et al.* 2001).

Carved from a solid block, this headrest (*kali*) was used as a pillow to prevent the elaborate hairdressing of high-status people from becoming disarranged. A fine ridge is found at each end of the bar and another runs along the centre of the underside. Short flat linking bars between the feet are broken. Most known headrests of this type appear to have been collected on Cook's second and third voyages (Kaeppler 1978: 228–9), suggesting that the style went out of fashion by the nineteenth century, being replaced by others.

256

256 Headrest

Fiji

Early/mid-nineteenth century

Wood, whale ivory, coir

L. 52.8 cm

Cambridge, CUMAA: Z3665

Collected by Baron Anatole von
Hügel in Fiji, 1875–7.

This type of headrest (*kali*), in which two separate
pairs of legs are tied snugly into a horizontal bar,
is more associated with Fiji and with Fiji-based
Tongan canoe builders in the first half of the
nineteenth century. The bar has a beautiful natural
ripple in the wood (probably *Casuarina sp.*) and
the legs are inlaid with small discs of whale ivory,
associated with Tongan work on Fijian artefacts.

257 Headrest

Fiji/Tonga

Early nineteenth century

Wood

L. 31.1 cm

Exeter, RAMM: E1612

Donated by Bishop Henry Phillpotts; collected by
Lt George Phillpotts, 1843–5.

An elegant form of headrest associated with
Tonga, it may have been made in eastern Fiji.
It has 'FEEJEE ISLANDS' in faded ink on the
top, so is likely to have been collected in Fiji.

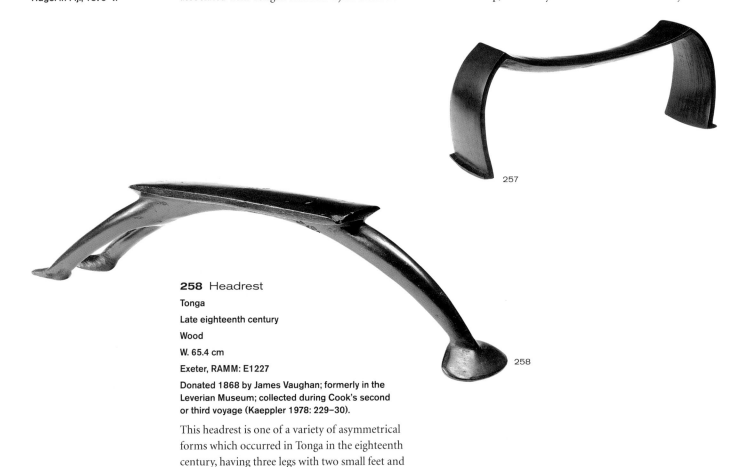

257

258 Headrest

Tonga

Late eighteenth century

Wood

W. 65.4 cm

Exeter, RAMM: E1227

Donated 1868 by James Vaughan; formerly in the
Leverian Museum; collected during Cook's second
or third voyage (Kaeppler 1978: 229–30).

This headrest is one of a variety of asymmetrical
forms which occurred in Tonga in the eighteenth
century, having three legs with two small feet and
one large.

258

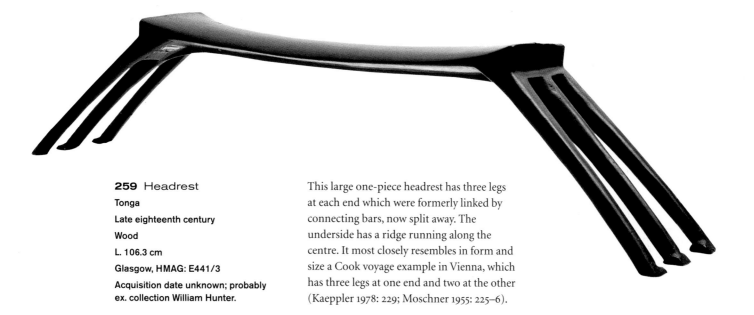

259 Headrest

Tonga

Late eighteenth century

Wood

L. 106.3 cm

Glasgow, HMAG: E441/3

Acquisition date unknown; probably ex. collection William Hunter.

This large one-piece headrest has three legs at each end which were formerly linked by connecting bars, now split away. The underside has a ridge running along the centre. It most closely resembles in form and size a Cook voyage example in Vienna, which has three legs at one end and two at the other (Kaeppler 1978: 229; Moschner 1955: 225–6).

260 Club/headrest

Tonga/Fiji

Late eighteenth/early nineteenth centuries

Wood, whale ivory

L. 110.5 cm

Auckland, AM: 31810

Acquired 1948; ex. collection William Oldman, no. 535 (Oldman 2004: 12, pl. 23); previous history not known.

A unique object cut from one block, the carving of this club/headrest was a *tour de force* by an unnamed Tongan or Fiji/Tongan master carpenter. The bar is a pole club of the type called *povai* in Tonga; the legs, with a few breaks, have Tongan stylistic associations. The whole piece is inlaid with forty-one stars, crescents and birds of whale ivory, which is associated with Tongan carvers in Fiji. They produced whale-ivory objects, or inlaid others, for their chiefly mentors and sponsors to use as shrines and as strategic presentations to allies.

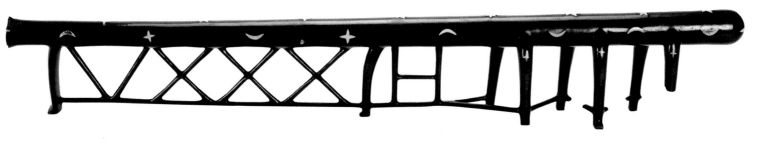

261 Club

Tonga

Mid-/late eighteenth century

Wood, coir

L. 116.0 cm

Exeter, RAMM: E1217

Donated 1868 by James Vaughan; formerly in the Leverian Museum, collected during Cook's second or third voyage (Kaeppler 1978: 238–9).

There was a wide variety of medium-sized clubs in use in the region, mainly in Fiji and Tonga – those from Samoa probably being Tonga-derived. This example has a pointed spatulate form with criss-cross coir binding on the lower shaft. The head is decorated with shallow circles on both sides; the upper shaft has alternating panels of scratched engraving on either side of the median line. As has been seen in the Cook Islands (no. 202), binding with coir cord was a way of consecrating or making objects special. Surface carving could be interpreted as an equivalent process.

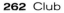

262 Club

Tonga

Mid-/late eighteenth century

Wood

L. 111.0 cm

Mark and Carolyn Blackburn Collection

Formerly in the Leverian Museum, collected during Cook's third voyage (Force and Force 1968: 124; Kaeppler 1999: 29–30).

This flat-topped club with a lozenge-section upper shaft is completely covered in geometric, zoomorphic and anthropomorphic engraved designs. It is among the finest examples of the club-makers' art and Kaeppler (1999: 30) considers it may have been presented to Cook by the Tu'i Tonga. The meanings, zoning and iconography of Tongan club designs are obscure, but they may be connected to tattoo, matting and barkcloth designs – all forms of surface marking and wrapping (Mills 2003).

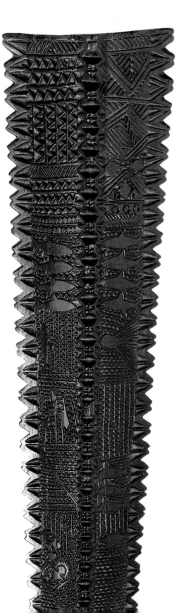

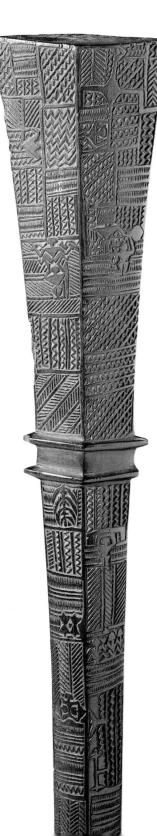

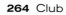

263 Club

Tonga

Mid-/late eighteenth century

Wood

L. 102.0 cm

Cambridge, CUMAA: D1914.79

Acquired 1914, ex. collection Trinity College, Cambridge; donated 1775 by the Earl of Sandwich; collected 1773–4 during Cook's second voyage (Kaeppler 1978: 39, 238).

Similarly covered in carefully zoned engraving, some incorporating zoomorphic and anthropomorphic figures, this club of *apa'apai* form has a plain double collar separating the head from the shaft, and a small lug at the butt. Regarding the significance of clubs, the Revd John Thomas observed that 'many of the gods had what was called the hala, or way, which was a carved club – most sacred, by which the god was supposed to enter the priest' (Larsson 1960: 67).

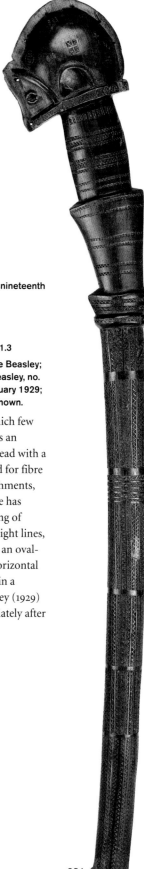

264 Club

Fiji

Late eighteenth/early nineteenth centuries

Wood

L. 107.0 cm

London, BM: 1941.Oc.1.3

Donated 1941 by Irene Beasley; ex. collection Harry Beasley, no. 2279, acquired 25 January 1929; previous history not known.

A type of club of which few examples exist, it has an anthropomorphic head with a median crest pierced for fibre and/or feather attachments, now lost. The handle has usual Fijian engraving of zigzags between straight lines, and then swells into an oval-section neck with horizontal bands of engraving in a different style. Beasley (1929) published it immediately after he acquired it.

263

264

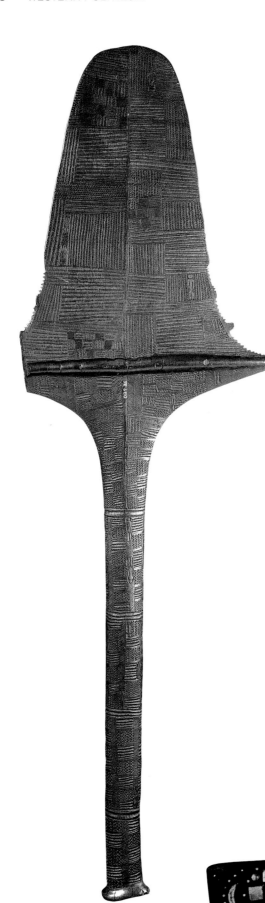

265 Paddle club

Fiji

Late eighteenth/early nineteenth centuries

Wood

L. 119.5 cm

Cambridge, CUMAA: 1932.680

Donated 1932 by E.K. Waterhouse; collected by his father's brother (either Joseph or Samuel Waterhouse, Methodist missionaries in Fiji in the 1850s).

This large paddle-shaped club is completely covered in engraved designs in what is regarded as Fijian style. Incorporated into the designs are several elongated anthropomorphic figures, different from those found on Tongan clubs. Clunie (1986: 185) considers this type (*culacula*) to be a priest's or chief's club, possibly also serving as a form of armour to protect against war arrows. Clunie (1977) provides detailed information on Fijian clubs and warfare.

266 Musket

USA/Fiji

Early/mid-nineteenth century

Metal, wood, whale ivory, glass beads

L. 145.5 cm

Aberdeen, MM: ABDUA 38487

Acquired 1915; collected 1876 in Fiji by A.J.L. Gordon (cousin of Sir A.H. Gordon, Governor of Fiji).

A United States Army 'Harper Ferry' flintlock, dated 1821, this musket will have arrived in Fiji during the bêche-de-mer trading days of the 1820s and 1830s. It is remarkable in the degree to which it has been 'domesticated' as a weapon by being inlaid with whale ivory segments and a few white trade beads on both sides of the stock and alongside the barrel. This work was done by Tongans resident in Fiji to enhance clubs, muskets and other valuables destined for exchange with peoples of the interior. Muskets were highly prized trade goods, used as clubs if their main function failed. Clunie (1983) has discussed this and the other two surviving examples, all acquired by Arthur Gordon from the hill tribes of Viti Levu after the 1876 'Little War' (Gordon 1879).

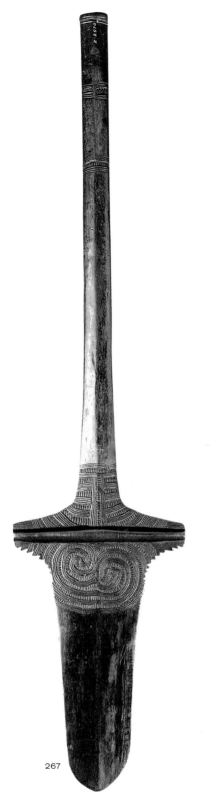

267

267 Paddle club with Maori designs

Fiji

Early/mid-nineteenth century

Wood

L. 109.2 cm

Cambridge, CUMAA: Z2970

Acquired 1900; previous history not known.

There are about forty clubs in collections with a Fijian form and New Zealand Maori engraved designs. Walcott (1912), Larsson (1960: 107–9) and Phelps (1976: 181, 203) have discussed the puzzle briefly. A club in Cambridge with a 'Maori' handle (Z3111) may furnish the clue. It was collected in March 1876 by Baron von Hügel with information that it was called 'Vaka Nairai … owing to some peculiarity in its carving which was first worked on the island of Nairai'. Bêche-de-mer traders and others picked up crew from the Bay of Islands in New Zealand in the 1820s, and it is possible that a Maori jumped ship, settled on Nairai and began to decorate Fijian clubs. The standardized style and lack of confidence in execution suggests that he may not have been a specialist carver, but someone who turned his hand to it in the style he knew.

268 Club

Fiji

Early/mid-nineteenth century

Wood, whale ivory, coir

L. 110.5 cm

Private collection

Ex. collection A.H.L.F. Pitt Rivers, Farnham, Dorset; acquired 25 August 1882 from Sir Arthur Gordon, first Governor of Fiji, 1875–80.

Inlaid with seventy-four pieces of whale ivory and bone, this is the kind of 'royal' club which Sir Arthur Gordon will have received from Cakobau or another powerful chief in the 1870s. The thirteen small ivory discs in the head may be earlier inlay than the larger shapes down the shaft. This inlay was done by Tongan craftsmen based in Fiji, providing chiefs with valuable items for strategic exchanges and presentations. Unusual is a deep cup-like depression in the butt, which may have been for drinking kava (*yaqona*). This is from Pitt Rivers' second collection; the first went to Oxford (Waterfield 2002).

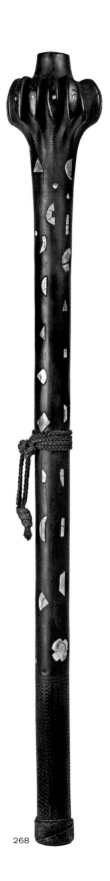

268

Collectors, dealers and institutions

BY KAREN JACOBS

This appendix lists in alphabetical order the main collectors and dealers (and some institutions) mentioned in this book. This includes people who collected 'in the field', and others through whose hands these objects subsequently passed. Biographical sketches are provided, plus other information relevant to Polynesian objects, including bibliographical references. Many of the listed collectors have an entry in the *Oxford Dictionary of National Biography*. Dunmore (1991) and Gunson (1978) give overviews of the main voyagers and missionaries respectively.

Allan, George (1736–1800) Lawyer (until 1790) and antiquary. His private museum opened to the public in 1792 (in Darlington until 1794, then at Blackwell Grange). On his death it remained at Blackwell Grange until 1822, when it was bought for £400 by the Newcastle Literary and Philosophical Society (prior to a planned auction). It forms the foundation of the Hancock Museum, University of Newcastle (Jessop 2003).

Anderson, John (1726–96) Held the Chair of Natural Philosophy at the University of Glasgow. He bequeathed his estate, collections and library to found a new university (Anderson's Institution, now Strathclyde University). His scientific, natural history and ethnographical collections were housed in the Andersonian Museum. In 1888 most ethnographical material was donated to the Hunterian Museum (Jackson 1979; Wood 2004–5).

Balfour, Henry (1863–1939) Curator of the Pitt Rivers Museum, Oxford (1891–1939). A zoologist, naturalist and collector, he travelled widely, including to Australia and the Pacific (Hutton 1939; La Rue 2004–5).

Banks, Sir Joseph (1743–1820) Studied at Christ Church, Oxford, and devoted his life to the study of natural history (Carter 1988; Gascoigne 1994). A self-funded member of Cook's first voyage (1768–71), he collected extensively and donated collections to Christ Church (now in the Pitt Rivers Museum), and to **Lord Sandwich** (now in Cambridge and the British Museum). He continued to acquire material from Cook's subsequent voyages; he gave a collection to **Thomas Pennant** that went to Cambridge, and transferred other Cook third-voyage material to the British Museum (Beaglehole 1962; Coote 2004; Kaeppler 1978: 40–42).

Bean, Thomas (1726–96) A.B. (Able-Bodied seaman) on HMS *Discovery* during Cook's third voyage, 1776–80 (Beaglehole 1967: II: 1473; Kaeppler 1978: 46).

Beasley, Harry Geoffrey (1881–1939) Wealthy brewery owner and private collector. In 1928 he established the Cranmore Ethnological Museum, Chislehurst, Kent. He bequeathed the bulk of his collection to museums in Britain, the British Museum having first choice. His wife, Irene Marguerite Beasley, administered the distribution (Phelps 1976: 15; Waterfield and King forthcoming).

Beechey, Sir Frederick William (1796–1856) Naval officer and hydrographer. He commanded HMS *Blossom* during an expedition to the Pacific in 1825–8. Together with his lieutenants, **Edward Belcher** and **George Peard**, he transferred over 340 artefacts to the Pitt Rivers Museum, Oxford, the British Museum and the Royal Albert Memorial Museum, Exeter (Beechey 1831; Bockstoce 1977). In 1836 Beechey returned to the Pacific on a surveying expedition, but bad health forced him to retire.

Belcher, Sir Edward (1799–1877) Assistant surveyor on the voyage of HMS *Blossom* to the Pacific (1825–8), commanded by **Frederick Beechey**. He commanded HMS *Sulphur* during a hydrographic survey expedition, 1835–42, after Beechey became ill (Belcher 1843).

Belfast Natural History and Philosophical Society Founded in 1821, the Society encouraged local ship owners to acquire objects for the museum. In 1910 the collection was transferred to the Ulster Museum, where it formed the nucleus of the ethnographical collections (Glover 1994: 2).

Bennet, George (1775–1841) Belonged to the London Missionary Society deputation, together with Revd Daniel Tyerman, which visited missionary stations around the world (1821–9). Three years (1821–4) were spent in Polynesia (Bennet 1833; Montgomery 1831). He made a large ethnographical collection which was distributed to the LMS Museum, the Saffron Walden Museum, the Sheffield Literary and Philosophical Society, and the Leeds Philosophical and Literary Society (Woroncow 1981).

Bevan, Professor Anthony Ashley (1859–1933) Orientalist, biblical scholar and benefactor to the Cambridge University Museum of Archaeology and Anthropology (CUMAA), providing funds for the building and the ethnographical collections. A gallery was named after him, now the Bevan work room.

Blackburn, Revd John Stationed in New Zealand around 1844, he was a donor to the Yorkshire Philosophical Society Museum (Starzecka 1998: 154).

Bond, Lt Francis Godolphin (1765–1839) First Lt on HMS *Providence* during Captain William Bligh's (1754–1817) second (successful) expedition to Tahiti (1791–3) to transfer breadfruit trees to the West Indies (Oliver 1988).

Boulter, Daniel (1740–1802) Dealer in books, natural history and ethnographical material – including artefacts purchased from Cook's ships. He opened his *Museum Boulterianum* in Great Yarmouth in 1778 and produced a sale catalogue (Boulter 1793; Jessop 2003: 93; Kaeppler 1974: 70).

Brady, George (1832–1921) Physician, who with his brother Henry (1835–91), a chemist, donated artefacts to CUMAA in 1891, including material collected in Polynesia in 1835–7 by the Quaker missionary **Revd Daniel Wheeler**. Both brothers were members of the Royal Society (http://www.royalsoc.ac.uk; CUMAA 1892: 6).

Brassey, Baroness Annie (1839–87) Travelled around the world in 1876 with her husband Baron Thomas Brassey (1836–1918) and their children in the steam yacht *Sunbeam* (Brassey 1878). Subsequent voyages were made, during which collections were assembled and kept at their home, Durbar Hall. In 1889 the Hall became known as the 'Lady Brassey Museum', open to the public by appointment. In 1919 the collections were transferred to the Hastings Museum (http://www.hmag.org.uk).

Brooke, Sir Thomas (1830–1908) Lived in Huddersfield, and was a collector of books and Orientalia (Phelps 1976: 15, 411).

Bullock, William (early 1780s–after 1843) Silversmith, collector of natural history and ethnographical material. He opened a museum in Liverpool in 1795 and moved to London in 1809 where his 'London Museum' became popular, especially when moved to the Egyptian Hall, Piccadilly (1812). The Pacific collection contained Cook voyage objects, many obtained from the **Leverian Museum** sale (1806). His museum was sold at auction in 1819, after which he travelled in Mexico (Bullock 1979; Kaeppler 1974; Waterfield and King forthcoming).

Byron, Lord George Anson (1789–1868) Commander of HMS *Blonde* (1824–5) when the remains of King Kamehameha II (Liholiho) and Queen Kamamalu, who had both died of measles during their visit to Britain, were returned to Hawaii. **Edward Belcher** accompanied him. Byron erected a cross to the memory of **Captain Cook** at Kealakekua, Hawai'i (Byron 1826; Dunmore 1991: 45–6).

Calvert, Revd James (1813–92) Methodist missionary in Fiji 1838–55 (Gunson 1978: 352). Part of his collection was presented to Queen Victoria (now in the British Museum); part was donated by relatives to the Pitt Rivers Museum.

Christy, Henry (1810–65) Banker and textile manufacturer. He was interested in travelling and collecting ethnographical material himself or from third parties. On his death, his ethnographical collection (of over a thousand objects) was transferred to the British Museum and a fund was set up to sponsor the expansion of the BM's ethnographical collections (King 1997: 137–9).

Clarke, Louis (1881–1960) Succeeded **Baron von Hügel** as curator at CUMAA (1922–37). He later became director of the Fitzwilliam Museum, Cambridge (1937–46) (Ebin and Swallow 1984: 25).

Clerke, Captain Charles (1741–79) Midshipman on HMS *Dolphin* during John Byron's voyage to the Pacific (1764–6); Master's Mate and Third Lt on HMS *Endeavour* during Cook's first voyage (1768–71); Second Lt on HMS *Resolution* during Cook's second voyage (1772–5). He commanded HMS *Discovery* during the third voyage (1776–80) and took command of the expedition when Cook died. He died due to illness in Kamchatka (22 July 1779) and left his collections to **Joseph Banks** (Dunmore 1991: 59–60).

Colenso, William (1811–99) Printer and bookbinder. He joined the Church Missionary Society and moved to New Zealand in 1834 to set up their printing press. He travelled in North Island and printed the New Testament in the Maori language with Revd William Williams (Bagnall and Petersen 1948).

Conybeare, John Josias (1779–1824) Church of England clergyman, antiquary and geologist who published scientific papers. His descendant Frederick Cornwallis Conybeare (1856–1924) was a biblical and Armenian scholar who catalogued the Armenian manuscripts in the British Museum and the Bodleian Library, Oxford (Torrens 2004–5; Margoliouth and Stearn 2004–5).

Cook, Captain James (1728–79) Famous for his meticulous survey work, he commanded three major Pacific expeditions. The first (1768–71) was to observe the transit of Venus from Tahiti and the second (1772–5) to search for a southern continent. During the third (1776–80), to search for a northwest passage between the Pacific and Atlantic oceans, he 'discovered' the Hawaiian Islands, where he

was killed (14 February 1779). The majority of his third-voyage collection went to **Sir Ashton Lever** (Beaglehole 1955, 1961, 1967, 1974; Joppien and Smith 1985–8; Kaeppler 1978).

Croker, Thomas Crofton (1798–1854) Antiquary. The author of literary work ranging from Irish legends to historical and ethnographical studies. He focused on collecting antiquities between 1837 and 1846; his collection was auctioned soon after his death (McCormack 2004–5).

Cuming, Hugh (1791–1865) Conchologist and collector of natural history specimens. He travelled to Polynesia in 1827–8 in the schooner *Discoverer*, the first vessel designed specifically to store natural history objects (Dance 2004–5).

Cuming, Richard (1777–1870) Collector of geological specimens. He purchased Pacific artefacts at the **Leverian Museum** sale (1806) and later auctions. His son Henry Syer Cuming (1817–1902) expanded his collection and left it to the Metropolitan Borough of Southwark to be displayed. The Cuming Museum opened in 1906 (http://www.southwark.gov.uk/Discover Southwark/Museums/TheCumingMuseum).

Devon and Exeter Institution Founded in 1813 to promote public education, particularly in the history, literature and arts of southwest England. Initially a library and museum with natural history specimens and antiquities, the collections were transferred to the Exeter Museum (RAMM) between 1868 and 1871 (http://www.devonandexeterinstitution.org.uk).

Edgar, Revd Professor John (1798–1866) United Secession Church Minister and professor of theology at the Belfast Academical Institution (Miller 2004–5). He was the donor of one object to the Ulster Museum.

Erskine, Captain John Elphinstone (1806–87) Commander of HMS *Havannah* on a surveying voyage (1849–51) to the western Pacific (as instructed in 1849 by **Sir George Grey**, Governor of New Zealand) (Erskine 1853).

Forster, Johann Reinhold (1729–98) and George Adam (1754–94) Father and son, both joined Cook's second voyage as naturalists and published their experiences (J. Forster 1778, 1982, 1996; G. Forster 1777, 2000). They sent a collection of about 181 objects to Oxford (PRM) in 1776 with a 'Catalogue of Curiosities' (Coote *et al.* 2000; Gathercole 1970) and donated about 500 objects to the Institute of Ethnology, University of Göttingen (Hauser-Schäublin and Krüger 1998).

Franks, Sir Augustus Wollaston (1826–97) Began working in the British Museum in 1851, and became Keeper of the Department of British and Medieval Antiquities and Ethnography. Franks made acquisitions using his own resources and the **Henry Christy** Fund. He recorded other museum collections in notebooks, which may have been wishlists for BM acquisitions, but which are now valuable documents since many of these collections have been dispersed (Caygill and Cherry 1997; King 1997: 149).

Fuller, Captain Alfred Walter Francis (1882–1961) Solicitor, army officer and private collector. He retired due to partial deafness and devoted the rest of his life to collecting ethnographical artefacts, mainly from the Pacific. His collection (over 6,000 objects) was based on that of his father, Revd Alfred Fuller (1832–1927), and was sold to the Field Museum, Chicago, for £40,000 in 1958 (Force and Force 1971; Waterfield and King forthcoming).

Gill, Revd George (1820–80) London Missionary Society missionary. He was stationed on the Cook Islands, respectively on Mangaia (1845–57) and on Rarotonga (1857–60) (Gunson 1978: 346).

Gordon, Sir Arthur Charles Hamilton (1829–1912) Created Baron Stanmore in 1893; Colonial Governor of Fiji (1875–80), where he set up a system of indirect rule through Fijian chiefs; Governor of New Zealand (1880–83), while continuing his position as High Commissioner and Consul-General for the Western Pacific (1877–83) (Francis 2004–5; Gordon 1879; 1897–1912).

Gordon, Arthur John Lewis Cousin and private secretary of **Sir Arthur Gordon**. He joined the expeditionary force organized by the latter to stop an insurrection against the colonial administration in Fiji in 1876. He made donations to the Marischal Museum, University of Aberdeen (Hunt 1981: 5).

Gow, Louis (died 1945) Rector of the John Neilson School in Paisley. He spent time in Port Glasgow and saw service overseas (Paisley and Renfrewshire Gazette 1931).

Grey, Sir George (1812–98) Travelled in Australia (1837–9) before occupying colonial governorships in South Australia (1841–5), New Zealand (1845–53 and 1861–8) and South Africa (1854–61). He wrote on Maori mythology (Grey 1855). In 1854 he donated his Maori collection (more than a hundred objects) to the British Museum (Buick 1926; Grey 1841; Rutherford 1961; Starzecka 1998: 152).

Haslar Hospital Museum Founded in 1827 and attached to the Haslar Royal Naval Hospital near Portsmouth, the museum contained medical specimens and artefacts collected by men serving in the Royal Navy. In 1855 the Lords of the Admiralty presented the large ethnographical collection to the British Museum through Sir John Liddell (1794–1868), who held posts as inspector of fleets and hospitals, and deputy inspector-general of the Haslar Hospital (Archbold 2004–5; Starzecka 1998: 152).

Heath, Revd Thomas (1797–1848) London Missionary Society missionary, stationed on Manono, Samoa (1836–42, 1845–8) (Gunson 1978: 347).

Henry, Samuel Pinder (1800–52) Born in Tahiti, the son of LMS missionary William Henry (1770–1859, stationed in the Society Islands 1797–1848). He made trading voyages in Polynesia and to New South Wales (Dunmore 1991: 129).

Hewett, George Goodman Surgeon's mate on board HMS *Discovery*, in search of a northwest passage under the command of **George Vancouver**, 1791–5. He obtained artefacts from the Society and Hawaiian Islands, and the American northwest coast (now in the British Museum with his handwritten catalogue) (Read 1892: 100–104).

Hewett, Kenneth John (1919–94) London-based dealer in antiquities, books and ethnographical material. In 1949 he met **Robert and Lisa Sainsbury** and supplied them with objects for their collection. He acquired most of his material from auctions and private sources in the UK (Hooper 1997: I: lv–lvii; Waterfield and King forthcoming).

Higginson, Captain A.J. Visited New Zealand, including the Bay of Islands, in a clipper in the mid-nineteenth century.

Holdsworth, Arthur Obtained Cook voyage material at the sale of the **Leverian Museum** (1806). Kept at Widdicombe House, Kingsbridge, Devon, some of these were purchased for the Cambridge University museum by **Baron von Hügel** in 1921–2 and **Louise Clarke**, with further donations in 1927 (Tanner 1999: 3).

Hooper, James Thomas (1897–1971) Private collector, mainly of Polynesian material. He established the 'Totems Museum' at Arundel, Sussex (1957–63). The collection was largely dispersed at auctions at Christie's in 1976–83, with other material returning to Tahiti and Fiji (Phelps 1976; Waterfield and King forthcoming).

Huband, Arthur Esq Member of the Royal Dublin Society (1846–90), he donated ethnographical material in the mid-1800s.

Hügel, Baron Anatole Andreas Aloys von (1854–1928) Travelled to Australia and New Zealand in 1874 and stayed in Fiji (1875–7) with governor **Sir Arthur Gordon** (Roth and Hooper 1990). He assembled an extensive collection, which formed the nucleus of the Pacific collections at CUMAA. He became CUMAA's first curator in 1884 and expanded the collection through his own resources and those of his friends and colleagues (Ebin and Swallow 1984: 15; Herle 2005).

Humphrey, George (?1745–1825) London collector and dealer in natural history and ethnographical material. Proprietor of the *Museum Humfredianum*, which he sold by auction in 1779. Subsequently supplied Göttingen with Cook third-voyage material (Humphrey 1779; Jessop 2003: 93; Hauser-Schäublin and Krüger 1998).

Hunter, William (1718–83) Physician, obstetrician and teacher of anatomy. He developed a private museum in the 1760s to house his anatomical and coin collection. In 1781 Cook voyage material was acquired from Dr Fothergill and at the sale of **David Samwell**'s collection. Hunter's collection was bequeathed to the University of Glasgow with a fund to build a museum; the Hunterian Museum opened in 1807 and moved to Gilmorehill in 1870 (Kaeppler 1978: 42–3; MacKie 1985).

Hutchin, Revd John London Missionary Society missionary, stationed on Rarotonga 1882–1912.

Ipswich Literary Institute Based in the Old Ipswich Town Hall from the 1790s onwards. It was initially just a library, but objects were added after 1810, including the collection of **Admiral Page**. These items were transferred to the Ipswich Museum from the 1860s onwards (David Jones, personal communication 17 June 2005).

King, Captain James (baptised 1750–84) Naval officer and astronomer. He was Second Lt on HMS *Resolution* during Cook's third voyage (1776–80). He became First Lt when Cook died at Hawaii and eventually commanded HMS *Discovery* after **Captain Clerke**'s death. He prepared Cook's journal of the third voyage for publication and wrote the final part (Beaglehole 1967). He donated objects to **Sir Ashton Lever**, the British Museum and the National Museum of Ireland, Dublin (Kaeppler 1997: 238).

Knowles, John Midshipman on HMS *Blonde* sailing for Hawaii (1824–5) under **Lord Byron**.

Kotzebue, Captain Otto von (1787–1846) German navigator in Russian service. He commanded the brig *Rurik* on an expedition to the Arctic Ocean and the Pacific, 1815–18 (Chamisso 1986; Kotzebue 1821). In 1823 he commanded an expedition to Kamchatka (1823–6), during which he (re)visited the Hawaiian and Society Islands (Kotzebue 1830).

Leeds Philosophical and Literary Society Founded in 1819 to promote the development of science, literature and arts, particularly of the City of Leeds. A museum was established in Park Row; it was transferred in 1921 to the Corporation of Leeds to become the nucleus of the City Museum. Ethnographical material was disposed of after World War II, mostly to **Kenneth Webster** (http://www.leedsphiland lit.org.uk/).

Lever, Sir Ashton (1729–88) and the Leverian Museum Collector of natural and artificial curiosities, initially based at Alkrington Hall near Manchester. In 1775 he moved his museum, the Holophusicon, to Leicester House, London. It contained many artefacts from Polynesia collected during Cook's voyages (some sketched by Sarah Stone in 1783). Financial difficulties obliged Lever to dispose of his collection by lottery in 1786. James Parkinson (1730–1813) held the winning ticket and moved the museum to Albion Street near Blackfriars Bridge. The collection was eventually sold during a sixty-five-day auction in 1806 (Force and Force 1968; Haynes 2001; Kaeppler forthcoming; Leverian Museum 1979; Waterfield and King forthcoming).

London Missionary Society (LMS) Protestant Missionary Society, formally established in 1795 as the Missionary Society, and renamed the London Missionary Society in 1818. Missions began in 1797 in Tahiti, at Tongatapu and in the Marquesas. The Tongan and Marquesan missions were short-lived, but the Tahitian mission became the nucleus of the LMS in Polynesia (Gunson 1978: 12; Lovett 1899). A museum was established in London to house the artefacts sent back by missionaries (Phillips 1826; LMS n.d.). In 1890 the LMS loaned a collection – about 230 objects, mainly from Polynesia – to the British Museum. The museum purchased the loan in 1911 (Hasell 2004).

Lytton, Lord Edward Robert Bulwer (1803–73) Concurrently developed diplomatic and literary career (under the pseudonym Owen Meredith); Viceroy of India 1876–80 (Washbrook 2004–5).

MacGregor, Sir William (1846–1919) Served with the British Colonial Office in Fiji (1875–88), mainly as chief medical officer; he became the first administrator of British New Guinea in 1888. He left his collection to the University of Aberdeen (Joyce 1971; Hunt 1981: 5; Quinnell 2000).

Mahaffy, Arthur William (1869–1919) Colonial officer who served in the Pacific 1896–1914 (PRM database).

Malet, Sir Alexander (1800–86) Second baronet and diplomat. He worked in St Petersburg, Lisbon, The Hague, Vienna, Württemberg and Frankfurt (Howlett 2004–5).

Mason, Revd Dr Robert (died 1841) Collected objects in New Zealand 1822–39. On his death, the collection was transferred to Queen's College, Oxford (now in the Pitt Rivers Museum) (PRM database).

Meyrick, Sir Samuel Rush (1783–1848) Antiquary, known for his arms and armour collection. The collection, entirely formed for his son Llewellyn (1804–37), was set up in his house in Upper Cadogan Square, London, and then moved to Goodrich Court around 1827. In 1834 Francis Douce bequeathed to him a part of his collection of medieval and other antiquities (Meyrick 1836). The collection passed to a second cousin, Lt-General Augustus Meyrick, who lent it to the South Kensington Museum (1868–72). It was then sold privately; the remainder was given to the British Museum in 1878 (King 1997: 149–50; Lowe 2003).

Moillet, Alphonse (1812–50) Collected objects from all over the world through travellers and diplomats. In 1851 the collection (about 1,500 objects) was housed in the Moillet ethnographical museum, which formed the nucleus of the ethnographical collections of the Musée d'Histoire Naturelle et d'Ethnographie in Lille (Notter 1997: 61–4).

Nockells, Christopher Collected material during his travels in the Pacific and donated it to the University of Aberdeen in 1823 and 1833 (Hunt 1981: 3).

Oldman, William Ockelford (1879–1949) Dealer and collector of ethnographical artefacts. He produced sale catalogues in the 1890s; he retired as a dealer in 1927 but continued to purchase objects for his personal collection which he kept at his home in Clapham Park, London. He wrote catalogues of his Polynesian and Maori collections (Oldman 2004, 2004a). In 1948 his Polynesian collection was sold to the New Zealand Government and distributed to four museums. His wife, Dorothy Oldman, continued to disperse artefacts to the British Museum and sold the remainder at a Sotheby's auction in July 1950 (Kaeppler 2004; Neich and Davidson 2004; Waterfield and King forthcoming).

Page, Benjamin William (1765–1845) Naval officer. He mainly served in the East Indies and gathered a collection there; he also owned items from the Pacific (David Jones, personal communication 2005).

Patten, James (c. 1748–?) Surgeon on HMS *Resolution* during Cook's second voyage (1772–5). He donated his collection to Trinity College, Dublin, in 1777 (Freeman 1949: 1–3).

Peard, George (1783–1837) First Lt on HMS *Blossom* during an expedition to the Pacific and Bering Strait under **Frederick Beechey**, 1825–8 (Peard 1973).

Pennant, Thomas (1726–98) Of Downing Hall, Flint, Wales; he received a collection of Cook material from his friend **Joseph Banks**. The collection was inherited by the 8th Earl of Denbigh through his wife, Pennant's great granddaughter. In 1912 **Baron von Hügel** selected items for the Cambridge museum. The deposit was formally accessioned in 1925 (Tanner 1999: 3).

Phillpotts, George (1814–45) Son of Bishop Henry Phillpotts (1778–1869). He was senior lieutenant on the naval sloop HMS *Hazard*, which arrived in New Zealand in July 1844. In February 1845 the *Hazard* was dispatched to Kororareka (Russell in the Bay of Islands) in response to the growing tension. Phillpotts died in action in Ohaewai at Hone Heke's *pa* (fortress) on 30 June 1845 (Buick 1931; http://www.dnzb.govt.nz).

Pitt Rivers, Augustus Henry Lane Fox (1827–1900) Born Augustus Henry Lane Fox; began collecting historic firearms – an interest that arose from his military work. His collection was exhibited in the Bethnal Green Branch of South Kensington Museum (1874–8), then the main museum in South Kensington (1878). It was later presented to the University of Oxford where it formed the core of the Pitt Rivers Museum (opened in 1884). The museum display followed Pitt Rivers' interest in typology and evolution (Blackwood 1991; Chapman 1985; Lane Fox 1874). He formed a second collection which was displayed at Farnham in Dorset (Waterfield 2002).

Pringle, Sir John (1707–82) Professor of pneumatics and moral philosophy at Edinburgh University. He was later physician to the army in Flanders, after which he continued medical practice in London. He became President of the Royal Society in 1772 and was created a baronet in 1776 (Blair 2004–5).

Ramsden, Robert (died 1865) Formed a collection before 1864; based at Carlton Hall, Worksop, Nottinghamshire (Phelps 1976: 415).

Read, Sir Charles Hercules (1857–1929) Worked at South Kensington Museum. He was employed privately in 1874 by **Augustus Franks** to assist in registering **Henry Christy**'s ethnographical collections in the British Museum. In 1880 he became Assistant in the Department of Antiquities and succeeded Franks as Keeper of the Department of British and Medieval Antiquities and Ethnography in 1896 (until 1921) (Balfour 1929: 61).

Row, William (c. 1748–1832) Newcastle merchant and ship owner. He was associated with a ship called the *Three Bs*, which visited the northwest coast and Hawaii in 1792–3 (Jessop forthcoming).

Royal United Service Institution Museum Founded in 1831, the 'Naval and Military Museum' at Whitehall Yard aimed to advance the knowledge of naval and military science and literature (Bidwell 1991). It changed into 'United Service Institution' in 1839 and the 'Royal United Service Institution' in 1860. The museum also housed ethnographical material, some of which **Franks** bought for **Henry Christy** in the 1860s (Bidwell 1991; Chapman 1985: 16; King 1997: 152).

Sadler, F.W.R. Commanded the naval stores ship HMS *Buffalo* that sailed regularly between Sydney and the Bay of Islands (1833–5). He established a good relationship with Titore, a Ngapuhi chief, North Island, New Zealand (Starzecka 1998: 154).

Sainsbury, Sir Robert James (1906–2000) Businessman; known for his role as patron of the arts together with his wife, Lisa Ingeborg (b. 1912). They collected art from artists they befriended, such as Henry Moore, Francis Bacon and Alberto Giacometti; they also acquired ethnographical objects, many from the London dealer **John Hewett**. In 1973 their collection was donated to the University of East Anglia where it is housed in the Sainsbury Centre for Visual Arts (Hooper 1997; Sainsbury 1978).

Samwell, David (1751–98) Surgeon's mate and surgeon on HMS *Resolution* during Cook's third voyage (1776–80). His journal contains the first written record of the Maori language and a

lengthy account of Cook's death (Beaglehole 1967). In 1781 he sold his collection and followed **William Hunter**'s anatomy classes at the Hunterian school. During 1781–6 he served on ships such as the frigate *Crocodile* under **Captain King** (Kaeppler 1978: 43; Phillips 2004–5).

Sandwich, 4th Earl of: John Montagu (1718–92) First Lord of the Admiralty and Cook's patron. He donated Cook material to the British Museum and Trinity College, Cambridge (Kaeppler 1978: 39).

Scott, James Woodward Midshipman on HMS *Discovery* and HMS *Chatham* during **Vancouver**'s voyage (1791–5). He later became lieutenant and served in Europe.

Sheffield Literary and Philosophical Society Founded in 1822 to promote the study of the sciences, with a library and museum attached. It received donations from **George Bennet**, a native of Sheffield. In 1875 the Literary and Philosophical Society's collection formed the nucleus of the Western Park Museum; ethnographical material was dispersed to Cambridge and the British Museum. The Society closed in 1932 (http://www.sorby.org.uk/hist-1914-1954.shtml).

Silver, Steven William (1819–1905) Businessman who collected natural history and ethnographical specimens which he displayed at his private museum in his house at York Gate, Regent's Park, London. He also owned the York Gate Geographical and Colonial Library (Silver 1882; Simpson 1975). In 1906 his ethnographical collection was donated by Mrs Silver to the Pitt Rivers Museum, Oxford (PRM database).

Solander, Daniel (1733–82) Swedish botanist. He catalogued natural history specimens in the British Museum (1763). He met **Joseph Banks** in 1767, who took him as naturalist on Cook's first voyage (1768–71) (Duyker 1998).

Sparrow Simpson, Revd William (1828–97) Known for his knowledge of stone implements (Sparrow Simpson 1899); also a collector of ethnographical objects. He donated objects to the British Museum, which eventually purchased his collection in 1875 and 1895 via **Augustus Franks** (Starzecka 1998: 152).

Stutchbury, Samuel (1798–1859) Assistant curator of the Hunterian Museum of the Royal College of Surgeons in London. He joined the Pacific Pearl Company's commercial expedition to New South Wales as a naturalist in 1825. After a brief career as a dealer in natural history specimens, he became curator of the Bristol Institution 1831–50; he later went to Australia as a mineral surveyor for New South Wales (Stutchbury 1996; Branagan 2004–5).

Thomson, Gordon Augustus (1799–1886) Collector–traveller. He visited Tahiti and the Hawaiian Islands twice (1837–40). He may have visited Fiji, Tonga, Samoa, Easter Island, the Australs and Marquesas since he collected objects from there, but there are no records of these trips (Glover 1986; 1994; 2001).

Thurston, Sir John Bates (1836–97) Resident of Fiji, he joined the pre-colonial government of Seru Cakobau, paramount chief of Bau. He later became Governor of Fiji (1888–97) (Scarr 1973, 2004–5).

Vancouver, George (1757–98) Naval officer; sailed on Cook's second and third voyages as A.B. (Able-Bodied Seaman) and midshipman. Commanded HMS *Discovery* (a different vessel from that on Cook's third voyage) on a voyage to the Pacific and northwest coast of America (1791–5). After his death, his brother John published his journal (Vancouver 1798, 1984; Anderson 1960).

Vaughan, James Donated in 1868 more than thirty Pacific and northwest coast artefacts to the Exeter Museum (RAMM), which had been purchased at the **Leverian Museum** sale (1806).

Veitch, John Gould (1839–70) Botanist who visited the Far East (in 1860) and Australasia (1864), bringing back species new to Britain (Baigent 2004–5).

Wallis, Samuel (1728–95) Naval officer; commander of HMS *Dolphin* during a voyage round the world (1766–8). He sighted five previously unknown islands in the Tuamotus, Me'etia in the Society Islands and Tahiti, where he stayed for five weeks. He suffered from ill health during the voyage (Hawkesworth 1773; Robertson 1948).

Waterhouse, E.K. Received a collection, via his father, from one of his uncles, both of whom were missionaries in Fiji in the mid-nineteenth century: either Joseph Waterhouse (1828–81), stationed in Fiji 1850–57 and 1859–64, or Samuel Waterhouse (1830–1918), stationed in Fiji 1853–7 (Gunson 1978: 354).

Webster, Kenneth Athol (1906–67) New Zealander who moved to England and became a dealer and collector of New Zealand-related manuscripts, books, prints and artefacts. He collected privately and on behalf of the New Zealand government (Waterfield and King forthcoming).

Webster, William Downing (1868–1913) Dealer. He began his career as a stained-glass window designer; he turned to dealing in ethnographical material in the 1890s, producing illustrated sale catalogues (Webster 1895–1901). His remaining stock was sold by auction in 1904 at Stevens, London (Waterfield and King forthcoming).

Wheeler, Daniel (1771–1840) Served in the army; became a Quaker minister in 1816. In 1833–8 he visited Tahiti, Tonga, New Zealand, Hawaii, the Cook Islands and Australia in the cutter *Henry Freeling*. His journals were published by his son Daniel (Wheeler 1842).

Williams, Revd John (1796–1839) London Missionary Society missionary. He arrived in the Society Islands (Mo'orea and Huahine) in 1817. He established a mission station in Ra'iatea in 1818, visited several Cook Islands in the 1820s and introduced Christianity to Samoa in 1830. He actively collected artefacts for the LMS museum and published an account of his mission work (Williams 1837). He was killed at Erromango, Vanuatu, in 1839 (Gunson 1978; Gutch 1974).

Yorkshire Philosophical Society Founded 1822 to promote the study of natural science and antiquities. Later linked to the Yorkshire Museum and Botanical Gardens (http://www.yorksphil.org.uk).

Bibliography

COMPILED BY KAREN JACOBS, LUCIE CARREAU,
LUDOVIC COUPAYE, ANDREW MILLS AND STEVEN HOOPER

AITKEN, R.T.
1930 *Ethnology of Tubuai*. Bulletin 70. Honolulu: B.P. Bishop Museum.

ALLEN, M.
2004 Revisiting and revising Marquesan culture history: new archaeological investigations at Anaho Bay, Nuku Hiva Island. *Journal of the Polynesian Society*, 113(2): 143–96.

ANDERSON, A.
2002 New radiocarbon ages of colonization sites in East Polynesia. *Asian Perspectives*, 41(2): 242–57.

ANDERSON, B.
1960 *The life and voyages of Captain George Vancouver: surveyor of the sea*. Seattle: University of Washington Press.

ARCHBOLD, W.A.J.
2004–5 Liddell, Sir John (1794–1868). *Oxford Dictionary of National Biography*, Oxford University Press.

ATTENBOROUGH, D.
1990 The first figures to be collected from Easter Island. *CFS-Courier*, 125: 41–50.

BABADZAN, A.
1993 *Les dépouilles des dieux: essai sur la religion tahitienne à l'époque de la découverte*. Paris: Edition de la maison des sciences de l'homme.

BAGNALL, A.G. AND G.C. PETERSEN
1948 *William Colenso: printer, missionary, botanist, explorer, politician. His life and journeys*. Wellington: A.H. and A.W. Reed.

BAIGENT, E.
2004–5 Veitch family (per. 1768–1929). *Oxford Dictionary of National Biography*, Oxford University Press.

BALFOUR, H.
1929 Obituary: Sir Charles Hercules Read. *Man*, 29: 61–62.

BARRATT, G.
1988 *Southern and Eastern Polynesia*. Vol. 2 of *Russia and the South Pacific 1696–1840*. Vancouver: University of British Columbia Press.

BARROW, T.
1959 Free-standing Maori images. In *Anthropology in the South Seas*, J.D. Freeman and W.R. Geddes (eds), 111–20. New Plymouth: Thomas Avery.
1959a Maori godsticks collected by the Revd Richard Taylor. *Dominion Museum Records in Ethnology*, 1(5): 183–211.
1961 *Maori godsticks in various collections*. Wellington: Dominion Museum.
1973 *Art and life in Polynesia*. Rutland: Tuttle.
1979 *The art of Tahiti and the neighbouring Society, Austral and Cook Islands*. London: Thames & Hudson.

BEAGLEHOLE, J.C. (ED.)
1955, 1961, 1967, 1974 *The journals of Captain James Cook on his voyages of discovery*. 4 vols in 5. Cambridge: Cambridge University Press, published for the Hakluyt Society (Extra Series, 34–7).
1962 *The* Endeavour *journal of Joseph Banks 1768–1771*. 2 vols. Sydney: Angus & Robertson.

BEASLEY, H.G.
1928 *Fish hooks. Pacific Island records*. London: Sealey, Service & Co.
1929 A human and lotus form of club. *Man*, 29: 181.
1930 An unrecorded feather cape. *Man*, 30: 197.
1932 A carved wooden figure from Hawaii. *Man*, 32: 273.

BECKWITH, M.W.
1951 *The Kumulipo: a Hawaiian creation myth*. Chicago: University of Chicago Press.

BEECHEY, F.W.
1831 *Narrative of a voyage to the Pacific and Beering's Strait: …* London: Henry Colburn & Richard Bentley.

BELCHER, E.
1843 *Narrative of a voyage round the world, performed in Her Majesty's ship* Sulphur *during the years 1836–1842*. London: Henry Colburn.

BELICH, J.
1996 *Making peoples: a history of the New Zealanders, from Polynesian settlement to the end of the nineteenth century*. Honolulu: University of Hawaii Press.

BELLWOOD, P.
1978 *The Polynesians: prehistory of an island people*. London: Thames & Hudson.
2001 Keynote address: Polynesian prehistory and the rest of mankind. In *Pacific 2000*, C.M. Stevenson, G. Lee and F.J. Morin (eds), 11–25. Los Osos: Easter Island Foundation.

BENNET, G.
1833 *A brief sketch of missionary voyages and travels during the years 1821 to 1829*. London: Harjette & Savill.

BEST, E.
1924 *The Maori*. 2 vols. Wellington: Board of Ethnological Research and The Polynesian Society.

BIDWELL, S.
1991 A history of the Royal United Services Institute. *RUSI Journal* (http://www.rusi.org/militarysciences/history/).

BLACKWOOD, B.
1991 *The origin and development of the Pitt Rivers Museum*. Revised and updated by Schuyler Jones. Oxford: Pitt Rivers Museum.

BLAIR, J.S.G.
2004–5 Pringle, Sir John, first baronet (1707–1782). *Oxford Dictionary of National Biography*, Oxford University Press.

BOCKSTOCE, J.R.
1977 *Eskimos of Northwest Alaska in the early nineteenth century: based on the Beechey and Belcher collections and records compiled during the voyage of H.M.S. Blossom to Northwest Alaska in 1826 and 1827*. Oxford: Pitt Rivers Museum.

BOULTER, D.
[1793] *Museum Boulterianum. A catalogue of the curious and valuable collection of natural and artificial curiosities in the extensive museum of Daniel Boulter, Yarmouth*. London: Gardner *et al.*

BRANAGAN, D.F.
2004–5 Stutchbury, Samuel (1798–1859). *Oxford Dictionary of National Biography*, Oxford University Press.

BRASSEY, A.
1878 *A voyage in the Sunbeam: our home on the ocean for eleven months*. London: Longmans, Green & Co.

BRENCHLEY, J.L.
1873 *Jottings during the Cruise of H.M.S.* Curaçoa *among the South Seas Islands in 1865*. London: Longmans, Green.

BRIGHAM, W.T.
1899 *Hawaiian feather work*. Memoirs 1(1). Honolulu: B.P. Bishop Museum.
1903 *Additional notes on Hawaiian feather work*. Memoirs 1(5). Honolulu: B.P. Bishop Museum.
1906 *Old Hawaiian carvings*. Memoirs 2(2). Honolulu: B.P. Bishop Museum.
1911 *Ka Hana Kapa: the making of barkcloth in Hawaii*. Memoirs 3. Honolulu: B.P. Bishop Museum.
1918 *Additional notes on Hawaiian feather work, second supplement*. Memoirs 2(1). Honolulu: B.P. Bishop Museum.

BRITISH MUSEUM
1910 *Handbook to the ethnographical collections*. Oxford: Oxford University Press for the Trustees of the British Museum.
1925 *Handbook to the ethnographical collections*. 2nd edition. Oxford: Oxford University Press, printed by order of the Trustees.

BROSSES, C. DE
1756 *Histoire des navigations aux terres Australes …* 2 vols. Paris: Durand.

BUCK, P.H. [TE RANGI HIROA]
1927 *The material culture of the Cook Islands (Aitutaki)*. New Plymouth: Thomas Avery.
1934 *Mangaian society*. Bulletin 122. Honolulu: B.P. Bishop Museum.

1938 *Ethnology of Mangareva*. Bulletin 157. Honolulu: B.P. Bishop Museum.

1939 Mangarevan images. *Ethnologia Cranmorensis*, 4: 13–19.

1944 *Arts and crafts of the Cook Islands*. Bulletin 179. Honolulu: B.P. Bishop Museum.

1957 *Arts and crafts of Hawaii*. Special Publication 45. Honolulu: B.P. Bishop Museum.

1993 *Mangaia and the mission*. Suva: Institute of Pacific Studies, University of the South Pacific and B.P. Bishop Museum.

BUICK, L.T.

1926 *New Zealand's first war or the rebellion of Hone Heke*. Wellington: W.A.G. Skinner.

BULLOCK

1979 *Sale catalogue of the Bullock Museum 1819: a facsimile reprint with manuscript prices and buyers names*. London: Harmer Johnson & John Hewett.

BURROWS, E.G.

1938 Western Polynesia: a study in cultural differentiation. *Ethnological Studies*, 7: 1–192.

BUZACOTT, A.

1866 *Mission life in the islands of the Pacific, being a narrative of the life and labours of Rev. A. Buzacott*. London: Snow.

BYRON, G.A.

1826 *Voyage of HMS Blonde to the Sandwich Islands, in the years 1824–1825*. London: John Murray.

CALDER, A., J. LAMB AND B. ORR (EDS)

1999 *Voyages and beaches: Pacific encounters, 1769–1840*. Honolulu: University of Hawaii Press.

CAMPBELL, I.C.

2001 *Island kingdom: Tonga ancient and modern*. Christchurch: Canterbury University Press.

CARTER, H.B.

1988 *Sir Joseph Banks, 1743–1820*. London: British Museum (Natural History).

1998 Note on the drawings by an unknown artist from the voyage of HMS Endeavour. In *Science and exploration in the Pacific: European voyages to the southern oceans in the 18th century*, M. Lincoln (ed.), 133–4. Woodbridge: Boydell Press and the National Maritime Museum.

CAYGILL, M. AND J. CHERRY (EDS)

1997 *A.W. Franks: nineteenth century collecting and the British Museum*. London: British Museum Press.

CHAMISSO, A. VON

1986 *A voyage around the world with the Romanzov exploring expedition in the years 1815–1818 in the Brig* Rurik, *Captain Otto von Kotzebue*. Honolulu: University of Hawaii Press.

CHAPMAN, R.

1985 Arranging ethnology: A.H.L.F. Pitt Rivers and the typological tradition. In *Objects and others: essays on museums and material culture*, G.W. Stocking (ed.), 15–48. Wisconsin: University of Wisconsin Press.

CHRISTIE'S

1986 *Art and ethnography from Africa, North America and the Pacific area. Monday 23 June 1986*. London: Christie's South Kensington.

CLUNIE, F.

1977 *Fijian weapons and warfare*. Bulletin 2. Suva: Fiji Museum.

1983 Ratu Tanoa Visawaqa's breastplate. *Domodomo* (Sept. 1983): 123–5.

1983a The Fijian flintlock. *Domodomo* (Sept. 1983): 102–22.

1986 *Yalo i Viti. Shades of Fiji: a Fiji Museum catalogue*. Suva: Fiji Museum.

1996 Daveniyaqona: a sacred yaqona dish from Fiji. *Art Tribal*, 3–18.

2000 Burekalou and lialiakau: conduits for the speaking dead in Fiji. In *Heaven and hell and other worlds of the dead*, A. Sheridan (ed.), 118–19. Edinburgh: National Museums of Scotland.

COOK, J.

1777 *A voyage towards the South Pole, and round the world: …* 2 vols. London: W. Strahan.

COOK, J. AND J. KING

1785 *A voyage to the Pacific Ocean: … performed under the direction of Captains Cook, Clerke and Gore, in His Majesty's ships the* Resolution *and* Discovery, *in the years 1776, 1777, 1778, 1779 and 1780*. Second edition. 3 vols + atlas. London: G. Nicol and T. Cadell.

COOPER, W. ET AL.

1989 *Taonga Maori: treasures of the New Zealand Maori people*. Sydney: Australian Museum.

COOTE, J.

2004 *Curiosities from the* Endeavour: *a forgotten collection, Pacific artefacts given by Joseph Banks to Christ Church, Oxford after the first voyage*. Whitby: Captain Cook Memorial Museum.

2005 'From the Islands of the South Seas, 1773–4': Peter Gathercole's special exhibition at the Pitt Rivers Museum. *Journal of Museum Ethnography*, 17: 8–31.

COOTE, J. ET AL.

2000 'Curiosities sent to Oxford': the original documentation of the Forster collection at the Pitt Rivers Museum. *Journal of the History of Collections*, 7(2): 177–92.

2001 *The Forster collection Pitt Rivers Museum* (http://projects.prm.ox.ac.uk/forster/home.html).

CORNEY, B.G. (ED.)

1913, 1915, 1919 *The quest and occupation of Tahiti by emissaries of Spain during the years 1772–1776*. 3 vols. London: Hakluyt Society.

COX, J.H. AND W.H. DAVENPORT

1988 *Hawaiian sculpture*. 2nd edition. Honolulu: University of Hawaii Press.

CRANSTONE, B.A.L AND H.J. GOWERS

1968 The Tahitian mourner's dress: a discovery and a description. *British Museum Quarterly*, 32(3/4): 138–44.

CUMAA

1892 *Annual Report*. Cambridge: Cambridge University Museum of Archaeology and Ethnology.

DANCE, P.S.

2004–5 Cuming, Hugh (1791–1865). *Oxford Dictionary of National Biography*, Oxford University Press.

D'ALLEVA, A.

1998 *Art of the Pacific*. London: Weidenfeld & Nicolson.

DAVID, A.

1995 *The voyage of HMS Herald*. Carlton: University of Melbourne Press.

DAVIDSON, J.

1975 The wooden image from Samoa in the British Museum: a note on its context. *Journal of the Polynesian Society*, 84(3): 352–5.

1987 *The prehistory of New Zealand*. Auckland: Longman Paul.

DAVIES, J.

1961 *The history of the Tahitian mission, 1799–1830: with supplementary papers from the correspondence of the missionaries*, C.W. Newbury (ed.). Cambridge: Cambridge University Press for the Hakluyt Society.

DENING, G.

1980 *Islands and beaches: discourse on a silent land, Marquesas, 1774–1880*. Honolulu: University of Hawaii Press.

1992 *Mr. Bligh's bad language: passion, power, and theatre on the* Bounty. Cambridge: Cambridge University Press.

1996 *Performances*. Chicago: University of Chicago Press.

2004 *Beach crossings: voyaging across times, cultures and self*. Melbourne: University of Melbourne Press.

DERRICK, R.A.

1950 *A history of Fiji*. Suva: Government Printer.

DOUGLAS HYDE

1978 *The art of the Pacific: a commemoration of Captain Cook*. Dublin: Douglas Hyde Gallery.

DUFF, R.

1959 Neolithic adzes of Eastern Polynesia. In *Anthropology in the South Seas*,

J.D. Freeman and W.R. Geddes (eds), 121–48. New Plymouth: Thomas Avery.
1969 (ed.) *No sort of iron: culture of Cook's Polynesians.* Christchurch: AGMANZ.

DUNMORE, J.
1991 *Who's who in Pacific navigation.* Honolulu: University of Hawaii Press.

DURRANS, B.
1979 Ancient Pacific voyaging: Cook's views and the development of interpretation. In *Captain Cook and the South Pacific,* The British Museum Yearbook 3, 137–65. London: British Museum Publications.

DUYKER, E.
1998 *Nature's argonaut: Daniel Solander, 1733–1782.* Melbourne: Melbourne University Press.

EBIN, V. AND D.A. SWALLOW
1984 'The proper study of mankind …' – great anthropological collections in Cambridge. Cambridge: University Museum of Archaeology and Anthropology.

EDGE-PARTINGTON, J.
1899 Note on a stone battle-axe from New Zealand. *Journal of the Anthropological Institute of Great Britain and Ireland,* 29(3/4): 305–6.

EDGE-PARTINGTON, J. AND C. HEAPE
1890, 1895, 1898 *An album of the weapons, tools, ornaments, article of dress, etc., of the natives of the Pacific Islands.* 3 vols. Manchester: privately printed. Reprinted 1969 by Holland Press.

EDMOND, R.
1998 Translating cultures: William Ellis and missionary writing. In *Science and exploration in the Pacific: European voyages to the southern oceans in the 18th century,* M. Lincoln (ed.), 149–61. Woodbridge: Boydell Press and the National Maritime Museum.

EDWARDS, E.
2003 *Ra'ivavae, archaeological survey, Austral Islands, French Polynesia.* Los Osos: Easter Island Foundation.

ELLIS, W.
1826 *Narrative of a tour through Hawaii, or, Owhyhee: …* London: H. Fisher, Son, & P. Jackson.
1829 *Polynesian researches.* 2 vols. London: Dawsons of Pall Mall.

EMORY, K.P.
1934 *Tuamotuan stone structures.* Bulletin 118. Honolulu: B.P. Bishop Museum.
1938 Notes on wooden images. *Ethnologia Cranmorensis,* 2: 3–7.
1939 *Archaeology of Mangareva and neighboring atolls.* Bulletin 163. Honolulu: B.P. Bishop Museum.

1947 *Tuamotuan religious structures and ceremonies.* Bulletin 191. Honolulu: B.P. Bishop Museum.
1975 *Material culture of the Tuamotu Archipelago.* Pacific Anthropological Records 22. Honolulu: B.P. Bishop Museum.

ERSKINE, J.
1853 *Journal of a cruise among the islands of the Western Pacific including the Feejees and others inhabited by the Polynesian negro races in her Majesty's ship.* Havannah. London: John Murray.

EWINS, R.
1982 *Fijian artefacts: the Tasmanian Museum and Art Gallery collection.* Hobart: Tasmanian Museum & Art Gallery.

FEHER, J.
1969 *Hawaii, a pictorial history.* Special Publication 58. Honolulu: B.P. Bishop Museum.

FINNEY, B.R.
2003 *Sailing in the wake of the ancestors: reviving Polynesian voyaging.* Honolulu: B.P. Bishop Museum.

FIRTH, R.
1940 The analysis of mana: an empirical approach. *Journal of the Polynesian Society,* 49: 483–510.
1959 Ritual adzes in Tikopia. In *Anthropology in the South Seas. Essays presented to H.D. Skinner,* J.D. Freeman and W.R. Geddes (eds), 149–59. New Plymouth: Thomas Avery.
1965 *Primitive Polynesian economy.* London: Routledge & Kegan Paul.
1967 *The work of the gods in Tikopia.* London: Athlone Press.

FISCHER, S.R.
1993 *Easter Island studies: contributions to the history of Rapanui in memory of William T. Mulloy.* Oxford: Oxbow.
2005 *Island at the end of the world: the turbulent history of Easter Island.* London: Reaktion Books.

FLEURIEU, C.P.C., COMTE DE
1801 *A Voyage round the world, performed during the years 1790, 1791, and 1792, by Etienne Marchand …* 2 vols. London: Longman, Rees, Cadell, jun. & Davies.

FORCE, R.W. AND M. FORCE
1968 *Art and artefacts of the 18th Century: objects in the Leverian Museum as painted by Sarah Stone.* Honolulu: B.P. Bishop Museum.
1971 *The Fuller collection of Pacific artifacts.* New York: Praeger Publishers.

FORSTER, G.
1777 *A voyage round the world in His Britannic Majesty's sloop,* Resolution, *commanded by*

Capt. James Cook, during the years 1772, 3, 4 and 5. 2 vols. London: B. White.
2000 *A voyage round the world,* N. Thomas and O. Berghof (eds). 2 vols. Honolulu: University of Hawaii Press.

FORSTER, J.R.
1778 *Observations made during a voyage round the world on physical geography, natural history, and ethic philosophy …* London: printed for G. Robinson.
1982 The Resolution *journal of Johann Reinhold Forster 1772–1775,* M.E. Hoare (ed.). 4 vols. London: The Hakluyt Society.
1996 *Observation made during a voyage round the world,* N. Thomas, H. Guest and M. Dettelbach (eds). Honolulu: University of Hawaii Press.

FOX, A.
1983 *Carved Maori burial chests: a commentary and a catalogue.* Auckland: Auckland Institute and Museum.

FRANCIS, M.
2004–5 Gordon, Arthur Charles Hamilton (1829–1912). *Oxford Dictionary of National Biography,* Oxford University Press.

FREEMAN, J.D.
1949 Polynesian collection of Trinity College, Dublin, and the National Museum of Ireland. *Journal of the Polynesian Society,* 58(1): 1–8.

FREYCINET, L.C.D. DE
1825 *Voyage autour du monde … sur les corvettes de S.M. l'Uranie et la Physicienne, pendant les années 1817, 18, 19, 20 … Atlas historique.* Paris: Chez Pillet Aîné [multi-volume publication, issued 1824–44].

GARANGER, J.
1967 *Pilons Polynésiens.* Paris: Musée de l'Homme.

GASCOIGNE, J.
1994 *Joseph Banks and the English Enlightenment: useful knowledge and polite culture.* Cambridge: Cambridge University Press.

GATHERCOLE, P.
[1970] *From the islands of the South Seas, 1773–4: an exhibition of a collection made on Captain Cook's second voyage of discovery by J.R. Forster. A short guide.* Oxford: Pitt Rivers Museum,
1976 A Maori shell trumpet at Cambridge. In *Problems in economic and social archaeology,* G. de G. Sieveking, I.H. Longworth and K.E. Wilson (eds), 187–99. London: Duckworth.

GATHERCOLE, P., A.L. KAEPPLER AND D. NEWTON
1979 *The art of the Pacific Islands.* Washington, DC: National Gallery of Art.

GELL, A.
1993 *Wrapping in images.* Oxford: Clarendon Press.
1998 *Art and agency.* Oxford: Clarendon Press.

2000 *On the road of the winds: an archaeological history of the Pacific Islands before European contact.* Berkeley: California University Press.

KIRCH, P.V. AND R.C. GREEN
2001 *Hawaiki, ancestral Polynesia: an essay in historical anthropology.* Cambridge: Cambridge University Press.

KIRCH, P.V. AND M.D. SAHLINS
1992 *Anahulu: the anthropology of history in the Kingdom of Hawaii.* 2 vols. Chicago: University of Chicago Press.

KJELLGREN, E. (ED.)
2001 *Splendid isolation: art of Easter Island.* New York: Metropolitan Museum of Art.

KJELLGREN, E. AND C.S. IVORY
2005 *Adorning the world: art of the Marquesas Islands.* New York: Metropolitan Museum of Art.

KOOIJMAN, S.
1972 *Tapa in Polynesia.* Bulletin 234. Honolulu: B.P. Bishop Museum.

KOTZEBUE, O. VON
1821 *A voyage of discovery, into the South Sea and Beering's Straits, for the purpose of exploring a North–East passage … 1815–1818.* 3 vols. London: Longman
1830 *A new voyage round the world in the years 1823, 24, 25 and 26.* 2 vols. London: H. Colburn & R. Bentley.

LA CAIXA
2001 *Islas de los mares del sur.* Barcelona: Fundación la Caixa.

LABILLARDIÈRE, J.J.H. DE
1800 *Voyage in search of La Pérouse, …, during the years 1791, 1792, 1793 and 1794.* London: John Stockdale.

LANE FOX, A.
1874 On the principles of classification adopted in the arrangement of his anthropological collection, now exhibited in the Bethnal Green Museum. *Journal of the Anthropological Institute of Great Britain and Ireland,* 4: 293–308.

LANGSDORFF, G.H. VON
1813 *Voyages and travels in various parts of the world during the years 1803, 1804, 1805, 1806, and 1807.* 2 vols. London: Colburn.

LA RUE, H.
2004–5 Balfour, Henry (1863–1939). *Oxford Dictionary of National Biography,* Oxford University Press.

LARSSON, K.E.
1960 *Fijian Studies.* Göteborg: Etnografiska Museet.

LAVONDÈS, A.
1968 *Traditional art of Tahiti.* Paris: Société des Océanistes.

LEACH, E.
1985 Concluding remarks. In *Transformations of Polynesian culture,* A. Hooper and J. Huntsman (eds), 219–23. Auckland: The Polynesian Society.

LEE, G.
1992 *Rock art of Easter Island; symbols of power, prayers to the gods.* Los Angeles: Institute of Archaeology, University of California.

LEVERIAN MUSEUM
1979 *Leverian Museum: a companion to the museum MDCCXC. The sale catalogue of the entire collection, 1806....* London: Harmer Johnson.

LEWIS, D.
1994 *We, the navigators: the ancient art of landfinding in the Pacific.* Honolulu: University of Hawaii Press.

LINNEKIN, J.
1990 *Sacred queens and women of consequence: rank, gender and colonialism in the Hawaiian Islands.* Ann Arbor: University of Michigan Press.

LINTON, R.
1923 *The material culture of the Marquesas Islands.* Memoirs 8(5). Honolulu: B.P. Bishop Museum.

LMS
1826 *Catalogue of the Missionary Museum, Austin Friars.* London: London Missionary Society.
n.d. (*c.* 1850s) *Catalogue of the Missionary Museum, Blomfield Street, Finsbury.* London: London Missionary Society.

LOVETT, R.
1899 *The history of the London Missionary Society 1795–1895.* 2 vols. London: Oxford University Press.

LOWE, R.
2003 *Sir Samuel Meyrick and Goodrich Court.* Little Logaston: Logaston Press.

LUOMALA, K.
1984 *Hula ki'i: Hawaiian puppetry.* Honolulu: Institute for Polynesian Studies.

MACKIE, E.W.
1985 William Hunter and Captain Cook: the 18th century ethnographic collection in the Hunterian Museum. *Glasgow Archaeological Journal,* 12: 1–18.

MALLON, S.
2002 *Samoan art and artists: o measina a Samoa.* Honolulu: University of Hawaii Press.

MALO, D.
1951 *Hawaiian antiquities (Moolelo Hawaii).* Honolulu: B.P. Bishop Museum.

MARCK, J.
1996 The first-order anthropomorphic gods of Polynesia. *Journal of the Polynesian Society,* 105: 217–58.

MARETU
1983 *Cannibals and converts: radical change in the Cook Islands.* Suva: Institute of Pacific Studies, University of the South Pacific and the Ministry of Education, Rarotonga.

MARGOLIOUTH, D.S. AND R.T. STEARN
2004–5 Conybeare, Frederick Cornwallis (1856–1924). *Oxford Dictionary of National Biography,* Oxford University Press.

MARSHALL, D.
1962 *Ra'ivavae: an expedition to the most fascinating and mysterious island in Polynesia.* New York: Doubleday.

MARINER, W.
1827 *An account of the natives of the Tonga Islands in the South Pacific Ocean: with an original grammar and vocabulary of their language,* John Martin (ed.). 3rd edition. Edinburgh: Constable.

MAUDE, H.E.
1968 *Of islands and men.* Oxford: Oxford University Press.

McCORMACK, W.J.
2004–5 Croker, Thomas Crofton (1798–1854). *Oxford Dictionary of National Biography,* Oxford University Press.

McMANUS, M.
1997 *A treasury of American scrimshaw: a collection of the useful and decorative.* New York: Penguin Studio.

MEAD, S.M.
1969 *Traditional Maori clothing: a study of technological and functional change.* Wellington: Reed.
1984 (ed.) *Te Maori: Maori art from New Zealand collections.* New York: Abrams.

MELVILLE, H.
1846 *Typee: a peep at Polynesian life.* London: Wiley & Putnam.

MÉTRAUX, A.
1940 *Ethnology of Easter Island.* Bulletin 160. Honolulu: B.P. Bishop Museum.

MEYER, A.J.P.
1995 *Oceanic Art.* 2 vols. Köln: Könemann.

MILLER, D.W.
2004–5 Edgar, John (1798–1866). *Oxford Dictionary of National Biography,* Oxford University Press.

MILLS, A.
2003 *Works of the tufunga: form, structure, pattern and iconography in Tongan clubs of the 18th and 19th centuries.* Unpublished MA dissertation. Sainsbury Research Unit, University of East Anglia.

MISSIONARY SKETCHES
1818 The family idols of Pomare. *Missionary Sketches*, 3: 1–3.
1824 Representations of Taaroa Upoo Vahu. *Missionary Sketches*, 14: 1.

MONTGOMERY, J.
1831 *Journal of voyages and travels by the Rev. Daniel Tyerman and George Bennet Esq. in the South Sea Islands … 1821–1829.* 2 vols. London: F. Westley and A.H. Davis.

MOORE, H.
1981 *Henry Moore at the British Museum.* Photographs by David Finn. London: British Museum Publications.

MORPHY, H.
1991 *Ancestral connections: art and an Aboriginal system of knowledge.* Chicago: University of Chicago Press.
1994 The anthropology of art. In *Companion encyclopaedia of anthropology*, T. Ingold (ed.), 648–85. London: Routledge.

MORPHY, H. AND M. PERKINS (EDS)
2005 *The anthropology of art.* Oxford: Blackwell.

MORRISON, J.
1935 *Journal of James Morrison, boatswain's mate on the* Bounty. London: Golden Cockerell Press.

MOSCHNER, I.
1955 Die Wiener Cook-Sammlung, Südsee-Teil. *Archiv für Völkerkunde*, 10: 136–253.

MUSÉE DE L'HOMME
1972 *La découverte de la Polynésie.* Paris: Société des Amis du Musée de l'Homme.

NEICH, R.
2001 *Carved histories: Rotorua Ngati Tarawhai woodcarving.* Auckland: Auckland University Press.

NEICH, R. AND J. DAVIDSON
2004 William O. Oldman: the man and his collection. In *The Oldman collection of Polynesian artefacts*, R. Neich and J. Davidson (eds), v–xliv. New edition of Polynesian Society Memoir 15, by W.O. Oldman. Auckland: the Polynesian Society.

NEWBURY, C.
1980 *Tahiti nui: change and survival in French Polynesia, 1767–1945.* Honolulu: University of Hawaii Press.

NEWELL, J.
2003 Irresistible objects: collecting in the Pacific and Australia in the reign of George III. In *Enlightenment: discovering the world in the eighteenth century*, K. Sloan and A. Burnett (eds), 246–57. London: British Museum Press.
2005 Exotic possessions: Polynesians and their eighteenth-century collecting. *Journal of Museum Ethnography*, 17: 75–88.

NEWTON, D. (ED.)
1999 *Arts of the South Sea Islands: Southeast Asia, Melanesia, Polynesia, Micronesia.* Munich and London: Prestel.

NOTTER A., ET AL.
1997 *Océanie: la découverte du paradis, curieux, navigateurs et savants.* Paris: Somogy.

OBEYESEKERE, G.
1992 *The apotheosis of Captain Cook: European mythmaking in the Pacific.* Princeton: Princeton University Press.

OLDMAN, W.O.
2004 *The Oldman collection of Polynesian artifacts.* New edition of Polynesian Society Memoir 15. Originally published 1943. Auckland: The Polynesian Society.
2004a *The Oldman collection of Maori artifacts.* New edition of Polynesian Society Memoir 14. Originally published 1938. Auckland: The Polynesian Society.

OLIVER, D.L.
1974 *Ancient Tahitian society.* 3 vols. Honolulu: University of Hawaii Press.
1988 *Return to Tahiti: Bligh's second breadfruit voyage.* Honolulu: University of Hawaii Press.

ORANGE, C.
1987 *The Treaty of Waitangi.* Wellington: Allen & Unwin.

ORLIAC, C.
2000 *Fare et habitat à Tahiti.* Marseilles: Parenthèses.

ORTIZ, G.
1994 *In pursuit of the absolute: art of the ancient world from the George Ortiz collection.* London: Royal Academy of Art.

OTTINO-GARANGER, P. ET AL.
1998 *Te patu tiki: le tatouage aux Iles Marquises.* Singapore/Mo'orea: Christine Gleizal.

PAISLEY AND RENFREWSHIRE GAZETTE
1931 Nelson School rector: Mr. Louis N. Gow appointed. *Paisley and Renfrewshire Gazette*, 28 November 1931.

PANOFF, M. (ED.)
1995 *Trésors des Iles Marquises.* Paris: Réunion des Musées Nationaux.

PARKINSON, S.
1773 *A journal of a voyage to the South Seas, in His Majesty's ship the* Endeavour. London: Stanfield Parkinson.

PEARD, G.
1973 *To the Pacific and Arctic with Beechey: the journal of Lieutenant George Peard of H.M.S. 'Blossom', 1825–1828,* M. Gough (ed.). London: Cambridge University Press for the Hakluyt Society.

PENDERGRAST, M.
1987 *Te aho tapu: the sacred thread.* Honolulu: University of Hawaii Press in association with Auckland Institute and Museum.
1998 The fibre arts. In *Maori: art and culture*, D.C. Starzecka (ed.), 114–46. London: British Museum Press.

PHELPS, S.J. [S.J.P. HOOPER]
1976 *Art and artefacts of the Pacific, Africa and the Americas: the James Hooper collection.* London: Hutchinson.

PHILLIPS, G.
2004–5 Samwell, David (1751–91). *Oxford Dictionary of National Biography*, Oxford University Press.

PHILLIPS, W.
1826 *Catalogue of the Missionary Museum, Austin Friars.* London: London Missionary Society.

POLE, L.
1987 *Worlds of man: ethnography at the Saffron Walden Museum.* Saffron Walden: Saffron Walden Museum.

POLE, L. AND S. DOYAL
2004 *Second skin: sacred and everyday uses of bark worldwide.* Exeter: Royal Albert Memorial Museum.

PORTER, D.
1815 *A voyage in the South Seas, in the years 1812, 1823 and 1814 …* London: Sir Richard Phillips & Co.

QUILLEY, G. AND J. BONEHILL (EDS)
2004 *William Hodges, 1744–1797: the art of exploration.* New Haven: Yale University Press.

QUINNELL, M.
2000 'Before it has become too late': the making and repatriation of Sir William MacGregor's official collection from British New Guinea. In *Hunting the gatherers: ethnographic collectors, agents and agency in Melanesia, 1870s–1930s*, M. O'Hanlon and R.L. Welsch (eds), 81–102. New York and Oxford: Berghahn Books.

READ, C.H.
1892 An account of a collection of ethnographical specimens formed during Vancouver's voyage in the Pacific Ocean, 1790–1795. *Journal of the Anthropological Institute of Great Britain and Ireland*, 21: 99–108.

RICHARDS, R.
Forthcoming *Austral Island paddles.*

ROBARTS, E.
1974 *The Marquesan journal of Edward Robarts 1797–1824*, G. Dening (ed.). Canberra: Australian National University Press.

ROBERTSON, G.
1948 *The discovery of Tahiti: a journal of the second voyage of H.M.S.* Dolphin *round the world, under the command of Captain Wallis, in the years 1766, 1767 and 1768.* H. Carrington (ed.). London: Hakluyt Society.

ROSE, R.C.
1978 *Symbols of sovereignty: feather girdles of Tahiti and Hawaii.* Pacific Anthropological Records 28. Honolulu: B.P. Bishop Museum.
1979 On the origin and diversity of 'Tahitian' janiform fly whisks. In *Exploring the visual art of Oceania*, S.M. Mead (ed.), 202–13. Honolulu: University of Hawaii Press.
1980 *Hawai'i: the royal isles.* Special Publication 67. Honolulu: B.P. Bishop Museum.

ROTH, H.L.
1891 *Crozet's voyage to Tasmania, New Zealand, the Ladrone Islands, and the Philippines in the years 1771–1772.* London: Truslove & Shirley.

ROTH, J. AND S. HOOPER (EDS)
1990 *The Fiji journals of Baron Anatole von Hügel, 1875–1877.* Suva: Fiji Museum and Cambridge University Museum of Archaeology and Anthropology.

ROTH, G.K.
1937 A composite 'tambua' from Fiji. *Man*, 37: 121–22.

ROUTLEDGE, K.
1919 *The mystery of Easter Island: the story of an expedition.* London: Hazell, Watson and Viney.

RUBIN, W. (ED.)
1984 *'Primitivism' in 20th century art.* 2 vols. New York: Museum of Modern Art.

RUTHERFORD, J.
1961 *Sir George Grey, K.C.B., 1812–1898: a study in colonial government.* London: Cassell.

RYDEN, S.
1963 *The Banks collection: an episode in 18th century Anglo-Swedish relations.* Stockholm: Almqvist & Wiksell.

SAHLINS, M.D.
1958 *Social stratification in Polynesia.* Seattle: Washington University Press.
1981 The stranger-king: Dumézil among the Fijians. *The Journal of Pacific History*, 16(3): 107–32.
1981a *Historical metaphors and mythical realities: the early history of the Sandwich Islands Kingdom.* Ann Arbor: University of Michigan Press.
1983 Raw women, cooked men, and other 'great things' of the Fiji Islands. In *The ethnography*

of cannibalism, P. Brown and D. Tuzin (eds), 72–93. Washington: Society for Psychological Anthropology.
1985 *Islands of history.* Chicago and London: University of Chicago Press.
1990 The political economy of grandeur in Hawaii from 1810 to 1830. In *Culture through time: anthropological approaches*, E. Ohnuki-Tierney (ed.), 26–56. Stanford: Stanford University Press.
1995 *How 'natives' think. About Captain Cook, for example.* Chicago and London: University of Chicago Press.
2004 *Apologies to Thucydides: understanding history as culture and vice versa.* Chicago: University of Chicago Press.

SAINSBURY, R.J. (ED.)
1978 *Robert and Lisa Sainsbury collection.* Norwich: University of East Anglia.

SALMOND, A.
1991 *Two worlds: first meetings between Maori and Europeans 1642–1772.* Auckland and London: Viking.
1997 *Between worlds: early exchanges between Maori and Europeans.* Auckland: Viking.
2003 *The trial of the cannibal dog: Captain Cook in the South Seas.* London: Penguin.

SCARR, D.
1973 *I, the very bayonet: a life of Sir John Bates Thurston.* Volume 1 of *The majesty of colour: a life of Sir John Bates* by D. Scarr. Canberra: Australian National University Press.
2004–5 Thurston, Sir John Bates (1836–1897). *Oxford Dictionary of National Biography*, Oxford University Press.

SCHOEFFEL, P.
1999 Samoan exchange and 'fine mats': an historical reconsideration. *Journal of the Polynesian Society*, 108(2): 117–48.

SHARP, A.
1964 *Ancient voyagers in Polynesia.* London: Angus & Robertson.

SHORE, B.
1989 Mana and tapu. In *Developments in Polynesian ethnology*, A. Howard and R. Borofsky (eds), 137–74. Honolulu: University of Hawaii Press.

SILVER, S.W.
1876 *Catalogue of the nature and art collection, Letcombe Regis, Wantage, Berks, formed by S.W. Silver.* [London: office of the colonies.]
1882 *Catalogue of the York Gate Geographical and Colonial Library.* Compiled by E.A. Petherick. London: R. Clay, Sons & Taylor.

SINOTO, Y.H. AND P.C. McCOY
1975 Report on the preliminary excavation of an early habitation site on Huahine, Society

Islands. *Journal de la Société des Océanistes*, 47: 143–86.

SIVASUNDARAM, S.
2005 *Nature and the godly empire: science and evangelical mission in the Pacific, 1795–1850.* Cambridge: Cambridge University Press.

SKINNER, H.D.
1974 *Comparatively speaking: studies in Pacific material culture.* Dunedin: University of Otago Press.

SMITH, B.
1985 *European vision and the South Pacific.* New Haven: Yale University Press.
1992 *Imagining the Pacific: in the wake of the Cook voyages.* New Haven: Yale University Press.

SÖDERSTRÖM, J.
1939 *Anders Sparmann's ethnographical collection from James Cook's second expedition to the Southern Pacific (1772–1775).* Stockholm: Ethnographical Museum of Sweden.

SOTHEBY'S
1978 *Catalogue of the George Ortiz collection of African and Oceanic works of art … Thursday, 29 June, 1978.* London: Sotheby Parke Bernet.

SPATE, O.H.K.
1979 *The Spanish lake.* London: Croom Helm.

ST. CARTMAIL, K.
1997 *The art of Tonga: ko e ngaahi 'aati 'o Tonga.* Honolulu: University of Hawaii Press.

STARZECKA, D.
1976 *Hawaii: people and culture.* London: British Museum Publications.
1998 (ed.) *Maori: art and culture.* 2nd edition. London: British Museum Press.

STIMSON, J.F.
1933 *Tuamotuan religion.* Bulletin 103. Honolulu: B.P. Bishop Museum.

STRATHERN, M.
1988 *The gender of the gift: problems with women and problems with society in Melanesia.* Berkeley: University of California Press.

STUTCHBURY, S.
1996 *Science in a sea of commerce: the journal of a South Seas trading venture (1825–27)*, D. Branagan (ed.). Sydney: Oxford University Press.

SUGGS, R.C.
1960 *The island civilizations of Polynesia.* New York: New American Library.

TANNER, J.
1999 *From Pacific shores: eighteenth-century ethnographic collections at Cambridge, the voyages of Cook, Vancouver and the first fleet.* Cambridge: Cambridge University Museum of Archaeology and Anthropology.

TAPSELL, P.
2000 *Pukaki: a comet returns*. Auckland: Reed.

TAYLOR, R.
1855 *Te ika a Maui, or New Zealand and its inhabitants*. London: Wertheim & Macintosh

TEILHET, J.H.
1979 The equivocal nature of a masking tradition in Polynesia. In *Exploring the visual art of Oceania*, S.M. Mead (ed.), 192–201. Honolulu: University of Hawaii Press.

THOMAS, N.
1990 *Marquesan societies: inequality and political transformation in eastern Polynesia*. Oxford: Clarendon Press.
1991 *Entangled objects: exchange, material culture and colonialism in the Pacific*. Cambridge and London: Harvard University Press.
1995 *Oceanic art*. London: Thames & Hudson.
2003 *Discoveries: the voyages of Captain Cook*. London: Allen Lane.

THOMSON, W.T.
1891 *Te Pito Henua, or Easter Island*. Washington DC: Smithsonian Institution.

TORRENS, H.S.
2004–5 Conybeare, John Josias (1779–1824). *Oxford Dictionary of National Biography*, Oxford University Press.

TURNBULL, D.
1998 Cook and Tupaia, a tale of cartographic méconnaissance? In *Science and exploration in the Pacific: European voyages to the southern oceans in the 18th century*, M. Lincoln (ed.), 117–31.Woodbridge: Boydell Press and the National Maritime Museum.

VALERI, V.
1985 *Kingship and sacrifice: ritual and society in ancient Hawaii*. Chicago: University of Chicago Press.
1985a The conqueror becomes king: a political analysis of the Hawaiian legend of 'Umi. In *Transformations of Polynesian culture*, A. Hooper and J. Huntsman (eds), 79–104. Auckland: The Polynesian Society.
1990 Constitutive history; genealogy and narrative in the legitimation of Hawaiian kingship. In *Culture through time: anthropological approaches*, E. Ohnuki-Tierney (ed.), 154–92. Stanford: Stanford University Press.

VANCOUVER, G.
1798 *A voyage of discovery to the North Pacific Ocean, and round the world …* 3 vols. London: Robinson and Edwards.
1984 *A voyage of discovery to the North Pacific Ocean and round the world 1791–1795*, W. Kaye Lamb (ed.). 4 vols. London: Hakluyt Society.

VAN TILBURG, J.A.
1992 *H.M.S.* Topaze *on Easter Island: Hoa Hakananai'a and five other museum sculptures in archaeological context*. London: British Museum Press.
1994 *Easter Island: archaeology, ecology and culture*. London: British Museum Press.
2004 *Hoa Hakananai'a*. London: British Museum Press.

VASON, G.
1810 *An authentic narrative of four years' residence at Tongataboo, one of the Friendly Islands, in the South Sea*. London: printed for Longman, Hurst, Rees & Orme.

VÉRIN, P.
1969 *L'ancienne civilisation de Rurutu (Iles Australes, Polynésie Française)*. Paris: ORSTOM.

VIOLA, H.J. AND C. MARGOLIS
1985 *Magnificent voyagers: the U.S. Exploring Expedition, 1838–1842*. Washington DC: Smithsonian Institution Press.

VON DEN STEINEN, K.
1925–1928 *Die Marquesaner und ihre Kunst*. 3 vols. Berlin: Reimer. Reprinted 1969.

WALCOTT, R.H.
1912 Note on Fijian clubs ornamented with Maori patterns. *Memoirs of the National Museum, Melbourne*, 4: 54–7.

WARDWELL, A.
1967 *The sculpture of Polynesia*. Chicago: Art Institute of Chicago.

WASHBROOK, D.
2004–5 Lytton, Edward Robert Bulwer, first earl of Lytton (1831–1891). *Oxford Dictionary of National Biography*, Oxford University Press.

WATERFIELD, A.H.
2002 Lt General Augustus Henry Lane Fox Pitt-Rivers. *Arts and Cultures*, 3: 58–71.

WATERFIELD, A.H. AND J.C.H. KING
Forthcoming *Provenance: Twelve collectors of tribal art in England who span two hundred years*. Geneva: Musée Barbier-Mueller.

WEBSTER, K.A.
1948 *The Armytage collection of Maori jade*. London: Cable Press.

WEBSTER, W.D.
1895–1901 *Illustrated catalogues of ethnographical specimens …* Bicester: printed privately.

WHEELER, D.
1842 *Memoirs of the life and gospel labours of the late Daniel Wheeler*. London: Harvey & Darton.

WHITEHOUSE, H.
1995 *Inside the cult: religious innovation and transmission in Papua New Guinea*. Oxford: Clarendon Press.
2004 *Modes of religiosity: a cognitive theory of religious transmission*. Walnut Creek: Altamira Press.

WHITEHOUSE. H. AND L.H. MARTIN (EDS)
2004 *Theorizing religions past: archaeology, history, and cognition*. Walnut Creek: Altamira Press.

WILKES, C.
1845 *Narrative of the United States Exploring Expedition, 1838–1842*. 5 vols. Philadelphia: Lea & Blanchard. Reprinted 1970 by Gregg Press.

WILLIAMS, J.
1837 *A narrative of missionary enterprises in the South Sea Islands*. London: J. Snow.

WILLIAMS, G.
1997 *The great South Sea: English voyages and encounters, 1570–1750*. New Haven: Yale University Press.
2004 (ed.) *Captain Cook: explorations and reassessments*. Woodbridge: Boydell Press.

WILLIAMS, T.
1858 *Fiji and the Fijians*, G. Stringer Rowe (ed.). London: Heylin.
1931 *The journal of Thomas Williams, missionary in Fiji, 1840–1853*, G.C. Henderson (ed.). 2 vols. Sydney: Angus & Robertson.

WILSON, J.
1799 *A missionary voyage to the Southern Pacific ocean, performed in the years 1769, 1797, 1798, in the ship* Duff, *commanded by Captain James Wilson*. London: T. Chapman.

WOOD, P.
2004–5 Anderson, John (1726–96). *Oxford Dictionary of National Biography*, Oxford University Press.

WORONCOW, B.
1981 George Bennet: 1775–1841. *Museum Ethnographer's Group Newsletter*, 12: 45–58.

WEBSITES CONSULTED:
British Museum Compass: http://www.thebritishmuseum.ac.uk/compass/

Cambridge University Museum of Archaeology and Anthropology: http://museum-server.archanth.cam.ac.uk/museum.html

Marischal Museum, University of Aberdeen: http://www.abdn.ac.uk/virtualmuseum/

Oxford Dictionary of National Biography: http://www.oxforddnb.com

Pitt Rivers Museum, Oxford: http://www.prm.ox.ac.uk/

Index

COMPILED BY STEVEN HOOPER AND ANDREW MILLS

Photographic credits and loans list